LIBRARIES NI
WITHDRAWN FROM STOCK

THE MONSTER BOOK OF MANGA

FAIRIES AND MAGICAL CREATURES

Edited by Ikari Studio

Collins

THE MONSTER BOOK OF MANGA: FAIRIES AND MAGICAL CREATURES
Copyright © 2007 by COLLINS DESIGN and maomao publications

Published in the UK in 2007 by
Collins, an imprint of
HarperCollins Publishers
77-85 Fulham Palace Road
Hammersmith
London W6 8JB

The Collins website address is
www.collins.co.uk

Collins is a registered trademark
of HarperCollins Publishers Ltd

10 09 08 07
6 5 4 3 2 1

First edition published by maomao publications in 2007
C/Tallers 22 bis, 3º1ª
08001 Barcelona, Spain
www.maomaopublications.com

English language edition first published in 2007 by
Collins Design, an imprint of
HarperCollins*Publishers*
10 East 53rd Street
New York, NY 10022, USA

All rights reserved. No part of this publication may be reproduced, stored in a retrieval system, or
transmitted, in any form or by any means, electronic, mechanical, photocopying, recording or
otherwise, without the prior written permission of the publishers.

A catalogue record for this book is available from the British Library.

ISBN 978 0 00 726436 0

Publisher: Paco Asensio
Editor: Cristian Campos
Text and illustrations: Ikari Studio (Santi Casas, Daniel Vendrell, David López)
Art Director: Emma Termes Parera
Layout: Zahira Rodriguez Mediavilla

Printed in China

WESTERN EDUCATION AND LIBRARY BOARD	
C502850763	
Bertrams	26.01.08
743.87	£15.99

CONTENTS

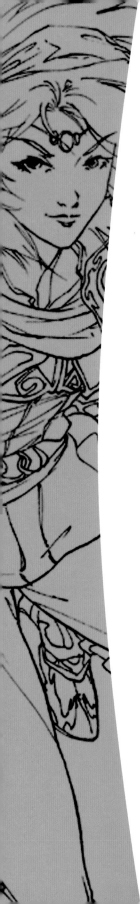

INTRODUCTION

Why combine Manga and fantasy? Perhaps because Manga is the most widely read comic style in the world: many of the new titles that are published daily have paved the way for an incredible diversity of new genres with extremely specialized plots. Fantasy and adventure stories are also common across all cultures: each has its own tradition, mainly oral, of magical beings and legendary heroes that parallel those created in fantasy literature. The legacy and powerful influence of fantasy writers such as J.R.R Tolkien and the wide variety of TSR worlds have served as the base for this genre's evolution. These epic stories captivated lots of Japanese writers, the first Manga comics dealt with these legends, such as the now legendary record of the Lodoss War.

Board games were also very influential since their great popularity left thousands of fans demanding more mythical stories. Later videogames got in on the action, letting players go to places they didn't have to imagine because they could see them on the screen—first in two dimensions and then in virtual reality. Today, the literary offspring of traditional myths, especially Manga versions and genre-based videogames, are one of the main influences for the world of fantasy literature.

Aside from finding useful examples of how to practice drawing, you'll meet the main characters of these myths and legends. You'll follow the step-by-step process for each illustration, in a way that

makes it easy to understand which elements must be mastered in order to achieve professional-looking illustrations. We'll start by following the selection process to give more volume to a character in a given space. Next, we'll take a closer look at the characters' anatomy, which is essential for any illustrator. Then we'll reveal the secrets for dressing these characters so that they look like real legendary heroes. Finally, we'll show you the secret power of color, which is capable of illuminating any drawing and turning it into art.

You'll also go on a journey to discover the world of legends. Enjoy a firsthand look at the marvelous landscapes, since in addition to the characters we've also recreated the places and settings where the stories can take place.

So take off on an incredible adventure: fly, on the back of the phoenix, from the fantastic world of the magical kingdom to the fairy-filled enchanted garden, ride a unicorn through the shadows of the haunted forest; go on horseback through the fields of legends, defending justice alongside the greatest heroes; and face the desolation and danger of the shadowlands before reaching the heart of darkness in the underworld. Because this is exactly how a fantasy kingdom should be.

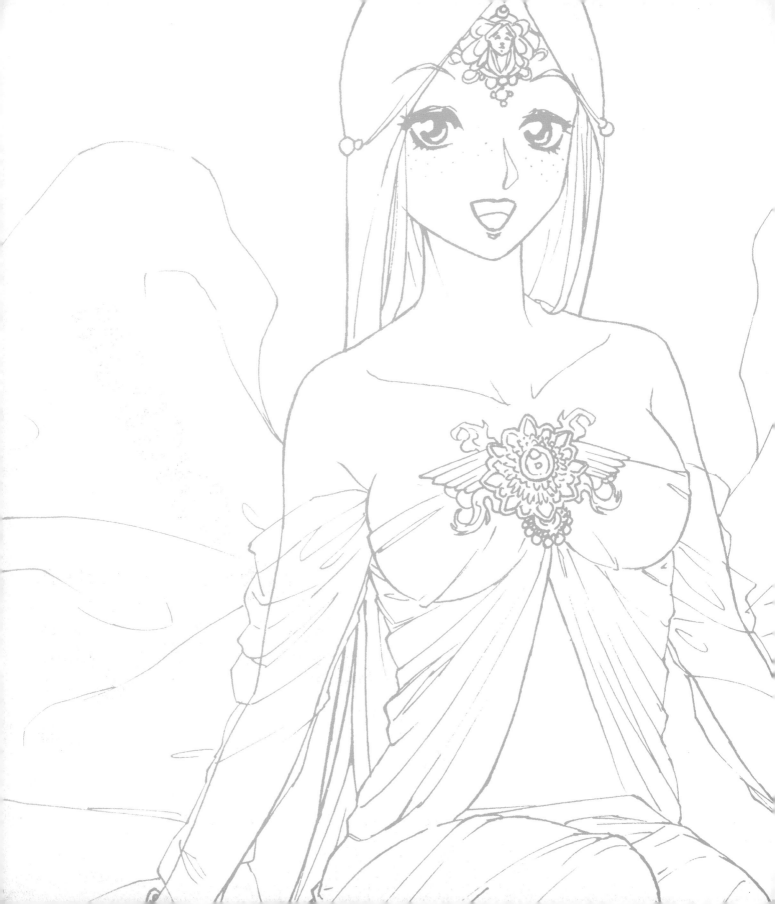

A MAGICAL KINGDOM

Empress of Light
Master of Time
Prince
Princess
Castle in the Clouds

EMPRESS OF LIGHT

The empress of this magical kingdom is noble and innocent, beautiful and natural. She is happy and has an appeasing smile. And this is why we'll be drawing a young maiden, a teenager who still maintains her youthful shine and hasn't lost the ability to be surprised by the marvelous things in her kingdom. It's very important to give characters personality, even those drawn in a simple manner.

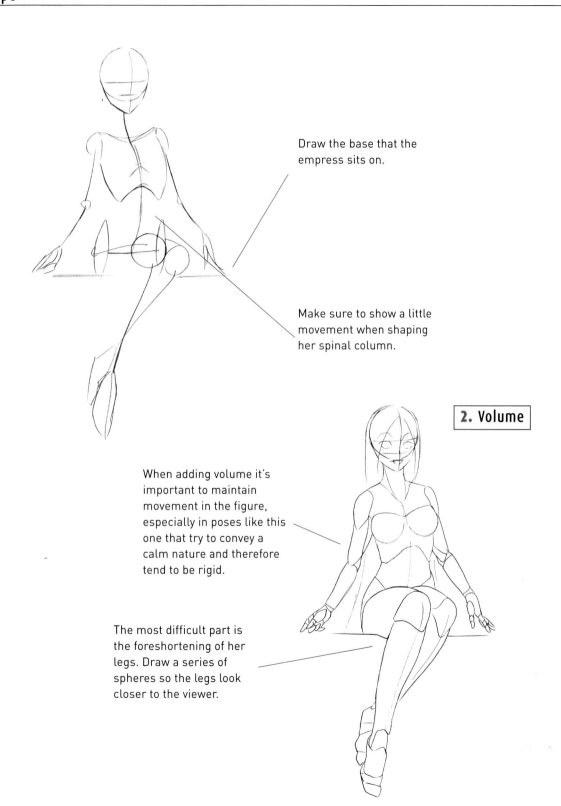

Draw the base that the empress sits on.

Make sure to show a little movement when shaping her spinal column.

2. Volume

When adding volume it's important to maintain movement in the figure, especially in poses like this one that try to convey a calm nature and therefore tend to be rigid.

The most difficult part is the foreshortening of her legs. Draw a series of spheres so the legs look closer to the viewer.

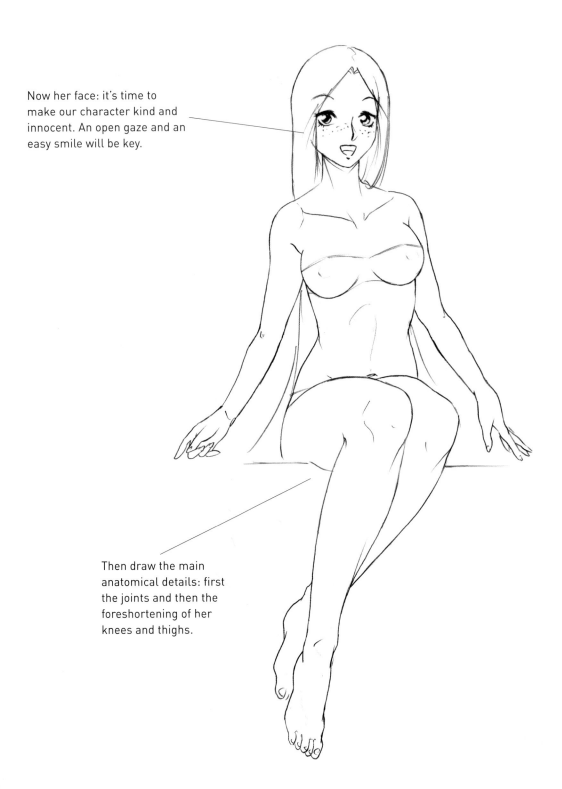

Now her face: it's time to make our character kind and innocent. An open gaze and an easy smile will be key.

Then draw the main anatomical details: first the joints and then the foreshortening of her knees and thighs.

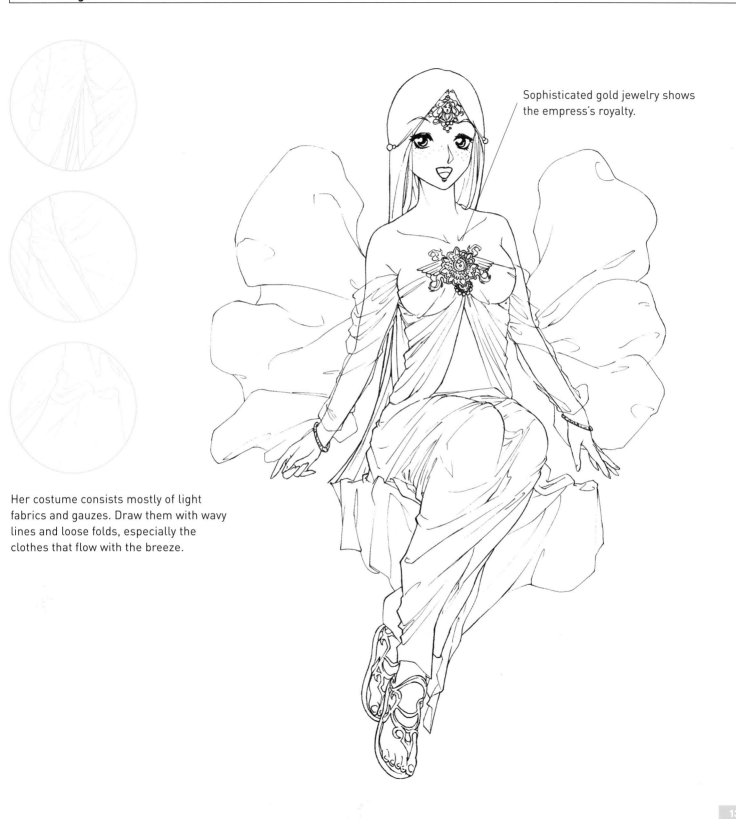

Sophisticated gold jewelry shows the empress's royalty.

Her costume consists mostly of light fabrics and gauzes. Draw them with wavy lines and loose folds, especially the clothes that flow with the breeze.

A soft light from on high bathes the scene; so don't use sharply contrasting shadows that harden our character's appearance.

Source of light

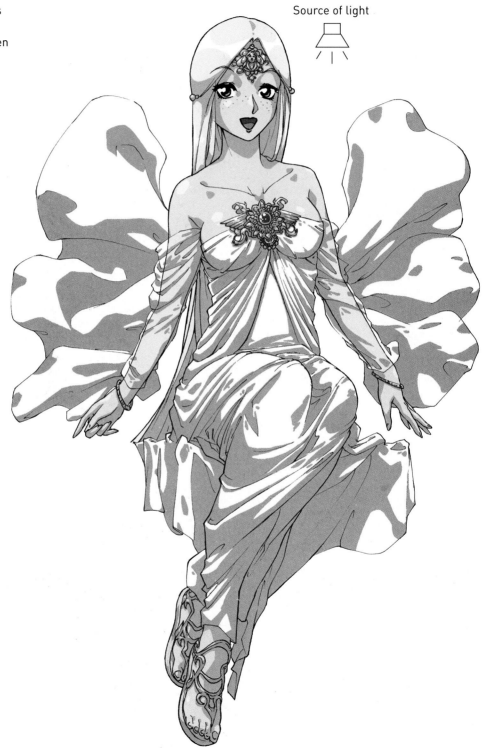

We'll lend greater contrast to her jewelry in order to highlight the precious stones and metals.

Color the image with soft tones. We'll use yellow and blue as base colors since they connote gold and the sky, making them perfect for the empress of our magical kingdom.

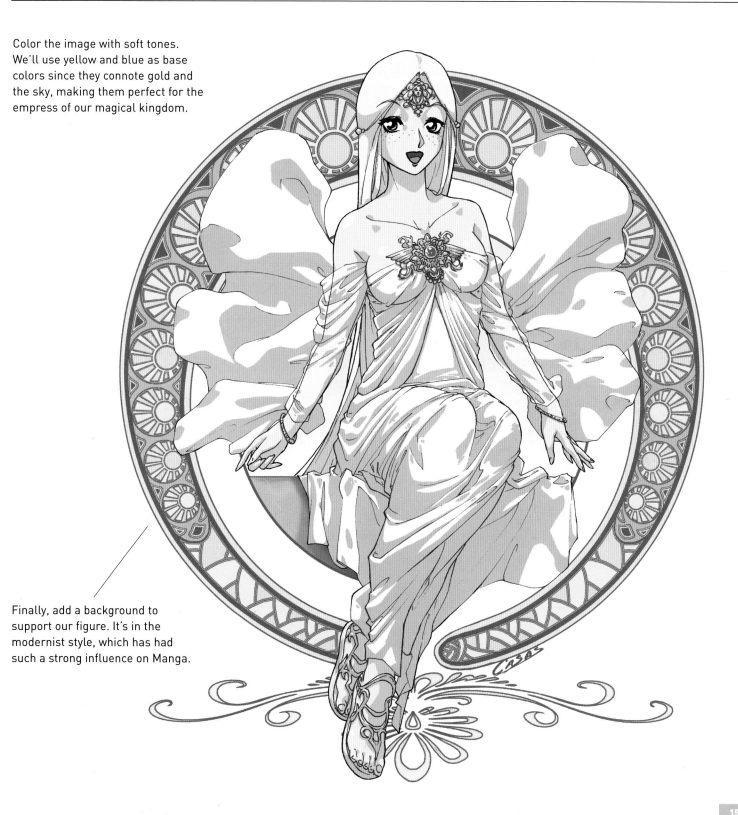

Finally, add a background to support our figure. It's in the modernist style, which has had such a strong influence on Manga.

MASTER OF TIME

We've named a very special wizard the Master of Time. This character is more talented than his coworkers since he devotes himself to studying the secrets of space, especially time. He is a traveler of dimensions, jumping from one era to another in search of knowledge and scientific gadgets beyond our wildest imagination.

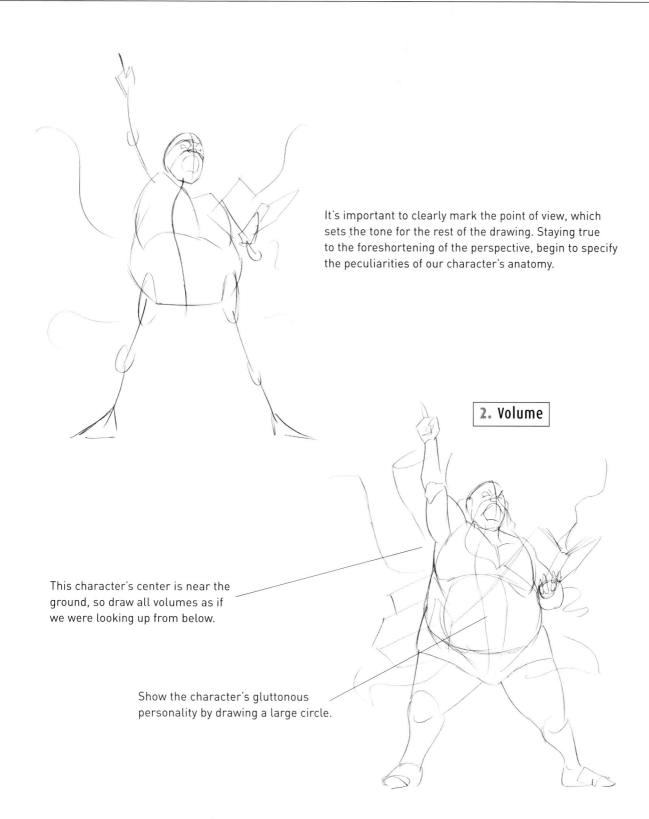

It's important to clearly mark the point of view, which sets the tone for the rest of the drawing. Staying true to the foreshortening of the perspective, begin to specify the peculiarities of our character's anatomy.

2. Volume

This character's center is near the ground, so draw all volumes as if we were looking up from below.

Show the character's gluttonous personality by drawing a large circle.

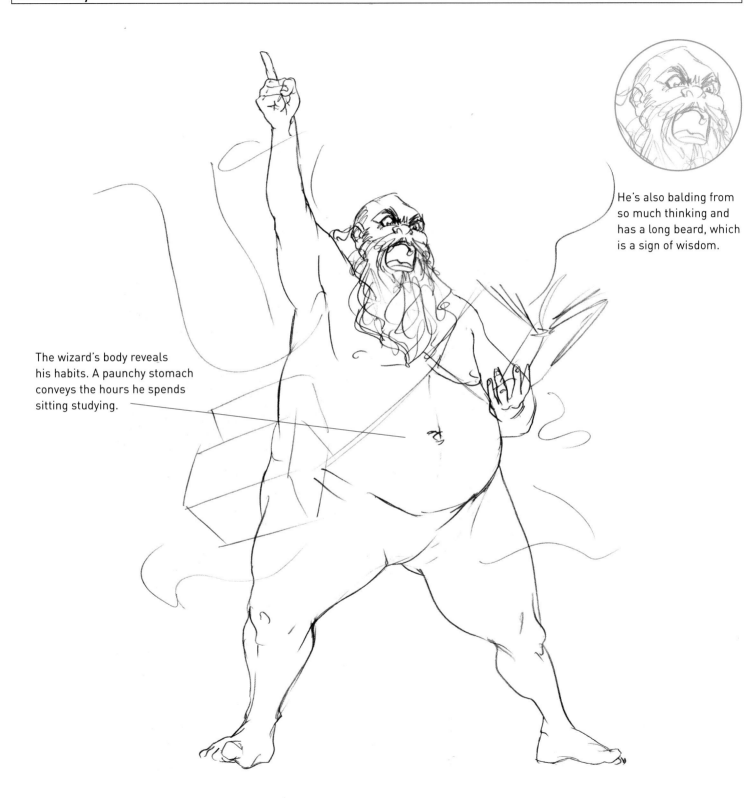

He's also balding from so much thinking and has a long beard, which is a sign of wisdom.

The wizard's body reveals his habits. A paunchy stomach conveys the hours he spends sitting studying.

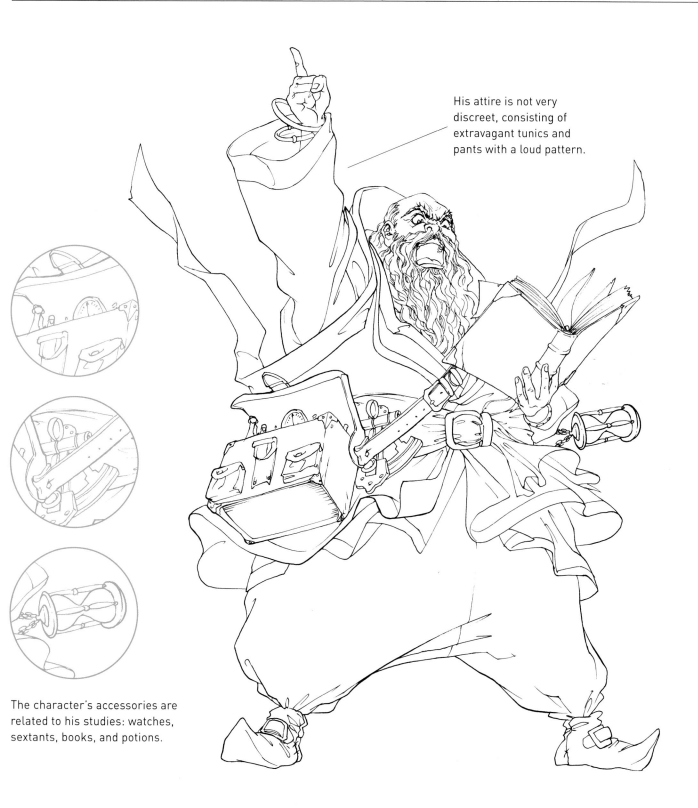

His attire is not very discreet, consisting of extravagant tunics and pants with a loud pattern.

The character's accessories are related to his studies: watches, sextants, books, and potions.

This is one of the drawing's strong points, as it is full of special effects. The main source of light comes from below the image, which means we invert the usual order of light and shade. What's more, the magical symbols make the light look more distinctive.

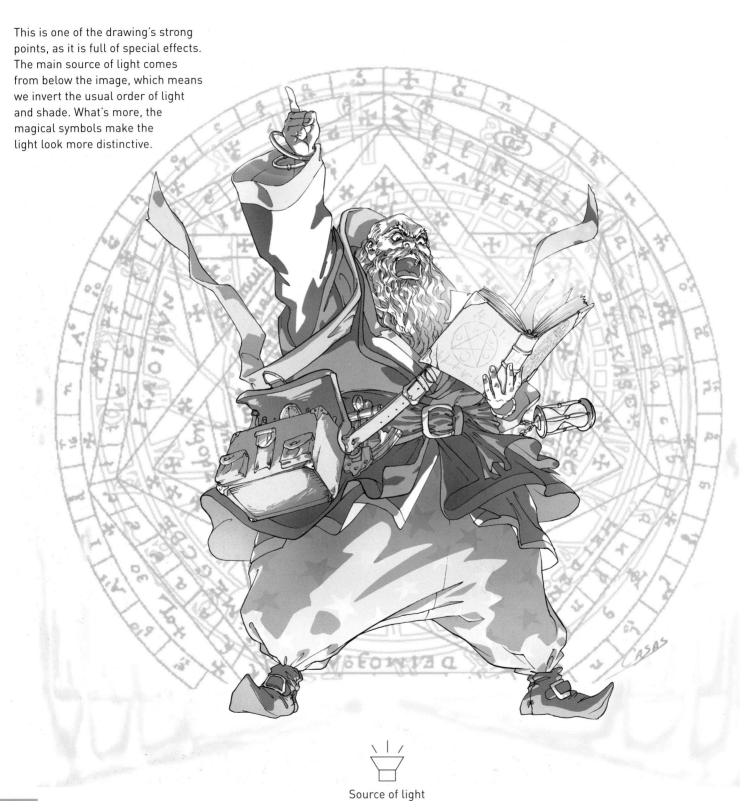

Source of light

Create a magical atmosphere by using bright colors and special effects.

There's nothing modest about this wizard's clothes. Use bold colors and patterns for his garb.

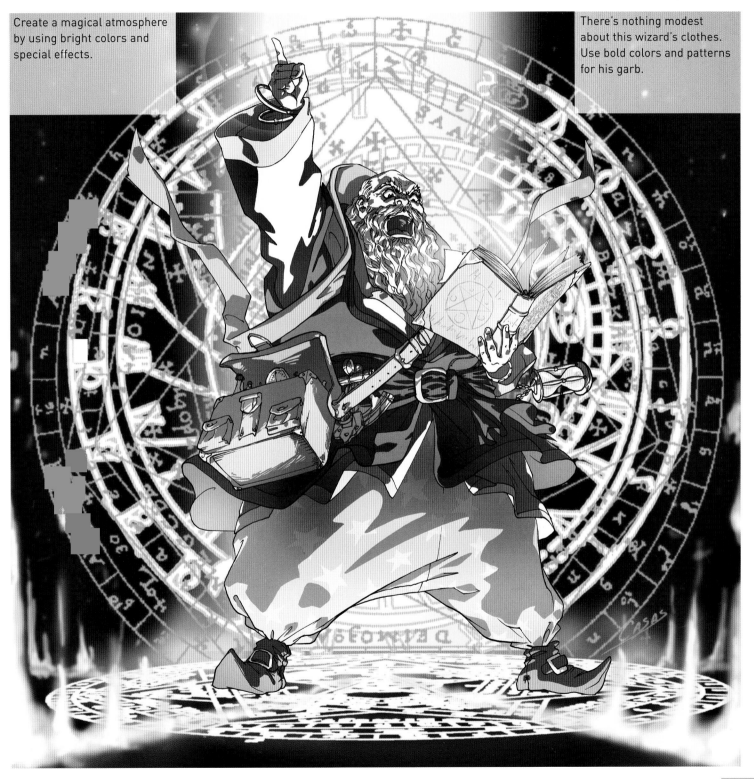

PRINCE

Princes are often the main characters in fantasy tales. In hundreds of stories, the prince of a forgotten kingdom becomes a hero thanks to his larger-than-life deeds. We'll use this archetype to construct our character, making him strong and attractive, while at the same time delicate and boyish.

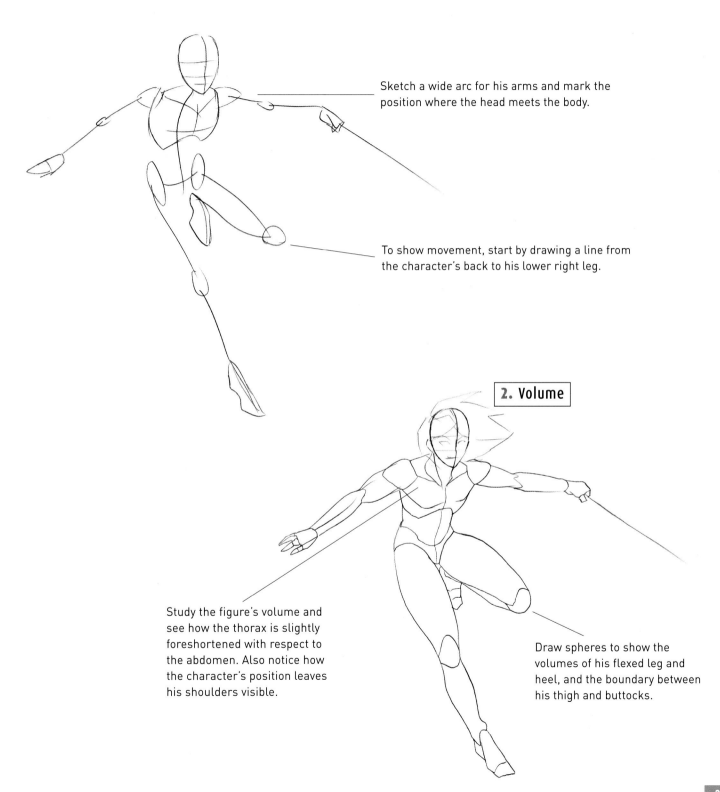

Sketch a wide arc for his arms and mark the position where the head meets the body.

To show movement, start by drawing a line from the character's back to his lower right leg.

2. Volume

Study the figure's volume and see how the thorax is slightly foreshortened with respect to the abdomen. Also notice how the character's position leaves his shoulders visible.

Draw spheres to show the volumes of his flexed leg and heel, and the boundary between his thigh and buttocks.

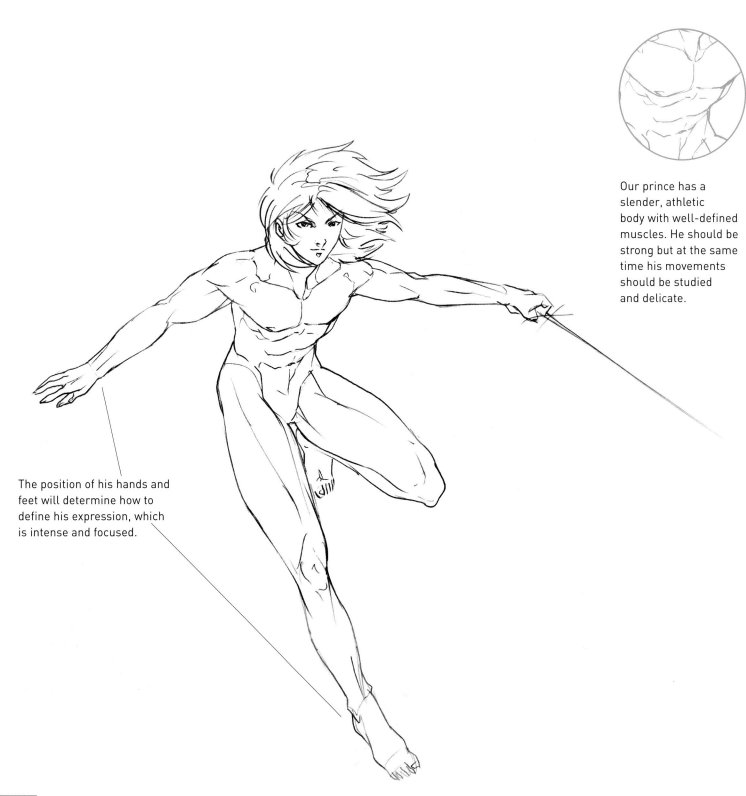

Our prince has a slender, athletic body with well-defined muscles. He should be strong but at the same time his movements should be studied and delicate.

The position of his hands and feet will determine how to define his expression, which is intense and focused.

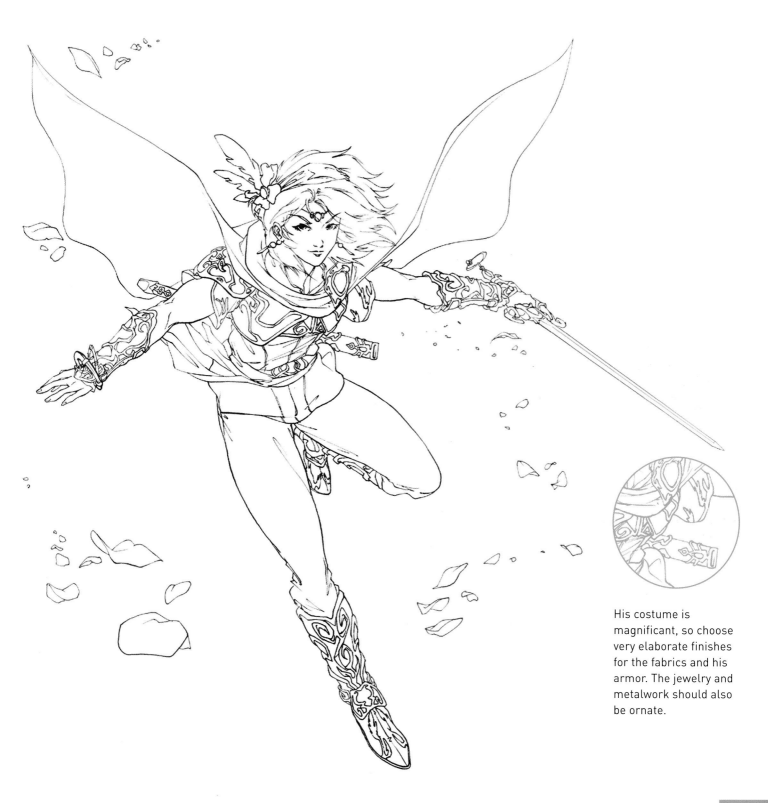

His costume is magnificant, so choose very elaborate finishes for the fabrics and his armor. The jewelry and metalwork should also be ornate.

Source of light

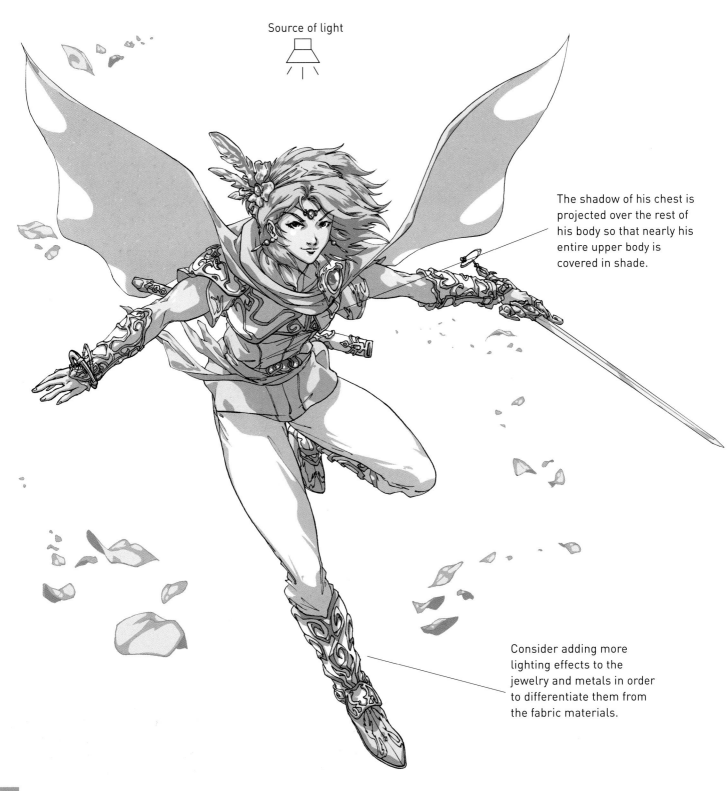

The shadow of his chest is projected over the rest of his body so that nearly his entire upper body is covered in shade.

Consider adding more lighting effects to the jewelry and metals in order to differentiate them from the fabric materials.

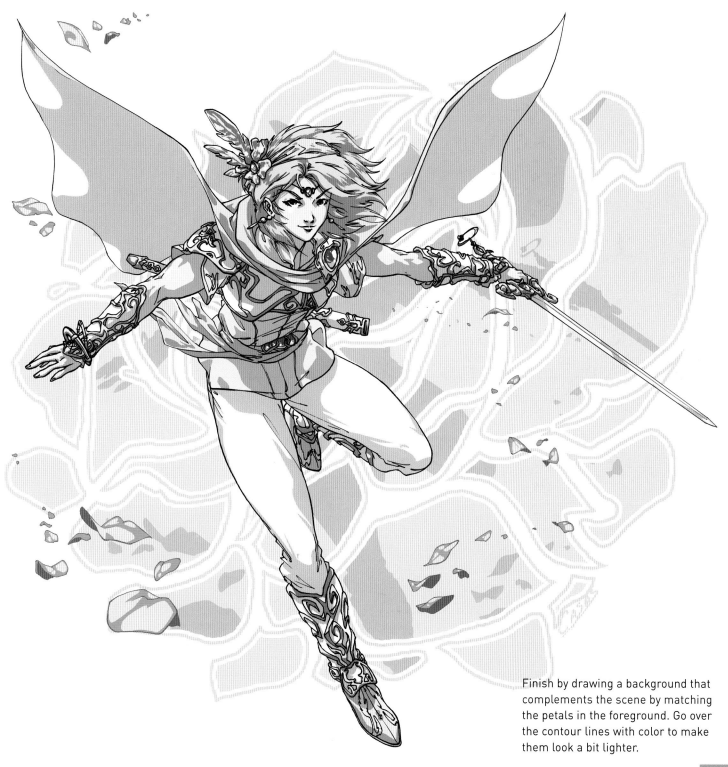

Finish by drawing a background that complements the scene by matching the petals in the foreground. Go over the contour lines with color to make them look a bit lighter.

PRINCESS

A princess is what every girl dreams of becoming. The princess in this fantasy kingdom is graceful and carefree, innocent and pure. She has a big heart and is loved by everyone. Although she's been strictly raised, she doesn't think twice about running through the beautiful gardens to play with her animals, and it hasn't kept her from fantasizing about her Prince Charming.

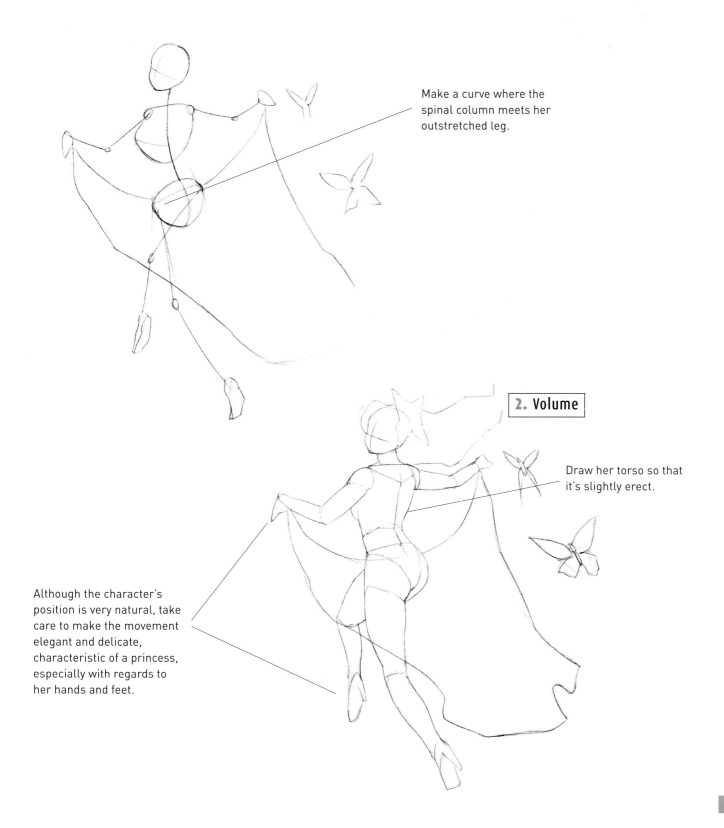

Make a curve where the spinal column meets her outstretched leg.

2. Volume

Draw her torso so that it's slightly erect.

Although the character's position is very natural, take care to make the movement elegant and delicate, characteristic of a princess, especially with regards to her hands and feet.

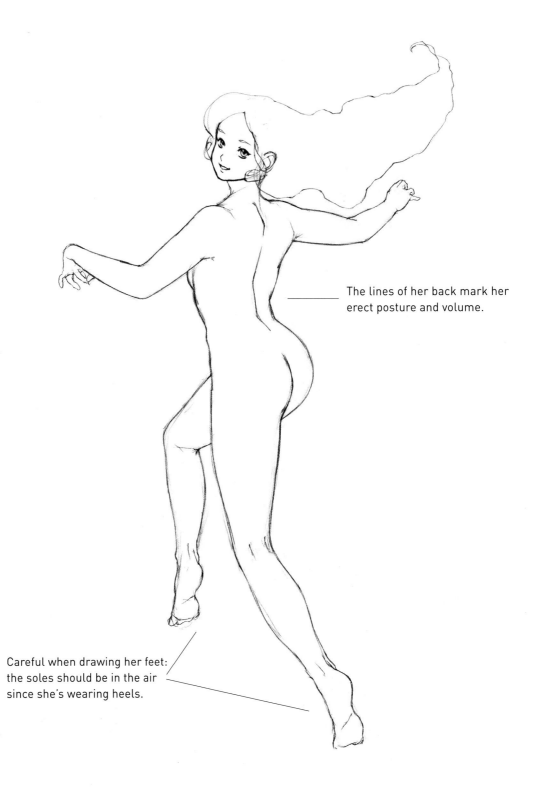

The lines of her back mark her erect posture and volume.

Careful when drawing her feet: the soles should be in the air since she's wearing heels.

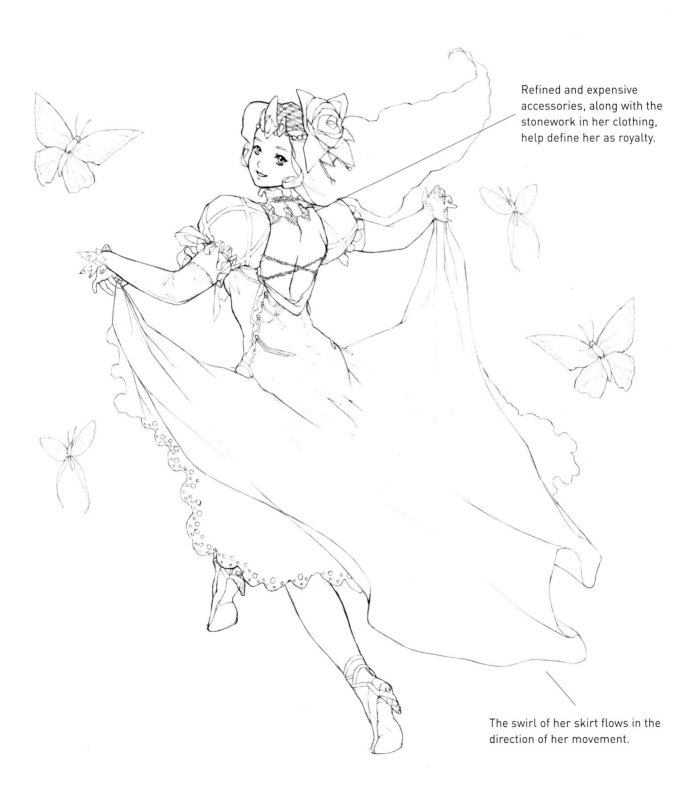

Refined and expensive accessories, along with the stonework in her clothing, help define her as royalty.

The swirl of her skirt flows in the direction of her movement.

Shade her clothes and hair by adding wrinkles. Then brighten her hair with lots of color.

Source of light

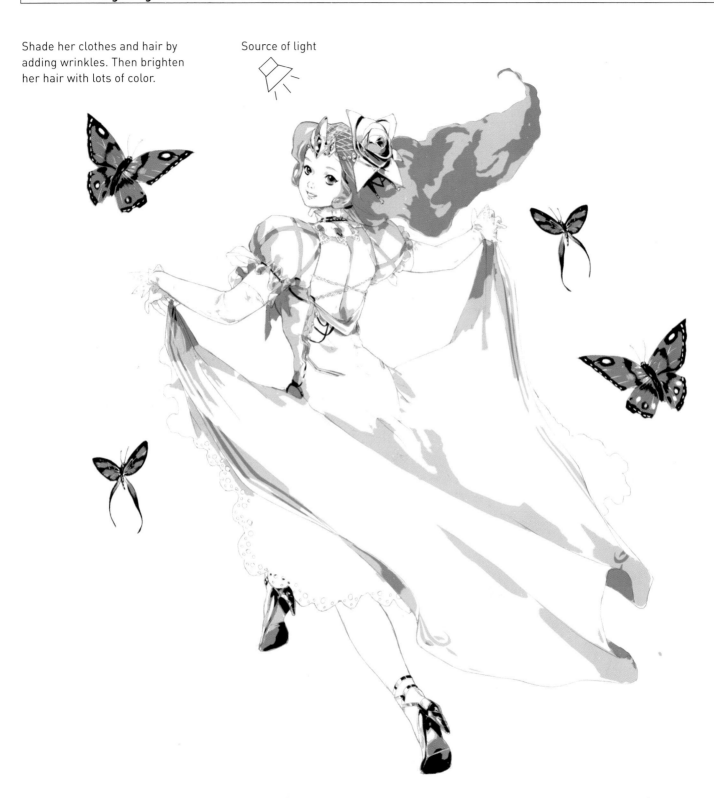

Choose autumn colors, which are warm and a good match for the princess's personality. Add highlights to the metallic accessories.

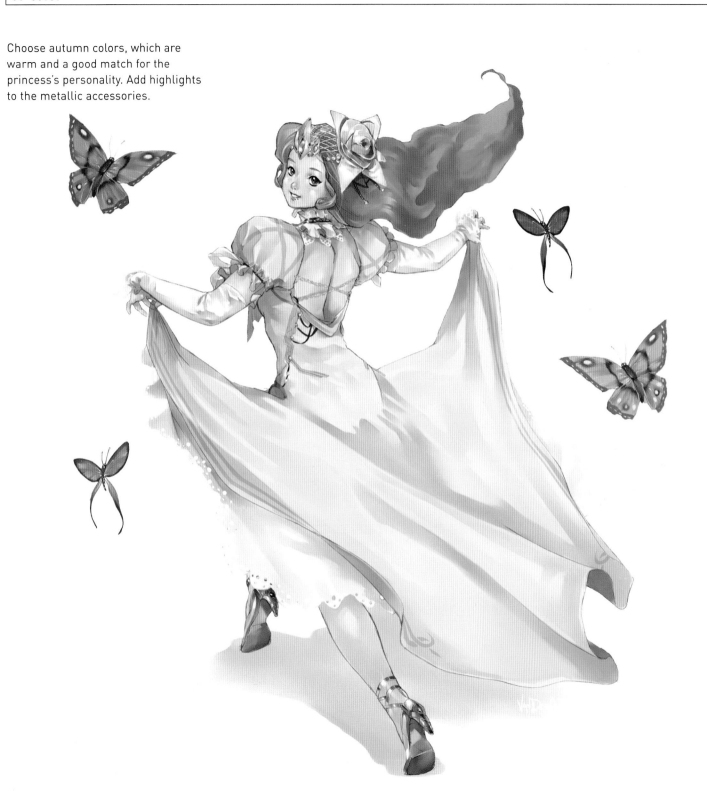

CASTLE IN THE CLOUDS

Castles are large fortified structures used for many things. Besides serving as homes for royal families, they are usually used for military purposes. They tend to be located in privileged areas and at higher altitudes in order to dominate over vast areas of land while being more resistant against sieges.

We're going to build our magnificent fantasy fortress high above the mountains, up in the clouds. It's a castle of light, casting a glow over all its kingdoms and protecting them from those who live in the shadows.

First inlay each of the elements: Mark the diagonal lines of the clouds and draw a rough sketch of the castle and its towers.

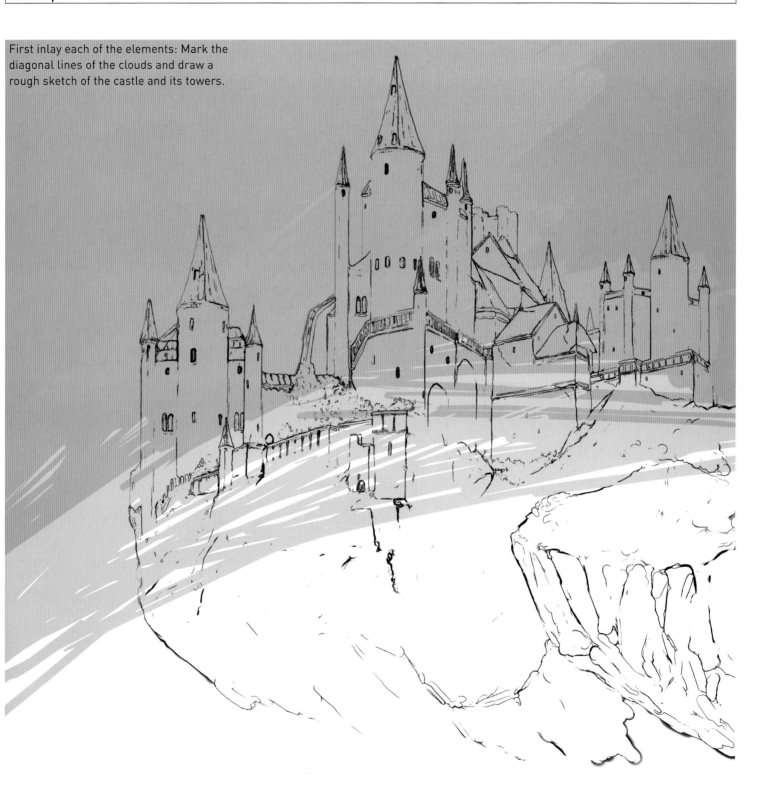

Next mark the main source of light, and then shade in the most important areas of light and shadow.

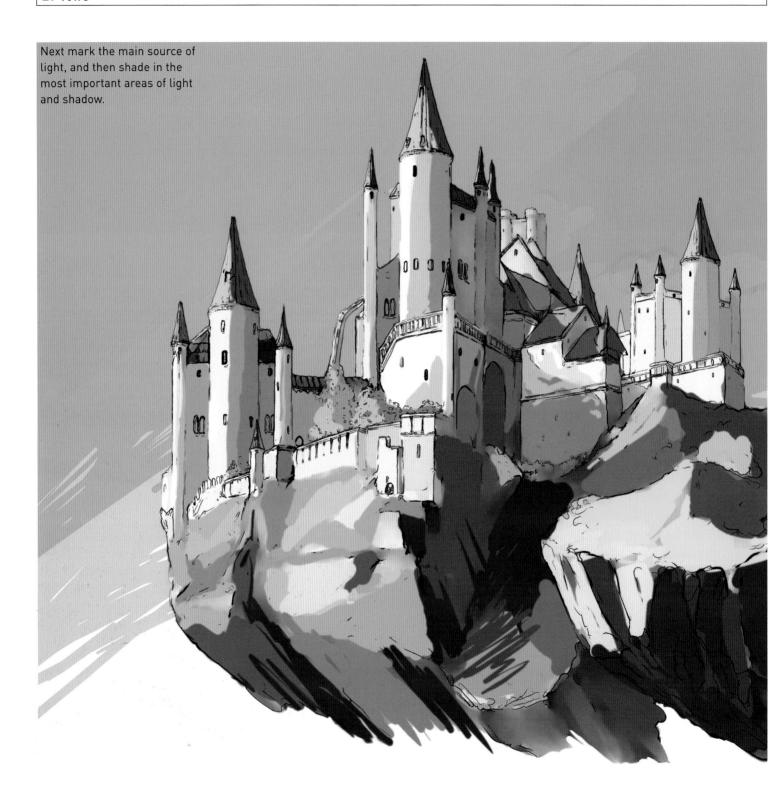

The colors in our sky should coincide with the colors we've used in our construction.

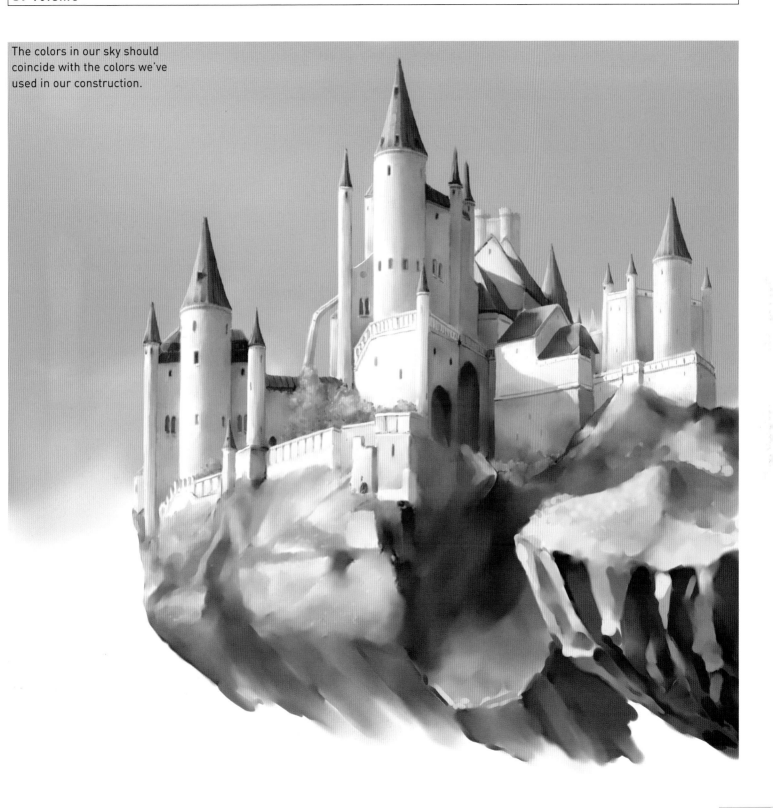

It's important to differentiate
textures in the drawing.

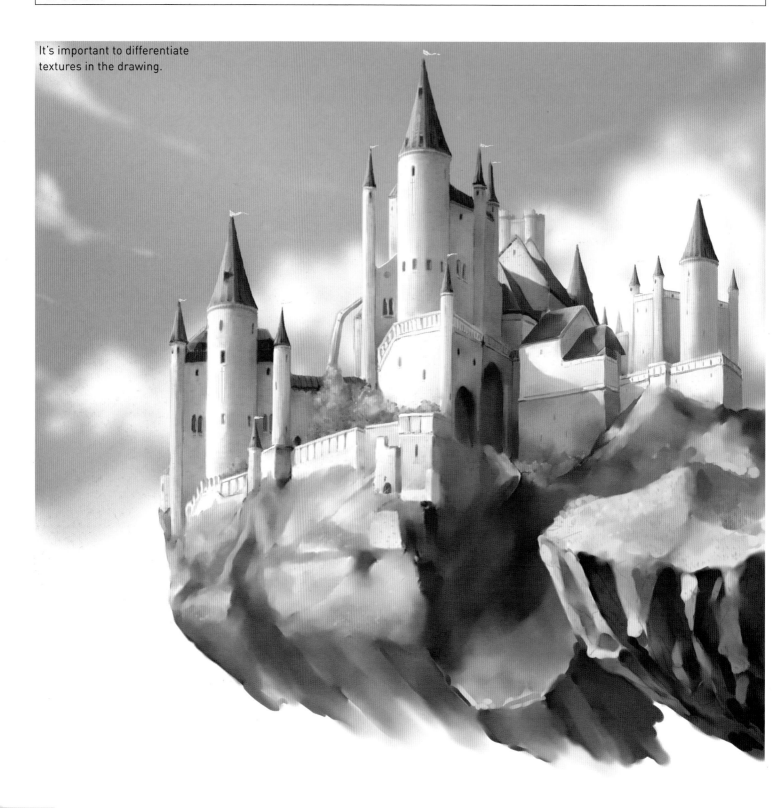

We'll complete the drawing by adding touches of color on the rooftops, the flags, and the peaks of the towers.

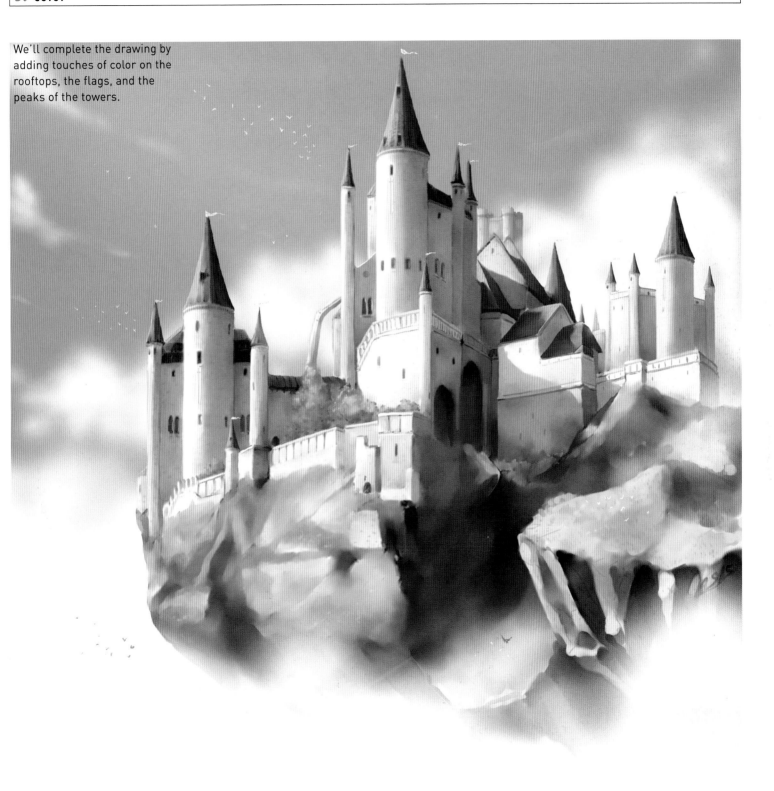

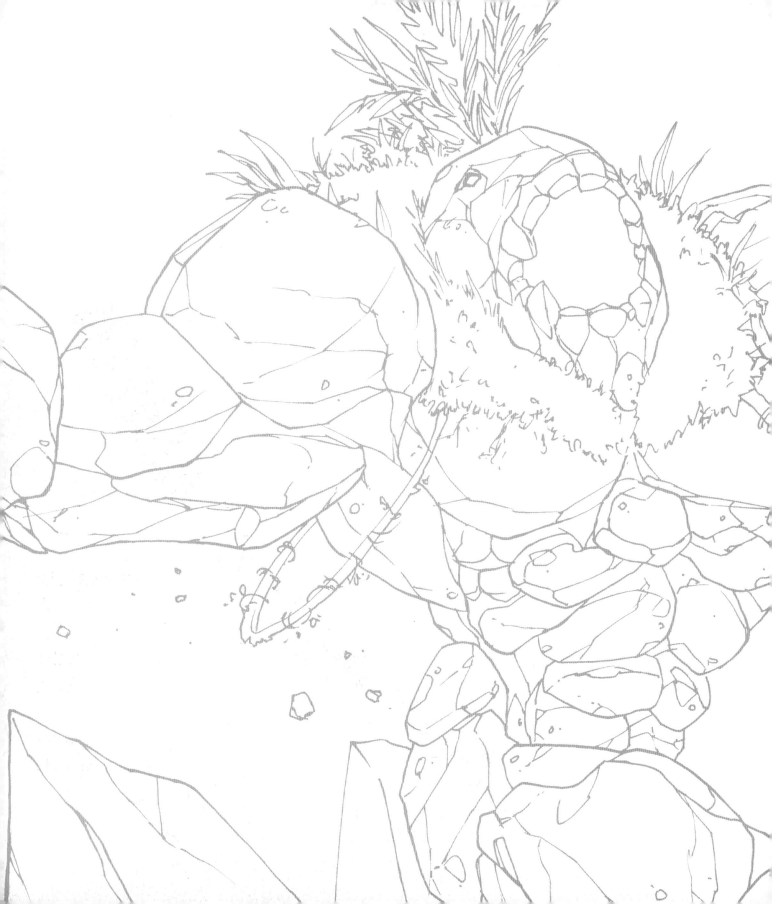

THE POWERS OF HEAVEN

The Elements:
Air
Fire
Water
Earth

Angel
God of Goodness

AIR

Let's embark on a series of elemental characters, each linked to a force of nature.

Many people believe fairies are tied to the air. Air is the element of the intellect and, for this reason, these beings are extremely dangerous, independent, and difficult to control once they are conjured. These powerful creatures can be summoned in open spaces, especially when the wind blows. They usually appear in the form of a blizzard or cloud with a somewhat human silhouette. When a gust of wind is not enough to ward off their enemies, they are able to turn into a cyclone and beat down on the land with the force of a hurricane.

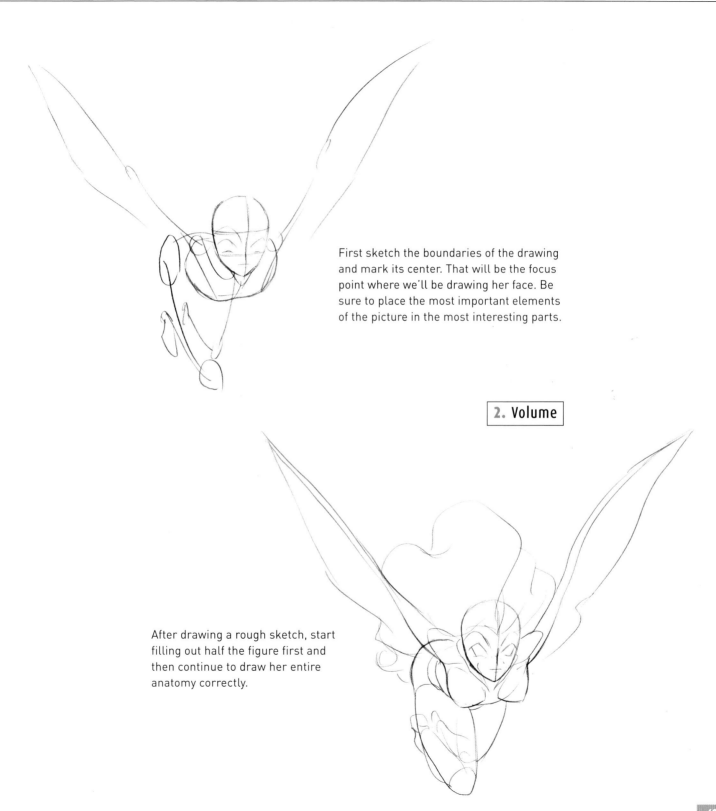

First sketch the boundaries of the drawing and mark its center. That will be the focus point where we'll be drawing her face. Be sure to place the most important elements of the picture in the most interesting parts.

2. Volume

After drawing a rough sketch, start filling out half the figure first and then continue to draw her entire anatomy correctly.

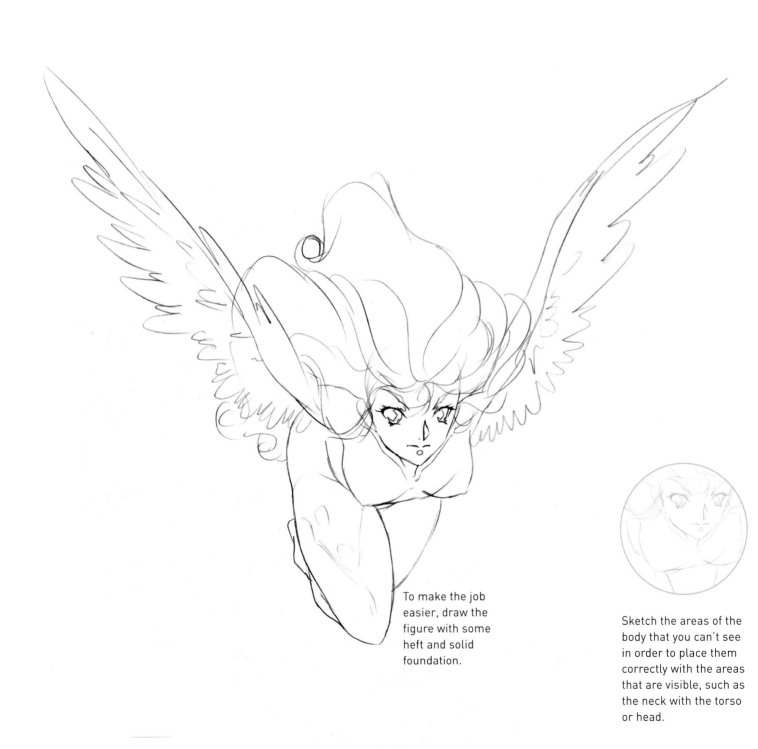

To make the job easier, draw the figure with some heft and solid foundation.

Sketch the areas of the body that you can't see in order to place them correctly with the areas that are visible, such as the neck with the torso or head.

Air basically consists of gusts that gain consistency to form something more cloudlike. We'll give the creature some wings and draw the tornado she comes out of.

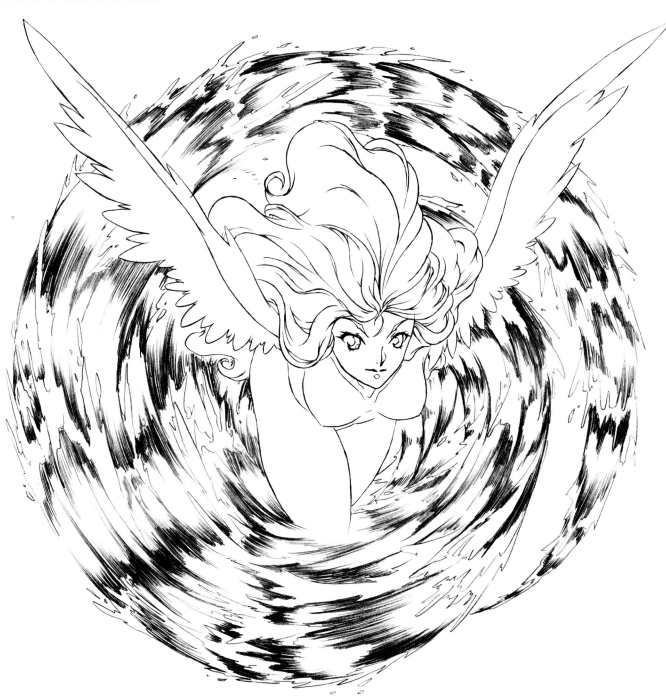

Since the lighting comes from above, almost the entire character will be shadowed because her position is practically horizontal.

Source of light

Use the effect of shadow and light on her face to make it interesting and more like a studio portrait.

To make the image more alive, choose yellow for the lighted areas. Yellow also breaks the monotony of the grays and blues predominating the drawing.

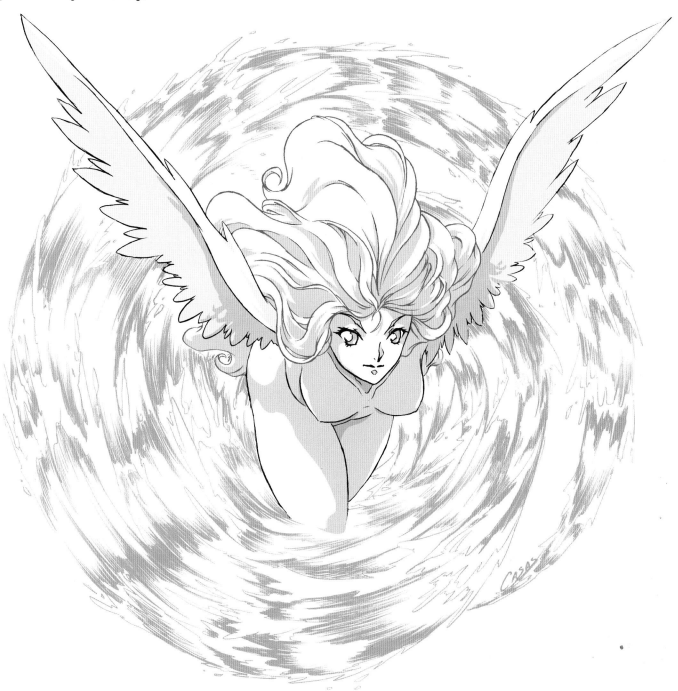

FIRE

Initially the idea was to develop characters that were linked to their elements, even in the shape of their bodies... but things turned out a bit differently. Our fire will be half-girl/half-element, like a fire demon. The force of fire should be at the center of this drawing. This element should look strong and vigorous as well as quick and agile.

1. Shape

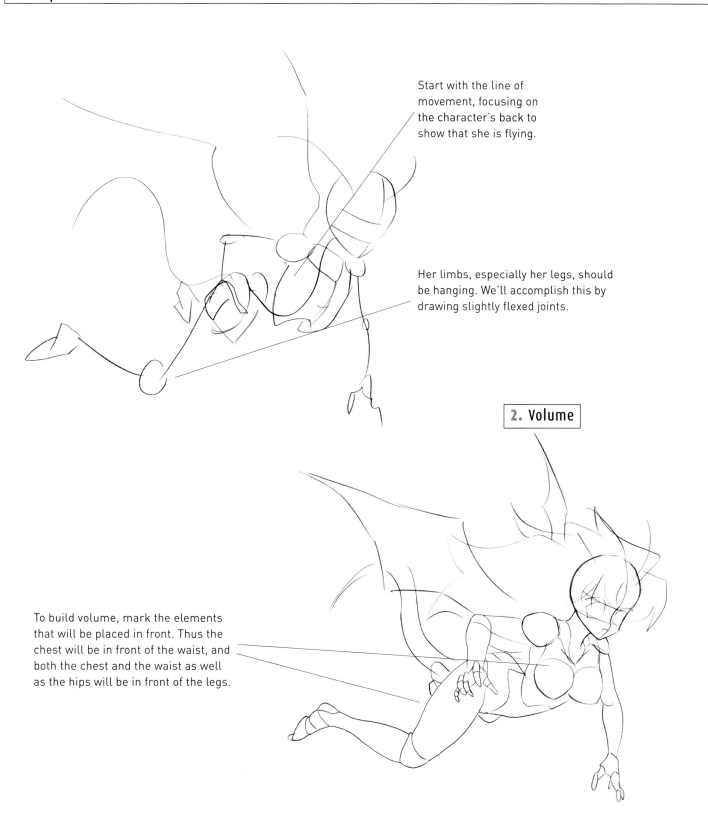

Start with the line of movement, focusing on the character's back to show that she is flying.

Her limbs, especially her legs, should be hanging. We'll accomplish this by drawing slightly flexed joints.

2. Volume

To build volume, mark the elements that will be placed in front. Thus the chest will be in front of the waist, and both the chest and the waist as well as the hips will be in front of the legs.

She has a strong and
athletic body, like fire
should have, and we'll
emphasize this with
powerful shoulders.

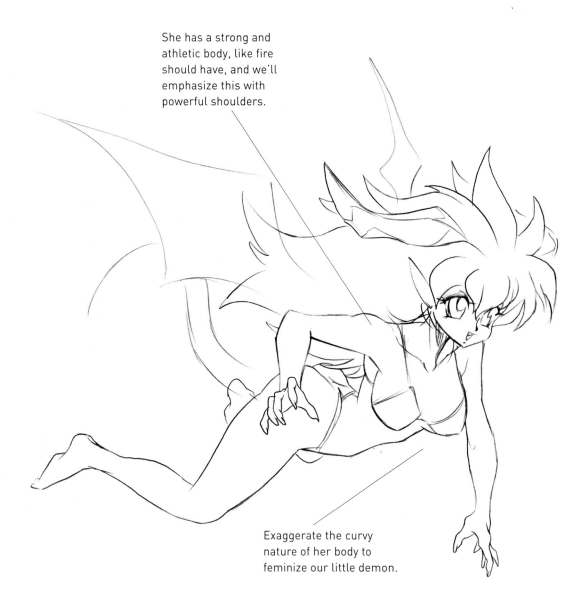

Exaggerate the curvy
nature of her body to
feminize our little demon.

Give our element some powerful
armor to bind her to the flames
blazing around her.

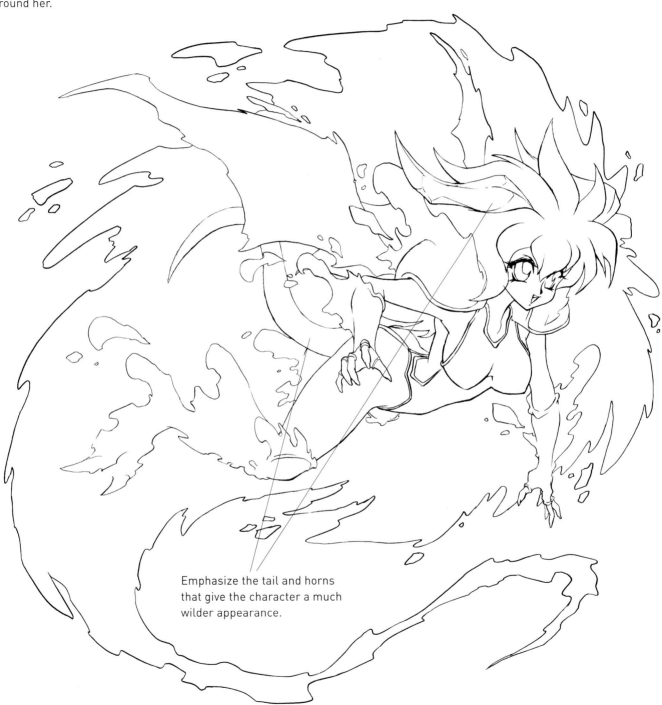

Emphasize the tail and horns
that give the character a much
wilder appearance.

Give the lighting the effect of a sudden blaze. Use contrasting shadows throughout the drawing and subtly blend the different textures.

Source of light

Choose the same range of colors found in fire. Reds
and yellows help tie the illustration to the element.

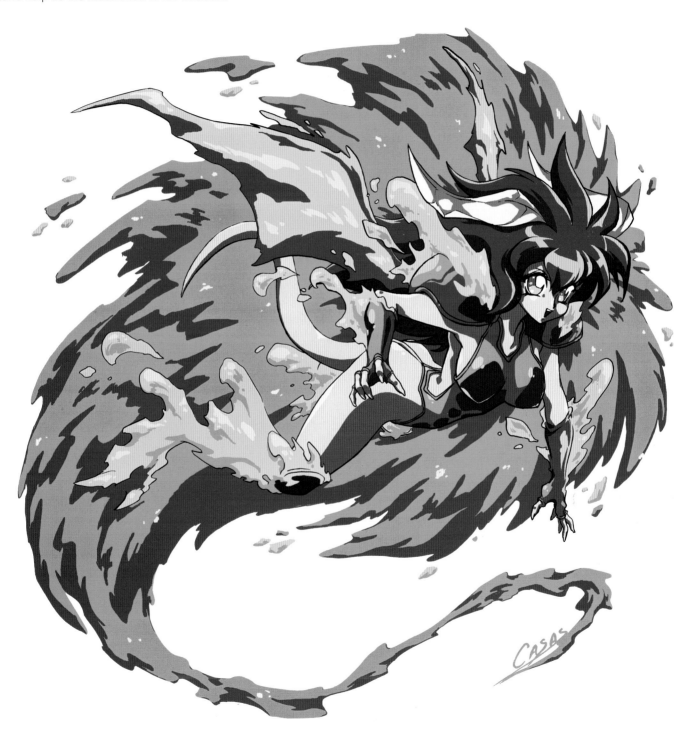

WATER

Water is a powerful genius tied to this life-giving source, and she'll usually shows her friendliest and most tender side. But water is a strong element because it also personifies absolute chaos; when it's enraged, it becomes one of nature's most destructive forces. Our character should reflect these two aspects. This dichotomy is part of what makes water so attractive.

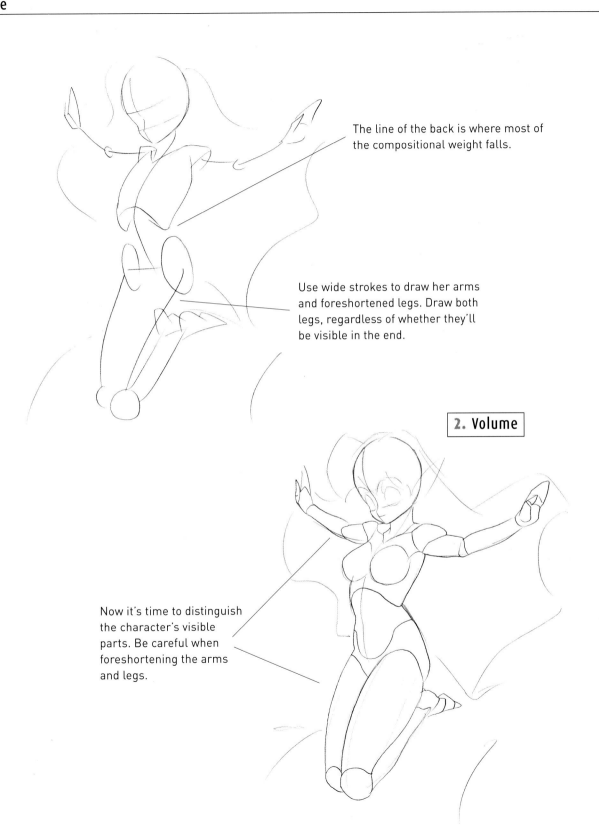

The line of the back is where most of the compositional weight falls.

Use wide strokes to draw her arms and foreshortened legs. Draw both legs, regardless of whether they'll be visible in the end.

2. Volume

Now it's time to distinguish the character's visible parts. Be careful when foreshortening the arms and legs.

Her body is smooth and
girlish to emphasize the
docile and benevolent
nature of water.

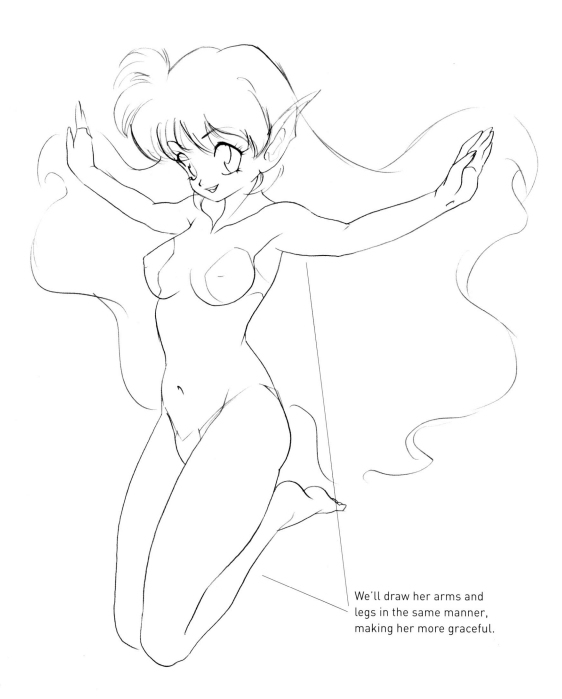

We'll draw her arms and
legs in the same manner,
making her more graceful.

Finish by connecting the girl's hair with the wave she's riding.

Her simple armor with sharp spikes conveys her strength, as well as her naughtiest, most unpredictable side.

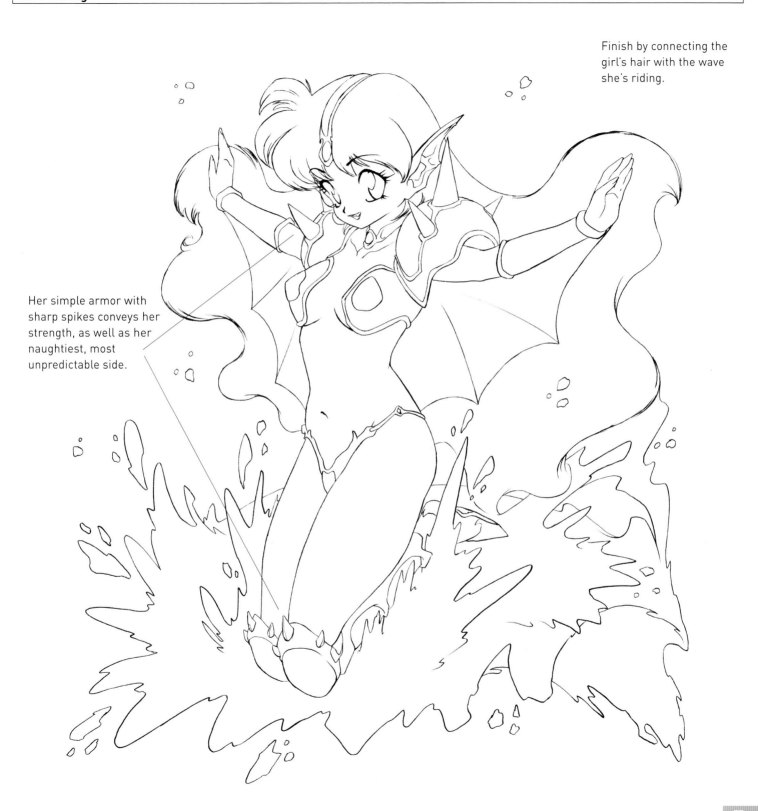

Source of light

The lighting should give the drawing a real aquatic look, so contrast different tones within the wave and add reflections of the water in the character's armor.

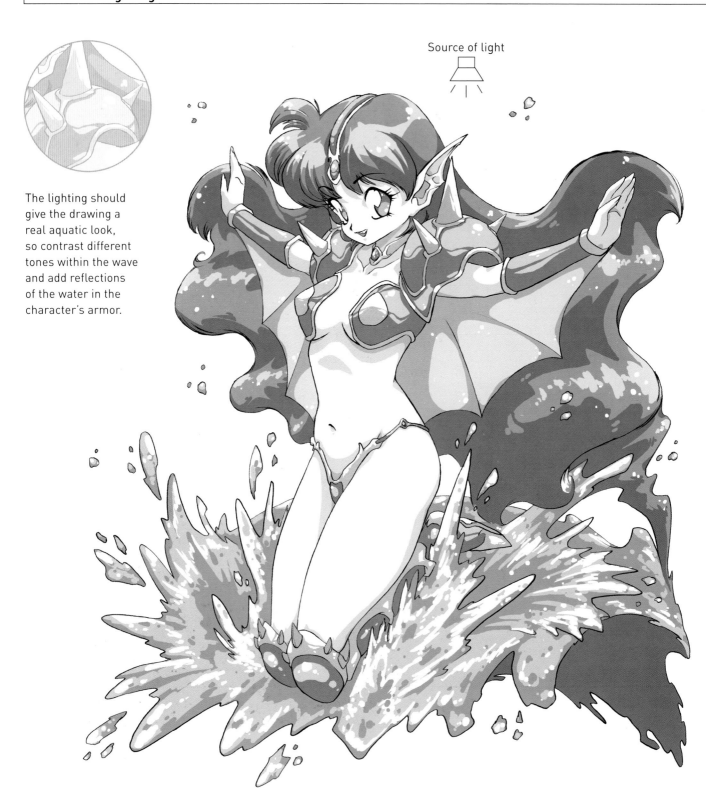

The colors match the drawing's theme. Blue is predominant, and yellow gives a brighter contrast and reflects the light falling on the girl's body.

Shaded areas are pink to define her delicate skin.

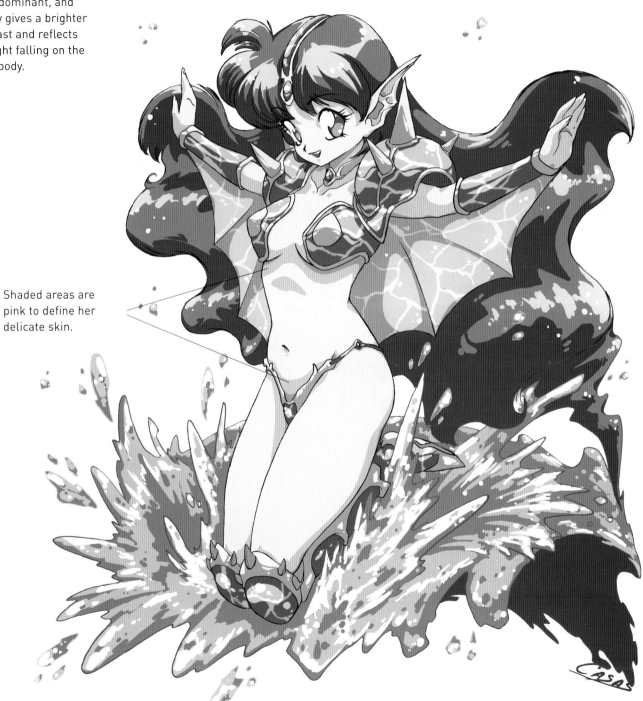

EARTH

The earth is a fundamental being who is vast, coarse, and strong. The earth stands upon its feet like a monstrous rock getting up to administer nature's harsh law. Its body is mostly made of rock, while some touches of vegetation will round out its appearance, giving it a more natural look.

1. Shape

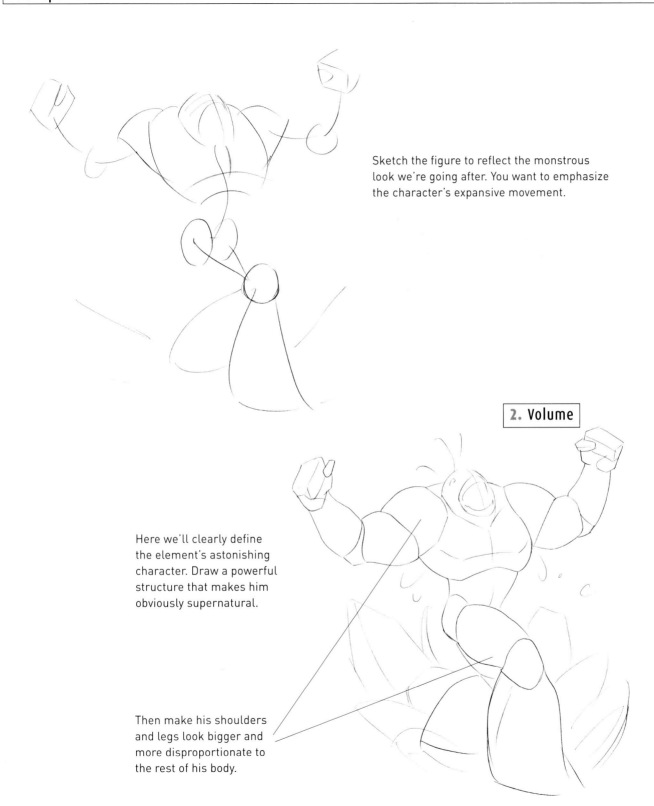

Sketch the figure to reflect the monstrous look we're going after. You want to emphasize the character's expansive movement.

2. Volume

Here we'll clearly define the element's astonishing character. Draw a powerful structure that makes him obviously supernatural.

Then make his shoulders and legs look bigger and more disproportionate to the rest of his body.

Giving the character a more humanlike anatomical structure helps shape the rocks forming his body.

Exaggerate the shoulders and triceps, the arm's biggest muscle groups, and finish with powerful forearms and fists.

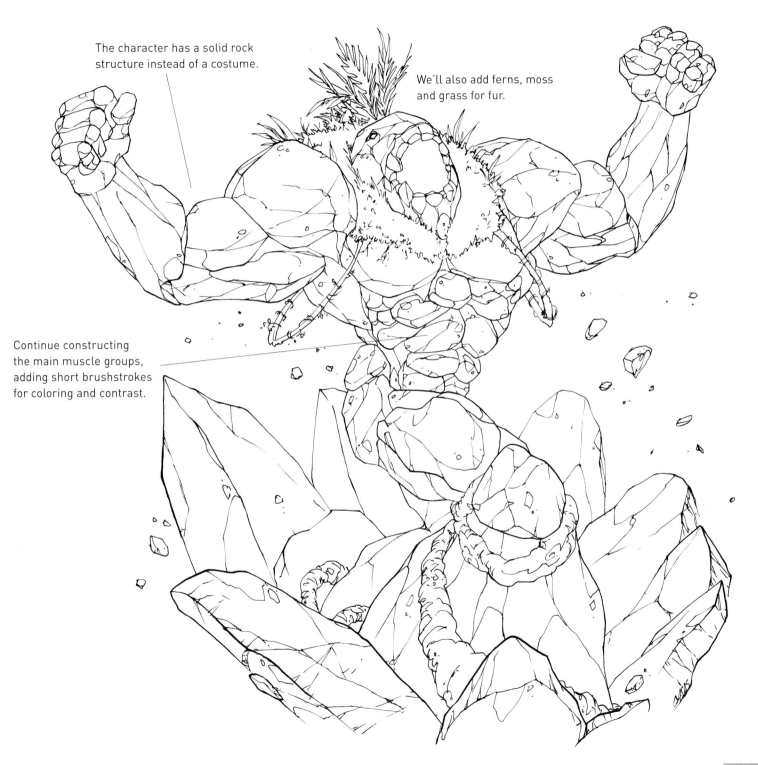

The character has a solid rock structure instead of a costume.

We'll also add ferns, moss and grass for fur.

Continue constructing the main muscle groups, adding short brushstrokes for coloring and contrast.

63

The lighting helps mark the different surface planes of the rocks that shape the character. We'll work more quickly if we think in terms of simple geometric shapes.

Source of light

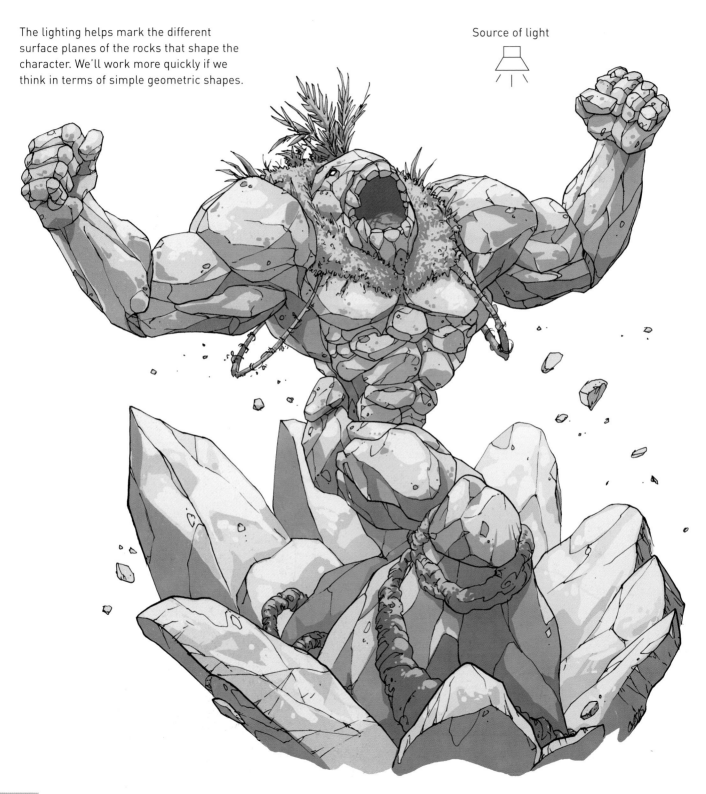

We'll use a few tricks to break the monotonous stone color.

Bright green tones for the vegetation.

Magical tattoos around the element's body emphasize his mythical nature.

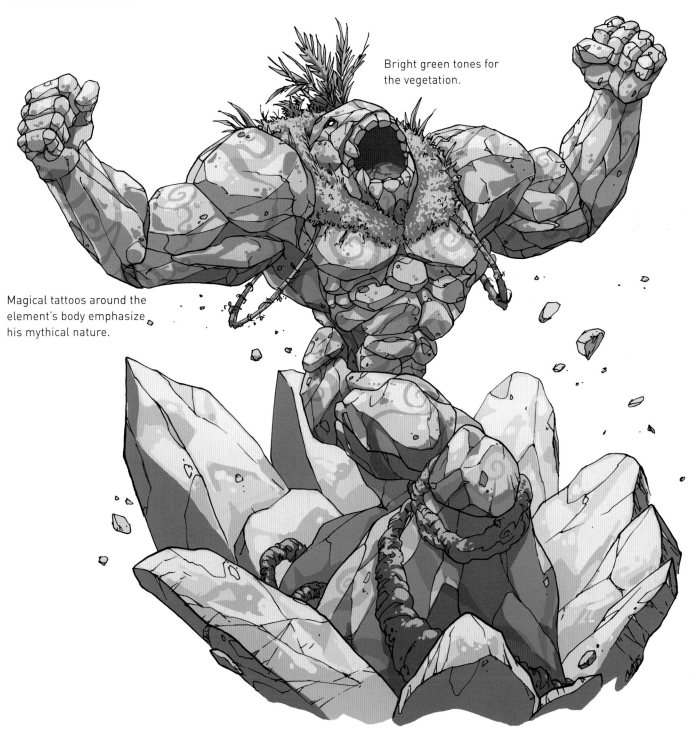

ANGEL

These heavenly dwellers live harmoniously with mankind and constantly watch after our safety. Very beautiful, young, and innocent, they differ physically from humans because they have large wings for flying. They have great magical powers for healing as well as fighting, but rarely fight since they hate it. They love playing and are also said to be capable of taking falling stars and turning them into beautiful jewelry.

1. Shape

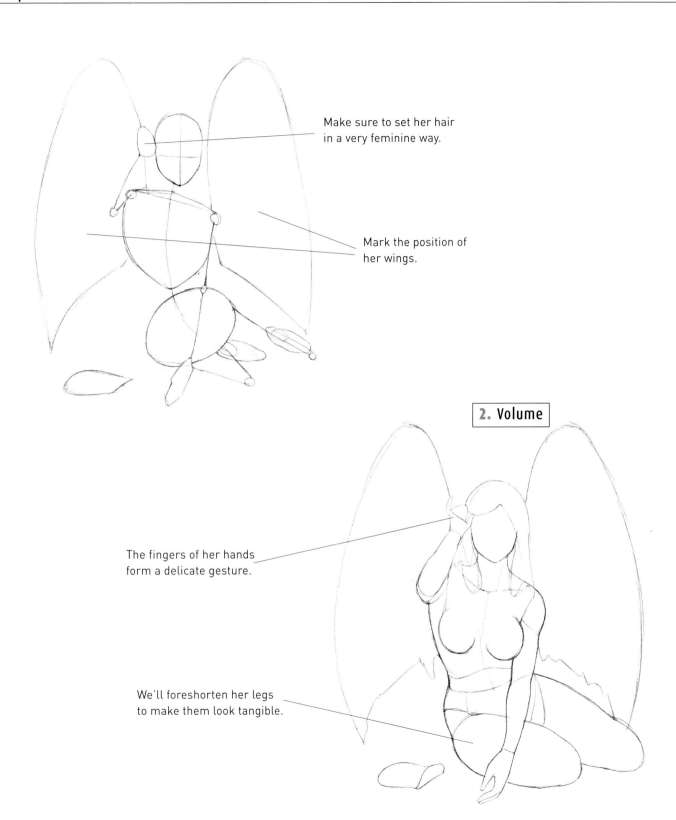

Make sure to set her hair in a very feminine way.

Mark the position of her wings.

2. Volume

The fingers of her hands form a delicate gesture.

We'll foreshorten her legs to make them look tangible.

Don't use straight lines to draw the angel's face and body—that's how you'll get her sweet expression. Studying bird anatomy will help you accomplish this.

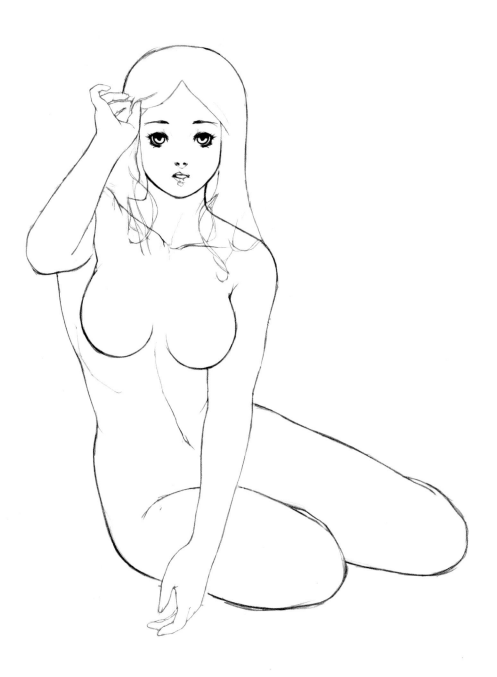

A laurel wreath gives the character a more natural and classical air.

Her dress should be simple, without any complicated accessories.

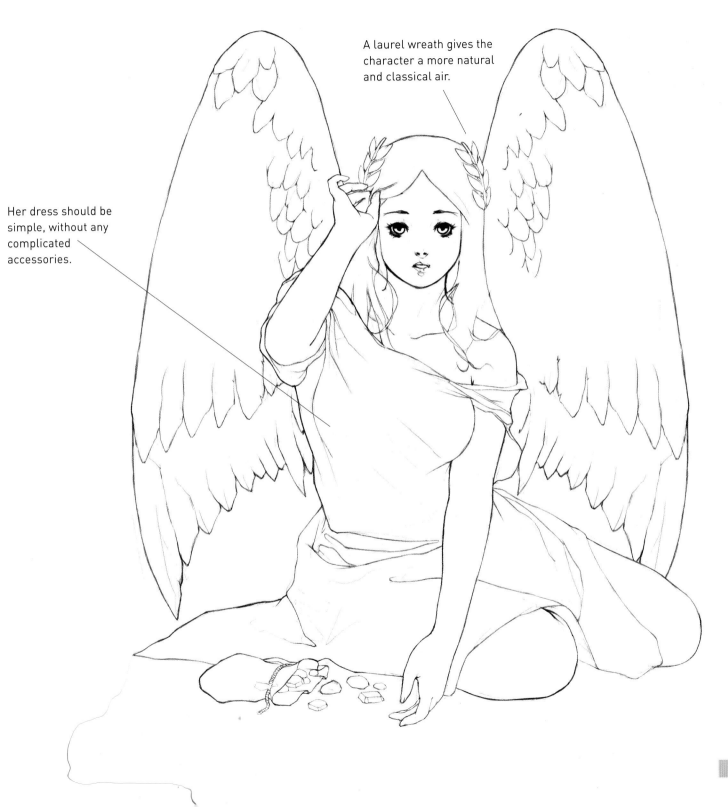

The lighting is pure and without much contrast. Use shading to draw the feathers.

Source of light

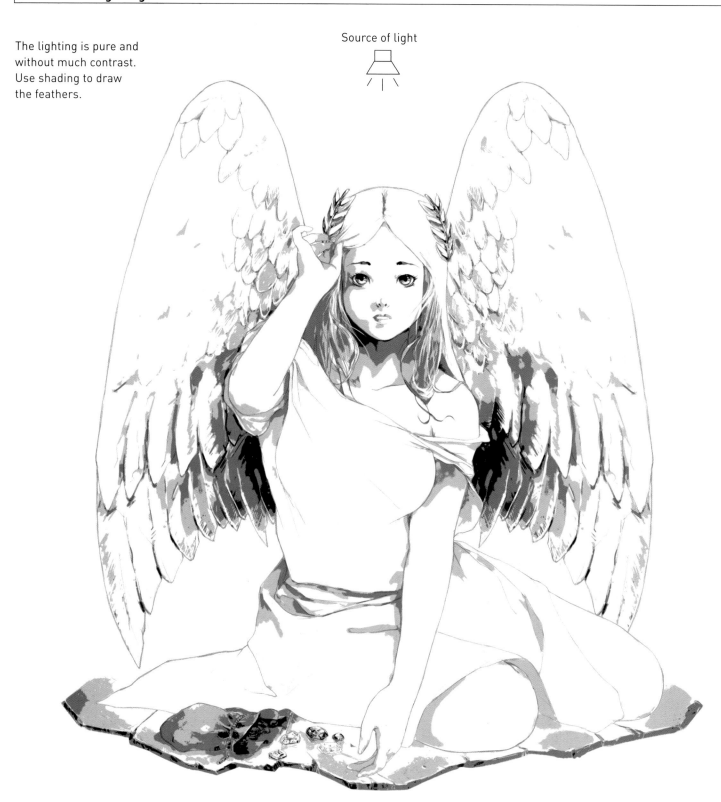

To show the character's
vitality choose warm
colors for her skin.

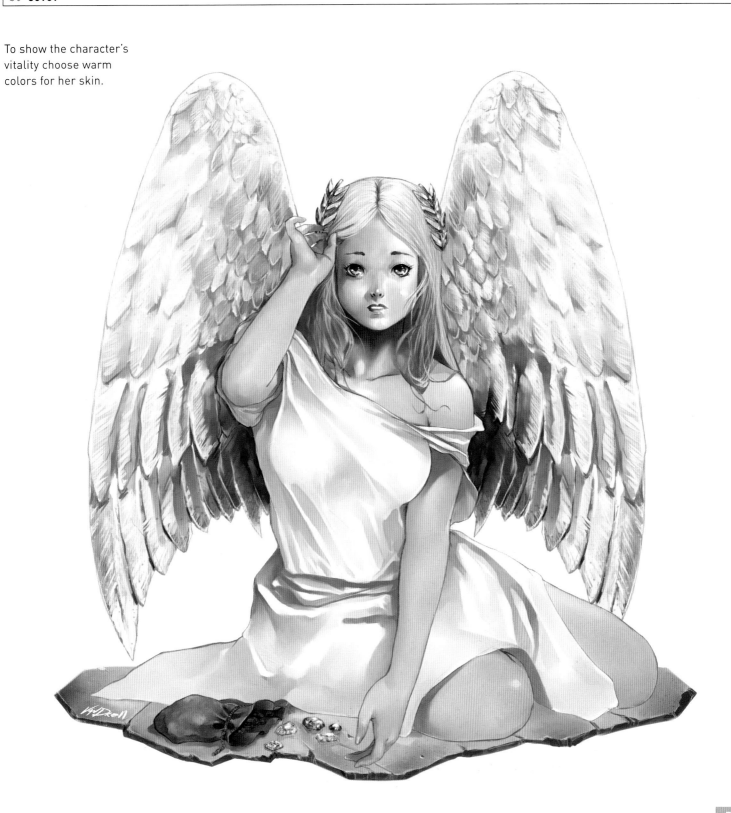

GOD OF GOODNESS

Somewhere in the sky above the beautiful castles lies the land of angels. These are the guardians of a force that keeps the light in our sky. This force has the appearance of wisdom and moderation and is the gateway toward a higher state. It is in constant battle against darkness, which is constantly gaining ground, not just in the world but in the hearts of many of its inhabitants. The light waits expectantly for the end to this perpetual war.

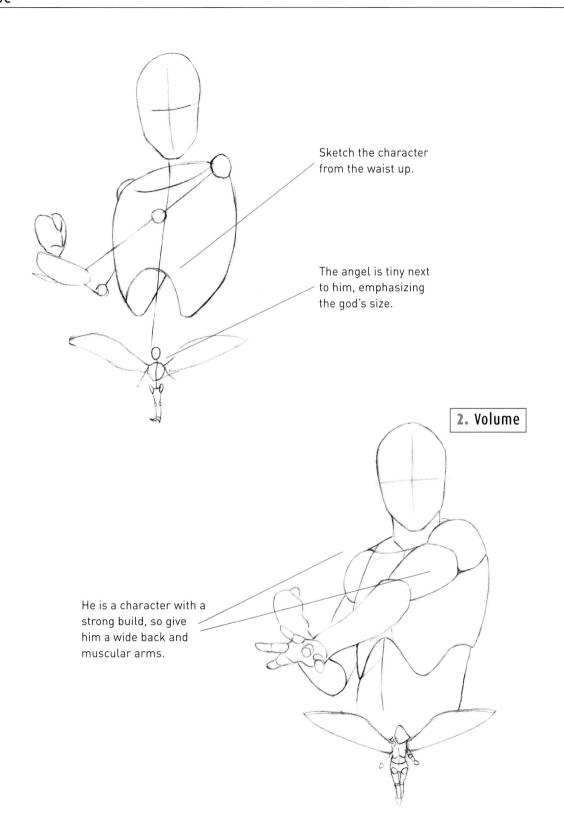

Sketch the character from the waist up.

The angel is tiny next to him, emphasizing the god's size.

2. Volume

He is a character with a strong build, so give him a wide back and muscular arms.

Give the god a serious and solemn expression, along with a well-toned abdomen and developed muscles.

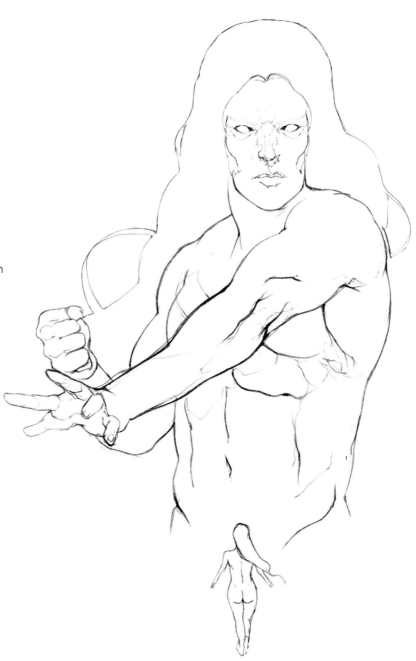

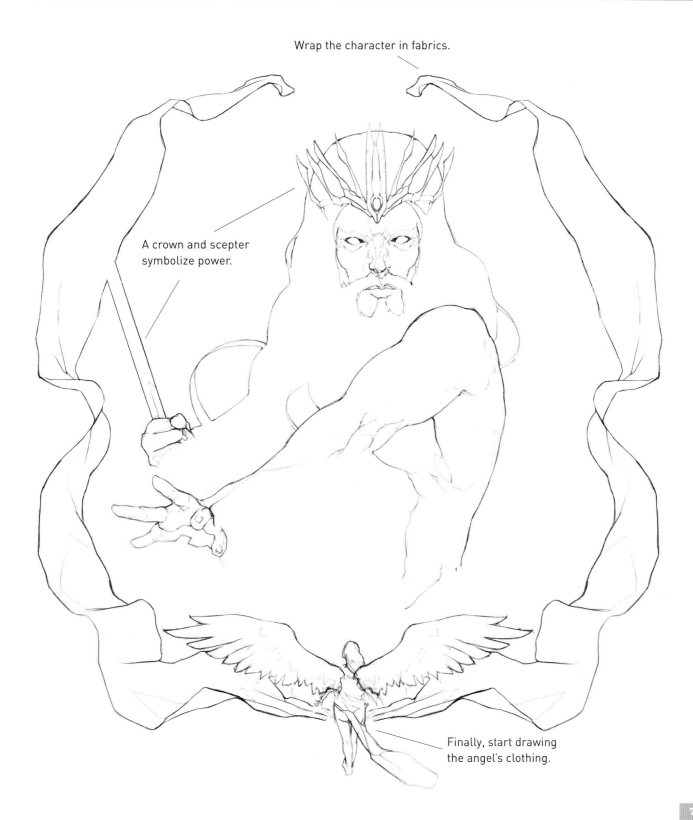

Wrap the character in fabrics.

A crown and scepter symbolize power.

Finally, start drawing the angel's clothing.

There are two light sources: one illuminates the omnipotent god and another emanates from him and falls over the figure of the angel.

Source of light

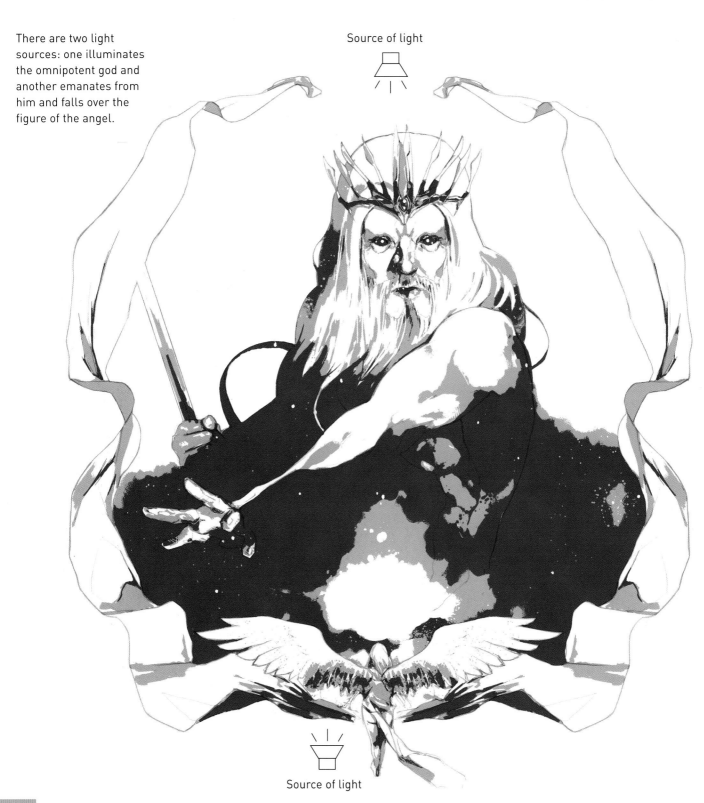

Source of light

Use a range of cold colors
and add a subtle aura of
light for the main character.
Then dot the background to
create a star-effect.

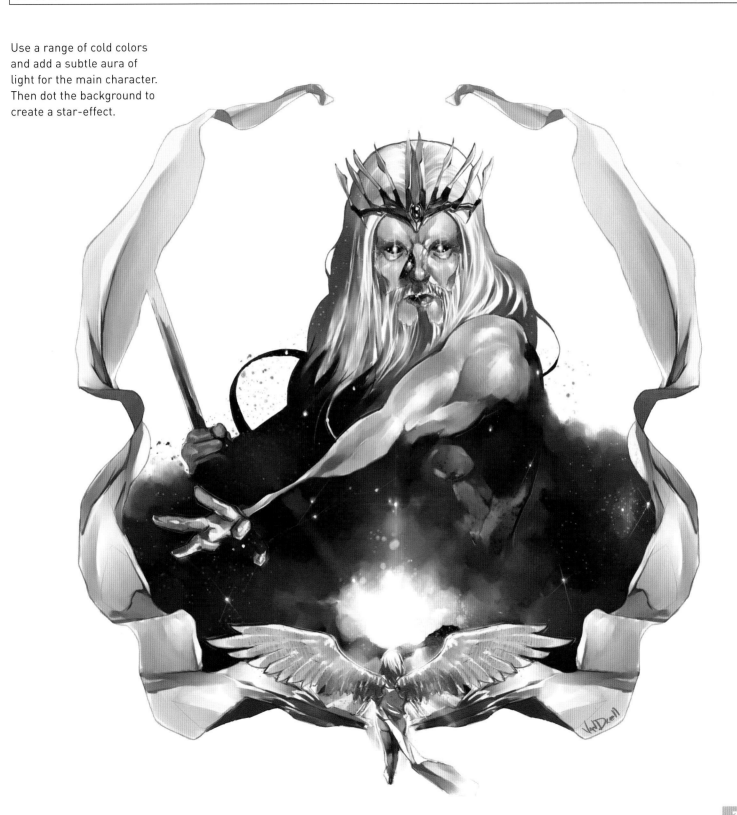

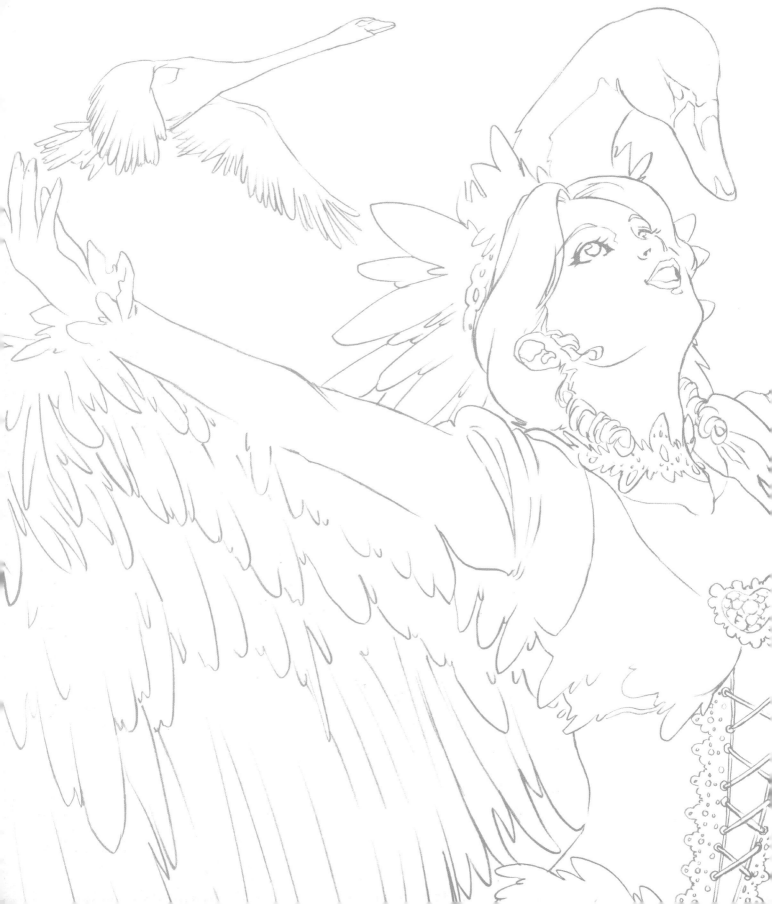

THE ENCHANTED GARDEN

ELF

Elves, or elves of light, are described as bright, semidivine, magical beings, similar to the literary image of fairies or nymphs. They are kind to men and look like tiny children with beautiful and friendly fairy features. They use magic to protect nature. Happy and cheerful, they flood the forests with fantasy.

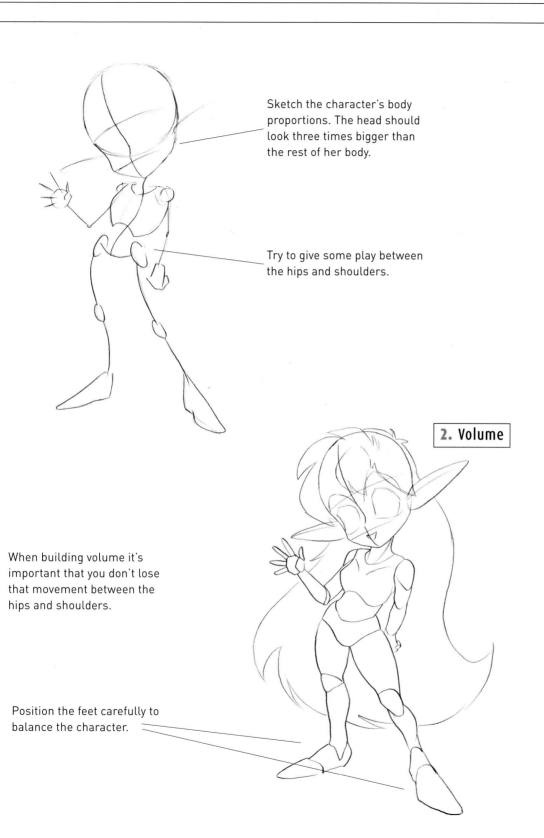

Sketch the character's body proportions. The head should look three times bigger than the rest of her body.

Try to give some play between the hips and shoulders.

2. Volume

When building volume it's important that you don't lose that movement between the hips and shoulders.

Position the feet carefully to balance the character.

The elf's head and feet are proportionately larger than the rest of her body, giving her a more fantastic look. In Manga the proportion would be similar to a super-deformed character.

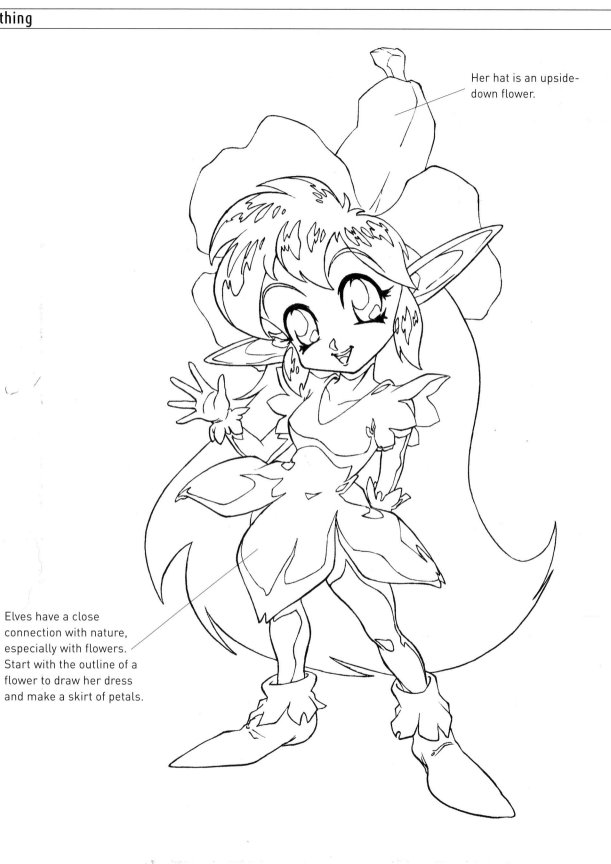

Her hat is an upside-down flower.

Elves have a close connection with nature, especially with flowers. Start with the outline of a flower to draw her dress and make a skirt of petals.

The lighting defines the figure's volumes. Notice how light and shade fall on the hat. Use them to differentiate textures since light affects each material differently.

Source of light

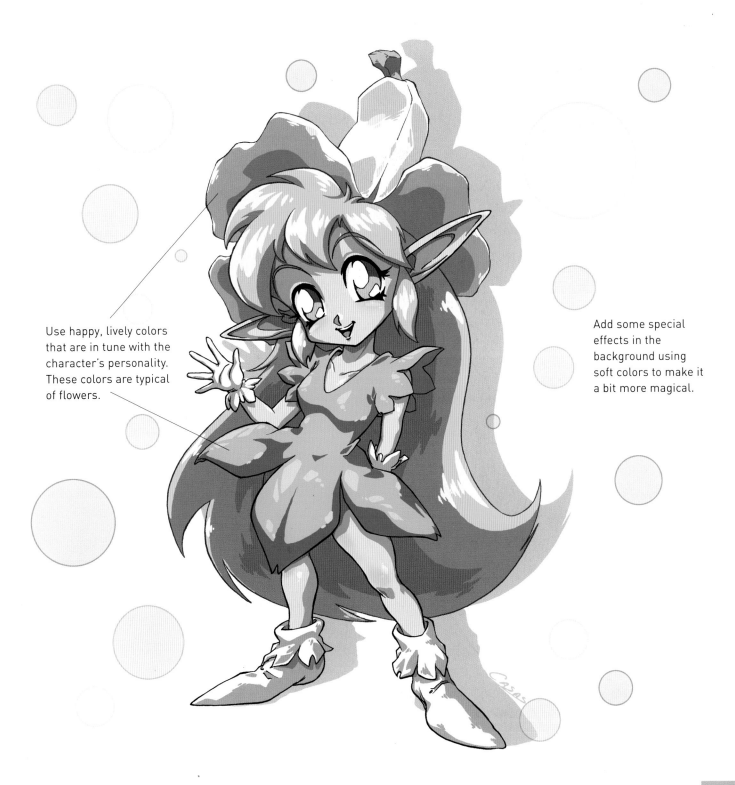

Use happy, lively colors that are in tune with the character's personality. These colors are typical of flowers.

Add some special effects in the background using soft colors to make it a bit more magical.

CHERUB

Our cherub looks like the Roman god Cupid: a boy with wings, equipped with a bow and arrow. He is said to be capable of spreading love among mortals. He is also said to be the son of Mars and Venus, the gods of war and love. Along with Venus, Cupid is considered the god of love, and establishes the connection between love and tragedy.

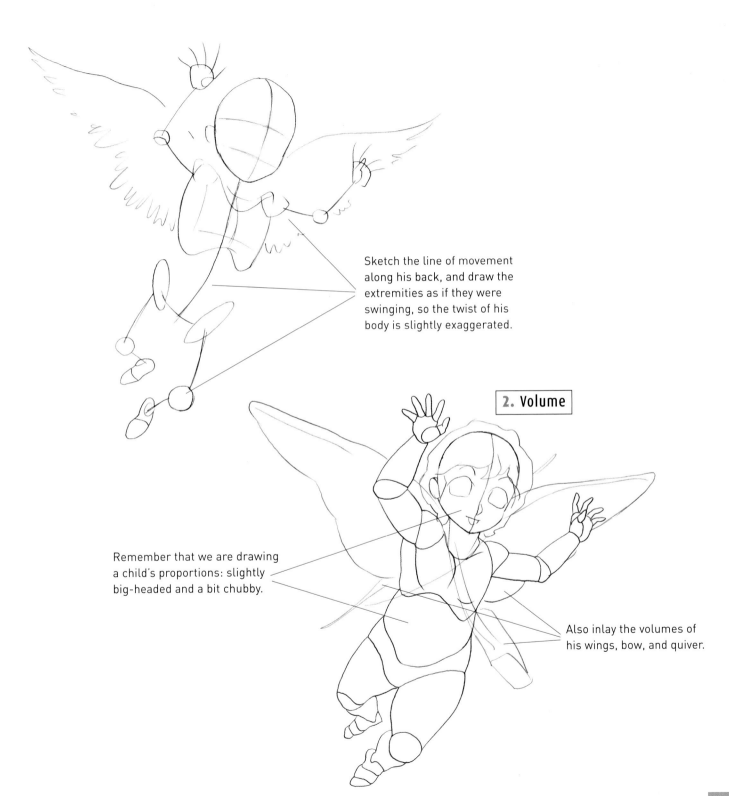

Sketch the line of movement along his back, and draw the extremities as if they were swinging, so the twist of his body is slightly exaggerated.

2. Volume

Remember that we are drawing a child's proportions: slightly big-headed and a bit chubby.

Also inlay the volumes of his wings, bow, and quiver.

Use soft lines to define his body. You are drawing a child, so his muscles aren't very developed.

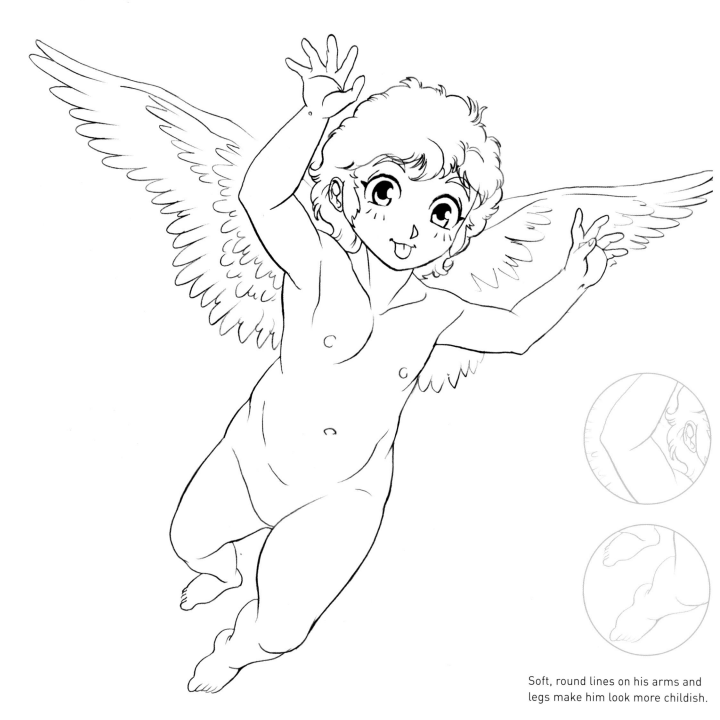

Soft, round lines on his arms and legs make him look more childish.

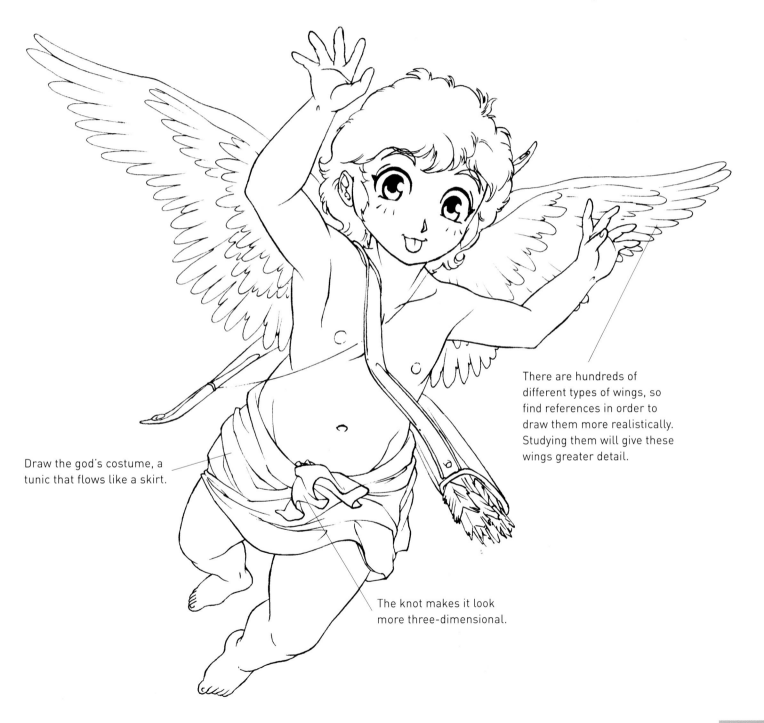

There are hundreds of different types of wings, so find references in order to draw them more realistically. Studying them will give these wings greater detail.

Draw the god's costume, a tunic that flows like a skirt.

The knot makes it look more three-dimensional.

Put the light behind the character, as
if the sun were behind him. The light
outlines his silhouette.

Source of light

Soft colors, especially pink, are better
for these kinds of characters. Add a
heart in the background, connecting
the cherub with his reputation.

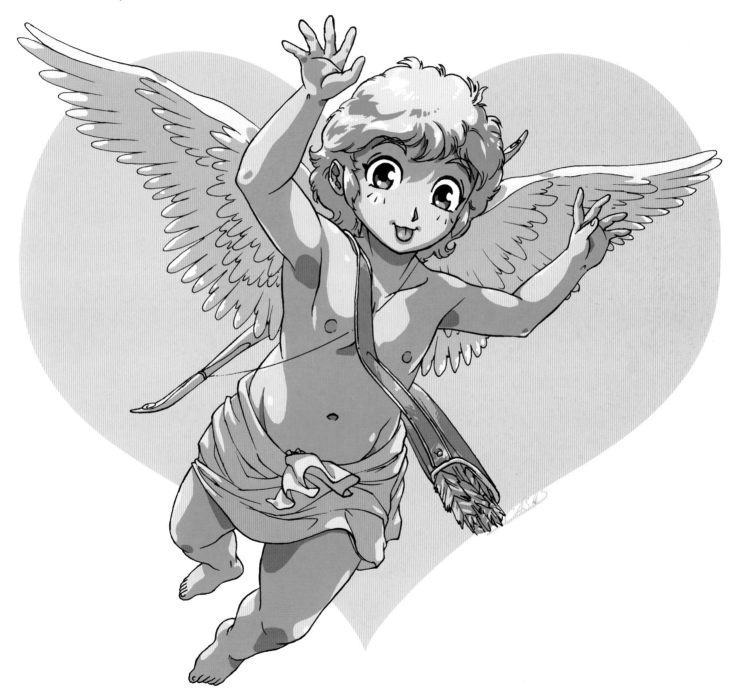

FAUN

Fauns are creatures that are closely tied to nature. They have a human body and goat legs, along with tiny horns and animal features. They protect the forest, and their happiness and good mood rubs off on everyone. Their personality is festive and fun, and they like to fill the forest with music. Our faun is also quite playful, so the goal is to represent this faun when he's being most expressive.

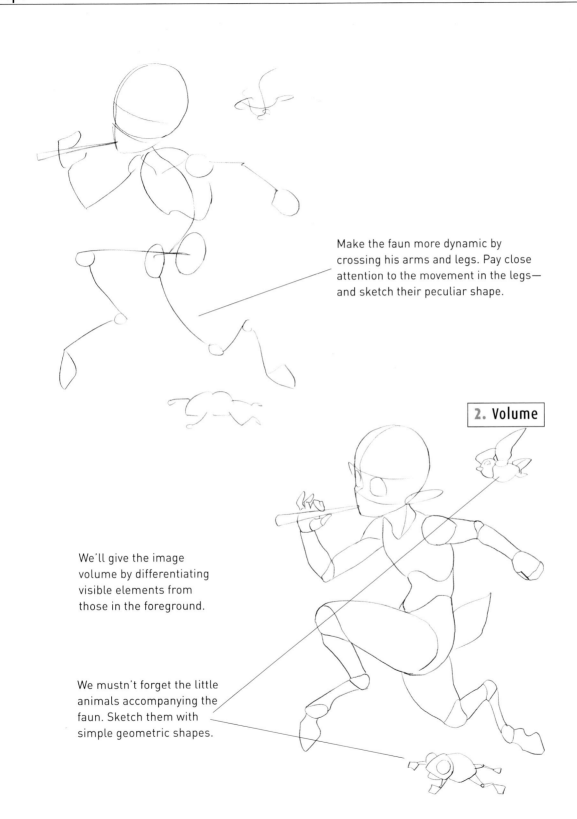

Make the faun more dynamic by crossing his arms and legs. Pay close attention to the movement in the legs—and sketch their peculiar shape.

2. Volume

We'll give the image volume by differentiating visible elements from those in the foreground.

We mustn't forget the little animals accompanying the faun. Sketch them with simple geometric shapes.

Combine the trunk of a thin,
active, and nervous youngster
with a ram's muscular legs.

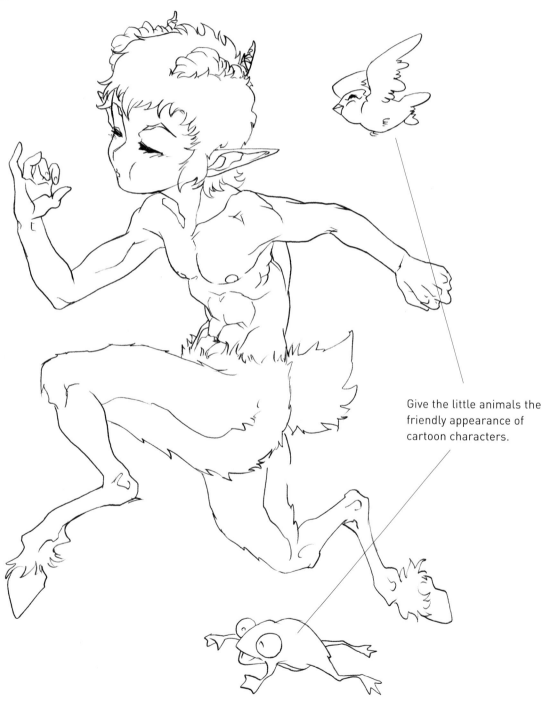

Give the little animals the
friendly appearance of
cartoon characters.

The faun's costume is
a simple loincloth.

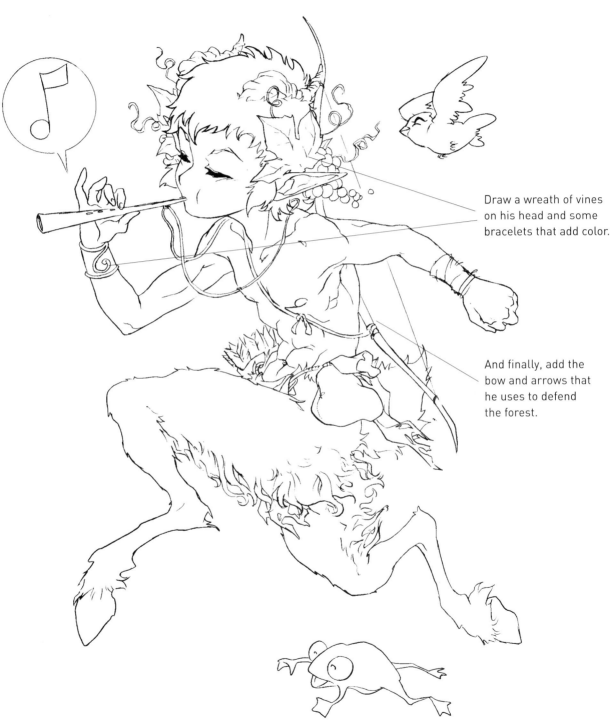

Draw a wreath of vines
on his head and some
bracelets that add color.

And finally, add the
bow and arrows that
he uses to defend
the forest.

A strong midday light makes it look as if the faun were crossing a break in the forest.

Source of light

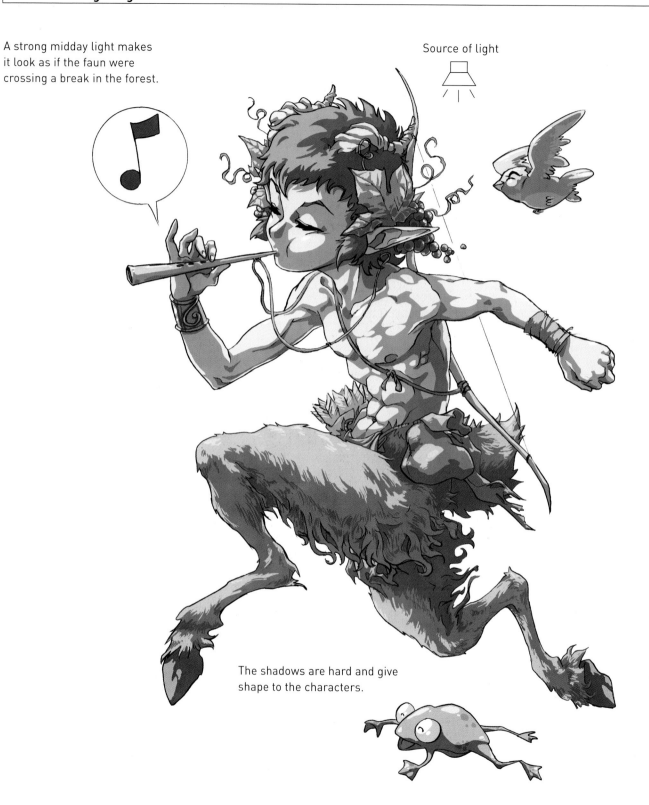

The shadows are hard and give shape to the characters.

Choose bright and intense colors for the illustration.

The animals and their attributes will be the trick for achieving tonal diversity.

Slightly curve the ground the character is running on to give him a greater sense of movement.

PIXIE

Pixies are a curious race of small, naughty beings. They have a bad name because of their playful nature, which is easily inclined toward jokes in bad taste. They are small and look similar to fairies, with pointy ears and almond-shaped eyes but without wings. They usually dress in well-worn green clothes. Our pixie will also be a bit mischievous; surely she's caused more than one human to get lost in the magical garden.

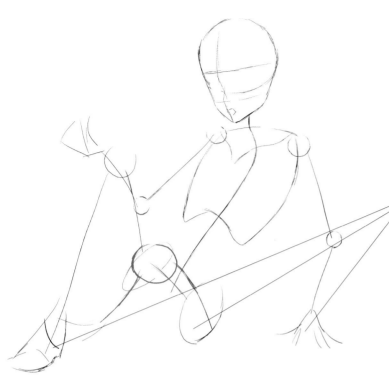

Whenever you draw a character sitting or lying down, it's a good idea to simplify the area where they will be resting. Mark three resting points for the pose: the buttocks, hand, and feet.

2. Volume

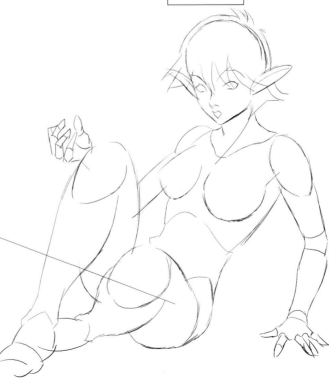

Working with volume should help when foreshortening the pixie's legs. In order to place the character correctly, draw the knee so it's in front of the thighs and the thighs in front of the hips.

Using curvaceous lines to
make her more attractive.

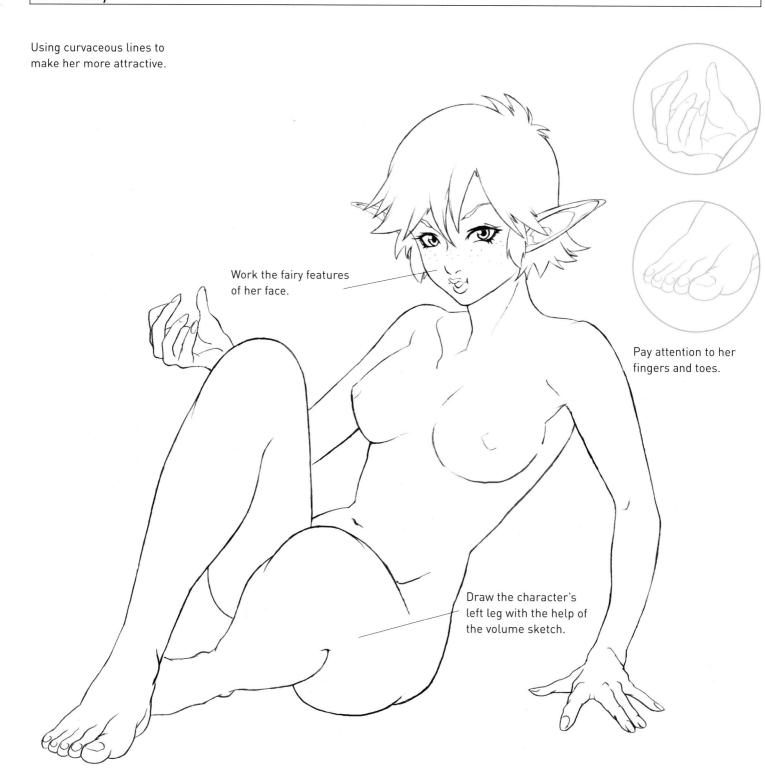

Work the fairy features
of her face.

Pay attention to her
fingers and toes.

Draw the character's
left leg with the help of
the volume sketch.

The pixie uses plants for clothing, so her outfit is crude, wild, and daring.

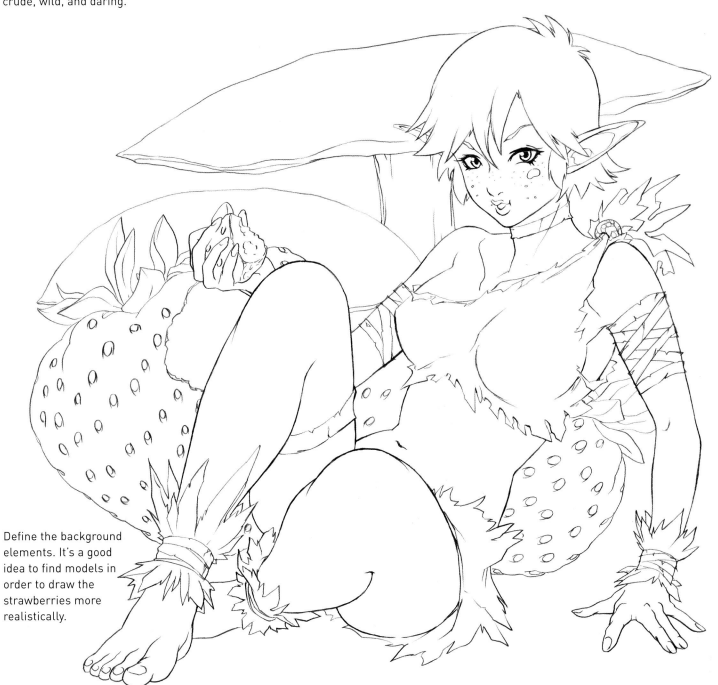

Define the background elements. It's a good idea to find models in order to draw the strawberries more realistically.

The lighting gives the character volume and lends structure to the background.

Source of light

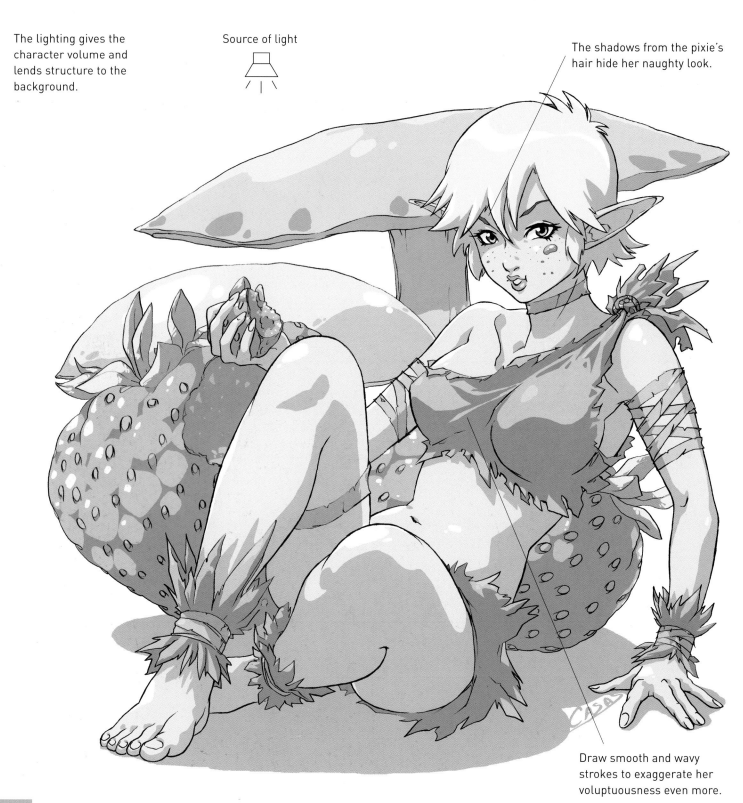

The shadows from the pixie's hair hide her naughty look.

Draw smooth and wavy strokes to exaggerate her voluptuousness even more.

Choose a range of warm colors so the pixie's
personality looks more attractive and open.
We'll use softer colors for the background,
and darker ones for the foreground.

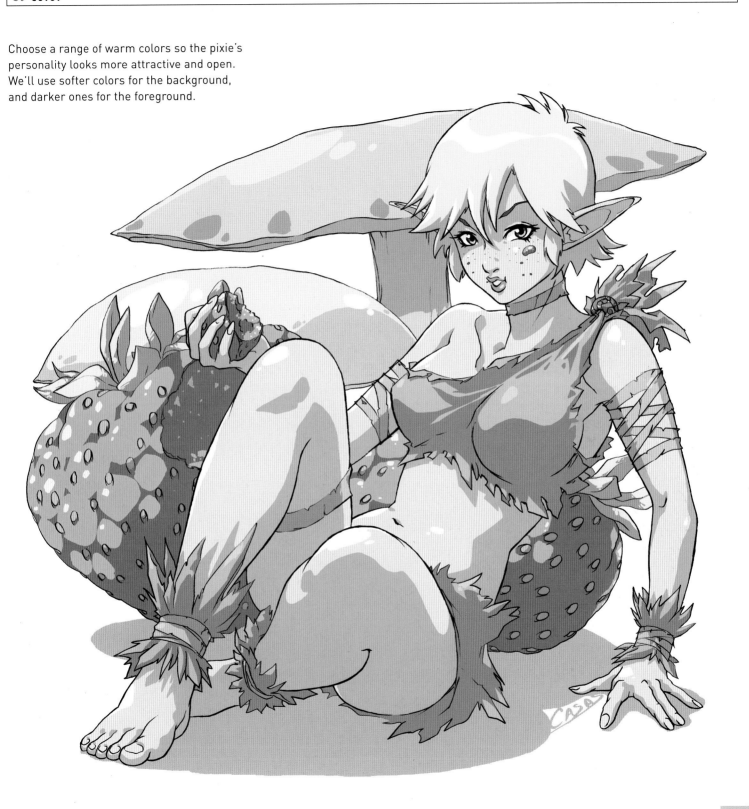

CENTAUR

Centaurs are also Greek mythological beings. They are a race of powerful, barbaric warriors that are human from the waist up and horses from the waist down. The archetype is of a wild, lawless being, that is slave to his animal passions. Legends, however, also tell us of centaurs such as Chiron and Pholus who were wise and friendly. We've opted for the warrior centaur, which will serve to guard our garden.

1. Shape

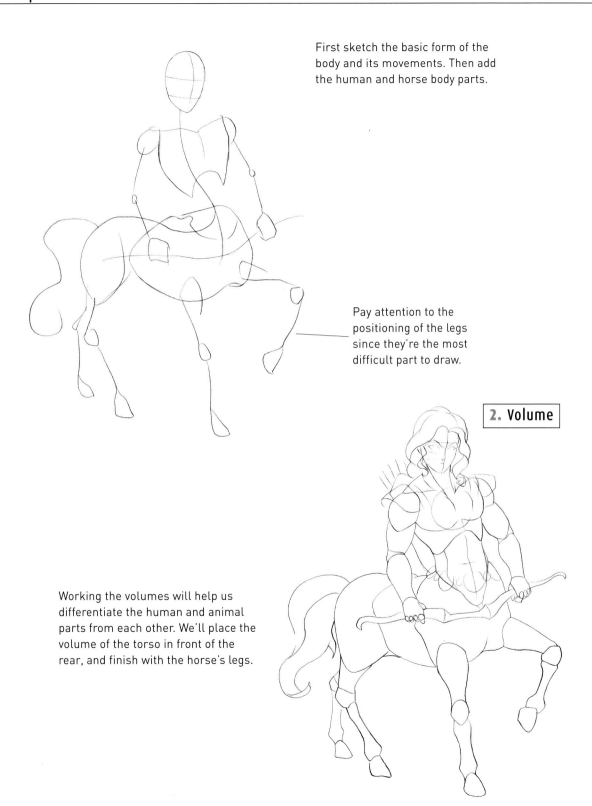

First sketch the basic form of the body and its movements. Then add the human and horse body parts.

Pay attention to the positioning of the legs since they're the most difficult part to draw.

2. Volume

Working the volumes will help us differentiate the human and animal parts from each other. We'll place the volume of the torso in front of the rear, and finish with the horse's legs.

We'll divide the anatomy into two parts. First, we'll sculpt the torso of a powerful warrior with a large back, wide chest, and strong arms.

Afterwards we'll draw the horse's muscular form, which gives it an athletic look.

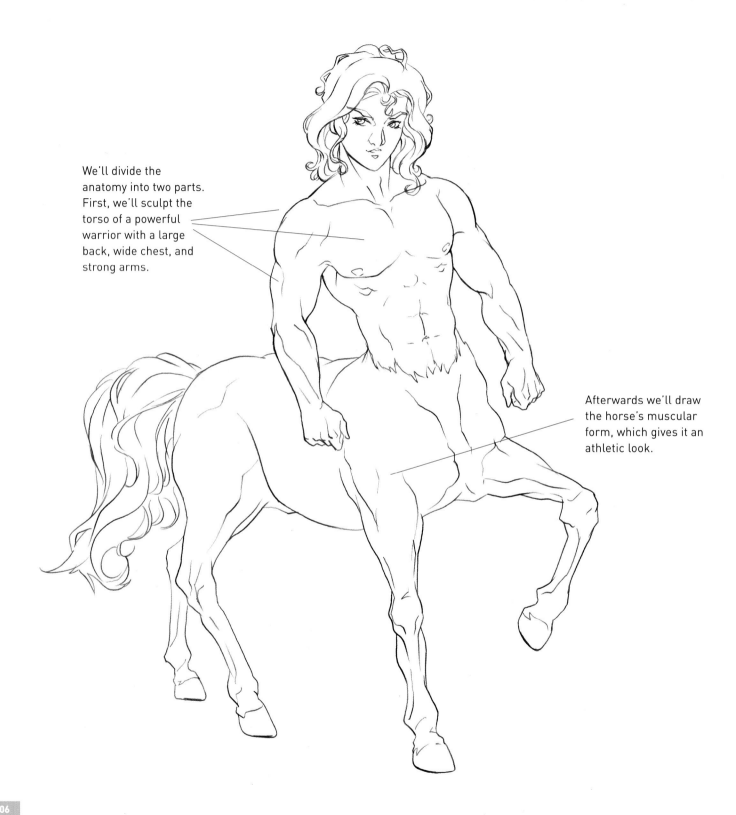

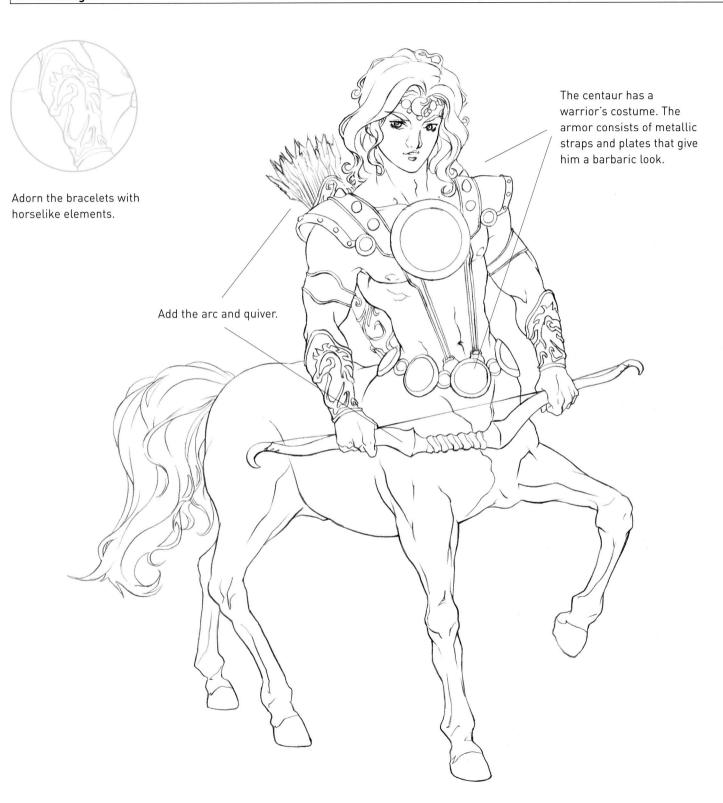

Adorn the bracelets with horselike elements.

Add the arc and quiver.

The centaur has a warrior's costume. The armor consists of metallic straps and plates that give him a barbaric look.

The lighting is from above and very simple. We'll add shadows created by the protruding elements of the armor, as well as that which the figure projects on the floor.

Source of light

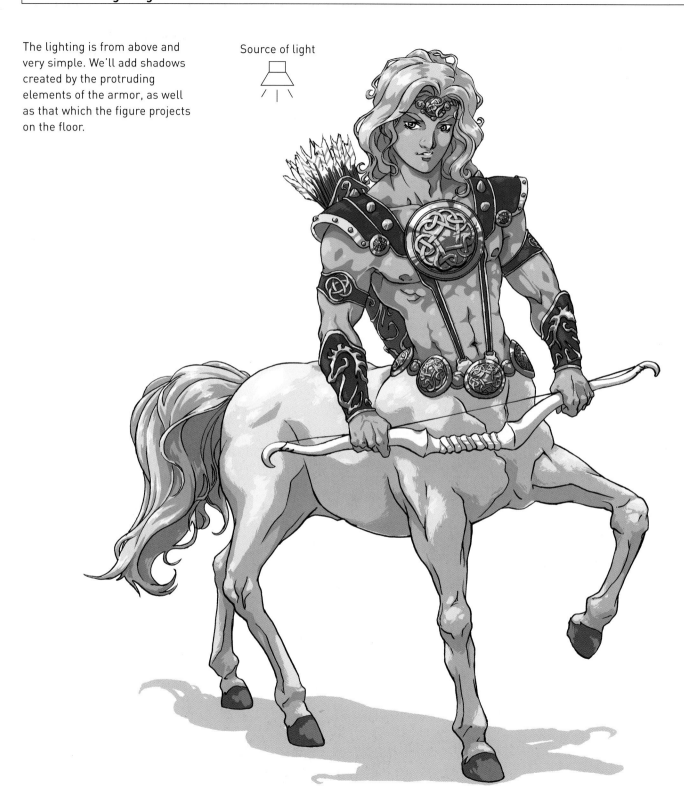

The tones used for our centaur are light and golden, evoking the summer and the countryside, while conveying that our character is outdoors.

We've added diverse decorative elements with a Celtic look to give the illustration more personality.

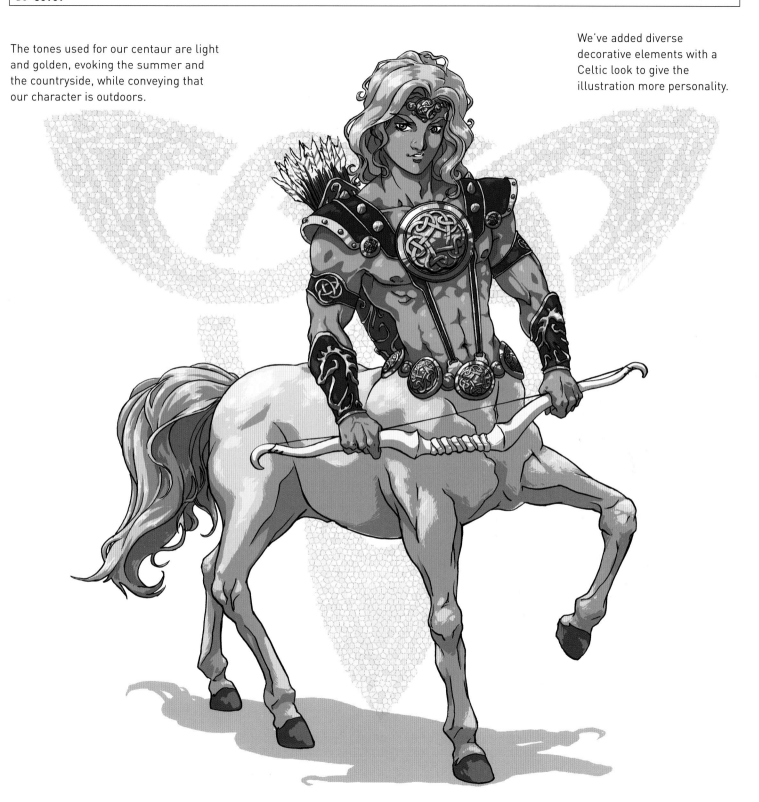

THE LADY OF THE LAKE

According to Arthurian legend, the Lady of the Lake was a woman who reigned over the island of Avalon. She had Arthur choose between a cup, a lance, a dish, and a sword as a symbol of the union between Camelot and Avalon. Arthur chose Excalibur, and then a sheath was made to guard this sword that had the power to keep its keeper from shedding a single drop of blood. With features similar to some water nymphs, she resembles the mythic Thetis as the protector of one of the greatest heroes of her time.

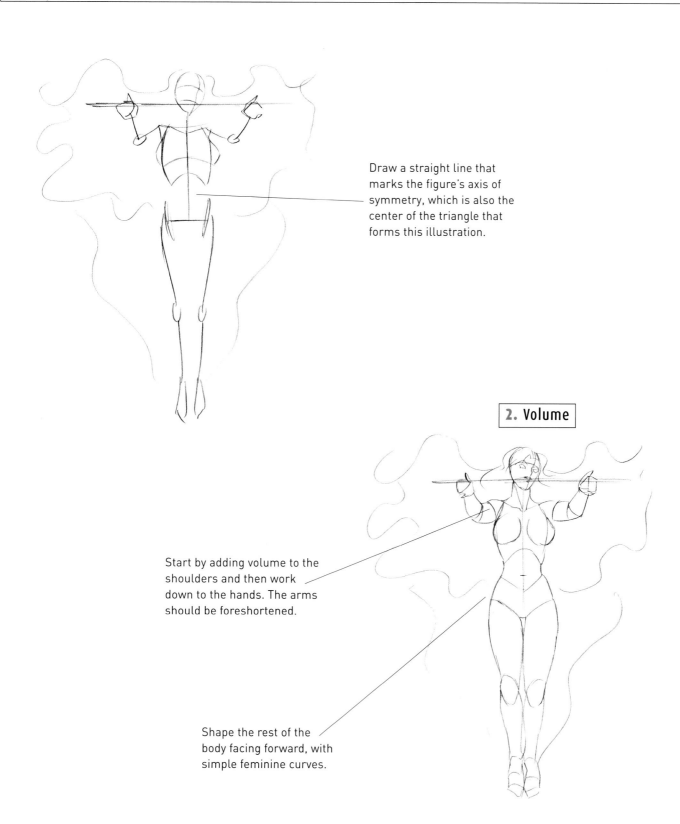

Draw a straight line that marks the figure's axis of symmetry, which is also the center of the triangle that forms this illustration.

2. Volume

Start by adding volume to the shoulders and then work down to the hands. The arms should be foreshortened.

Shape the rest of the body facing forward, with simple feminine curves.

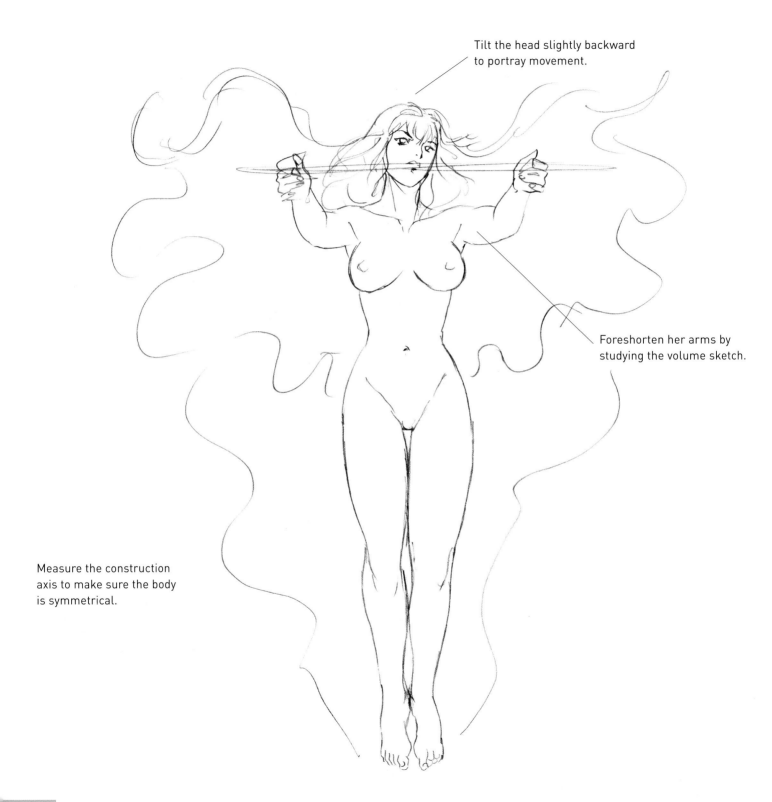

Tilt the head slightly backward to portray movement.

Foreshorten her arms by studying the volume sketch.

Measure the construction axis to make sure the body is symmetrical.

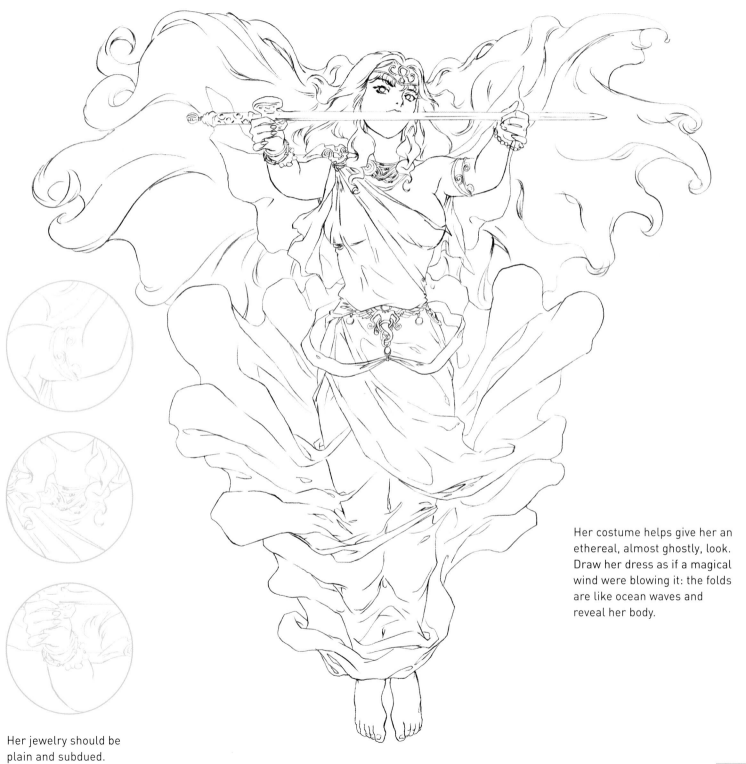

Her costume helps give her an ethereal, almost ghostly, look. Draw her dress as if a magical wind were blowing it: the folds are like ocean waves and reveal her body.

Her jewelry should be plain and subdued.

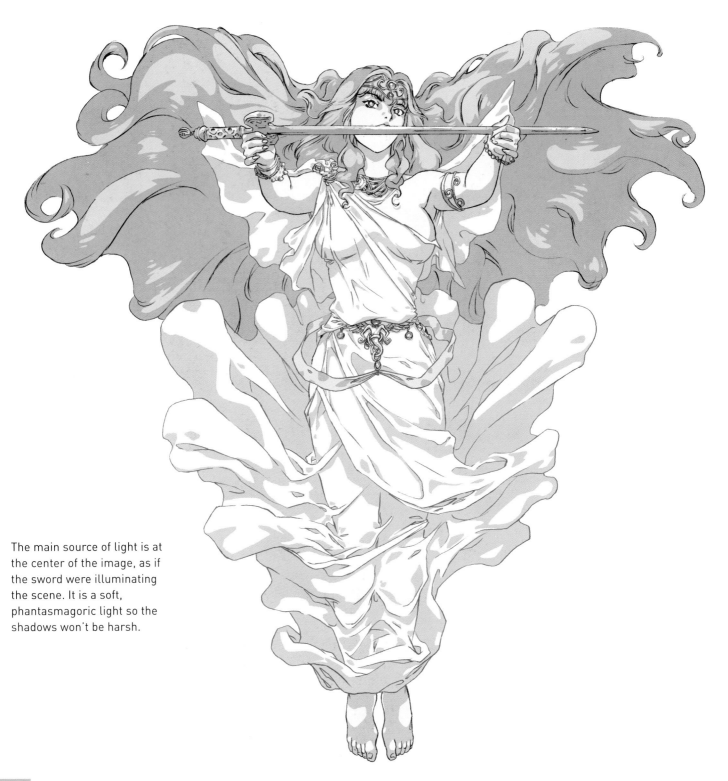

The main source of light is at the center of the image, as if the sword were illuminating the scene. It is a soft, phantasmagoric light so the shadows won't be harsh.

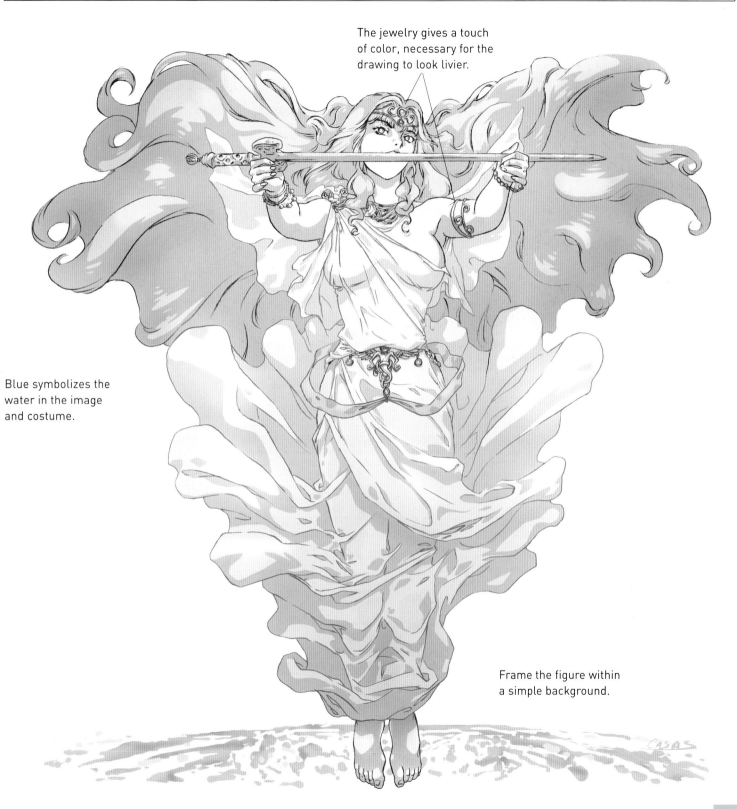

The jewelry gives a touch of color, necessary for the drawing to look livier.

Blue symbolizes the water in the image and costume.

Frame the figure within a simple background.

SIREN

Although Sirens were originally represented as half women and half birds, we prefer the more poetic vision of sirens as women with fish tails, similar to the mermaids of Neptune's court. There are many legends of sailors who lost their sanity because they became enchanted by the beauty and spellbinding songs of these mythological creatures.

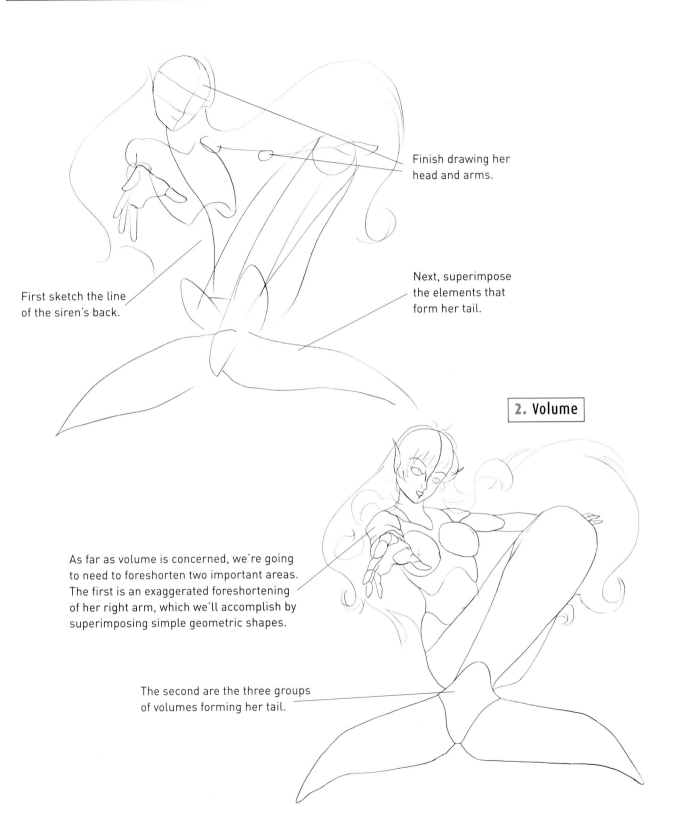

Finish drawing her head and arms.

First sketch the line of the siren's back.

Next, superimpose the elements that form her tail.

2. Volume

As far as volume is concerned, we're going to need to foreshorten two important areas. The first is an exaggerated foreshortening of her right arm, which we'll accomplish by superimposing simple geometric shapes.

The second are the three groups of volumes forming her tail.

An attractive face
completes the drawing.

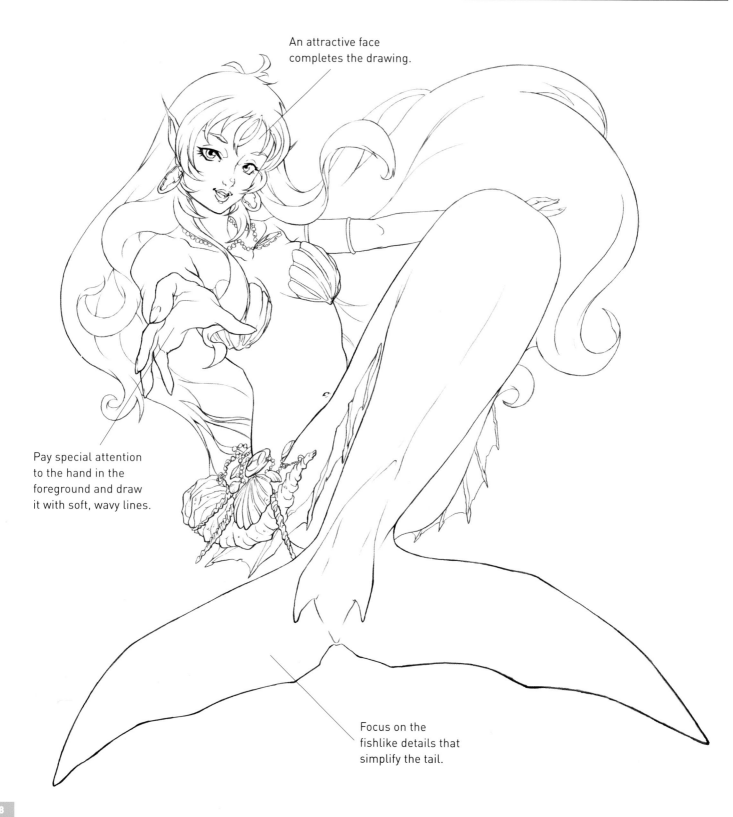

Pay special attention
to the hand in the
foreground and draw
it with soft, wavy lines.

Focus on the
fishlike details that
simplify the tail.

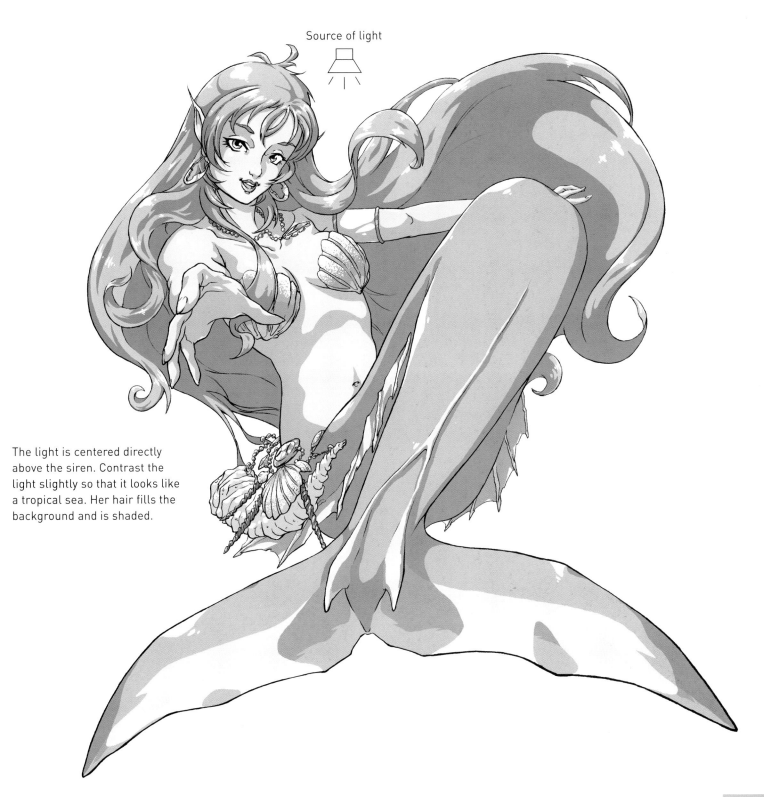

Source of light

The light is centered directly above the siren. Contrast the light slightly so that it looks like a tropical sea. Her hair fills the background and is shaded.

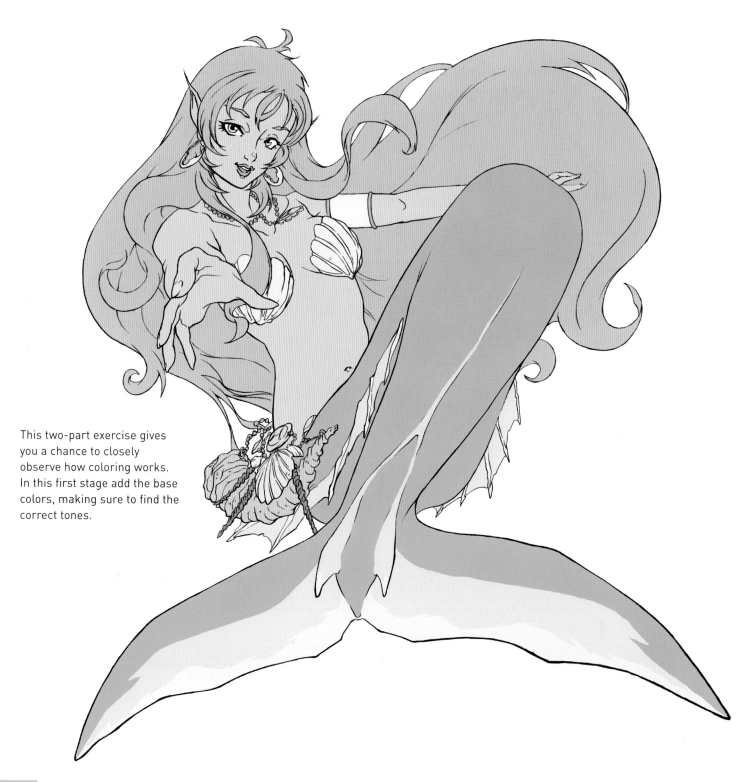

This two-part exercise gives you a chance to closely observe how coloring works. In this first stage add the base colors, making sure to find the correct tones.

Finish by painting a neutral oceanlike background and adding the tones of light and shadow that shape the illustration.

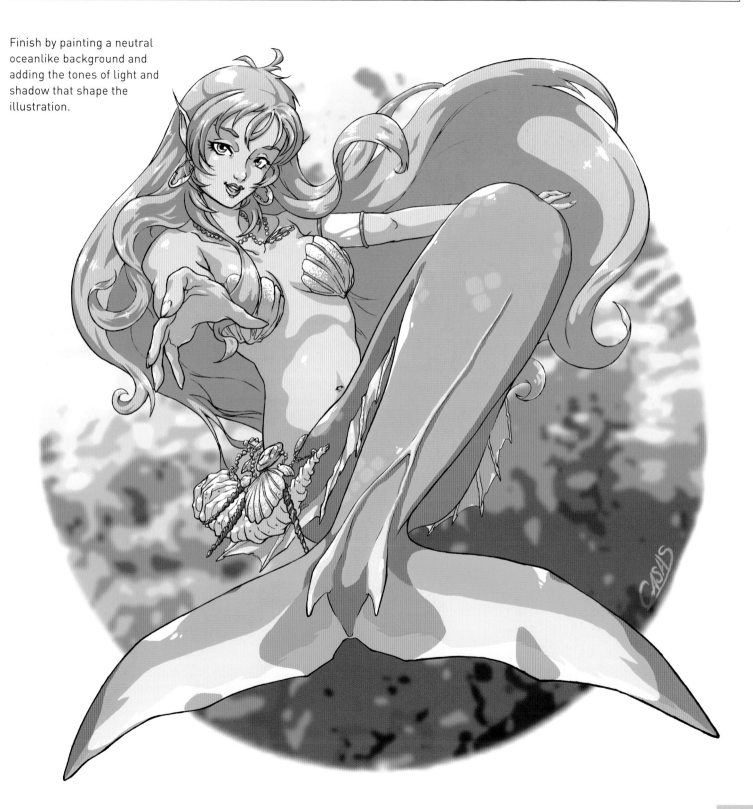

SWAN LADY

Our swan lady or white lady is a very special creature. There are hundreds of tales about children who get lost in the mountains, or in remote villages, in the middle of snowstorms, and then are found safe and sound, calmly at home, wearing dry clothes and without a sign of having been cold, hungry, or afraid. All of them say a woman dressed in white approached them and filled their souls with peace and warmth before showing them the way back home. This is our swan lady. She is a beautiful woman who is half human and half force of nature. Immortal, she lives at her almost frozen lake in the mountains, surrounded by swans, watching after mortals and the dangers they might face in winter.

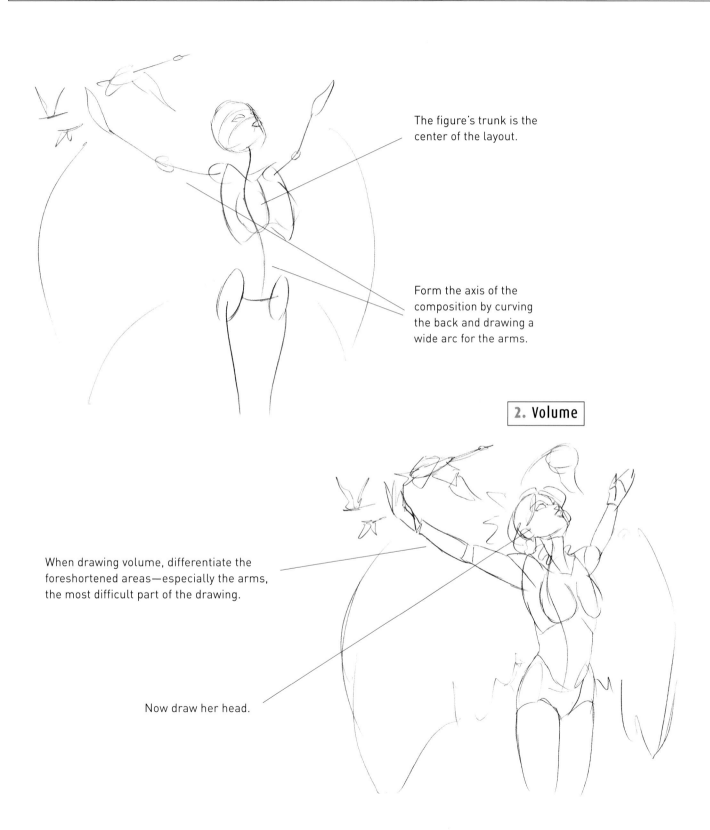

1. Shape

The figure's trunk is the center of the layout.

Form the axis of the composition by curving the back and drawing a wide arc for the arms.

2. Volume

When drawing volume, differentiate the foreshortened areas—especially the arms, the most difficult part of the drawing.

Now draw her head.

It's challenging to draw a head tilted backward and still make the face beautiful. Observing the volume makes this task a bit easier.

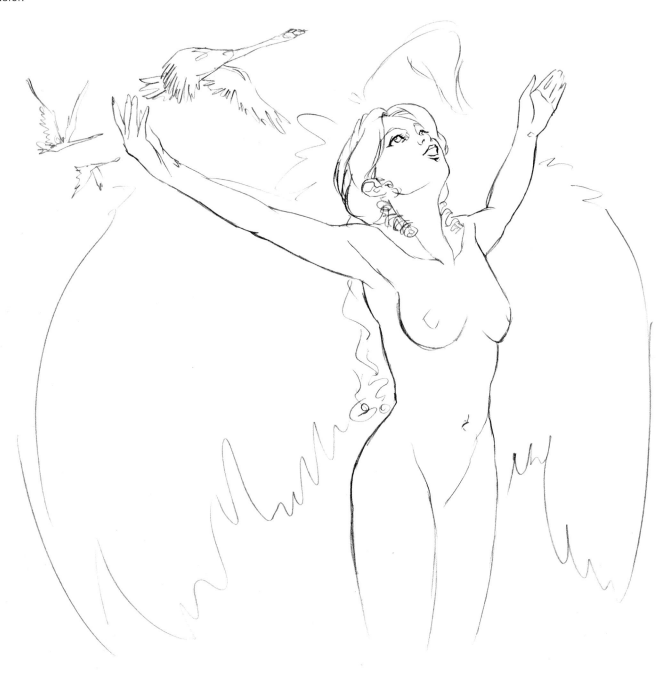

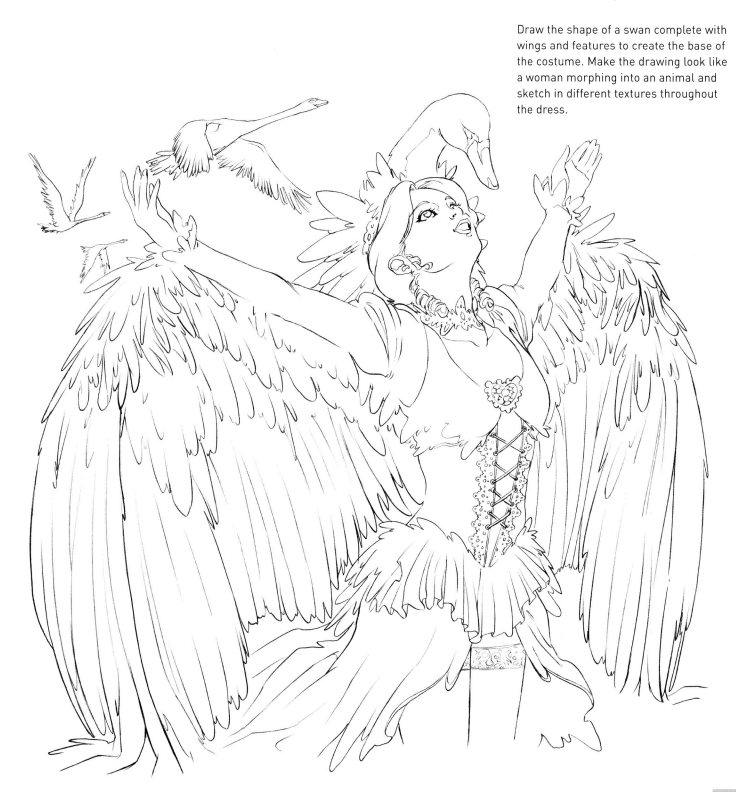

Draw the shape of a swan complete with wings and features to create the base of the costume. Make the drawing look like a woman morphing into an animal and sketch in different textures throughout the dress.

The light falls on the character from above, lending a touch of softness to all the elements. Its main focus is on the central axis of the drawing.

Source of light

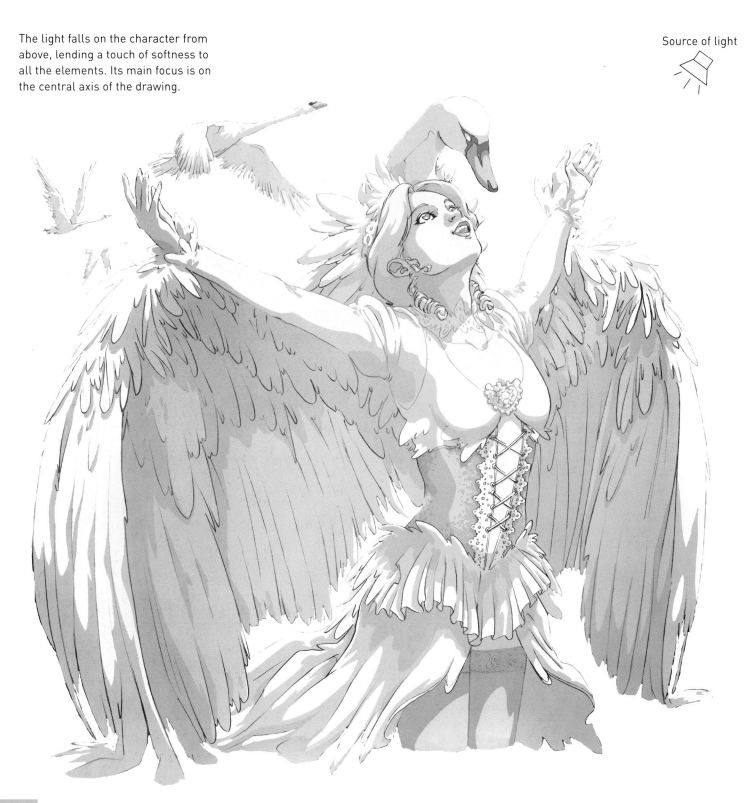

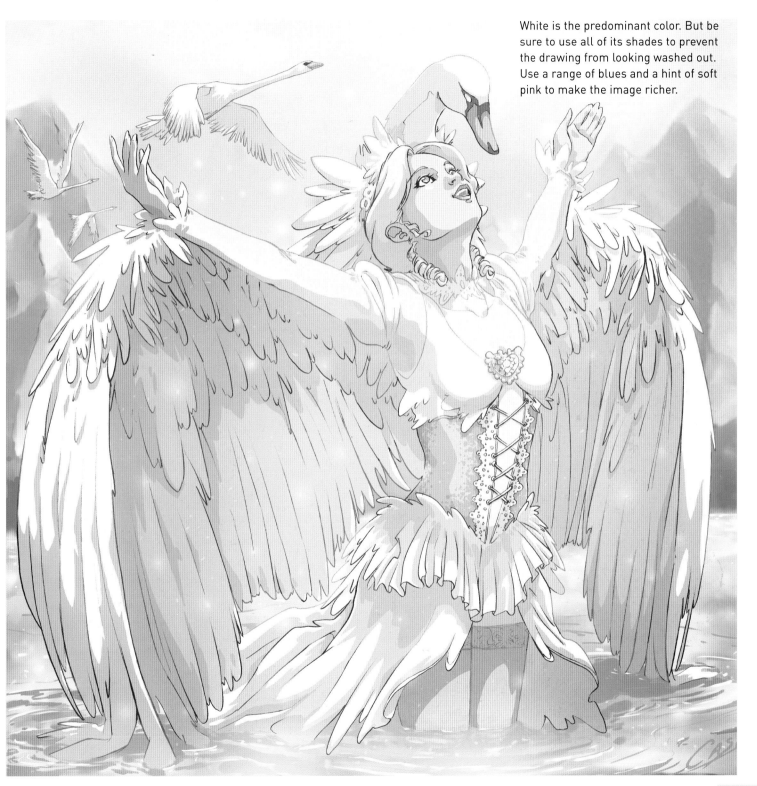

White is the predominant color. But be sure to use all of its shades to prevent the drawing from looking washed out. Use a range of blues and a hint of soft pink to make the image richer.

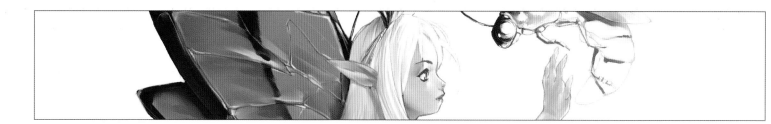

FAIRY

These good-natured, carefree creatures live in the forests and valleys in complete harmony with their environment and its inhabitants. Their games keep them busy. Although they look like beautiful humans, their small size, wings, and magic spells dispel this notion. The bright color of their wings complements their clothing, which is stitched together by dew, and their long hair, which is decorated with petals. They are best-known for the pretty songs and music that makes them the soul of the forest.

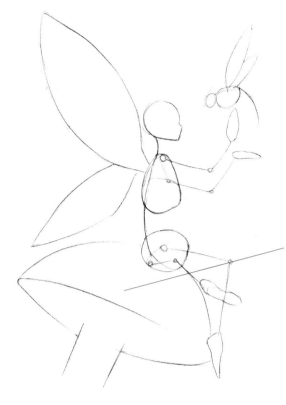

The background elements influence the main figure so sketch them too.

2. Volume

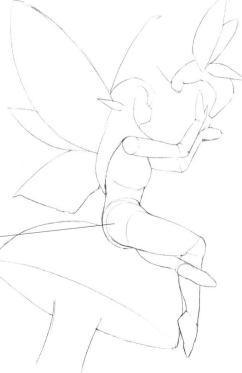

Consider depth when foreshortening. The other elements should also have a correct base.

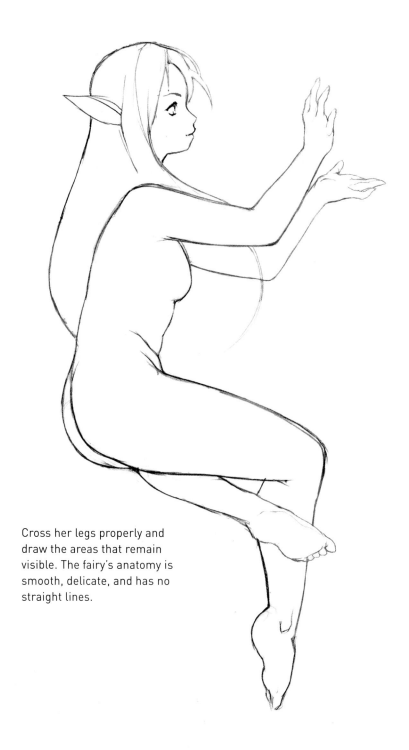

Cross her legs properly and draw the areas that remain visible. The fairy's anatomy is smooth, delicate, and has no straight lines.

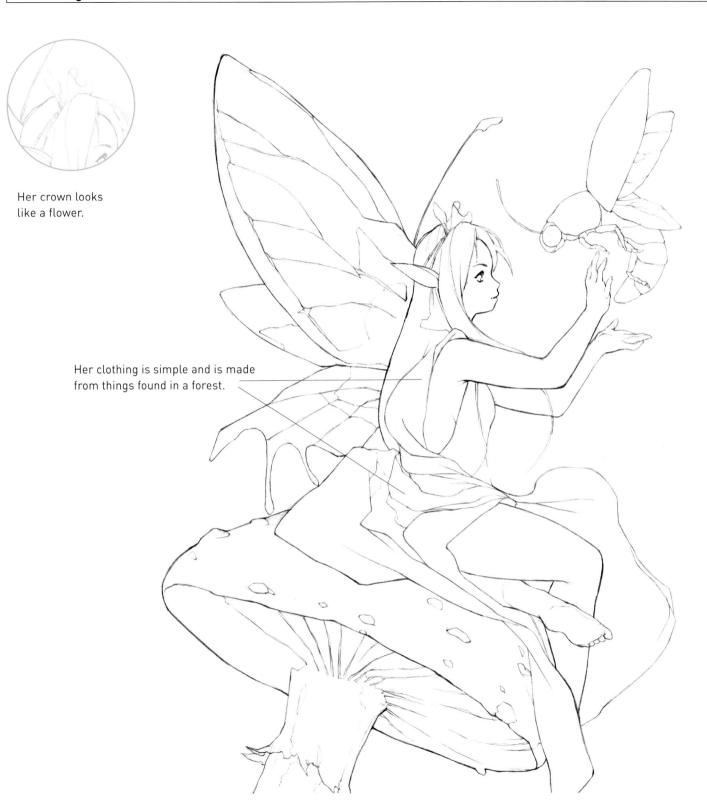

Her crown looks like a flower.

Her clothing is simple and is made from things found in a forest.

The light's focus is on the insect. Use this nocturnal lighting to create sharp contrast and add depth.

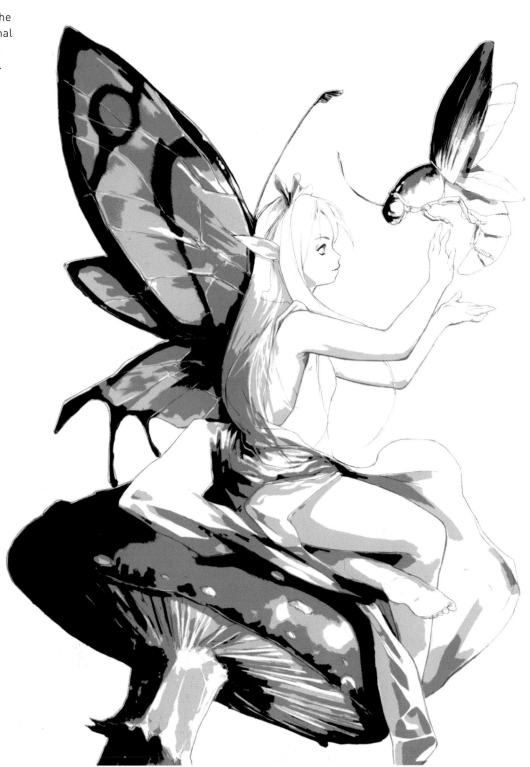

Source of light

Use happy, lively colors. Use
the light and shadows to
achieve specific tones.

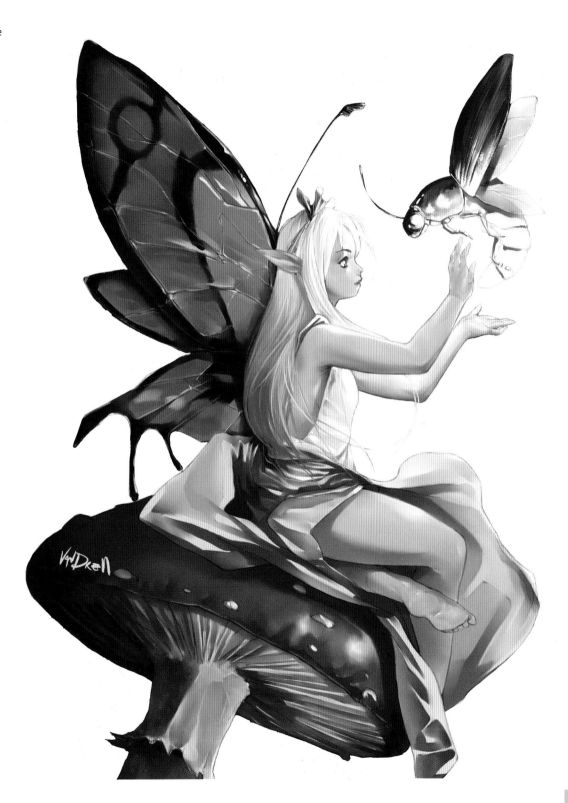

WATER NYMPH

Related to both fairies and sirens, water nymphs are lake fairies. Larger than their forest cousins and with characteristics that are more similar to sea animals than insects, you can usually see them jumping in the water and fluttering their wings. Their features are similar to those of their cousins but their legs always end in a beautifully colored fish tail. Their clothes are made of polished shells and very shiny, well-taken-care-of elements from the ocean floor. They are graceful and kind and are always willing to help.

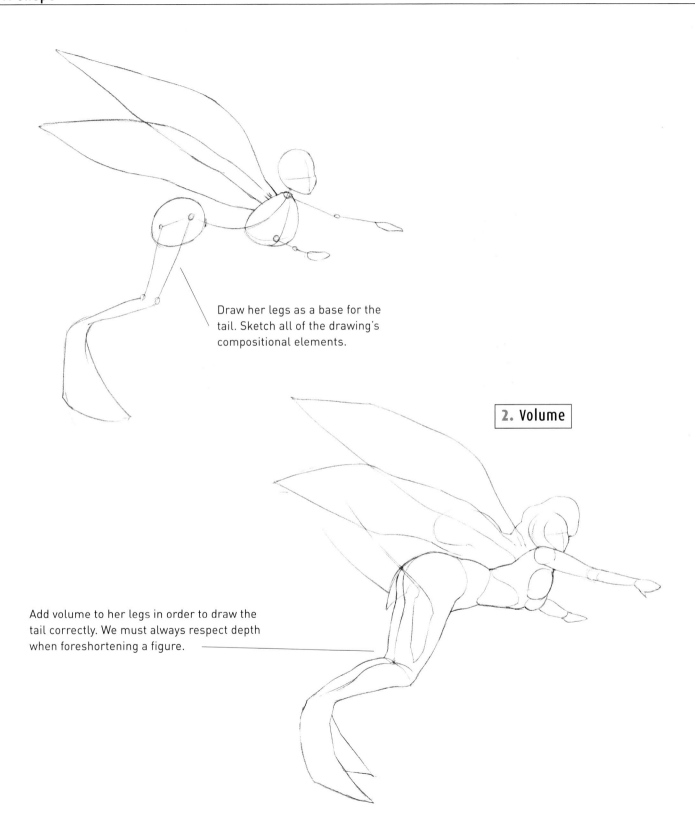

Draw her legs as a base for the tail. Sketch all of the drawing's compositional elements.

2. Volume

Add volume to her legs in order to draw the tail correctly. We must always respect depth when foreshortening a figure.

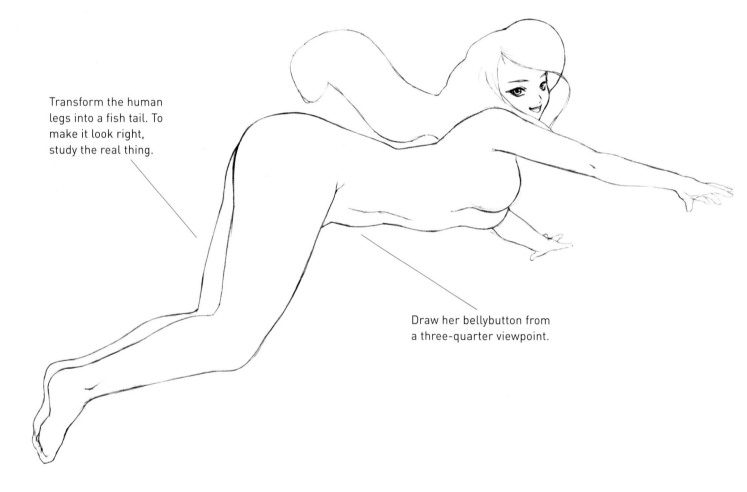

Transform the human legs into a fish tail. To make it look right, study the real thing.

Draw her bellybutton from a three-quarter viewpoint.

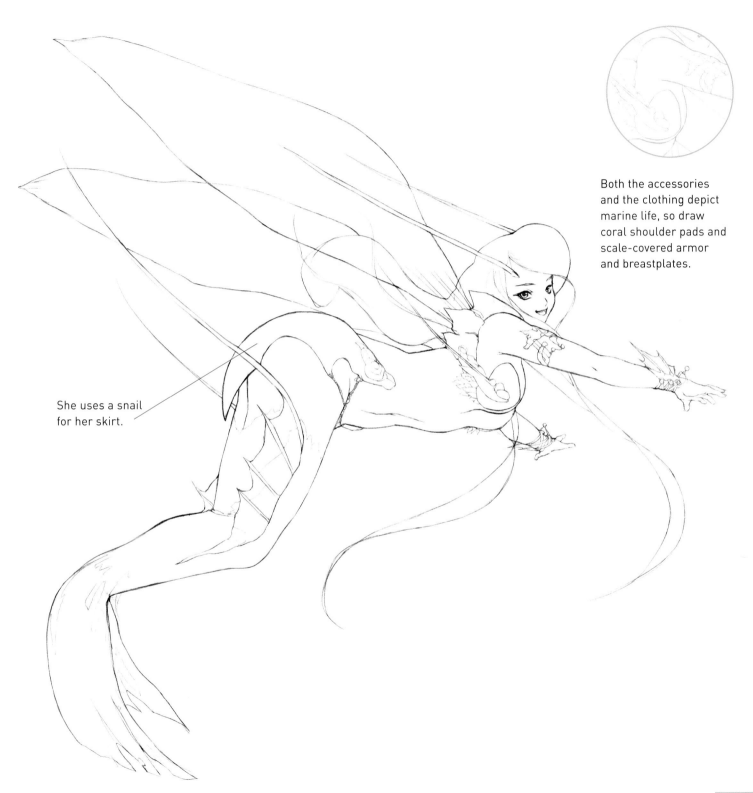

Both the accessories and the clothing depict marine life, so draw coral shoulder pads and scale-covered armor and breastplates.

She uses a snail for her skirt.

137

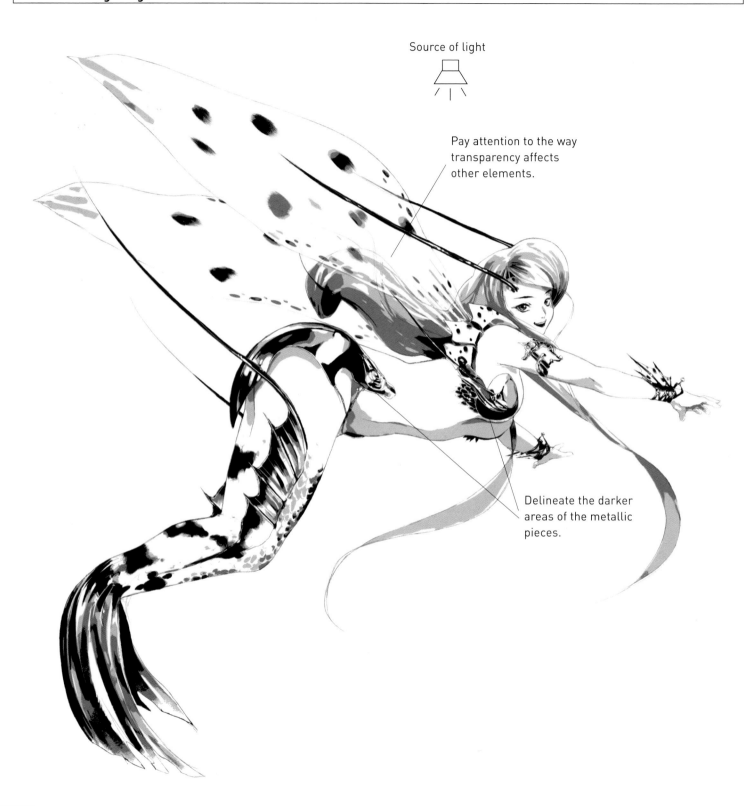

Source of light

Pay attention to the way transparency affects other elements.

Delineate the darker areas of the metallic pieces.

To contrast the coldness provided by the color blue and metallic tones, use a warm color for the skin. That way the character radiates vitality and happiness.

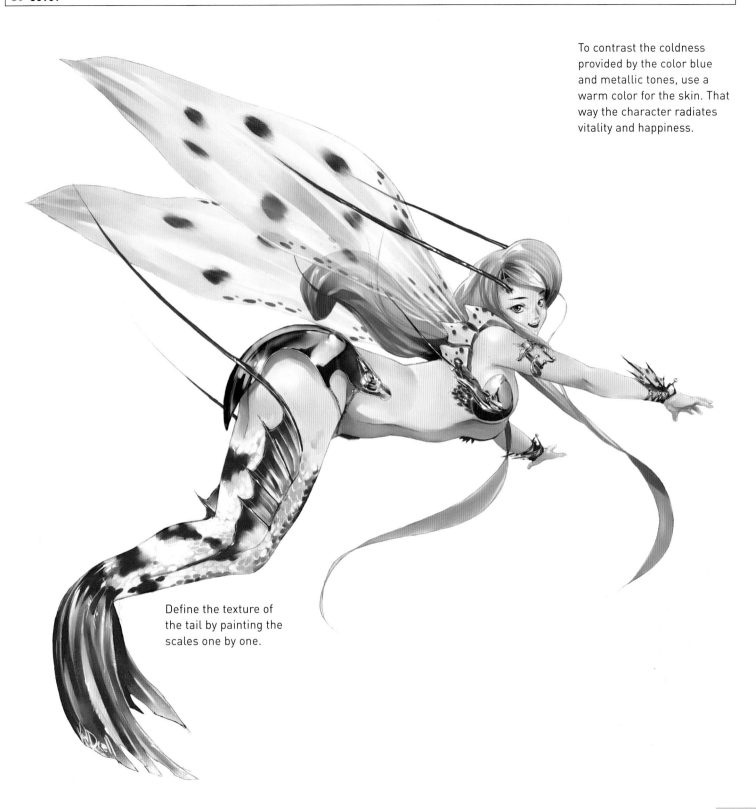

Define the texture of the tail by painting the scales one by one.

FAIRY GARDEN

Despite their noble intentions, sometimes fairies go a bit overboard when playing. That's why it's very dangerous to walk through their gardens, not to mention stopping to rest in them. Their terrible spells are capable of making a person fall into a deep slumber or engage in a long dance that might seem to last hours while really lasting for years. Many times elderly people have been seen coming out of the garden claiming that they had fallen asleep there as youngsters.

1. Shape

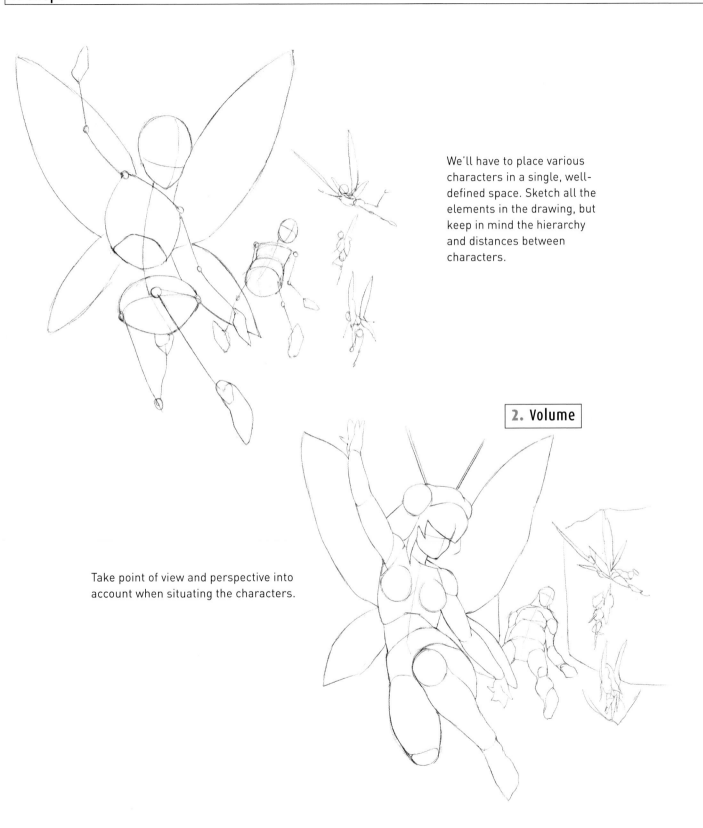

We'll have to place various characters in a single, well-defined space. Sketch all the elements in the drawing, but keep in mind the hierarchy and distances between characters.

2. Volume

Take point of view and perspective into account when situating the characters.

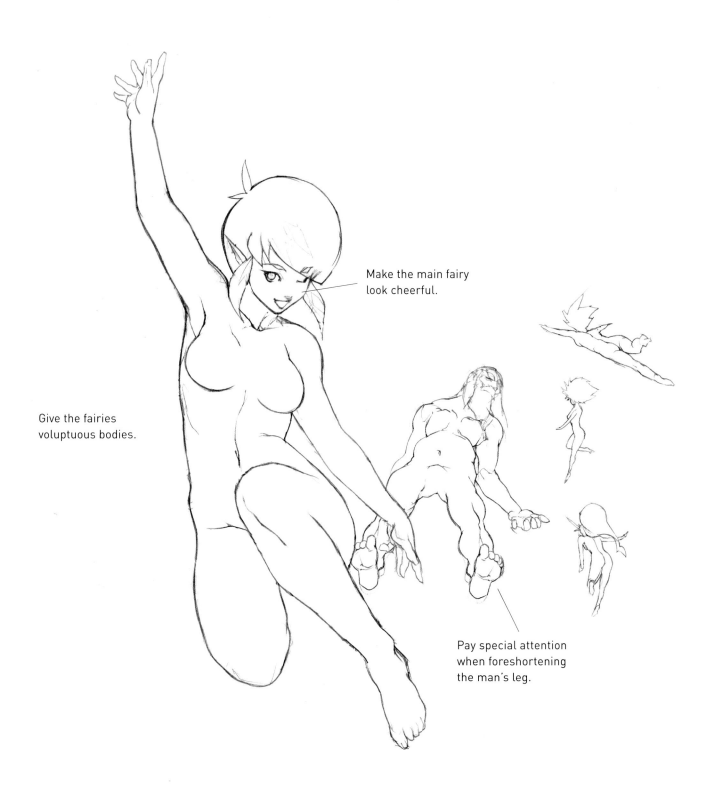

Make the main fairy look cheerful.

Give the fairies voluptuous bodies.

Pay special attention when foreshortening the man's leg.

Add a diaphanous piece of fabric to the fairy closest to us. That emphasizes her importance in relation to the rest of the figures.

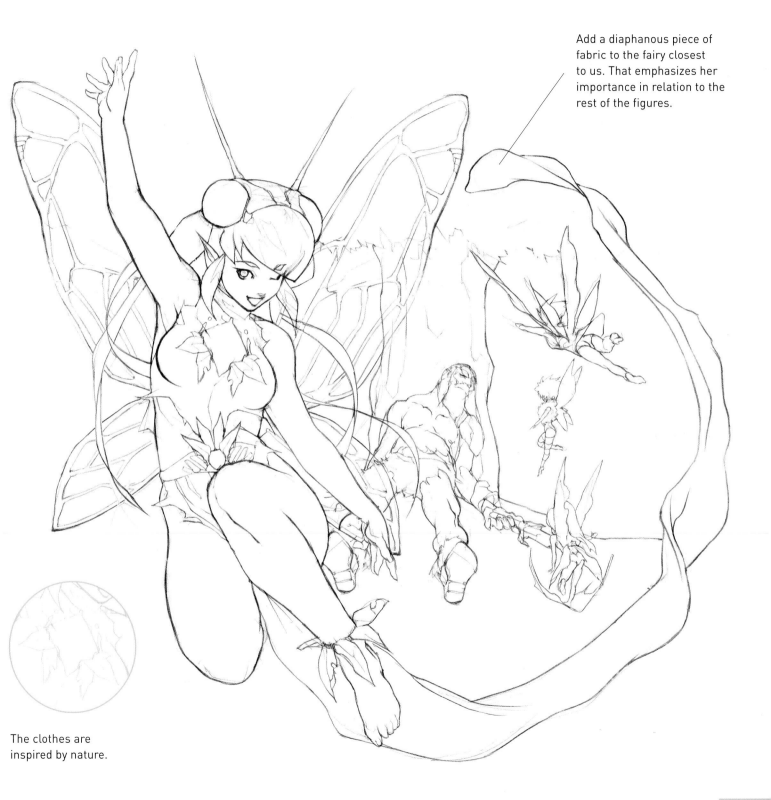

The clothes are inspired by nature.

Source of light

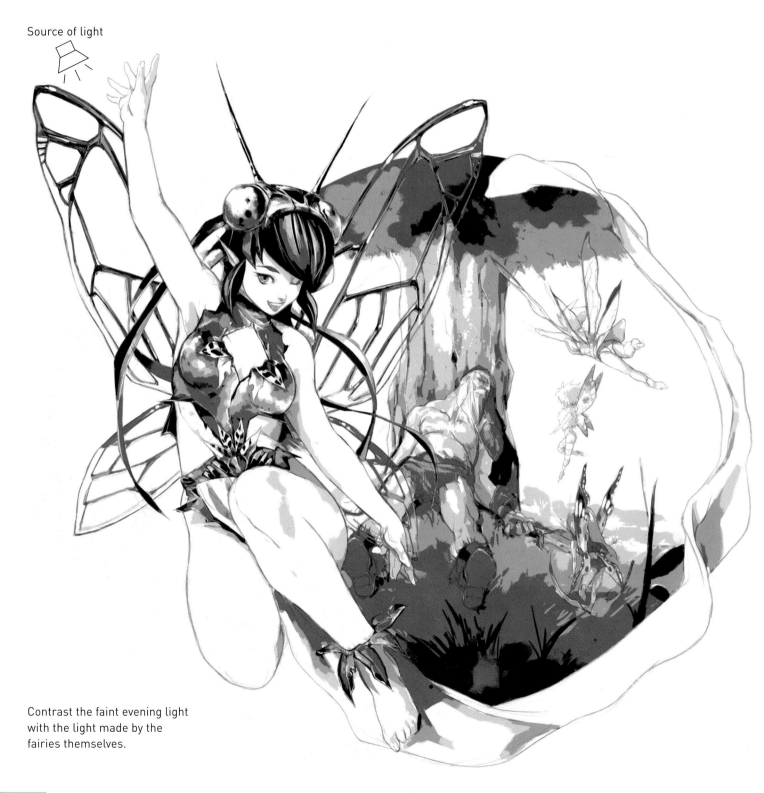

Contrast the faint evening light with the light made by the fairies themselves.

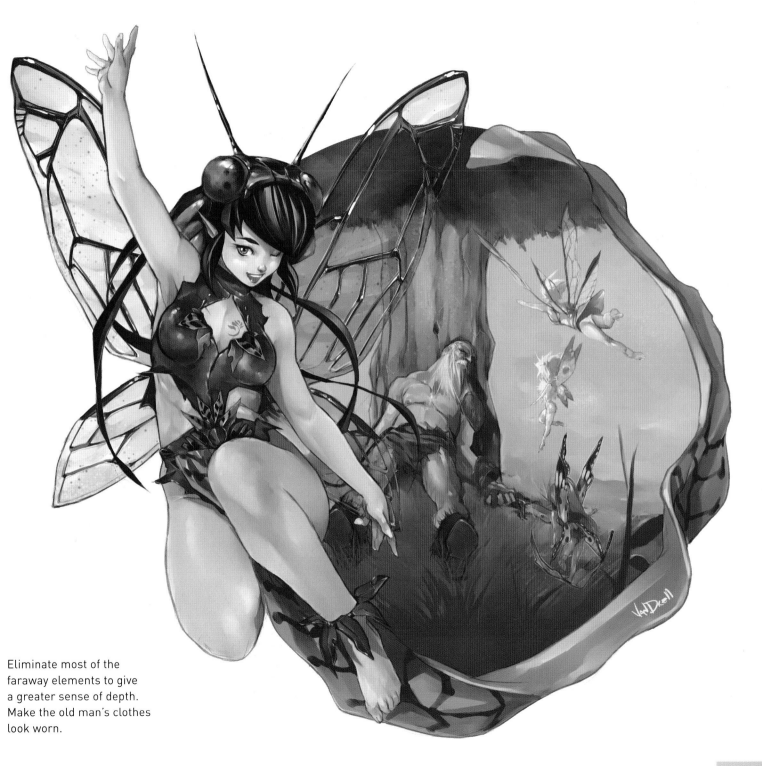

Eliminate most of the
faraway elements to give
a greater sense of depth.
Make the old man's clothes
look worn.

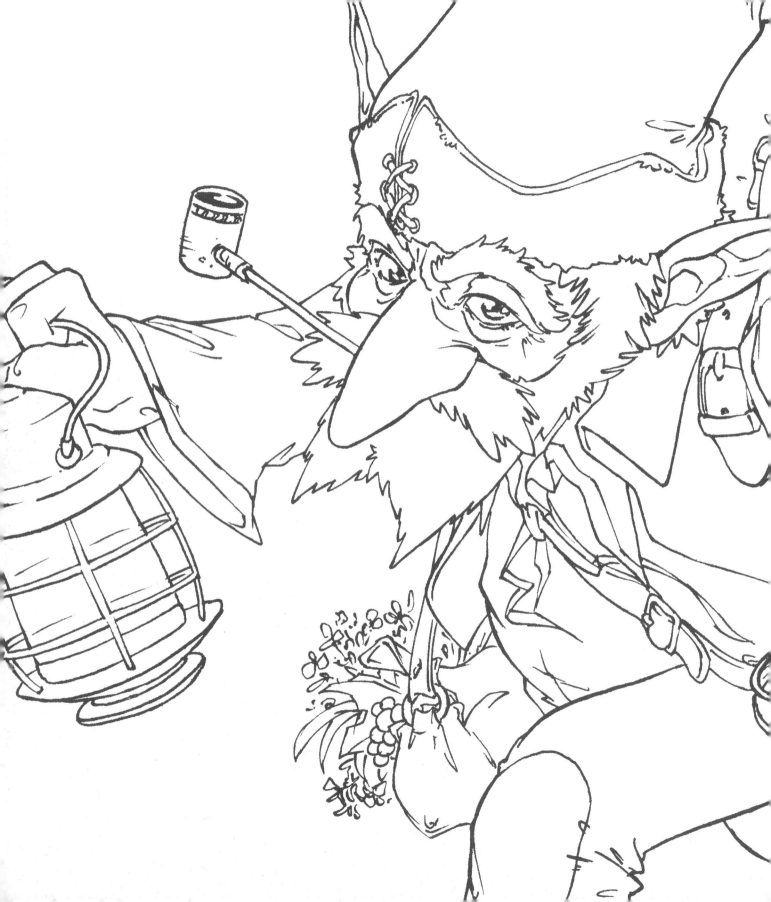

THE HAUNTED FOREST

MAGIC MUSHROOMS

Mushrooms inhabit the forest, usually growing in the humid ground underneath the canopy of trees. There are a great many varieties, from edible ones to poisonous ones to hallucinogenic ones. But these are magical mushrooms, much livelier than their ordinary cousins. These mushrooms have decided to live a much more active life and are one of the most special inhabitants of magical forests. Like their cousins, there are many types; we're going to introduce you to a few of them.

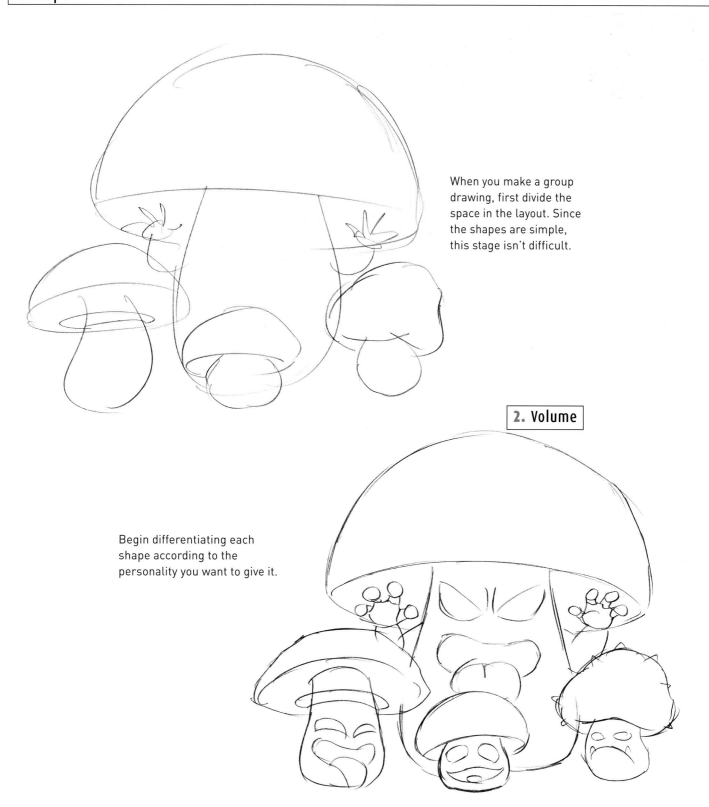

When you make a group drawing, first divide the space in the layout. Since the shapes are simple, this stage isn't difficult.

2. Volume

Begin differentiating each shape according to the personality you want to give it.

Finish defining their attributes—the giant
mushroom, the poisonous one, the tiny
ghost, and the hard, prickly one. Draw a
comical face on each figure.

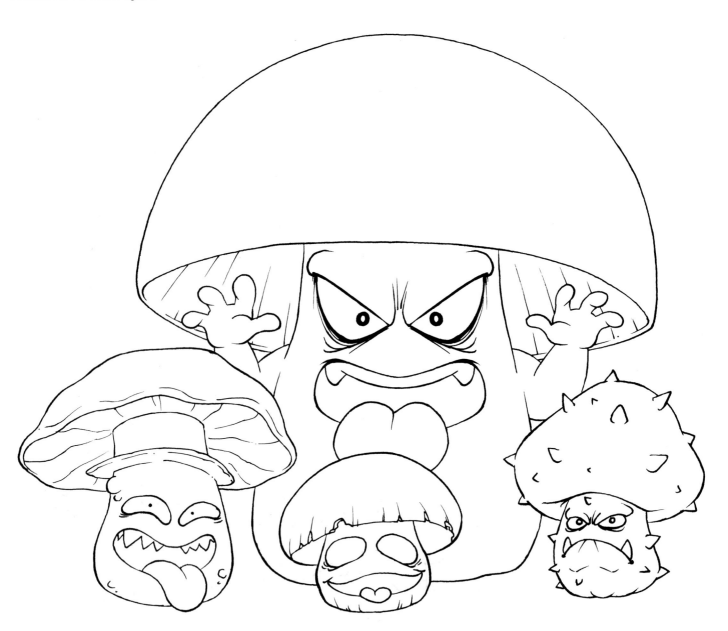

Notice how the crown of each mushroom projects
a shadow over the stem. Darkening shadows
makes the mushrooms look more dangerous.

Source of light

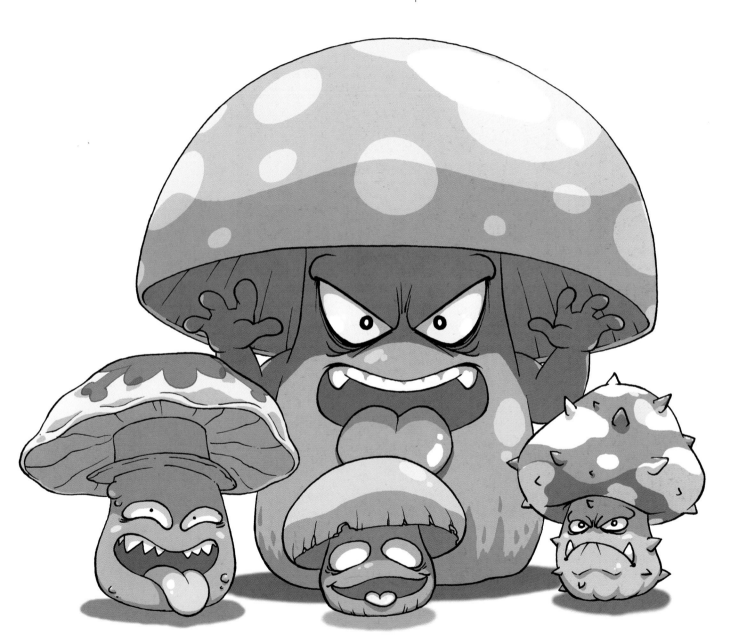

Use basic colors to
differentiate each mushroom,
giving each a tonal range
according to its personality.
Lively colors are more fun.

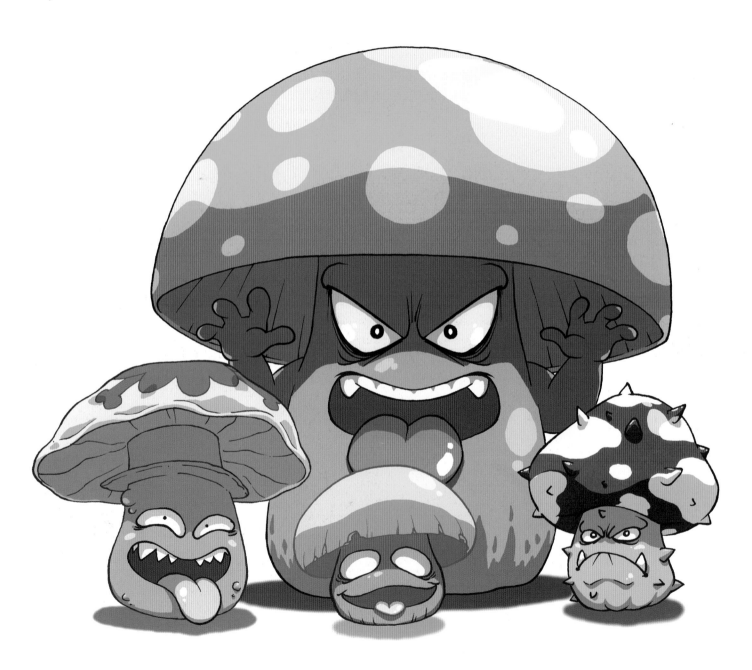

Finish with special effects: a
suspicious-looking yellow trail
for the poisonous mushroom and a
phantasmagoric neon-blue for the
ghostly mushroom.

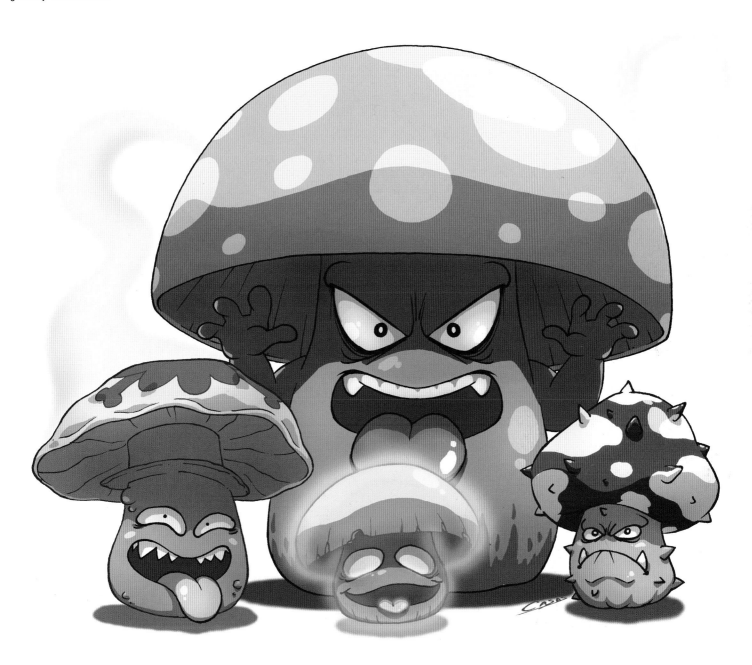

TREE MAN

Tree men are the giants of the forest. These trees are so old that they've learned to walk and speak. All trees are living creatures and they won't hesitate to demonstrate it. They are fierce protectors of the forest, noble warriors and wise advisers who have watched millennia pass by. They tend to be mistaken for ordinary trees until they are bothered or are needed to protect the forest from harmful creatures.

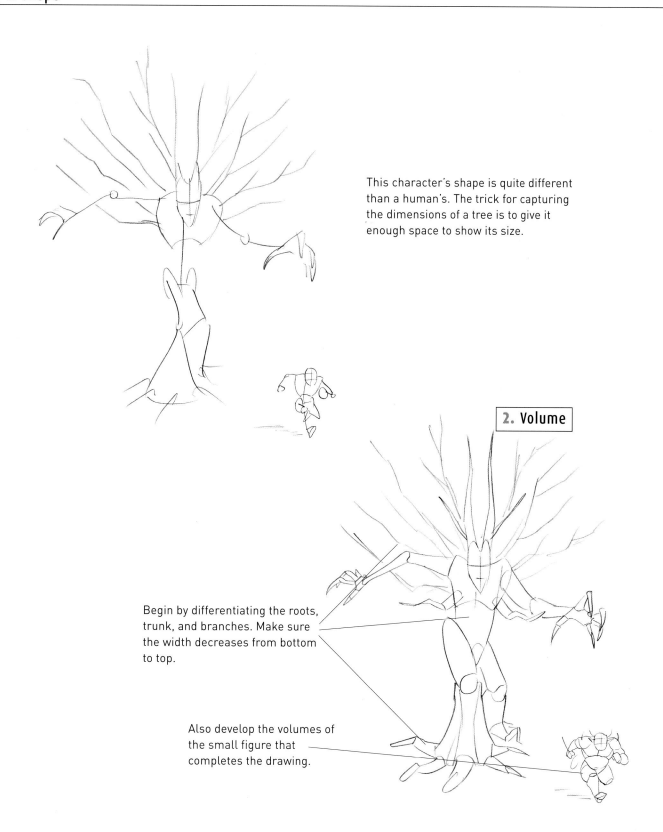

This character's shape is quite different than a human's. The trick for capturing the dimensions of a tree is to give it enough space to show its size.

2. Volume

Begin by differentiating the roots, trunk, and branches. Make sure the width decreases from bottom to top.

Also develop the volumes of the small figure that completes the drawing.

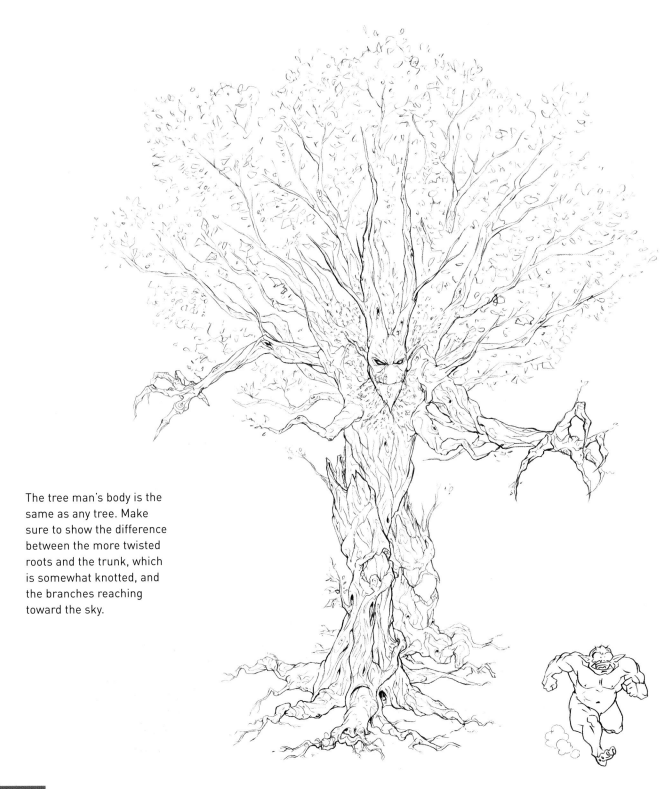

The tree man's body is the same as any tree. Make sure to show the difference between the more twisted roots and the trunk, which is somewhat knotted, and the branches reaching toward the sky.

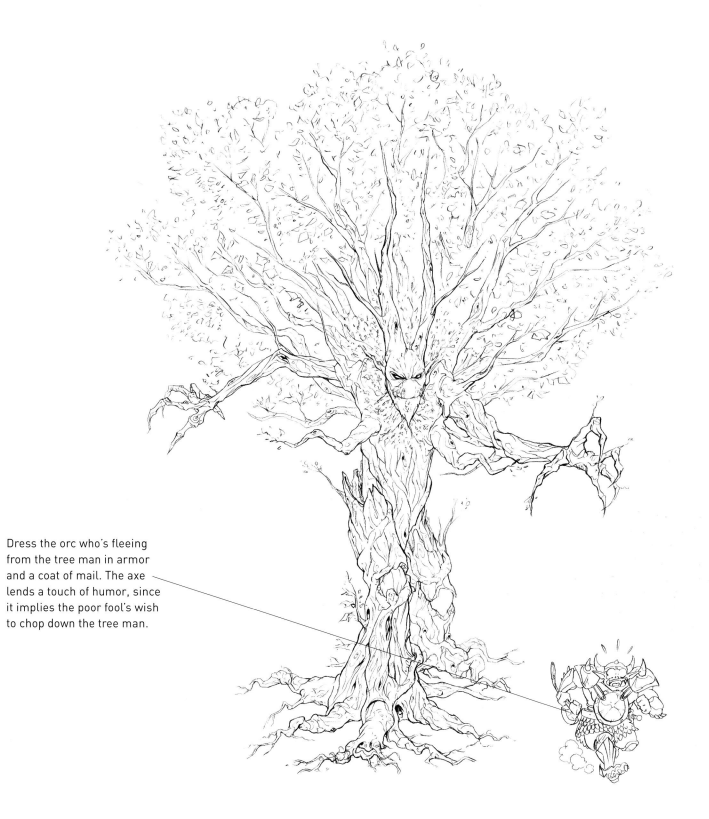

Dress the orc who's fleeing from the tree man in armor and a coat of mail. The axe lends a touch of humor, since it implies the poor fool's wish to chop down the tree man.

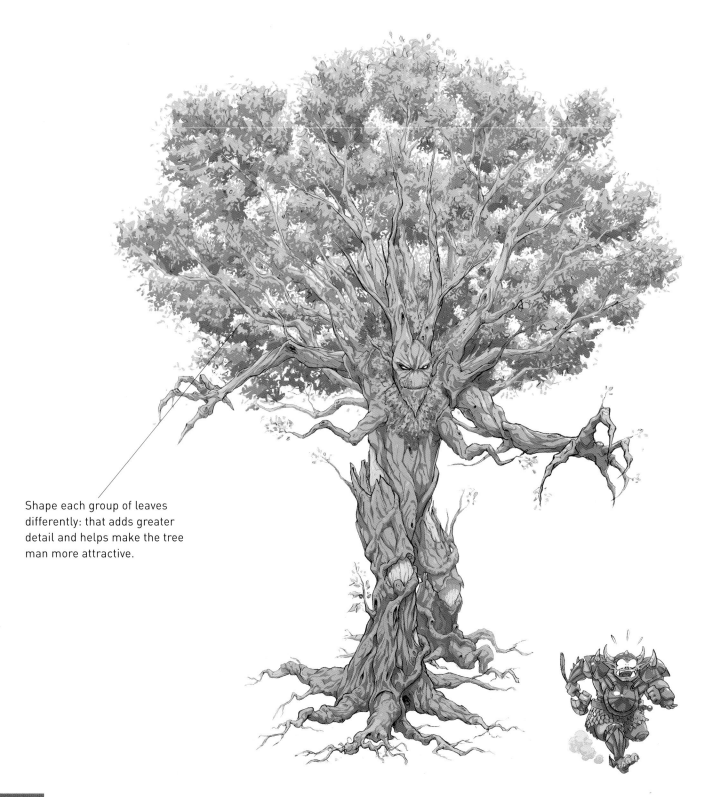

Shape each group of leaves differently: that adds greater detail and helps make the tree man more attractive.

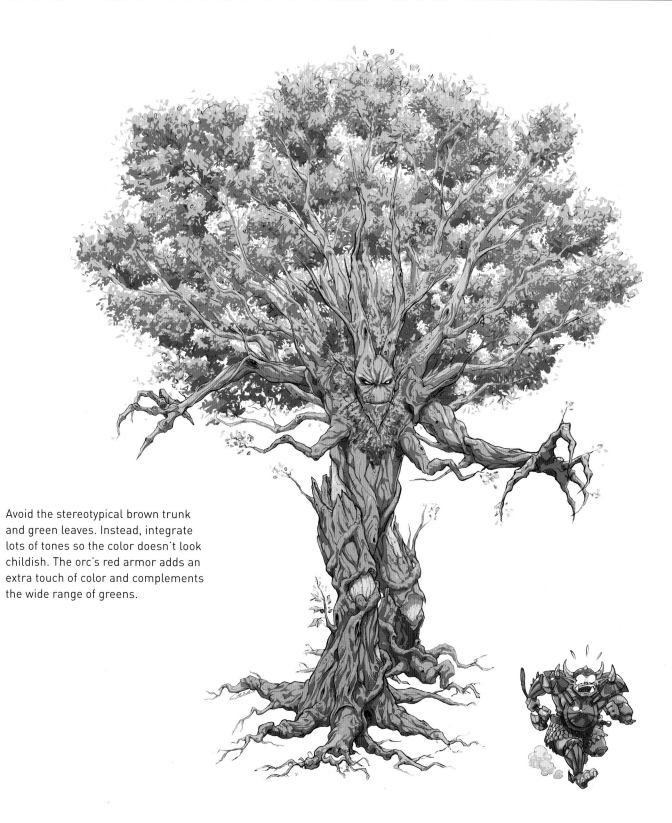

Avoid the stereotypical brown trunk and green leaves. Instead, integrate lots of tones so the color doesn't look childish. The orc's red armor adds an extra touch of color and complements the wide range of greens.

159

GNOME

Gnomes are small, supernatural beings who usually dwell underground or in forests. Tied to the powers of the earth, they are considered great, hard-working geniuses who are always busy looking after the greatest treasures of the earth. Originally they were considered benevolent creatures, but over time they've earned the reputation of being naughty; occasionally you will even hear about an evil genius. Physically speaking, they have big noses and enormous ears and are not the prettiest of creatures.

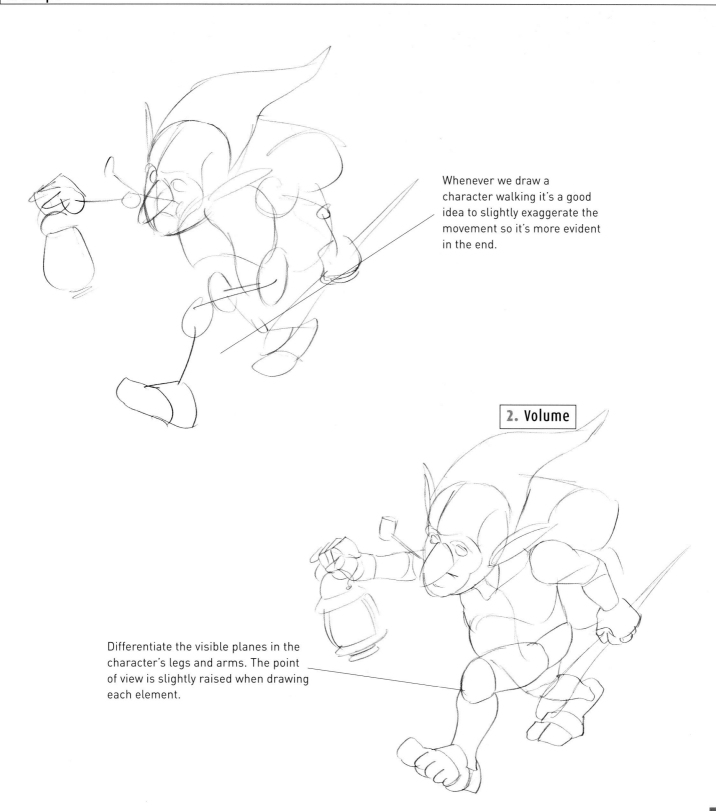

Whenever we draw a character walking it's a good idea to slightly exaggerate the movement so it's more evident in the end.

2. Volume

Differentiate the visible planes in the character's legs and arms. The point of view is slightly raised when drawing each element.

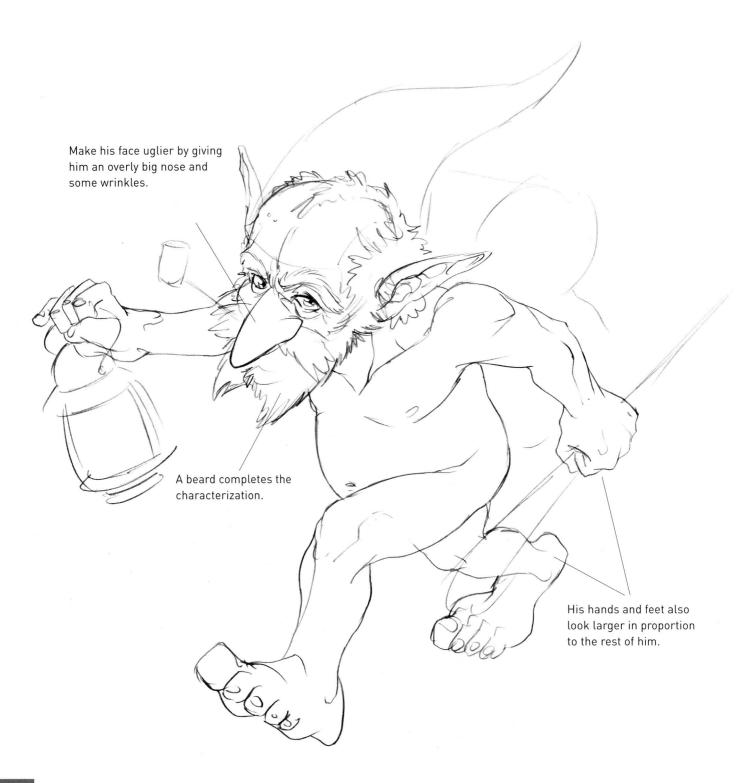

Make his face uglier by giving him an overly big nose and some wrinkles.

A beard completes the characterization.

His hands and feet also look larger in proportion to the rest of him.

Dress him like a mountain villager complete with a peaked hat.

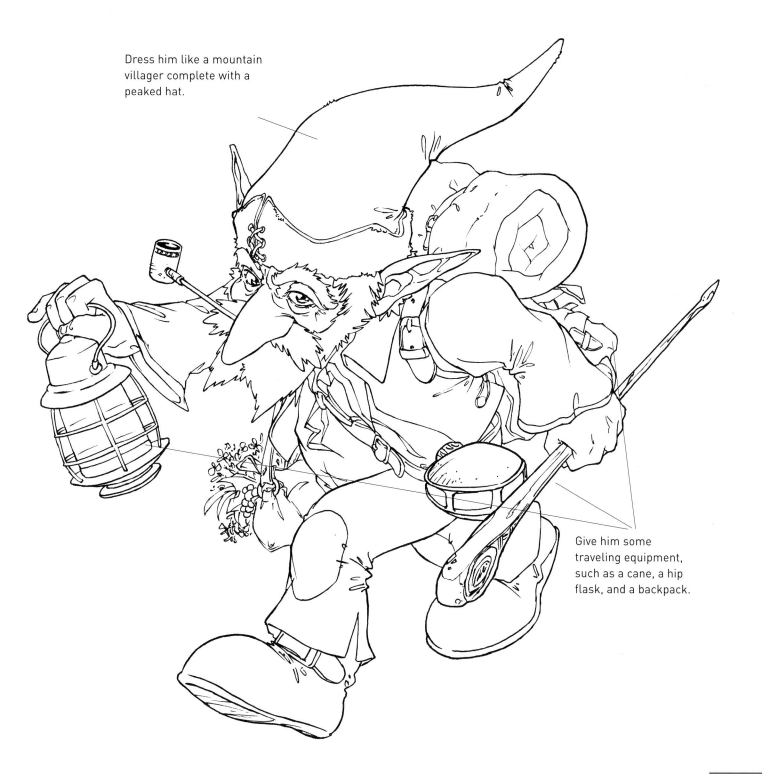

Give him some traveling equipment, such as a cane, a hip flask, and a backpack.

The source of light comes from the lantern swinging along with the gnome's motion. The shading gives the character shape, with the lantern in the center.

The shadows projected are also important, like the hat over the backpack.

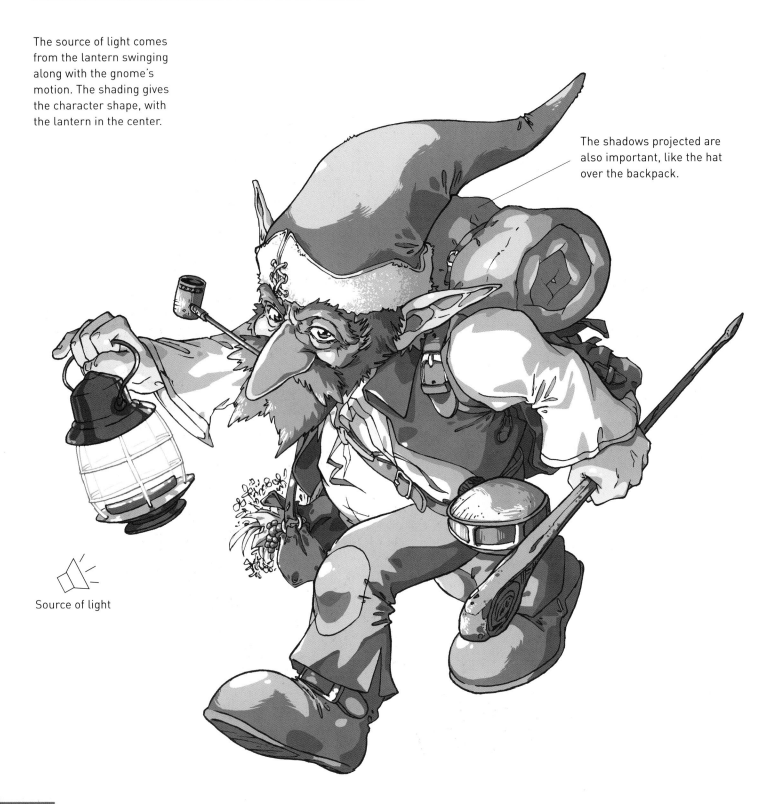

Source of light

The color should resemble a light bathing scene, so use colors that belong in the same tonal range. Finish with the background our character travels through.

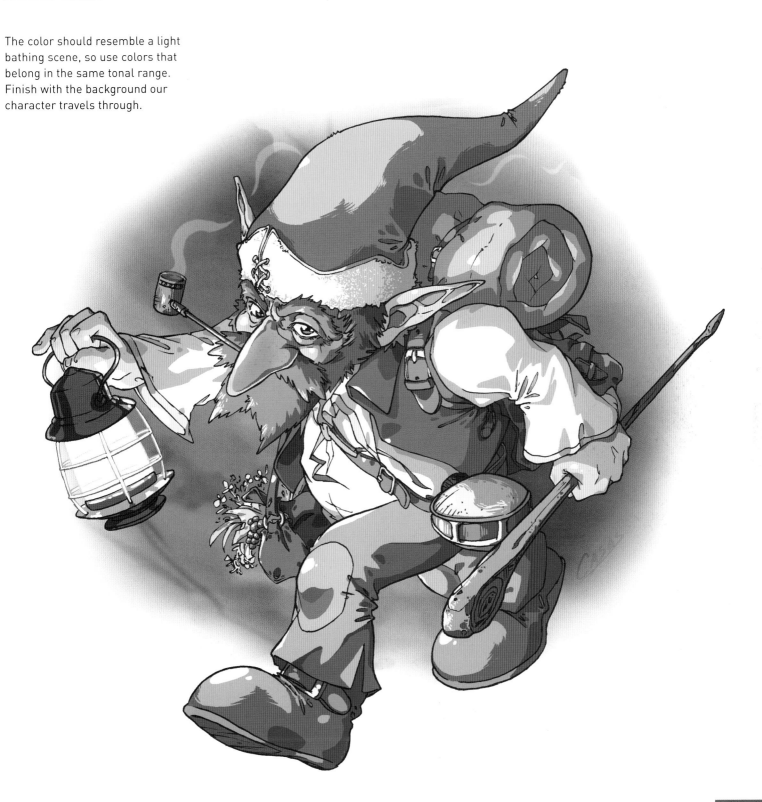

TROLL

Trolls are an anthropomorphic race. Sometimes they are diabolical giants who look like ogres, other times they are tamed savages who look more like men. They live below hills or mounds, and have a tendency to kidnap humans. Often they look aboriginal with enormous ears and noses, ugly and foul-smelling. They personify the dangers of the forest.

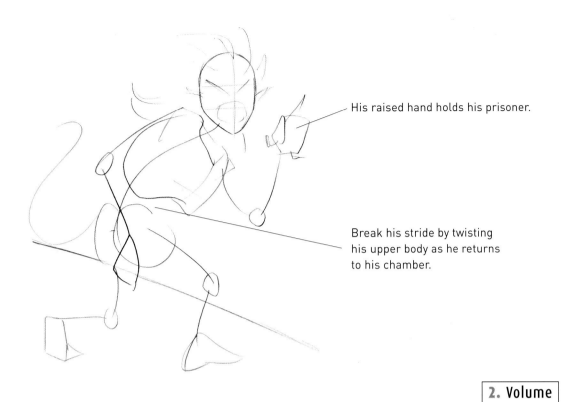

His raised hand holds his prisoner.

Break his stride by twisting
his upper body as he returns
to his chamber.

2. Volume

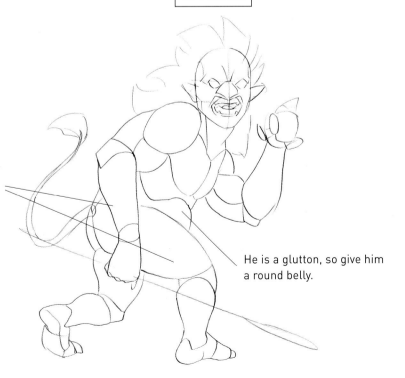

Define the structure of a
deformed human: the arms are
much bigger than normal and
the legs are short and strong.

He is a glutton, so give him
a round belly.

He has lots of hair on his skin and at the end of his tail.

The troll's gigantic arms are bulky with powerful muscles.

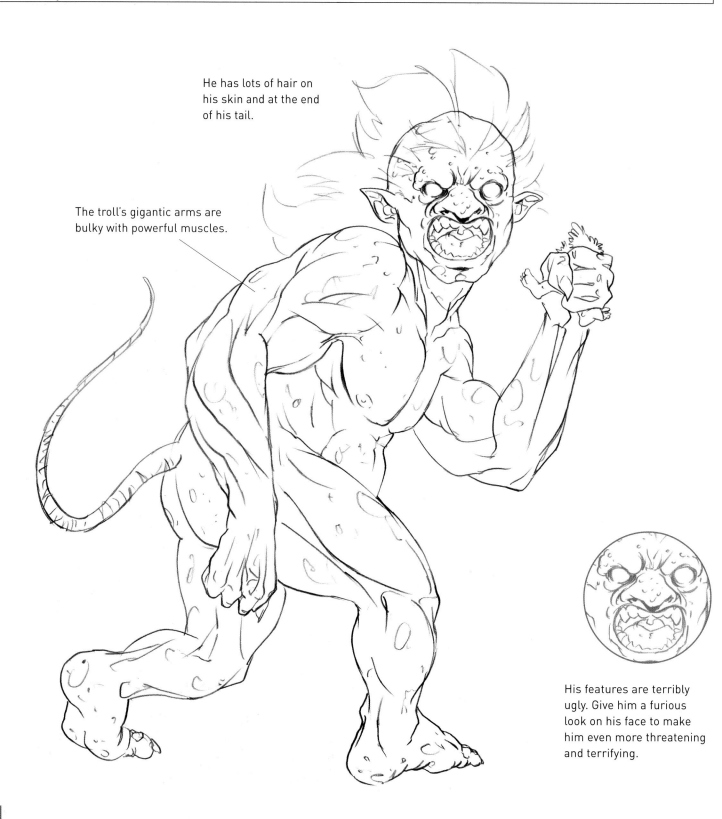

His features are terribly ugly. Give him a furious look on his face to make him even more threatening and terrifying.

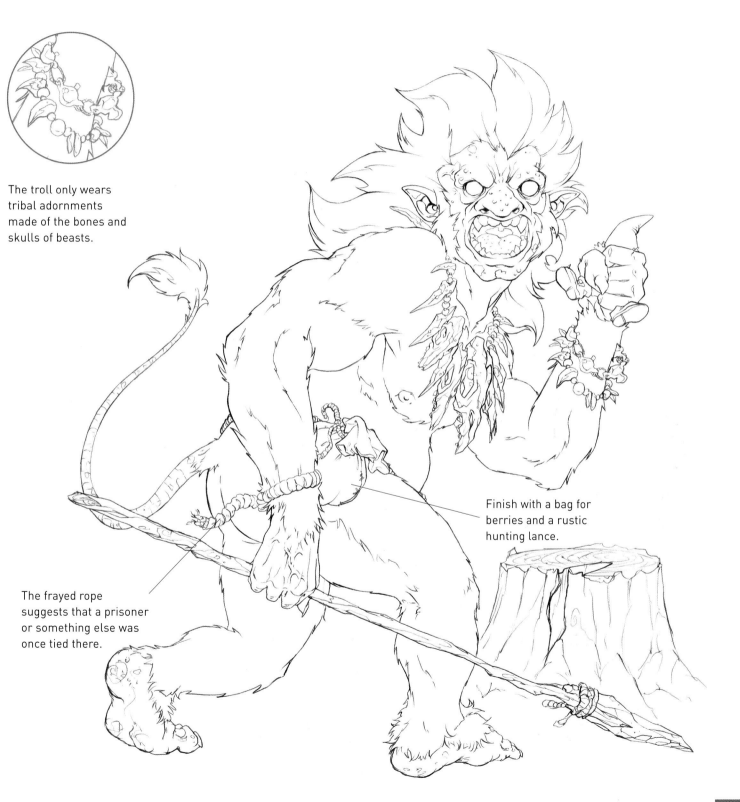

The troll only wears tribal adornments made of the bones and skulls of beasts.

Finish with a bag for berries and a rustic hunting lance.

The frayed rope suggests that a prisoner or something else was once tied there.

Place the light so that it completely illuminates his face and exaggerates his expression. This way he'll become truly terrifying.

Source of light

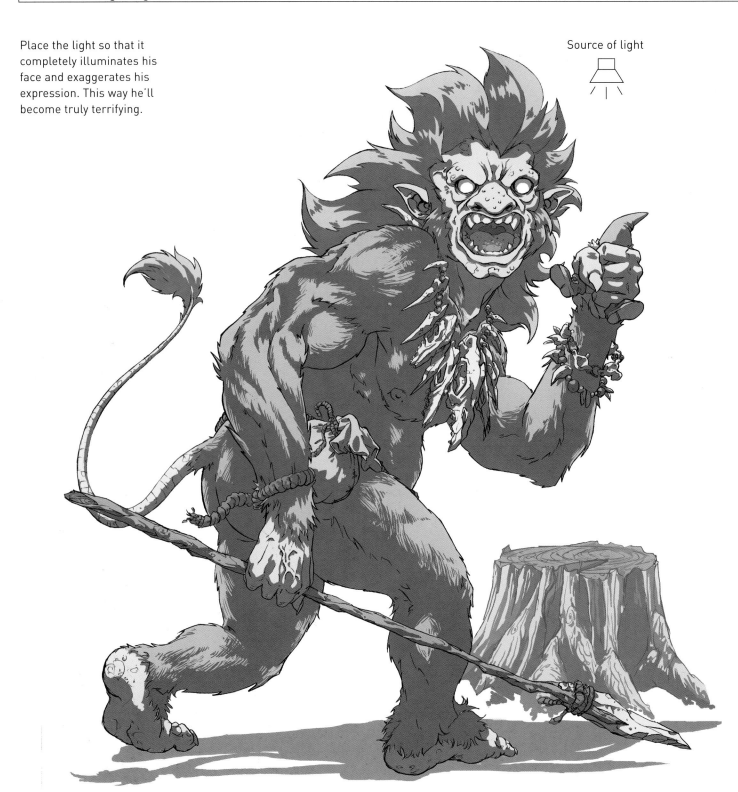

The strident color of the troll's
hair makes him look even stranger.
The gnome's red hat serves as a
secondary source of attention.

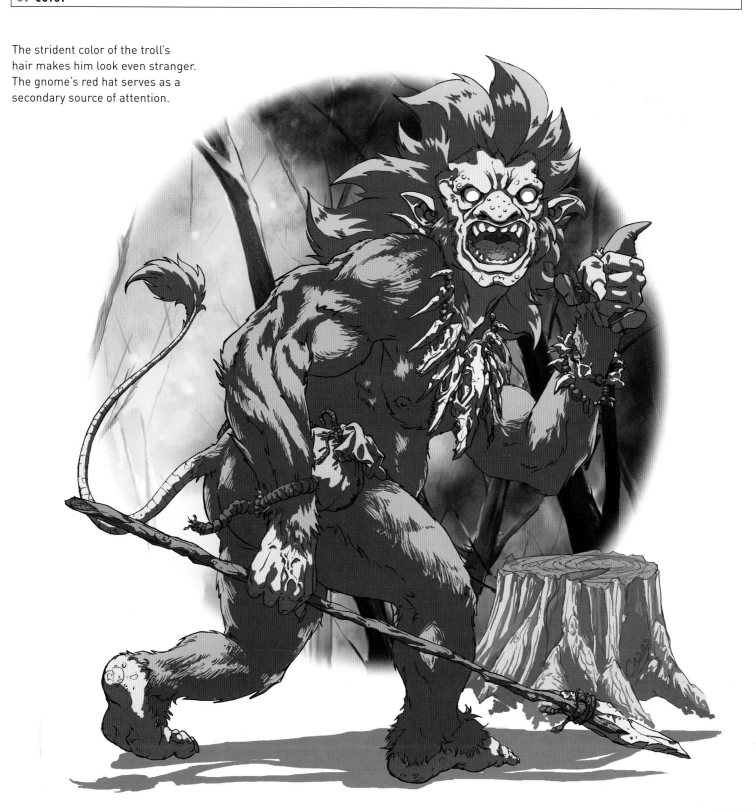

FOREST WITCH

The forest witch is almost as old as the forest itself. She practices magic that is tied to the oldest rituals. Many are frightened by the witch's spells, which have historically been tied to the devil. But not everything is all good or all bad when it comes to witches; it depends on how you look at them. Transforming objects, bewitching hearts, creating incredible potions and remedies are just some of their abilities. On full moon nights you'll see them flying on their brooms across the sky.

1. Shape

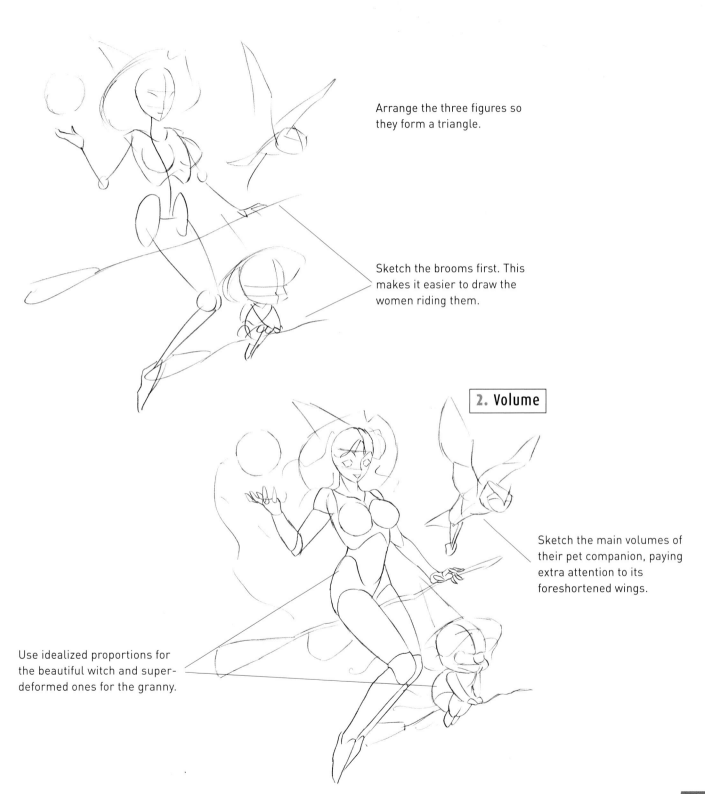

Arrange the three figures so they form a triangle.

Sketch the brooms first. This makes it easier to draw the women riding them.

2. Volume

Sketch the main volumes of their pet companion, paying extra attention to its foreshortened wings.

Use idealized proportions for the beautiful witch and super-deformed ones for the granny.

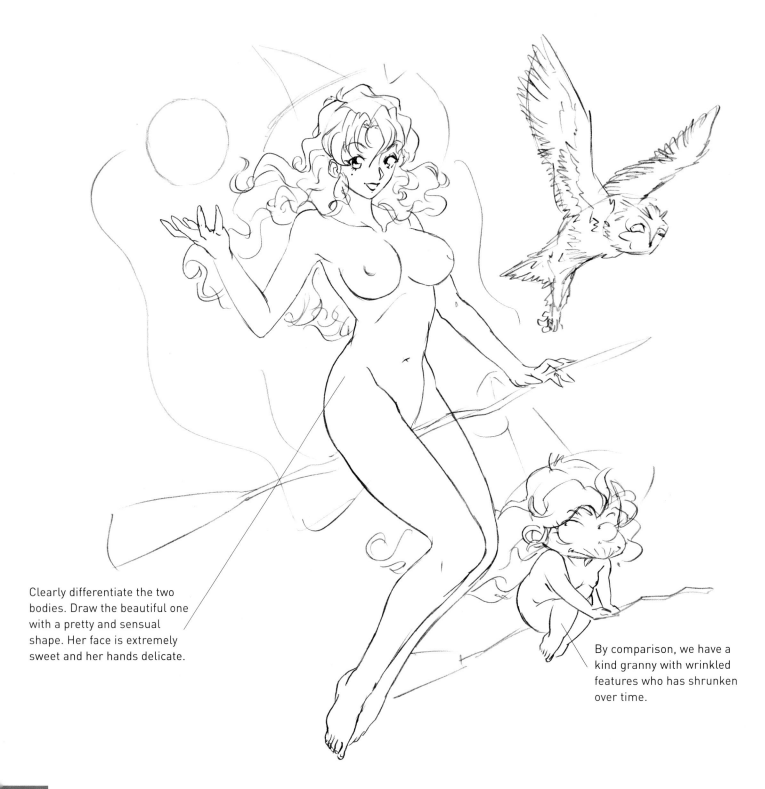

Clearly differentiate the two bodies. Draw the beautiful one with a pretty and sensual shape. Her face is extremely sweet and her hands delicate.

By comparison, we have a kind granny with wrinkled features who has shrunken over time.

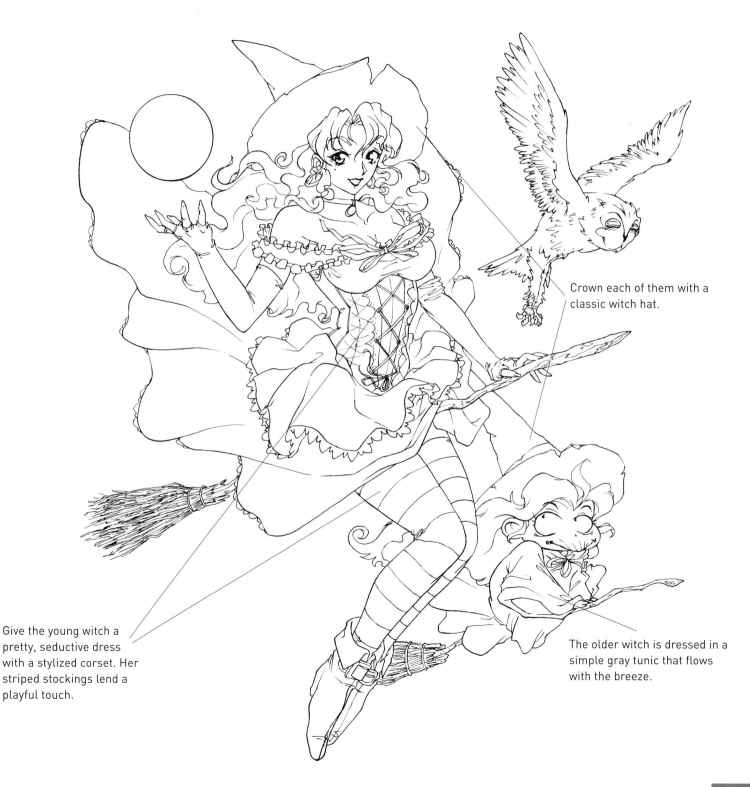

Crown each of them with a classic witch hat.

Give the young witch a pretty, seductive dress with a stylized corset. Her striped stockings lend a playful touch.

The older witch is dressed in a simple gray tunic that flows with the breeze.

Source of light

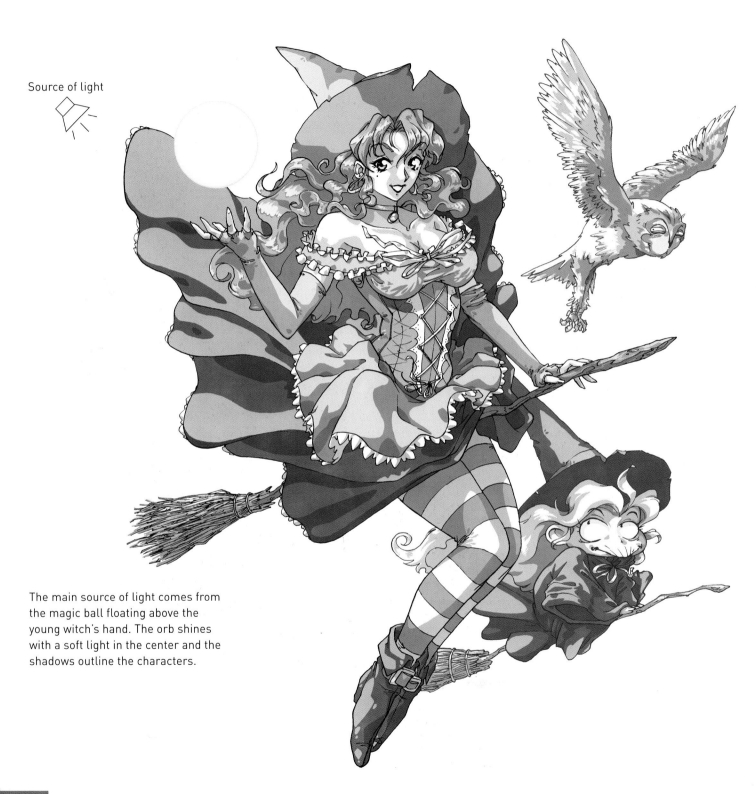

The main source of light comes from the magic ball floating above the young witch's hand. The orb shines with a soft light in the center and the shadows outline the characters.

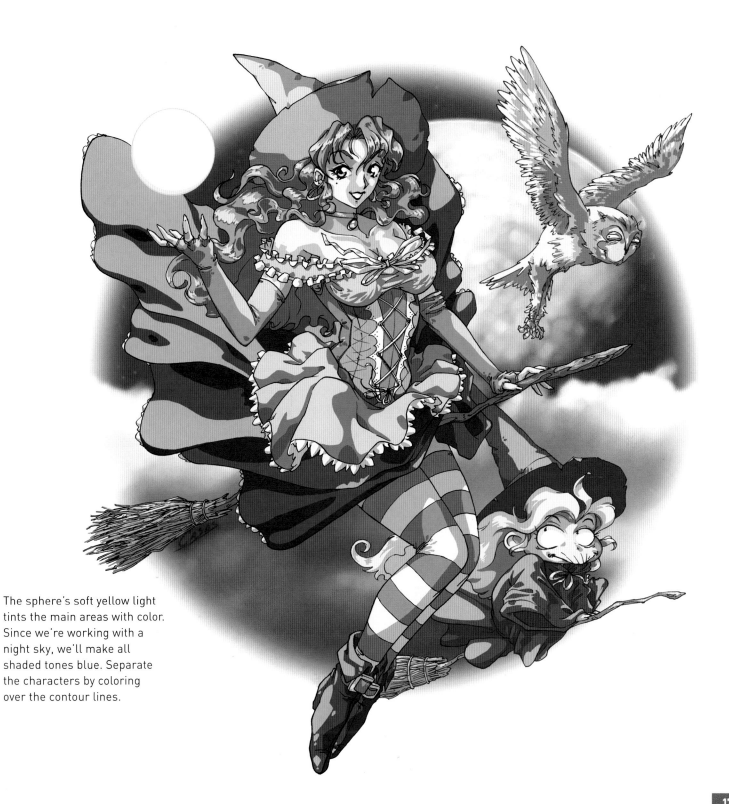

The sphere's soft yellow light tints the main areas with color. Since we're working with a night sky, we'll make all shaded tones blue. Separate the characters by coloring over the contour lines.

IMP

Distant cousins of goblins, these little demons are responsible for many headaches. Capable of driving an entire village mad with their dirty tricks, they are considered by many to be the scum of the earth. They are callous, deceitful, evil thieves who tend to visit the most devastated places, rummaging through the remains of a pillaged town after a giant battle. As the saying goes, "a bad penny always turns up"... and imps are no exception.

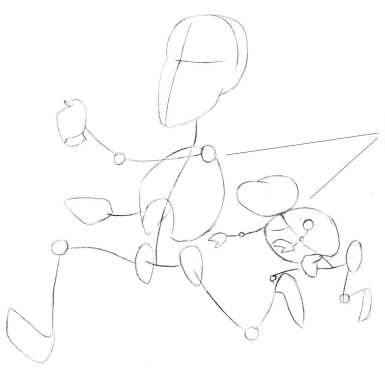

Pay attention to the imp's size compared to the rat.

2. Volume

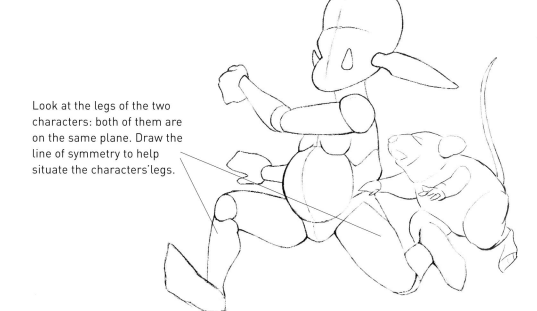

Look at the legs of the two characters: both of them are on the same plane. Draw the line of symmetry to help situate the characters' legs.

The imp is grotesque, so exaggerate his feet, belly, and hands.

Draw the fur only along the outline; the area inside will look better if we color it directly.

Add hairy accessories that make the imp more animal-like. He'll look even more savage if we draw him with very few clothes.

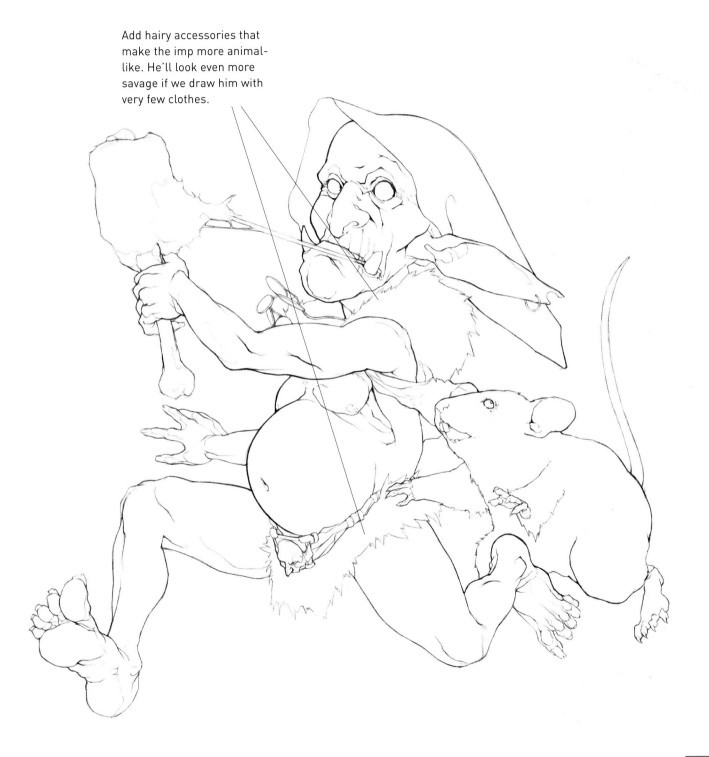

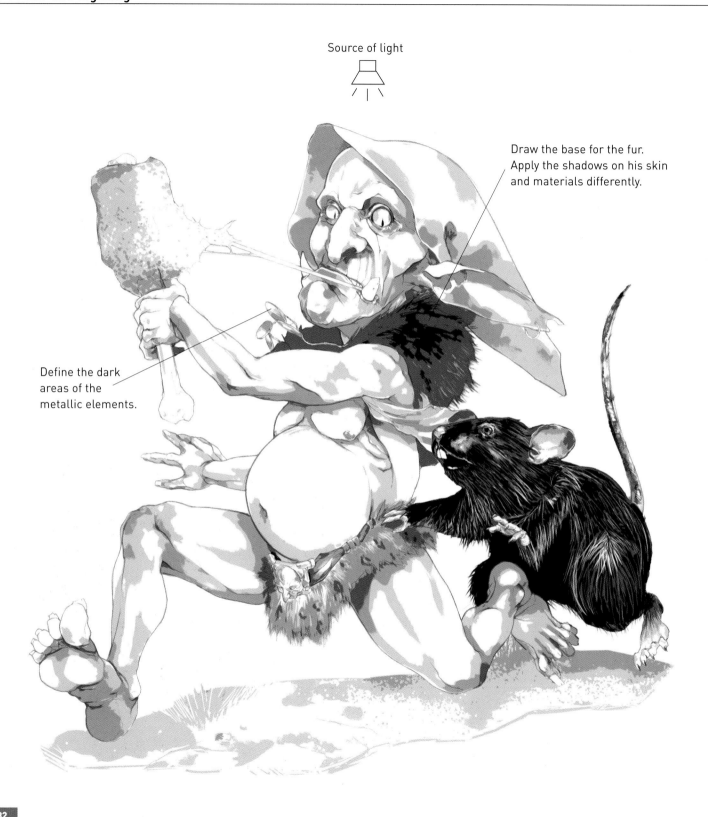

Source of light

Draw the base for the fur.
Apply the shadows on his skin
and materials differently.

Define the dark
areas of the
metallic elements.

Choose loud, contrasting colors to make the imp look weaker and more ridiculous.

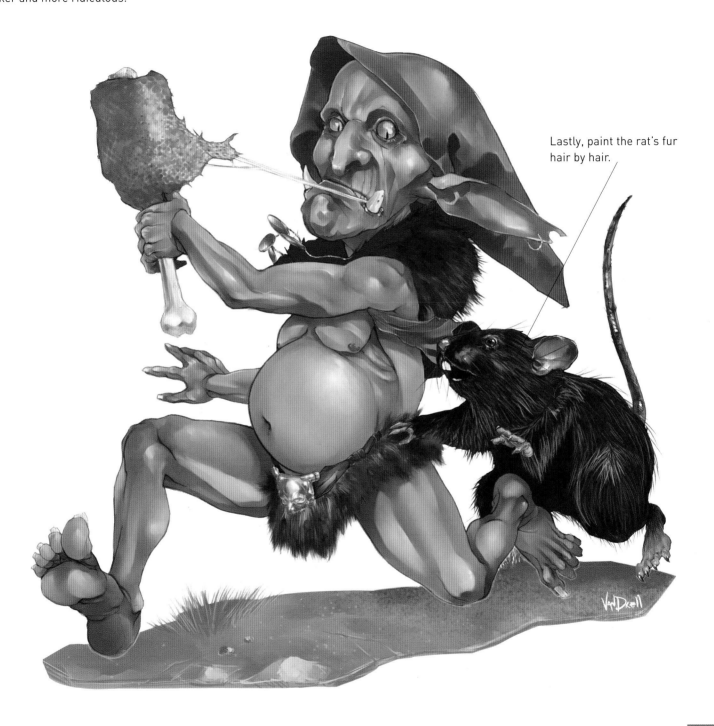

Lastly, paint the rat's fur hair by hair.

EARTH LADY

The beauty of flowers, the voices that have inhabited these lands for centuries, and the sap of the oldest trees are all the nutrients this queen of the forest needs. The origin of her magic may be unknown but her power as the guardian of the forest's inhabitants certainly isn't. All evil creatures that come into the forest with less-than-honorable intentions are known to end up as food for the roots of some tree. Posessing unusual beauty, the earth lady warms the hearts of some and frightens others.

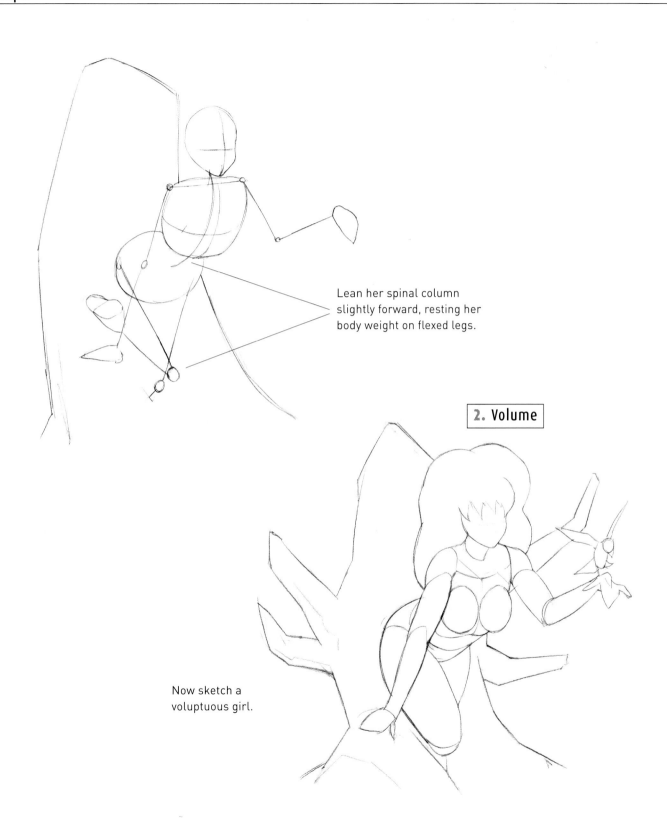

Lean her spinal column slightly forward, resting her body weight on flexed legs.

2. Volume

Now sketch a voluptuous girl.

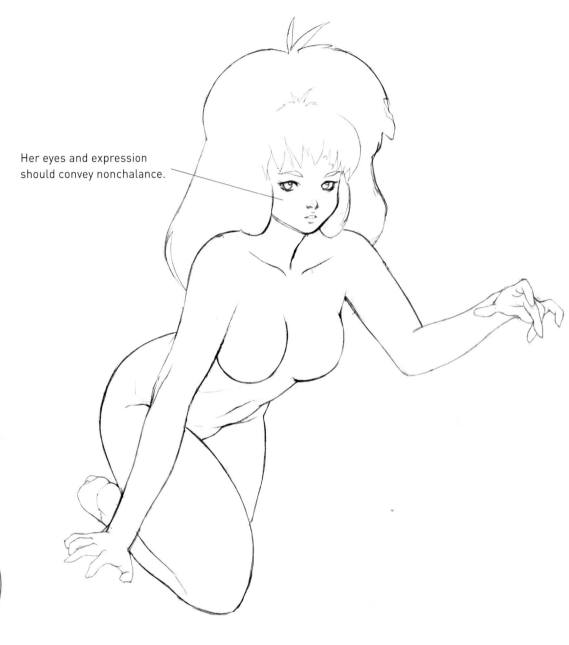

Her eyes and expression should convey nonchalance.

Draw her fingers in a delicate, feminine pose.

Blend the character with the
trunk and add some floral and
leaf ornaments.

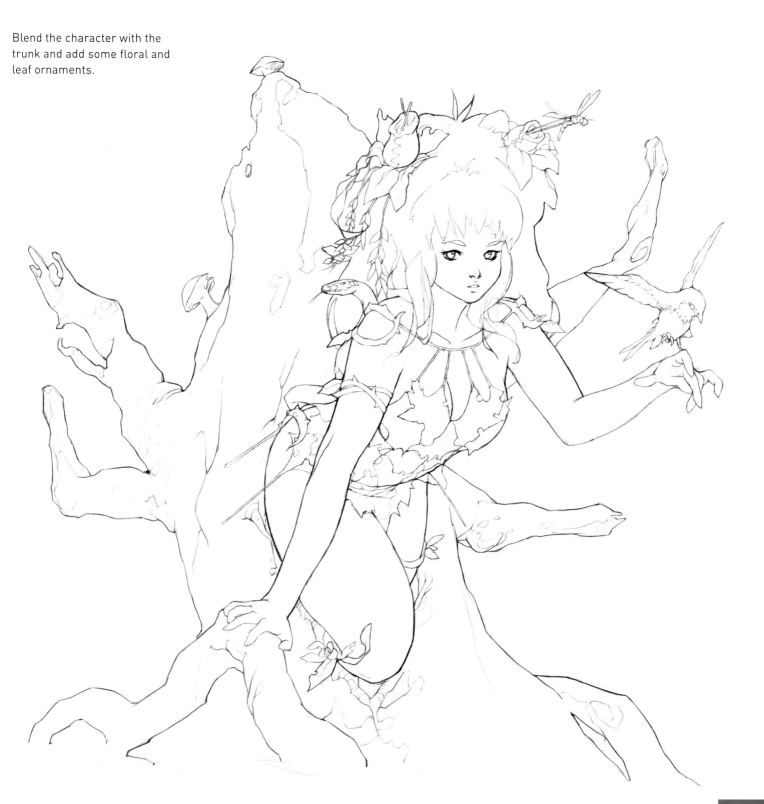

Add texture to the trunk by
shading it.

Source of light

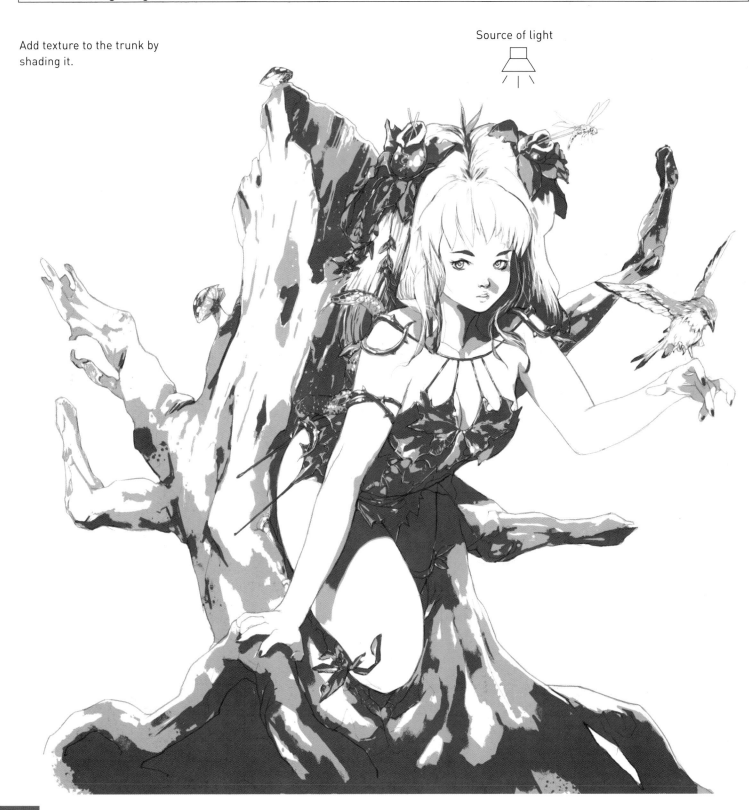

Choose earth tones and
greens, using bright colors
for the clothes and animals.

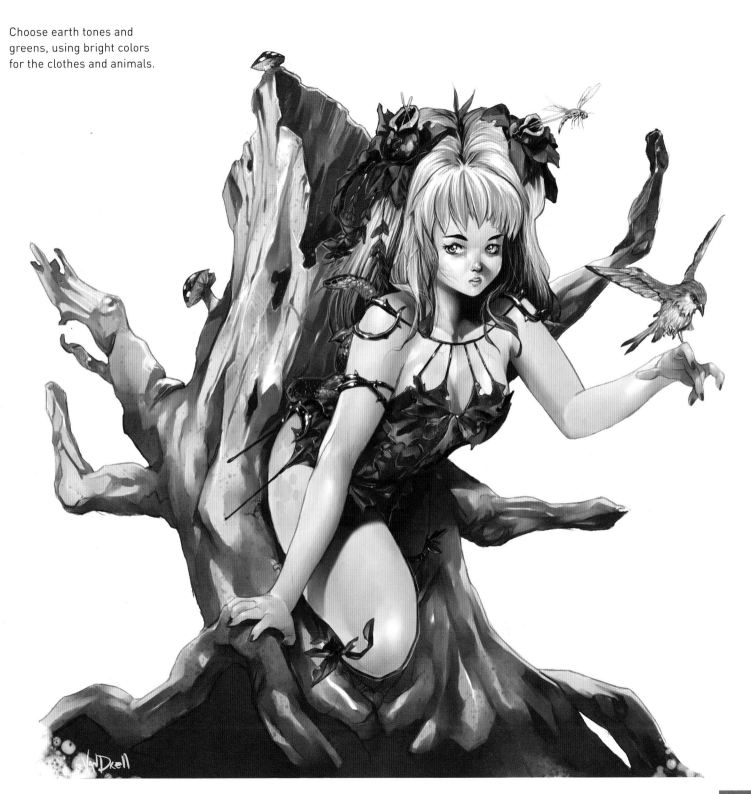

DARK FOREST

The world of fantasy is filled with immense forests. Many of the magical beings we find in this book are closely connected with nature, and the forest is their habitat. The forest provides a safe hideout for both good and bad creatures. In most societies the forest provides a strong dichotomy: It's a source of life, raw materials, and food, but at the same time hundreds of dangerous things lie within it.

First sketch the arrangement of the main elements.
The axis of the composition
is the river.

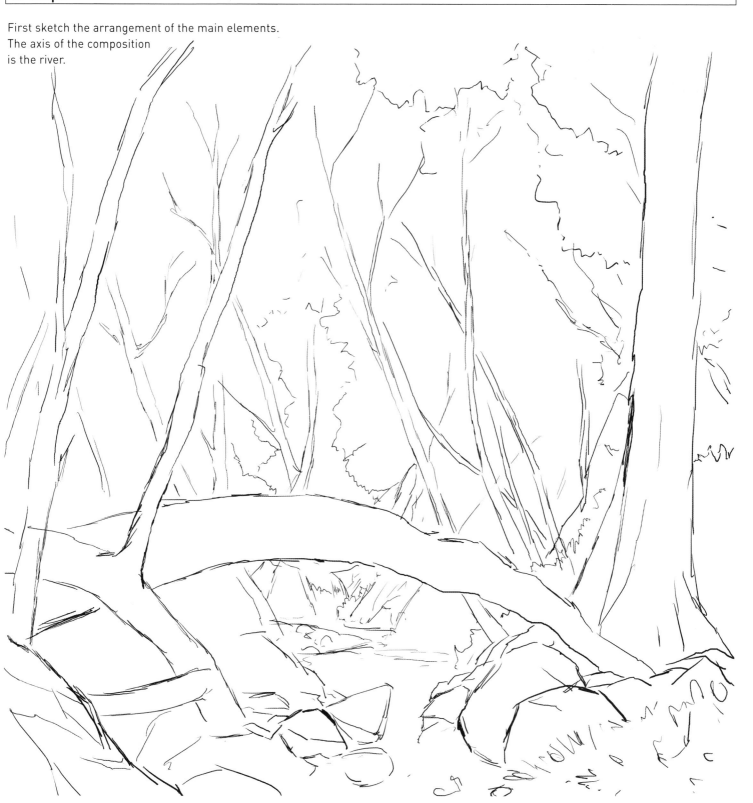

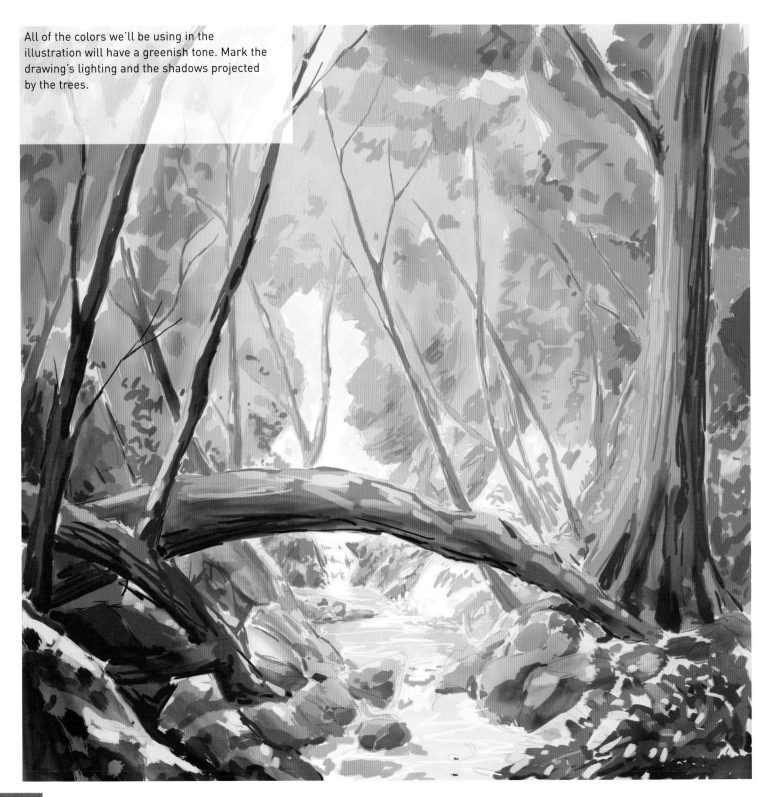

All of the colors we'll be using in the illustration will have a greenish tone. Mark the drawing's lighting and the shadows projected by the trees.

Shape all the objects, marking the volumes in each area. Elements that are farther away will look more faded: This is what we call an aerial perspective.

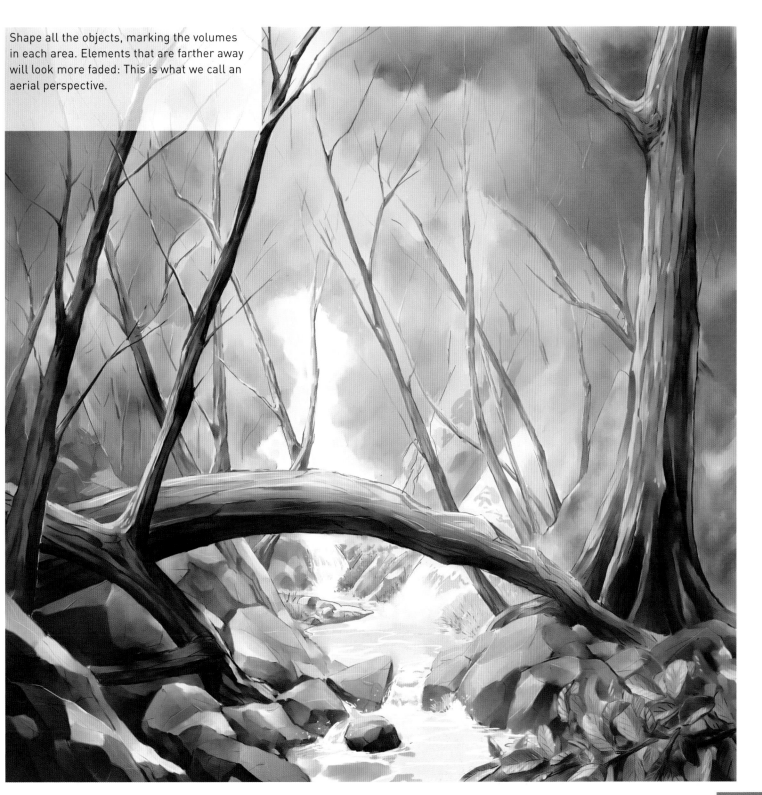

Finally, after working the textures of the objects closest to the foreground, add the light effects and finishing details.

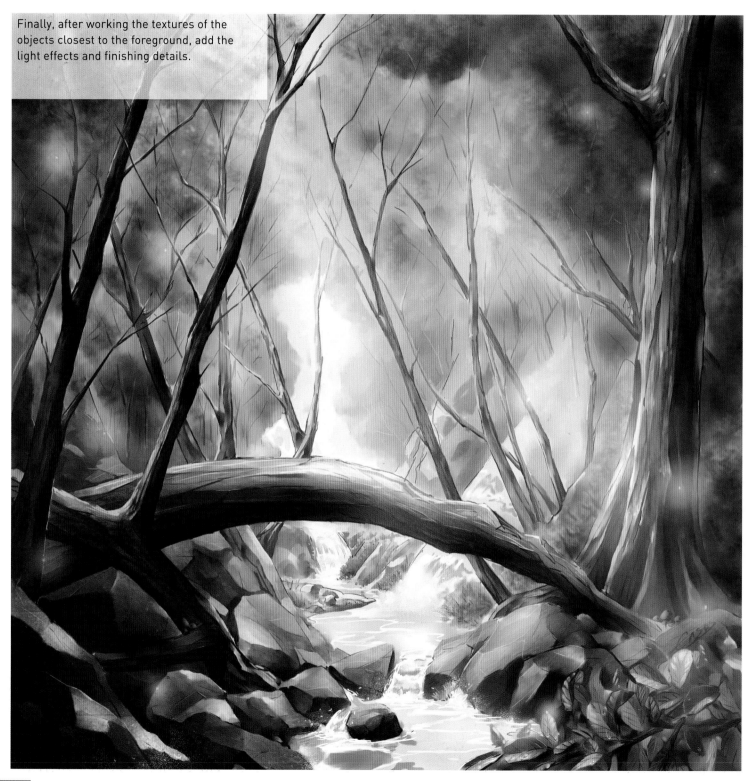

At night the forest shows both its most magical and its most threatening sides. Moonlight bathes the entire image in silver. The colors become less saturated and the tones combine. Fires now glow with greater intensity.

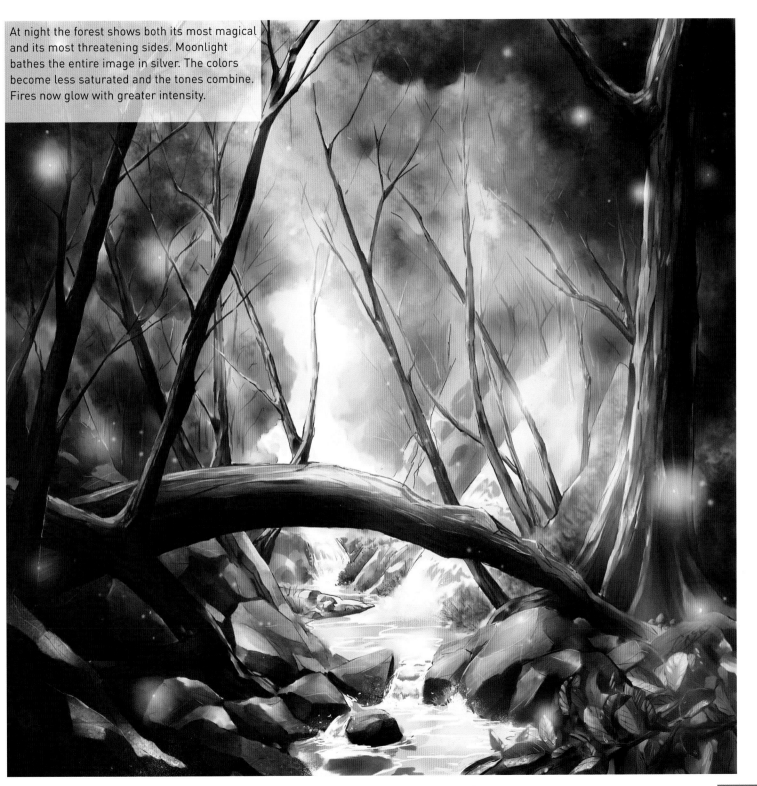

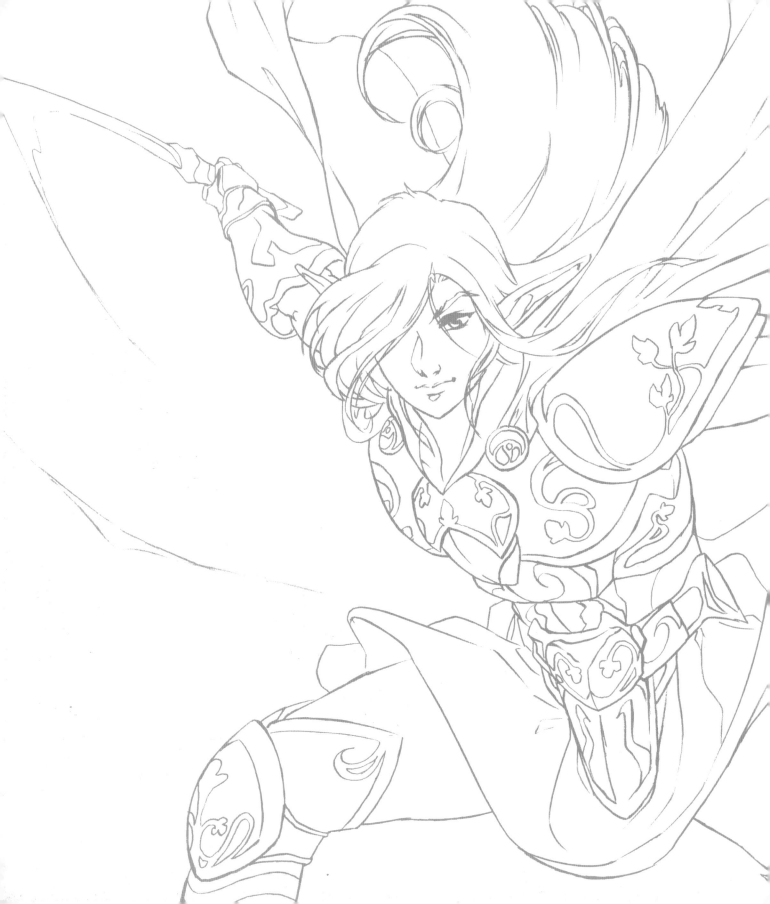

FIELDS OF LEGENDS

Weapon Master
Halflings
Elves
Dwarves
Orcs
The Winged
Humans
Chaos
Lizard Men

WEAPON MASTER

Many legends are based around magical weapons that in the hands of heroes bring empires together, defeat evil kings, and curse entire races. These arms wouldn't exist if it weren't for the wise and skillful hands that created them. The ancient forges made by the high elves, the gigantic ovens built by the dwarves, and the alchemy performed by humans have all been witness to the many skilled metal workers who've worked their art. Here's to them! Without them *legendary fields* wouldn't have its force of steel.

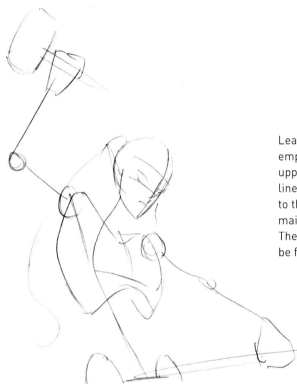

Leave the legs out so you can emphasize the character's upper body. Draw a diagonal line connecting the hammer to the anvil, which will be the main axis of the composition. The character's gaze should be focused on this line.

2. Volume

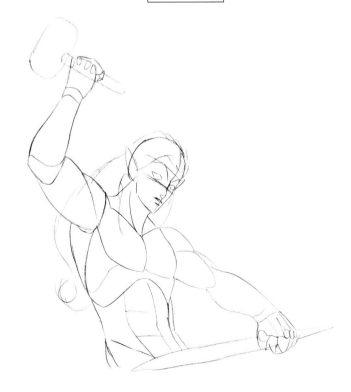

Use simple volumes to draw the character's strong torso and foreshortened body parts. Draw the character as if you were looking up slightly.

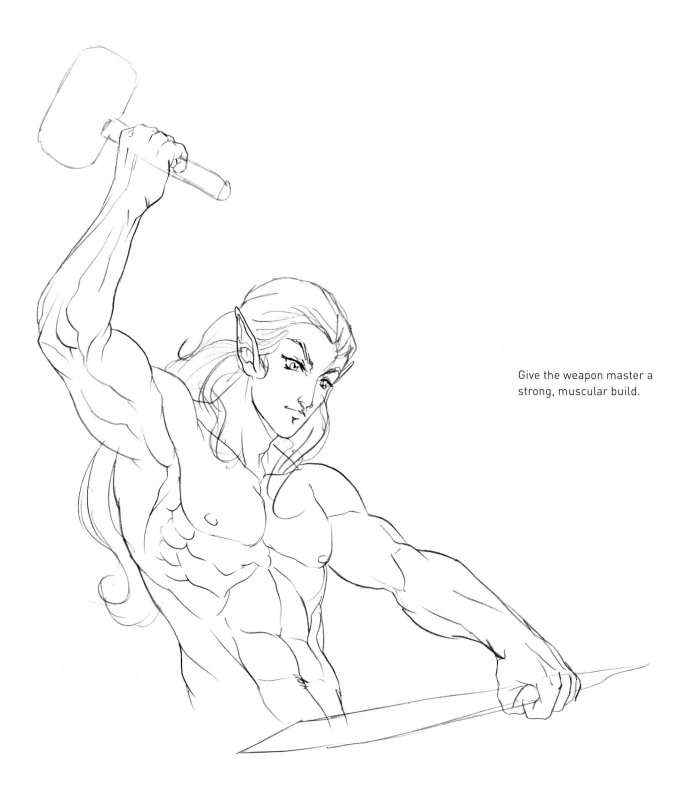

Give the weapon master a strong, muscular build.

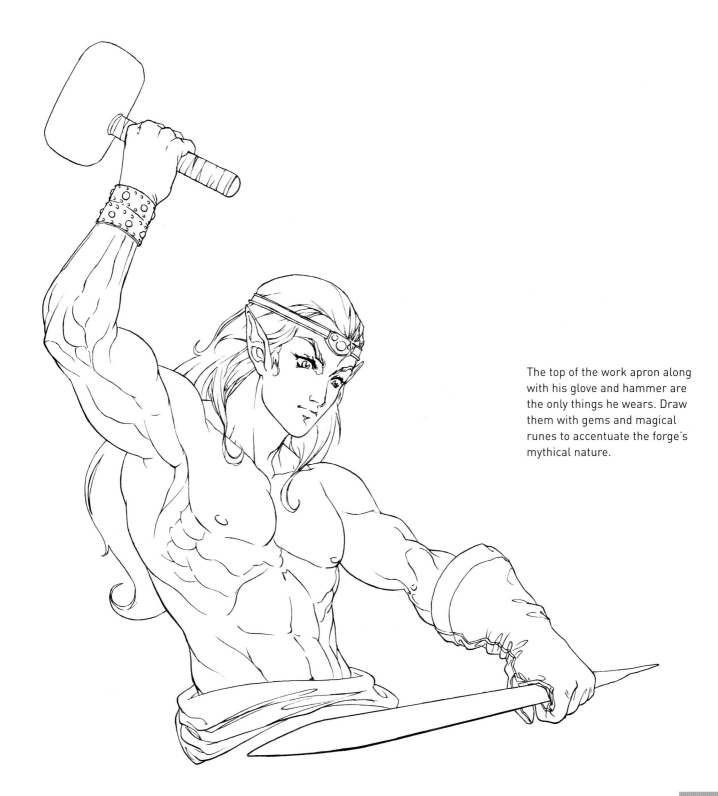

The top of the work apron along with his glove and hammer are the only things he wears. Draw them with gems and magical runes to accentuate the forge's mythical nature.

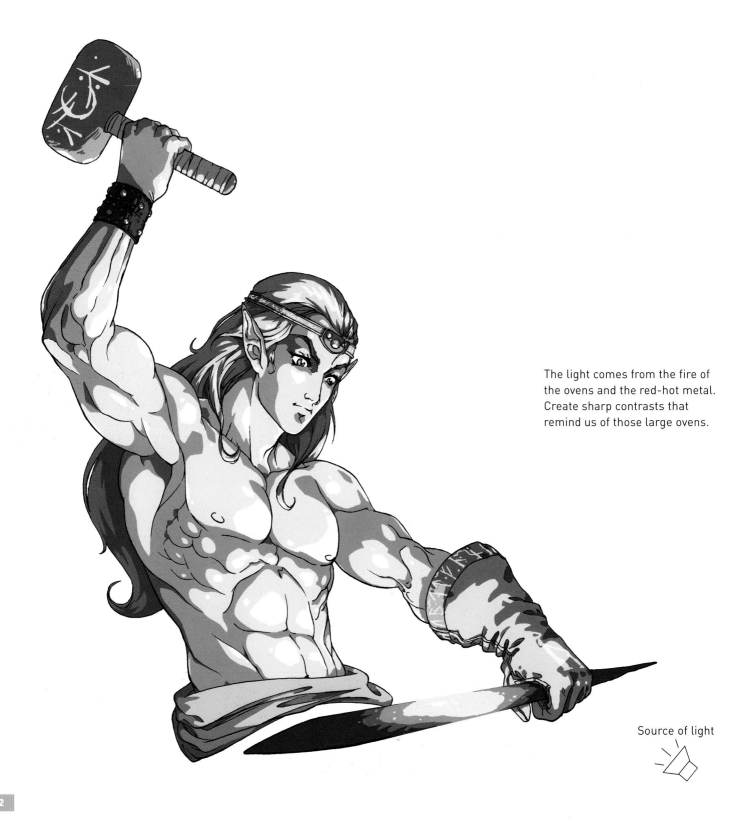

The light comes from the fire of the ovens and the red-hot metal. Create sharp contrasts that remind us of those large ovens.

Source of light

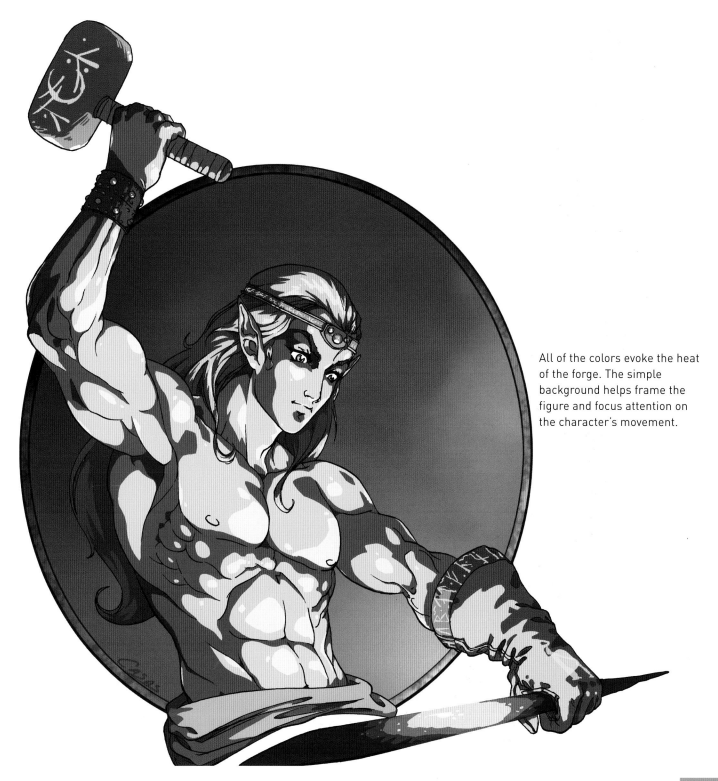

All of the colors evoke the heat of the forge. The simple background helps frame the figure and focus attention on the character's movement.

HALFLINGS

They are called halflings because of their height, perhaps because they are crossbred with humans, according to some legends. Others say they originally were a mix of humans and elves. They have lots of hair, especially on their feet. Some say they are cowards, others say they are crafty, but in reality they are a noble race. Curiosity has led a few of the halflings to go on greater adventures than those ever imagined by men or gods.

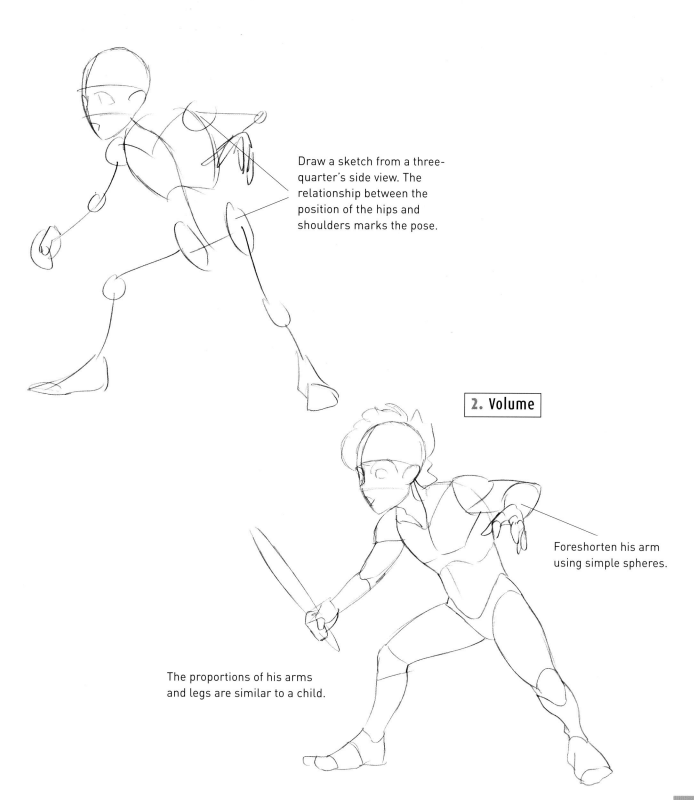

1. Shape

Draw a sketch from a three-quarter's side view. The relationship between the position of the hips and shoulders marks the pose.

2. Volume

Foreshorten his arm using simple spheres.

The proportions of his arms and legs are similar to a child.

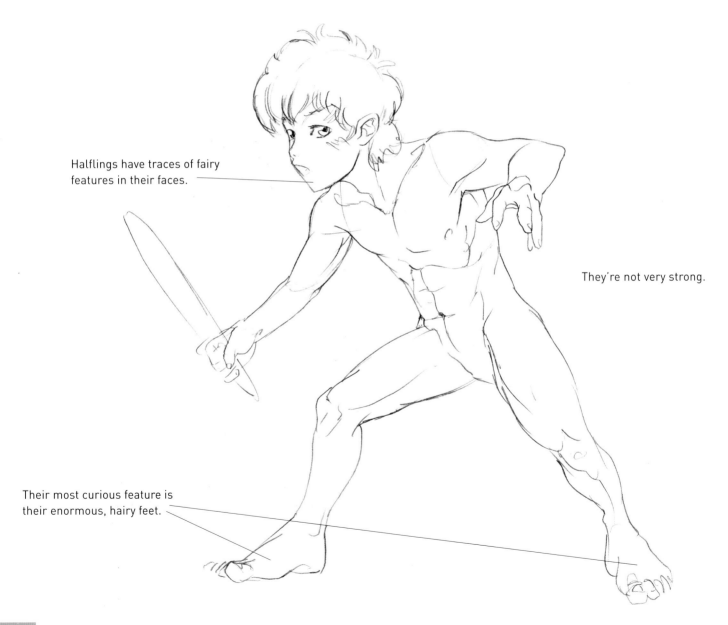

Halflings have traces of fairy
features in their faces.

They're not very strong.

Their most curious feature is
their enormous, hairy feet.

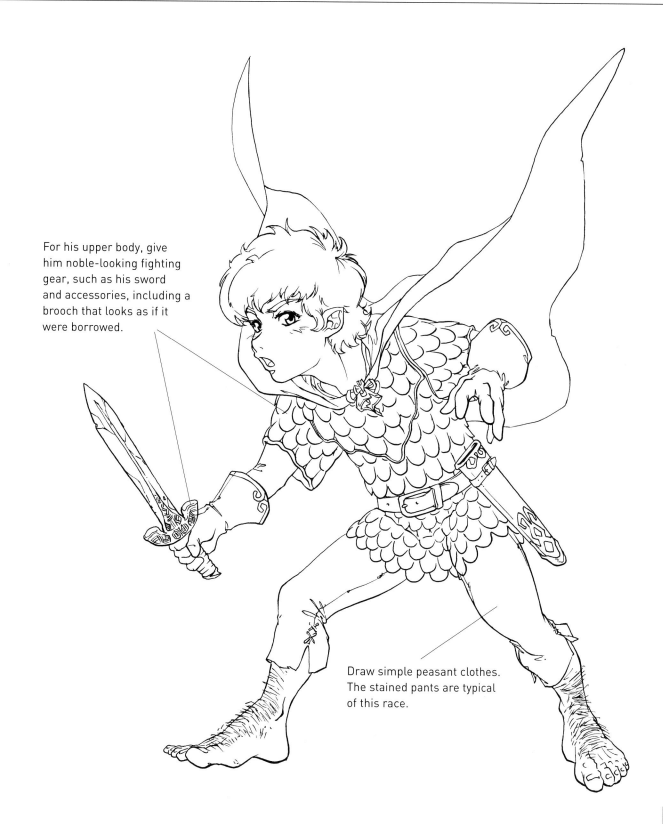

For his upper body, give him noble-looking fighting gear, such as his sword and accessories, including a brooch that looks as if it were borrowed.

Draw simple peasant clothes. The stained pants are typical of this race.

Distinguish between shiny or
matte surfaces when deciding
which areas to lighten and shade.

Source of light

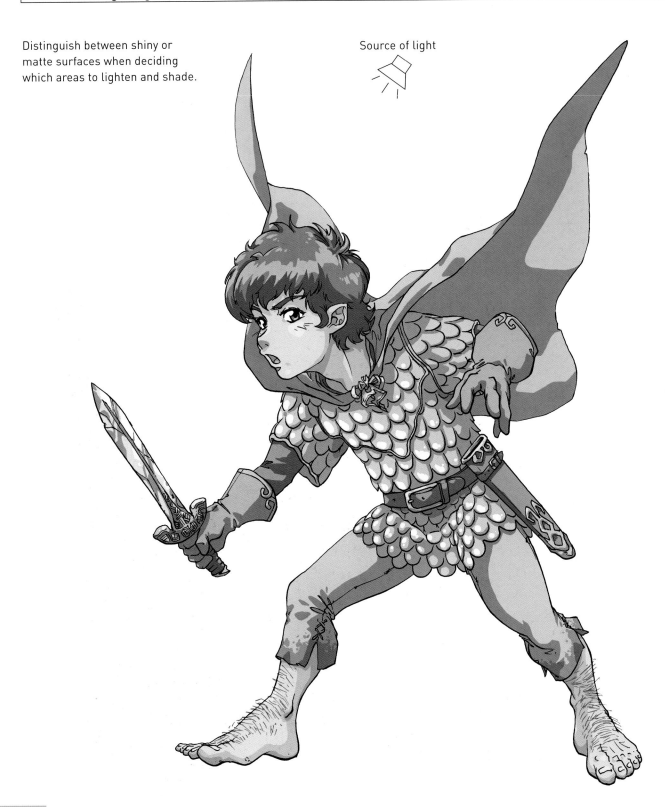

You don't have to choose a
very wide chromatic range.
But use a simple and natural
green for his pants and silver
and gold for his accessories.

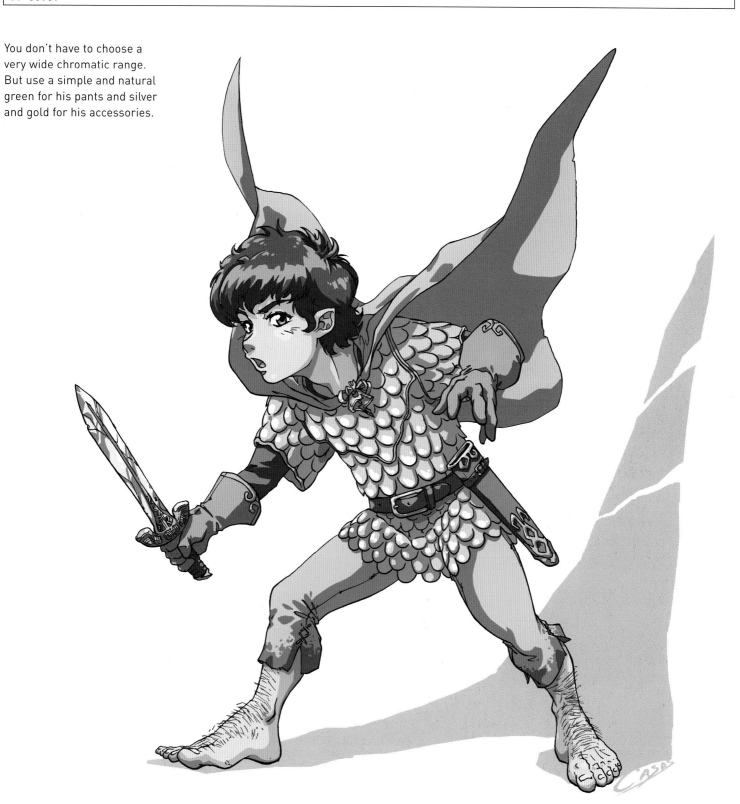

ELVES

Elves are tall beings that are svelte, agile, wise, and beautiful. They look like humans with fairy features and well-developed bodies. Talented and skillful with their hands, as well as with magic, they are connected to the natural forces of the world. Elves are almost immortal: They can't die of illness or old age, but they can perish from violence or from heartache because they are highly sensitive. Although sometimes they'll ally with humans to fight a common enemy, generally speaking, elves prefer to avoid relations with humans because they consider them barbarians.

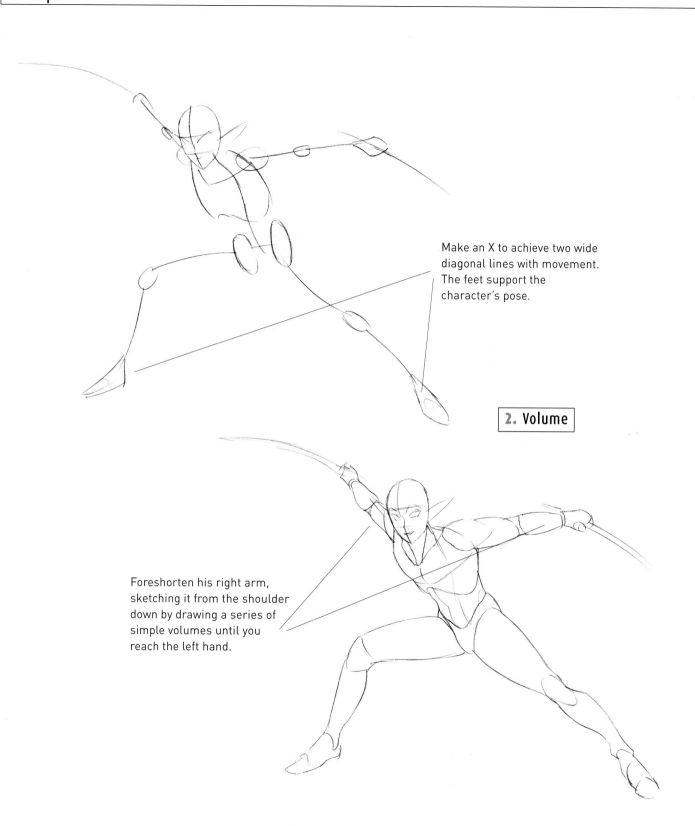

Make an X to achieve two wide diagonal lines with movement. The feet support the character's pose.

2. Volume

Foreshorten his right arm, sketching it from the shoulder down by drawing a series of simple volumes until you reach the left hand.

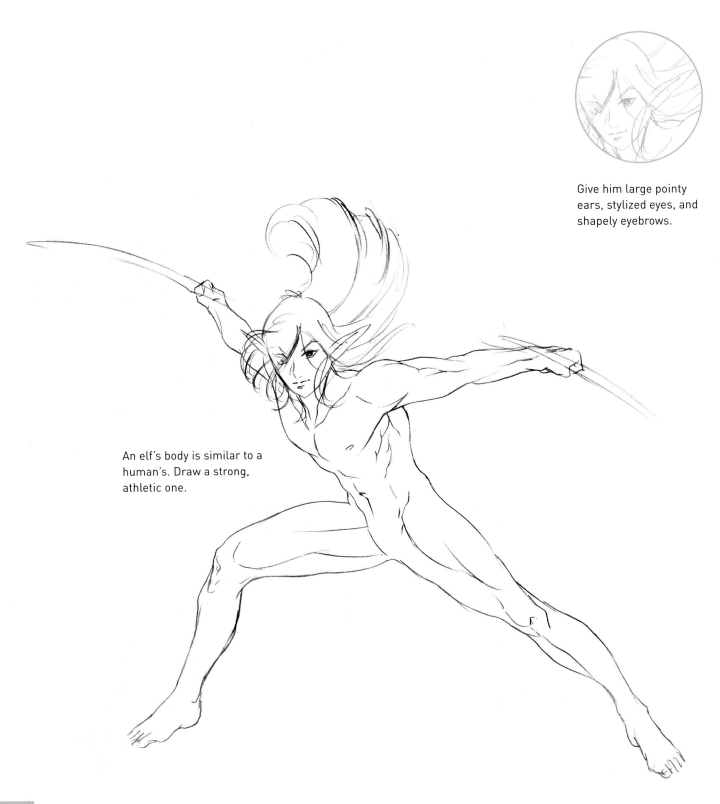

Give him large pointy ears, stylized eyes, and shapely eyebrows.

An elf's body is similar to a human's. Draw a strong, athletic one.

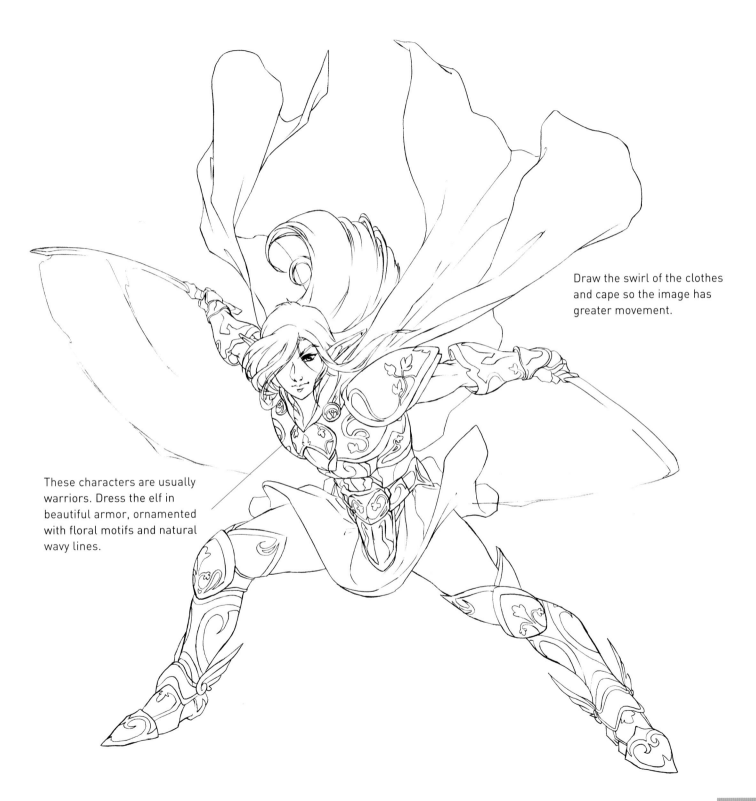

Draw the swirl of the clothes and cape so the image has greater movement.

These characters are usually warriors. Dress the elf in beautiful armor, ornamented with floral motifs and natural wavy lines.

The light helps define the swirl
of his clothes. It also helps show
the armor's highlights.

Source of light

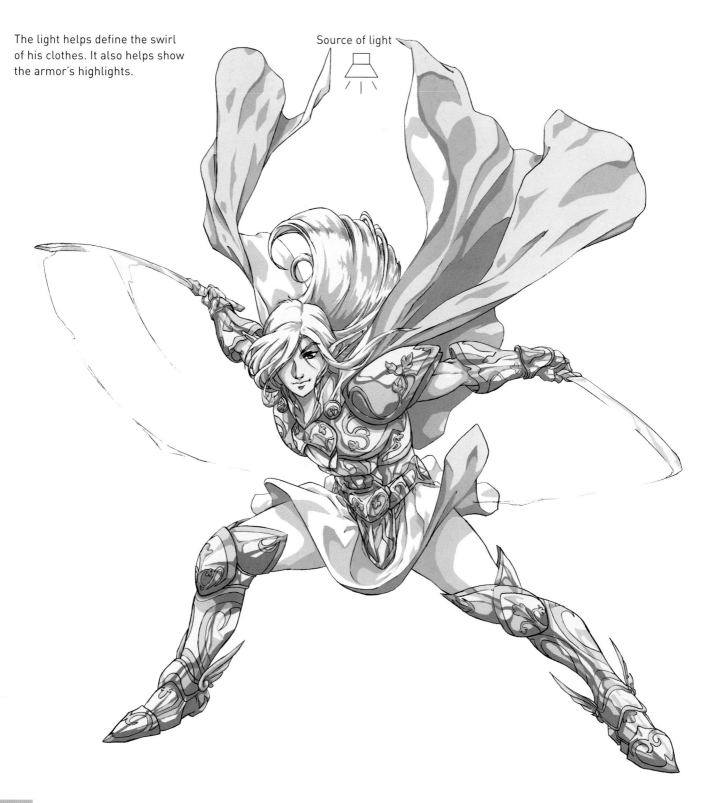

Choose colors that are connected with light and purity. White dominates in this elf's costume, but the golden ornaments add a hint of color.

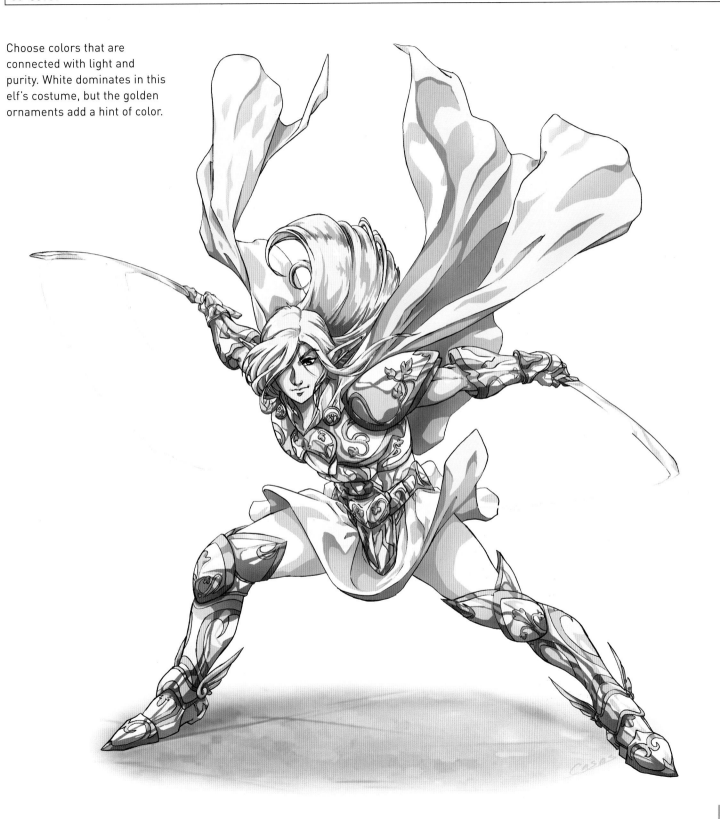

DWARVES

Dwarves are an ancient race. Physically they are like strong, powerful, stubborn blocks of stone. They look human, but they're shorter, with smaller extremities and long beards. They are considered masters of everything underground. These tough creatures live in the mines and mountains, where they sculpt their marvelous palaces and labyrinths. They are great craftsman, intelligent and industrious, and they have produced hundreds of amazing gadgets and weapons.

1. Shape

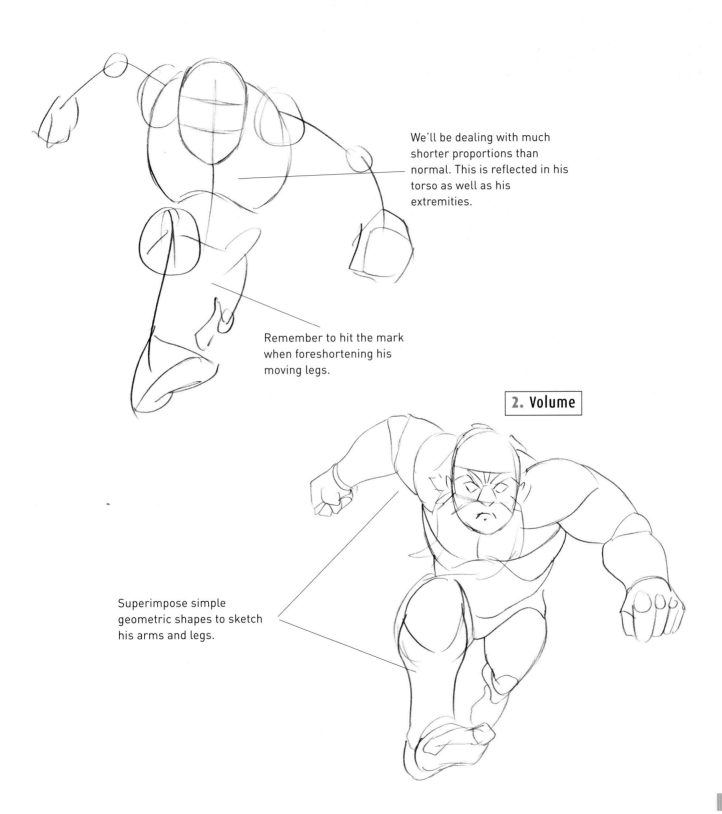

We'll be dealing with much shorter proportions than normal. This is reflected in his torso as well as his extremities.

Remember to hit the mark when foreshortening his moving legs.

2. Volume

Superimpose simple geometric shapes to sketch his arms and legs.

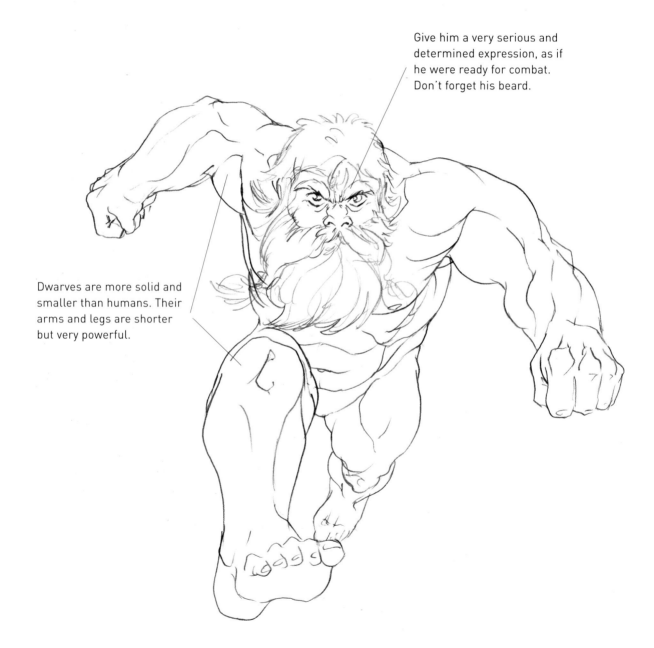

Give him a very serious and
determined expression, as if
he were ready for combat.
Don't forget his beard.

Dwarves are more solid and
smaller than humans. Their
arms and legs are shorter
but very powerful.

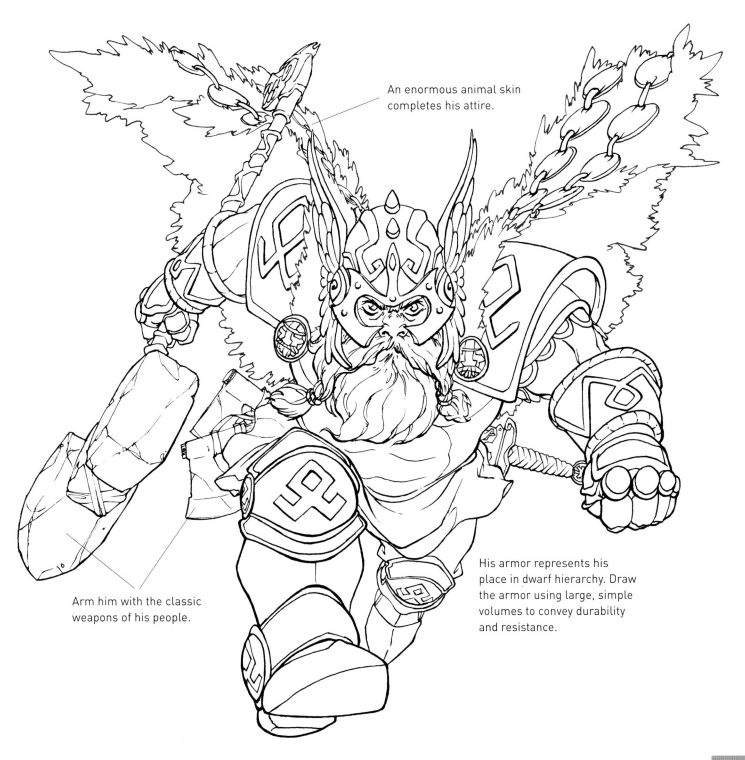

An enormous animal skin completes his attire.

Arm him with the classic weapons of his people.

His armor represents his place in dwarf hierarchy. Draw the armor using large, simple volumes to convey durability and resistance.

Lighting helps mark the different textures in the drawing. Use greater contrasting tones on metals.

Source of light

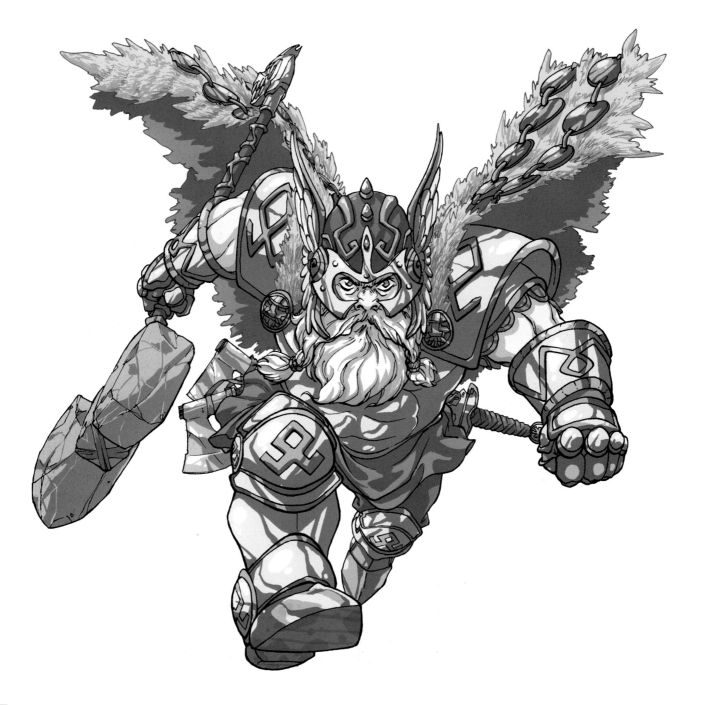

We'll achieve the gold-colored armor by combining yellow in the lighter areas with saturated brown tones for the shaded areas. Red provides a colorful counterpoint.

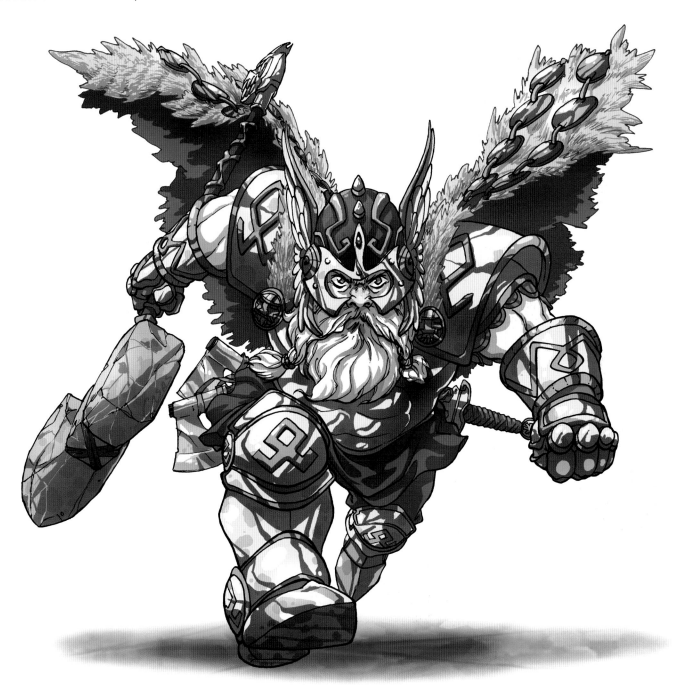

ORCS

Orcs are one of the humanoid races inhabiting the fantasy world. Their dark skin has green and gray tones. They are as tall as humans, but are much wider and with stronger builds. Their bodies are somewhat deformed, like their eyes, which are more accustomed to nighttime and glow red in the dark. They have a prominent lower jaw and large fangs. They aren't very intelligent and are not very skillful fighters, but they are determined and bloodthirsty.

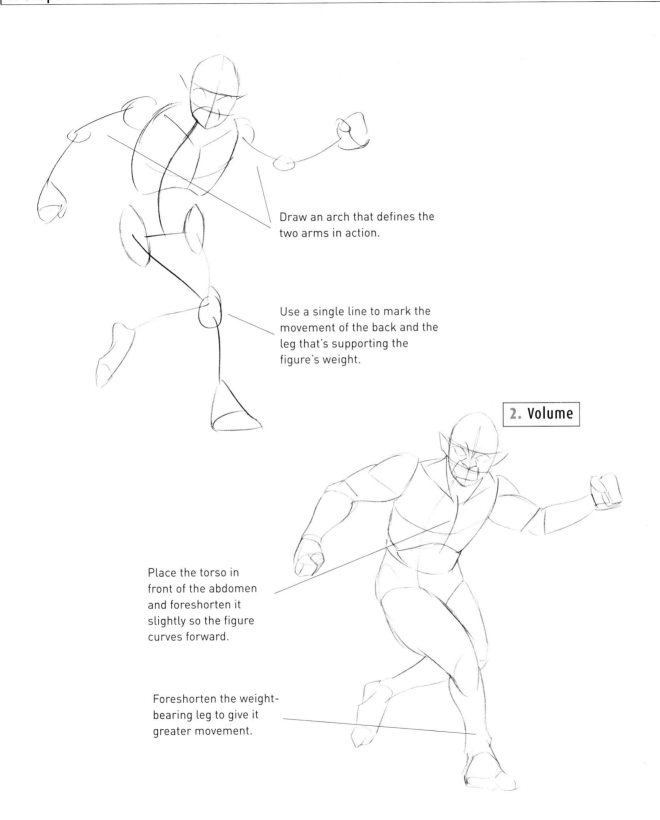

Draw an arch that defines the two arms in action.

Use a single line to mark the movement of the back and the leg that's supporting the figure's weight.

2. Volume

Place the torso in front of the abdomen and foreshorten it slightly so the figure curves forward.

Foreshorten the weight-bearing leg to give it greater movement.

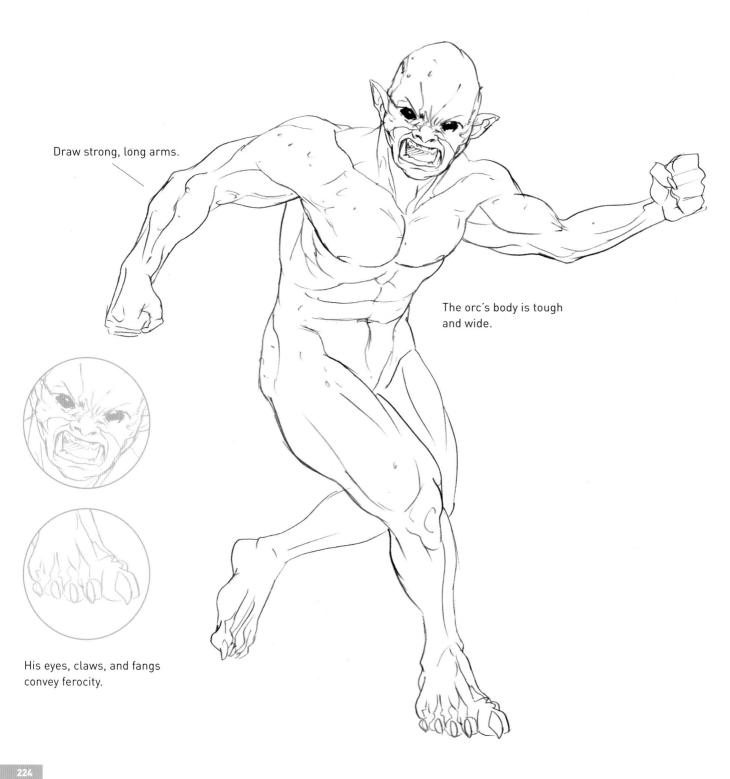

Draw strong, long arms.

The orc's body is tough and wide.

His eyes, claws, and fangs convey ferocity.

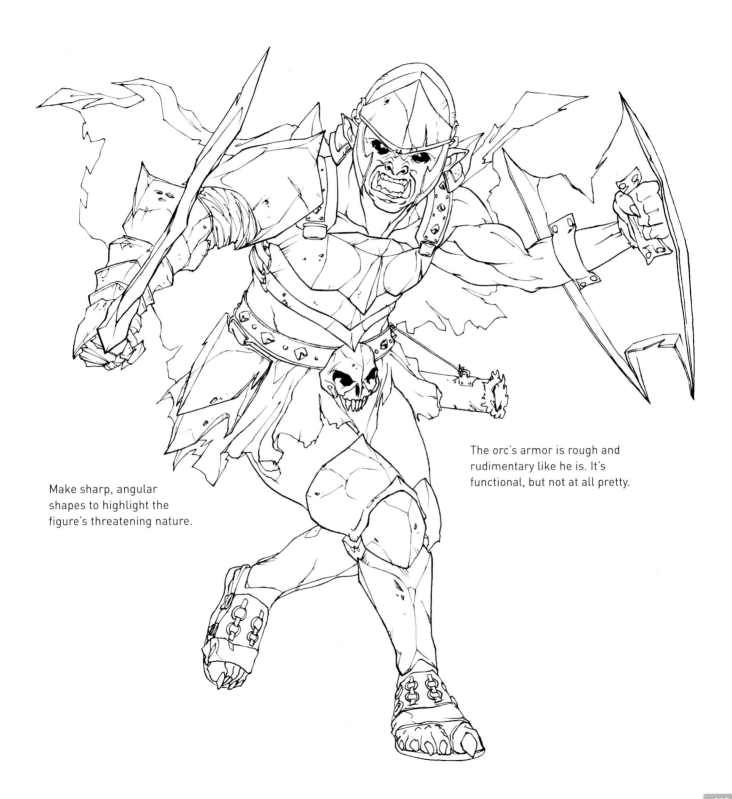

Make sharp, angular shapes to highlight the figure's threatening nature.

The orc's armor is rough and rudimentary like he is. It's functional, but not at all pretty.

Source of light

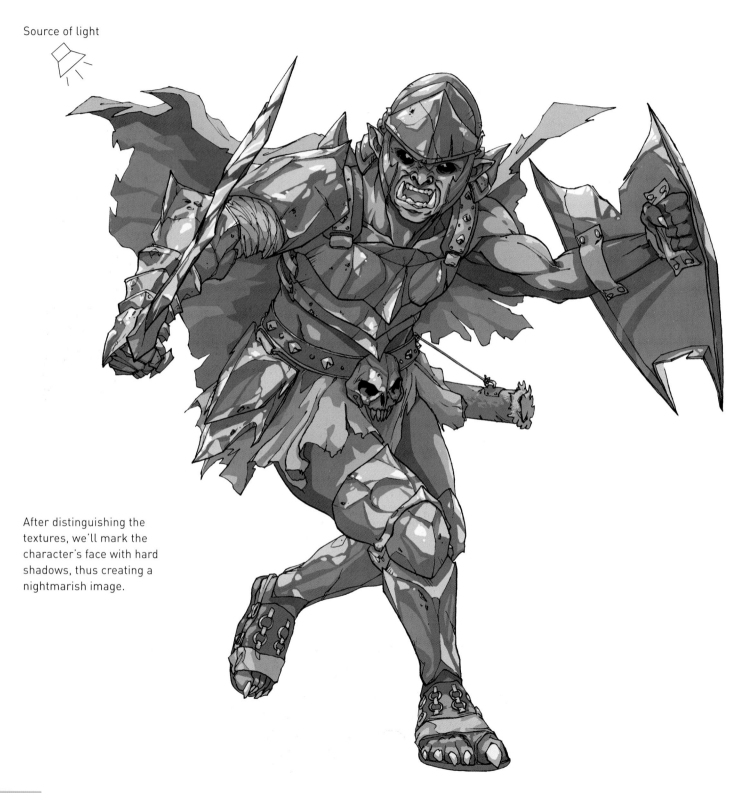

After distinguishing the textures, we'll mark the character's face with hard shadows, thus creating a nightmarish image.

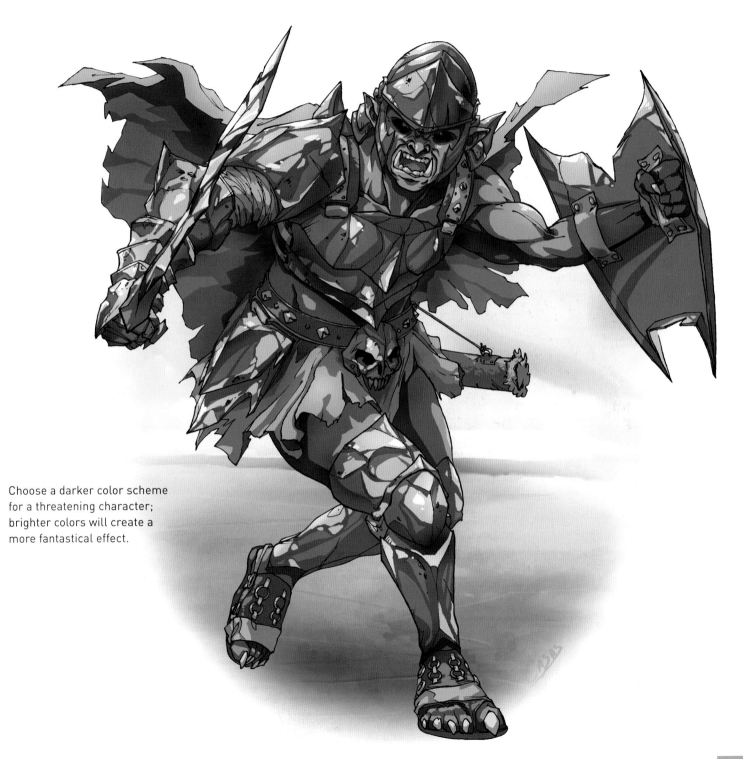

Choose a darker color scheme
for a threatening character;
brighter colors will create a
more fantastical effect.

THE WINGED

They say the Winged are another mixed race, a cross between humans and dragons, although others say they are elves that were magically turned into dragons. Whatever the case, these strong creatures comprise a proud, beautiful race. Their main distinguishing characteristics are their dragon attributes: enormous wings that help them fly, fairy features, and a prehensile tail that they also use when fighting. Although their appearance is more humanoid, their strength and powers are those of a dragon. They are of noble character, and usually live far from the noisy world, in the highest mountains, where the wind blows strong beneath their wings.

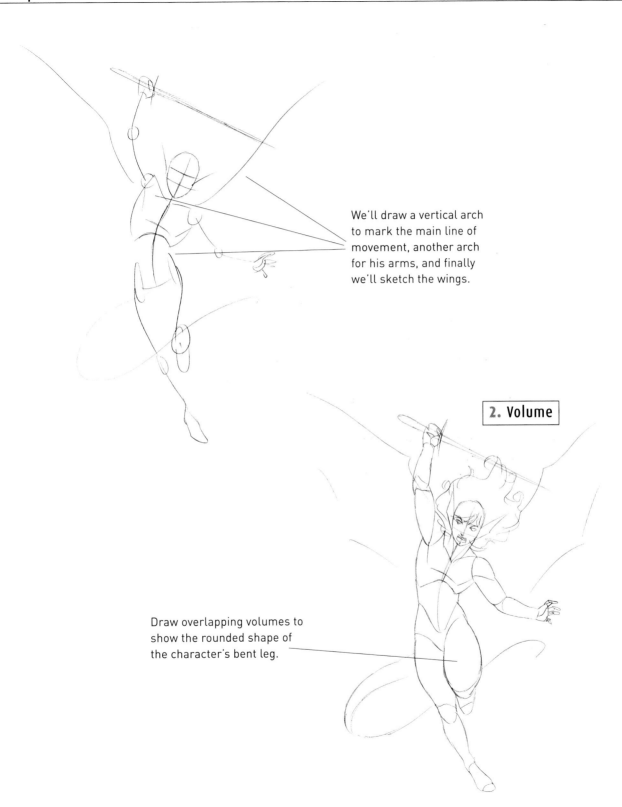

We'll draw a vertical arch to mark the main line of movement, another arch for his arms, and finally we'll sketch the wings.

2. Volume

Draw overlapping volumes to show the rounded shape of the character's bent leg.

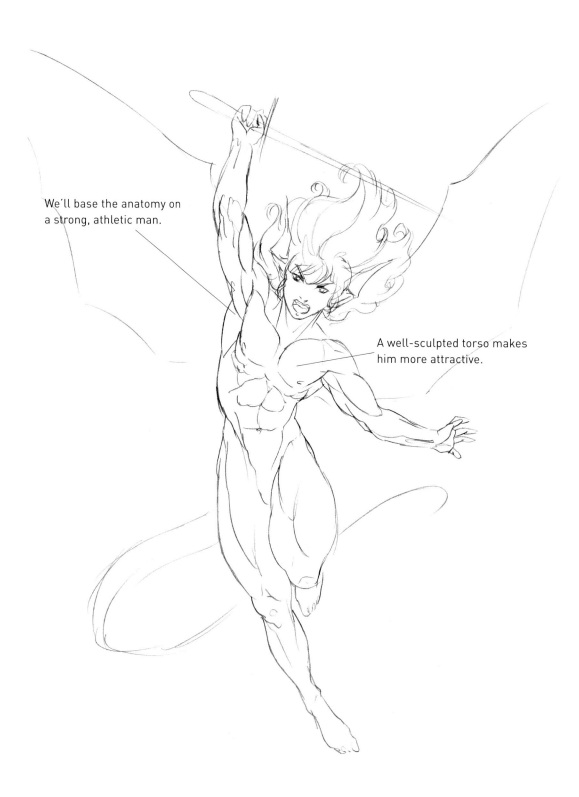

We'll base the anatomy on a strong, athletic man.

A well-sculpted torso makes him more attractive.

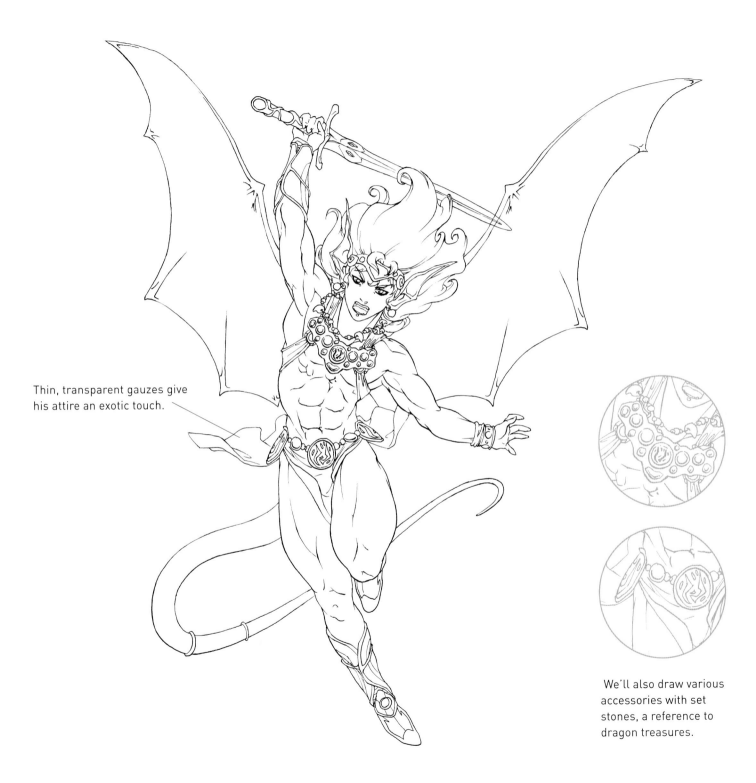

Thin, transparent gauzes give his attire an exotic touch.

We'll also draw various accessories with set stones, a reference to dragon treasures.

Source of light

The lighting is direct and outlines his figure against the sky. We'll leave almost half his body in shade. Enrich the image by playing with transparency in areas like the wings and sword.

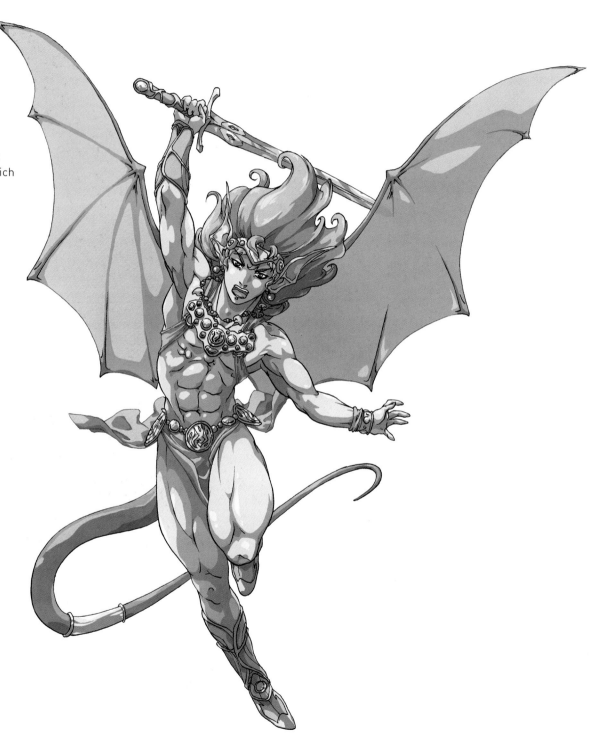

Use green to paint the character's draconian attributes, thus making him look fantastical, and pink and fuchsia for his clothes to create a contrast with the rest of the colors in the image.

HUMANS

Thanks to their strong ideals and convictions, human beings come far in this world of powerful mythical creatures. They have overcome physical and mental deficiencies with bravery, faith, and courage so much so that this relatively young species has thrived and grown in population. Capable of confronting any adversity, humans don't hesitate in facing enemies that might appear to be more able. However, fanaticism and ambition have brought them near the dark side on more than one occasion.

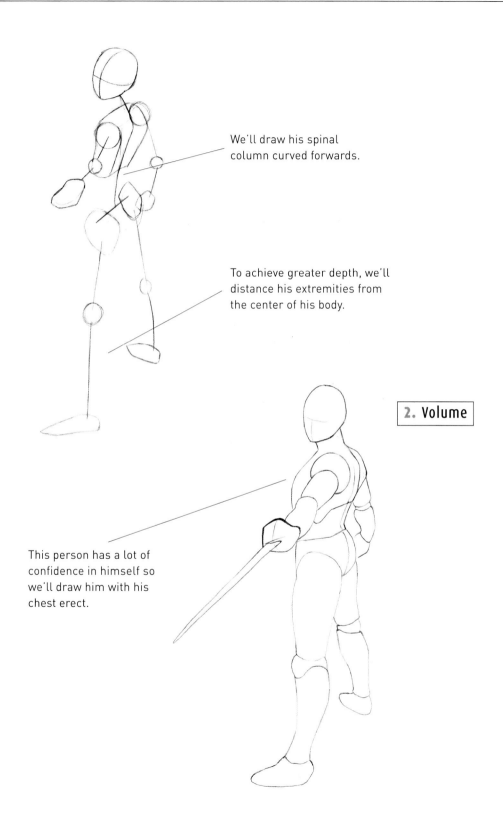

We'll draw his spinal column curved forwards.

To achieve greater depth, we'll distance his extremities from the center of his body.

2. Volume

This person has a lot of confidence in himself so we'll draw him with his chest erect.

He has a defiant look,
disheveled hair, and an
athletic build.

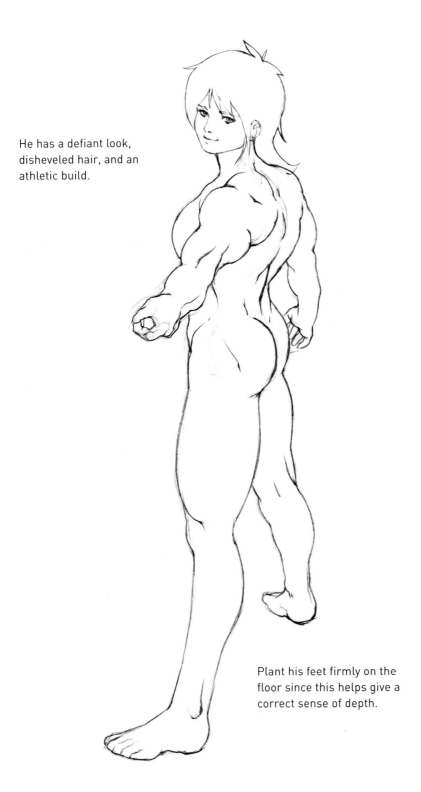

Plant his feet firmly on the
floor since this helps give a
correct sense of depth.

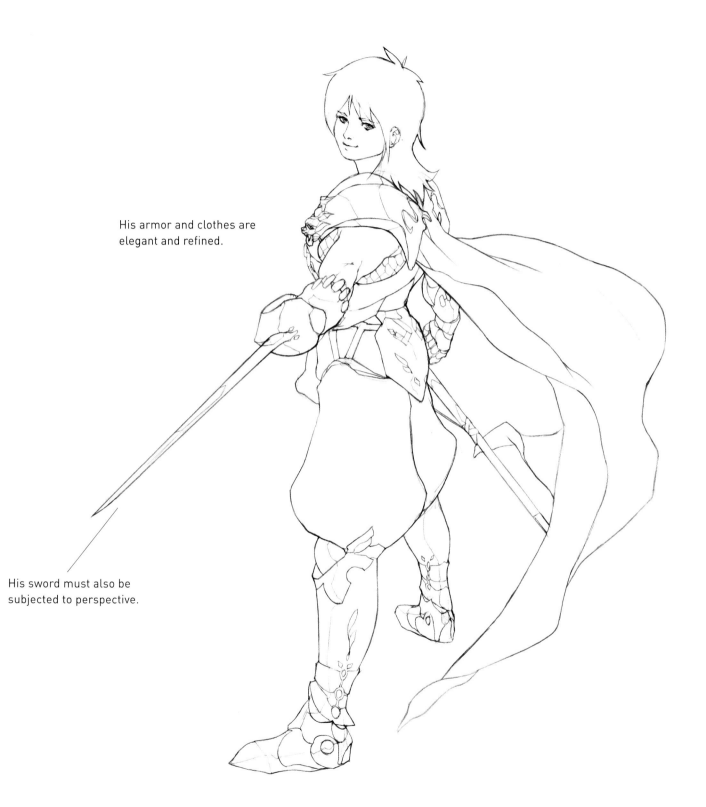

His armor and clothes are
elegant and refined.

His sword must also be
subjected to perspective.

The source of light creates shade beneath the cape. Use shading to develop the creases in his attire.

Source of light

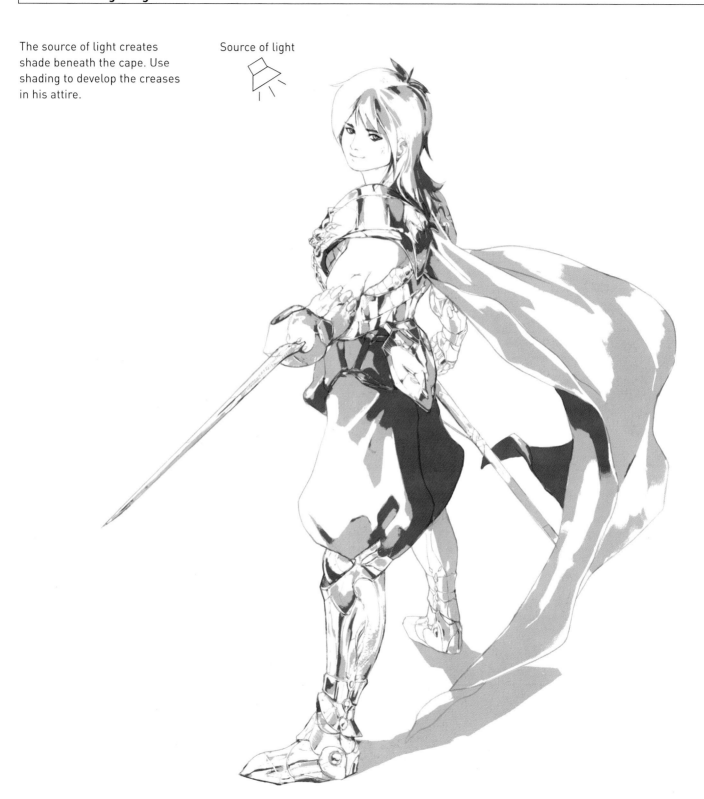

Paint his armor so that it looks well-kept and shiny. Choose warm colors that reflect his noble character.

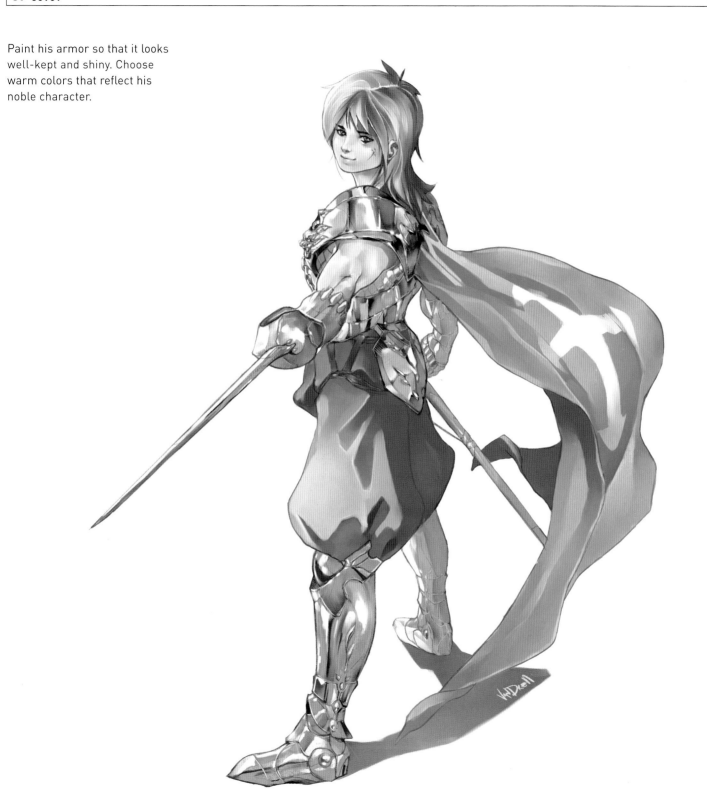

CHAOS

The warriors of chaos are considered one of the most fearsome soldiers around. They were once men but they sold their souls to darkness, and now they are killing machines, dedicated to a never-ending fight. Possessing evil weapons and dressed in dark armor, they are relentless when it comes to fighting. It is said that they have sworn loyalty to the gods of the underworld and so instill fear wherever they go.

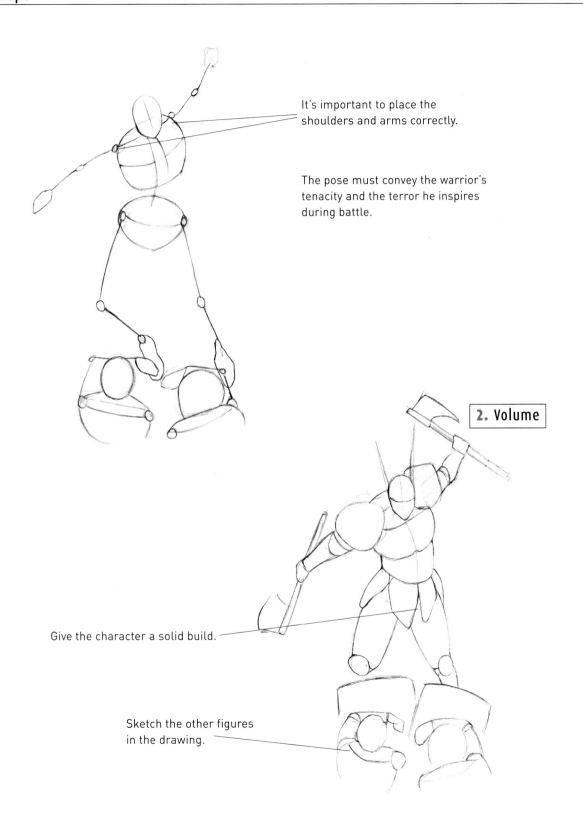

It's important to place the shoulders and arms correctly.

The pose must convey the warrior's tenacity and the terror he inspires during battle.

2. Volume

Give the character a solid build.

Sketch the other figures in the drawing.

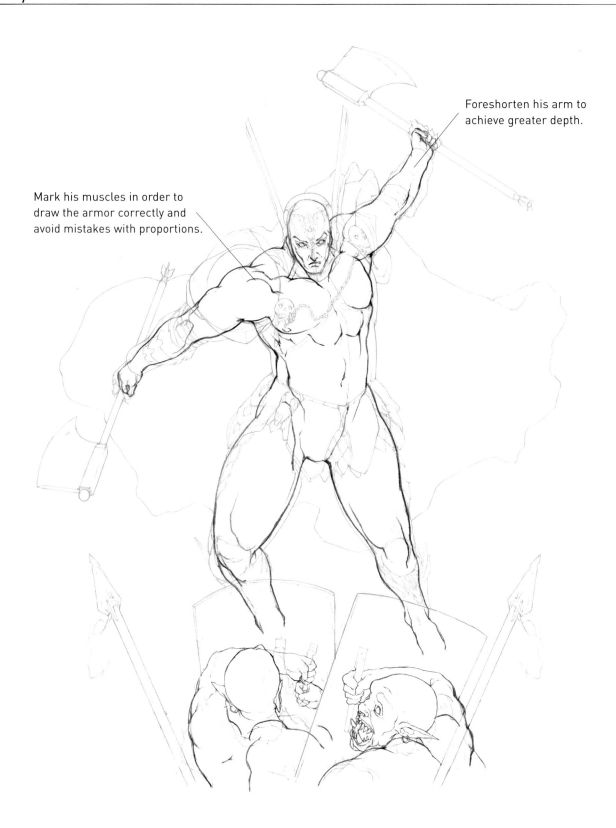

Foreshorten his arm to achieve greater depth.

Mark his muscles in order to draw the armor correctly and avoid mistakes with proportions.

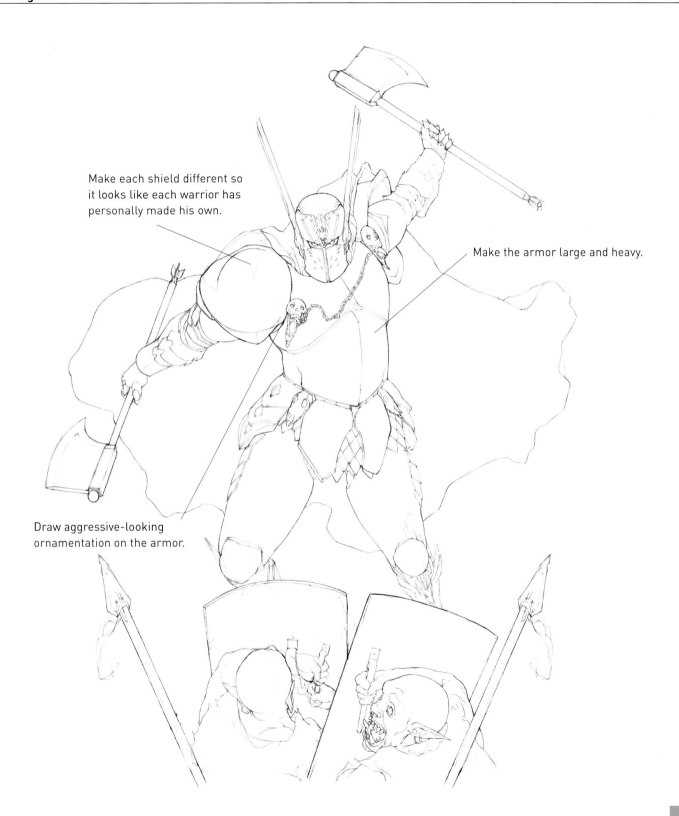

Make each shield different so it looks like each warrior has personally made his own.

Make the armor large and heavy.

Draw aggressive-looking ornamentation on the armor.

By creating heavy contrasts between light and shadows, you'll make the image look like a nocturnal battle, even without drawing a background. Accentuate the lighting by marking the shadows the main character casts over himself and the other characters.

Source of light

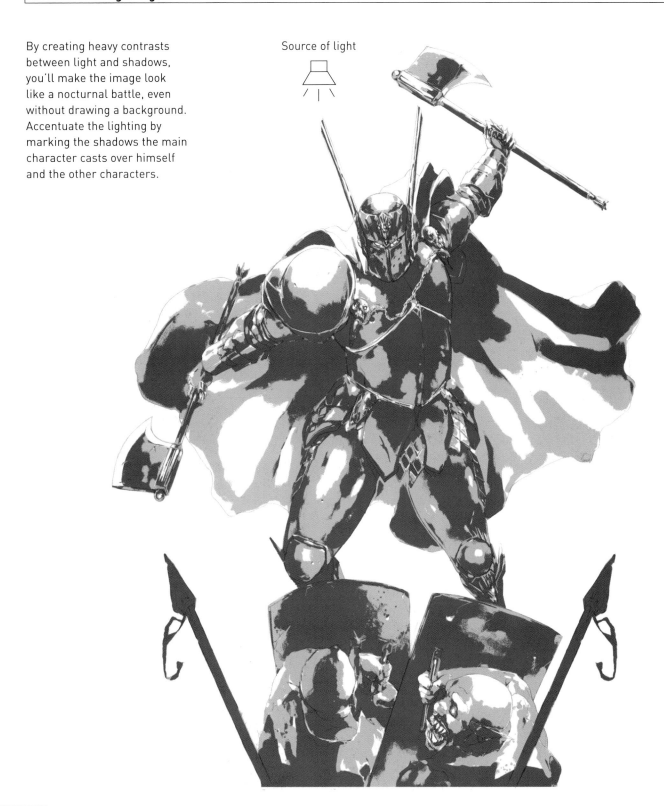

Apply color to create a jagged
texture. Choose a dark tone and
contrast it with the few areas of
axial light, like the one generated
by the warrior.

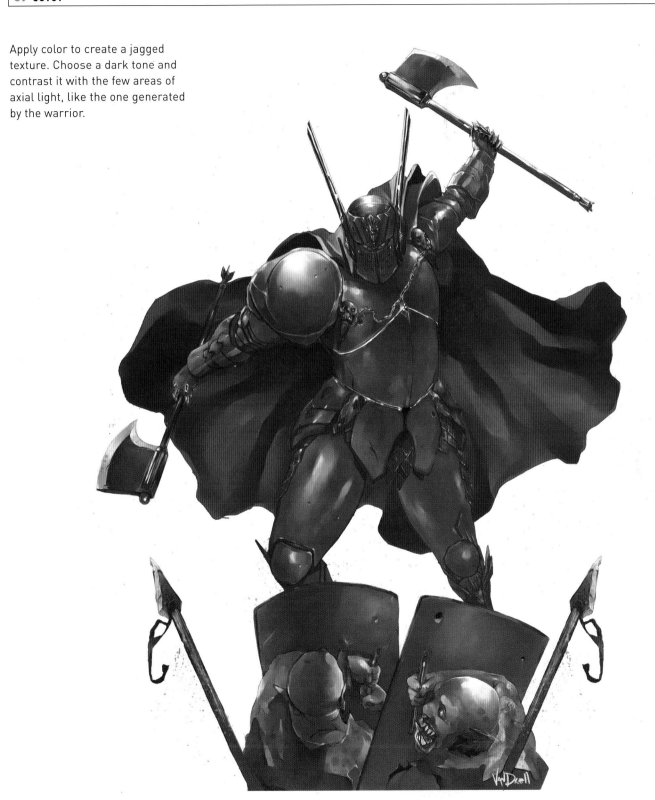

LIZARD MEN

Seemingly coming out of nowhere, these beings travel in packs razing land and stealing whatever they can. They pay tribute to the reptilian forefathers that gave them their unmistakable appearance. Lizard men have very varied features, depending on the region they come from. They are skillful and lethal at war, and quickly learn new fighting techniques from their enemies. The only thing that keeps them from being unstoppable is their relatively low IQ.

1. Shape

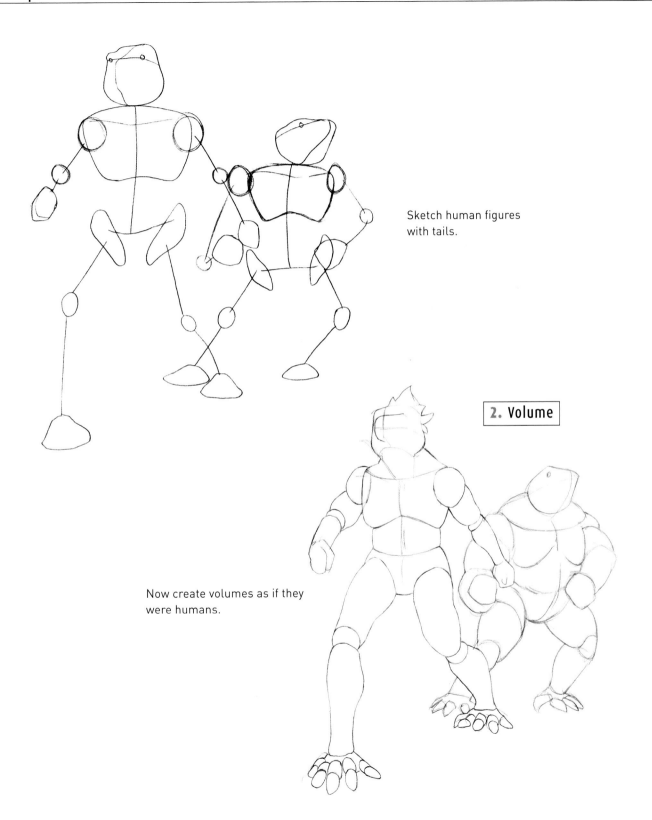

Sketch human figures with tails.

2. Volume

Now create volumes as if they were humans.

Use reference books so that you can mix human and the lizard features in a logical way.

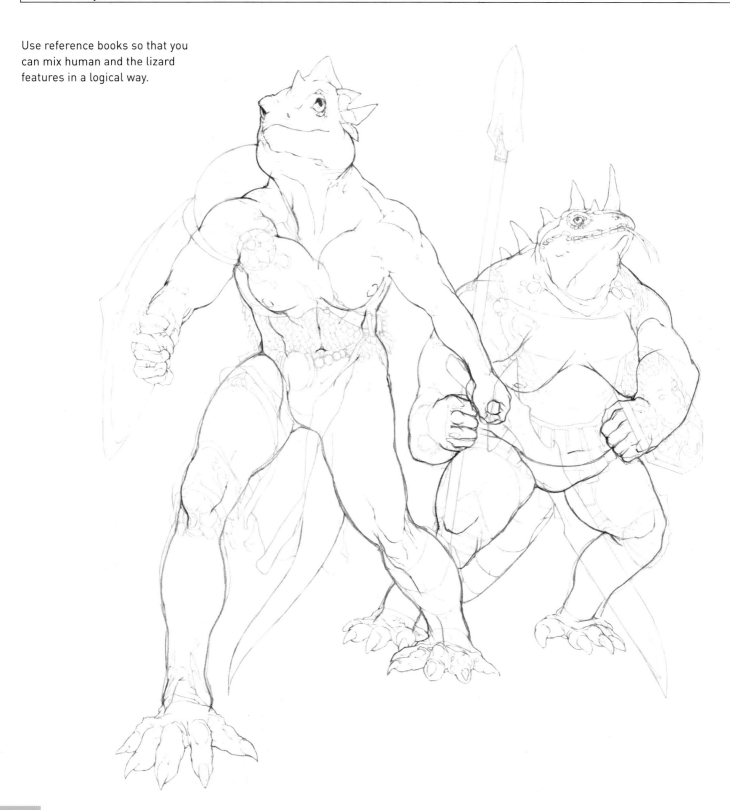

4. Clothing

The lizard in the foreground is agile and fights on the front line: it uses light, practical armor that allows great mobility.

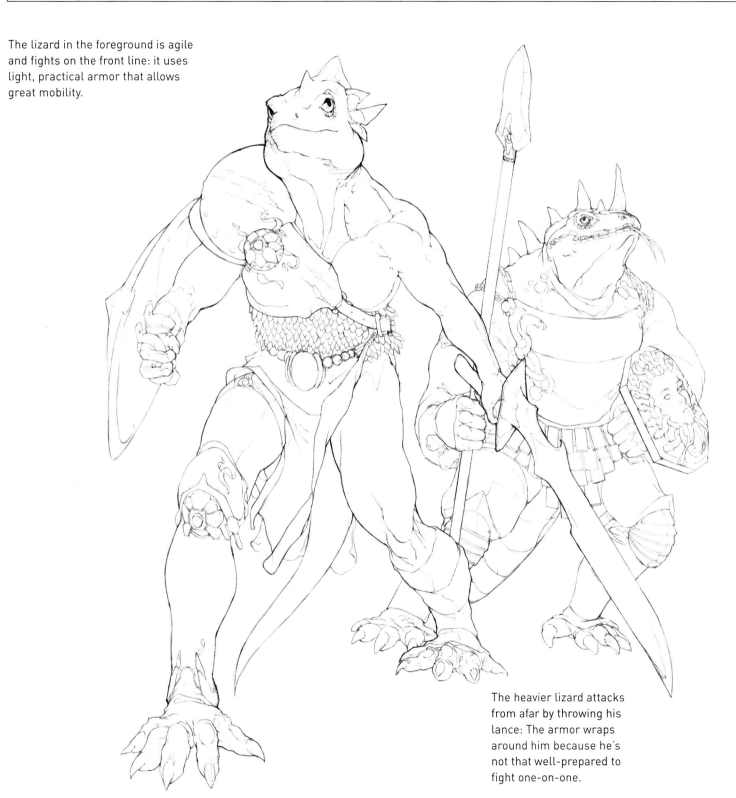

The heavier lizard attacks from afar by throwing his lance: The armor wraps around him because he's not that well-prepared to fight one-on-one.

Mark shaded areas with patches of color. Next mark the dark metallic areas with lighter patches to indicate that the armor is a bit worn.

Source of light

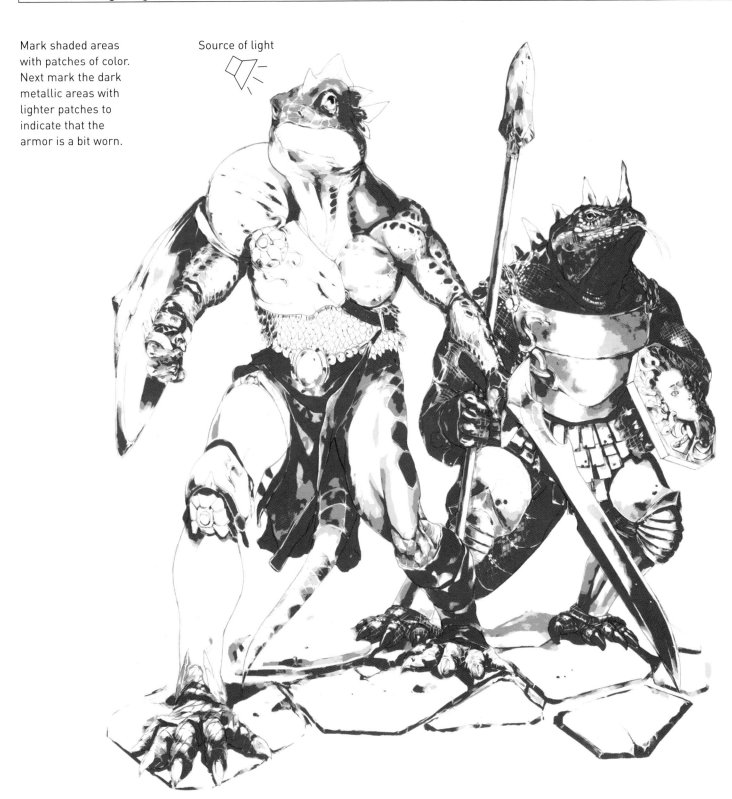

Give the skin a scaly texture
with paint. We'll also use
color to gain greater depth.

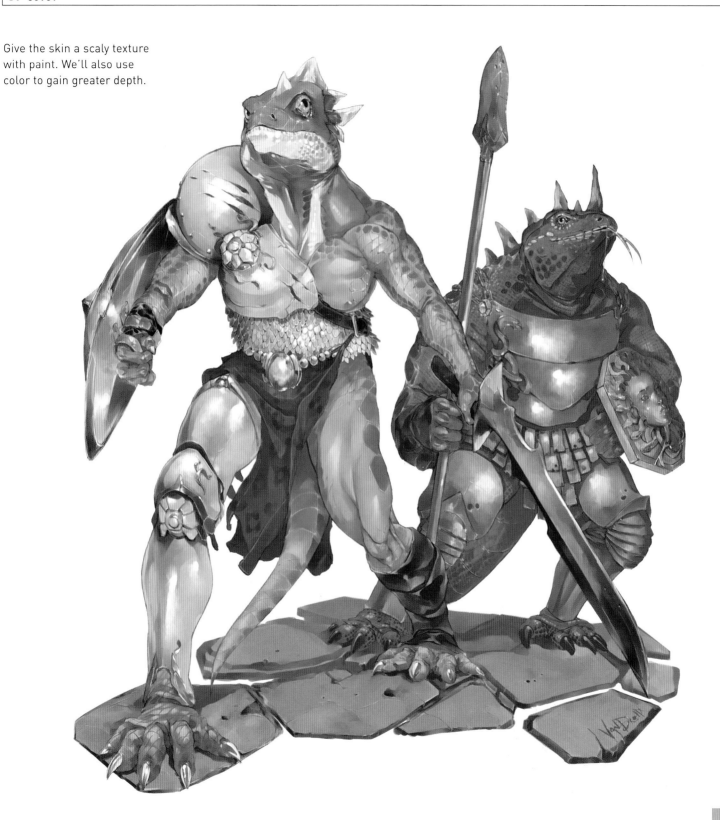

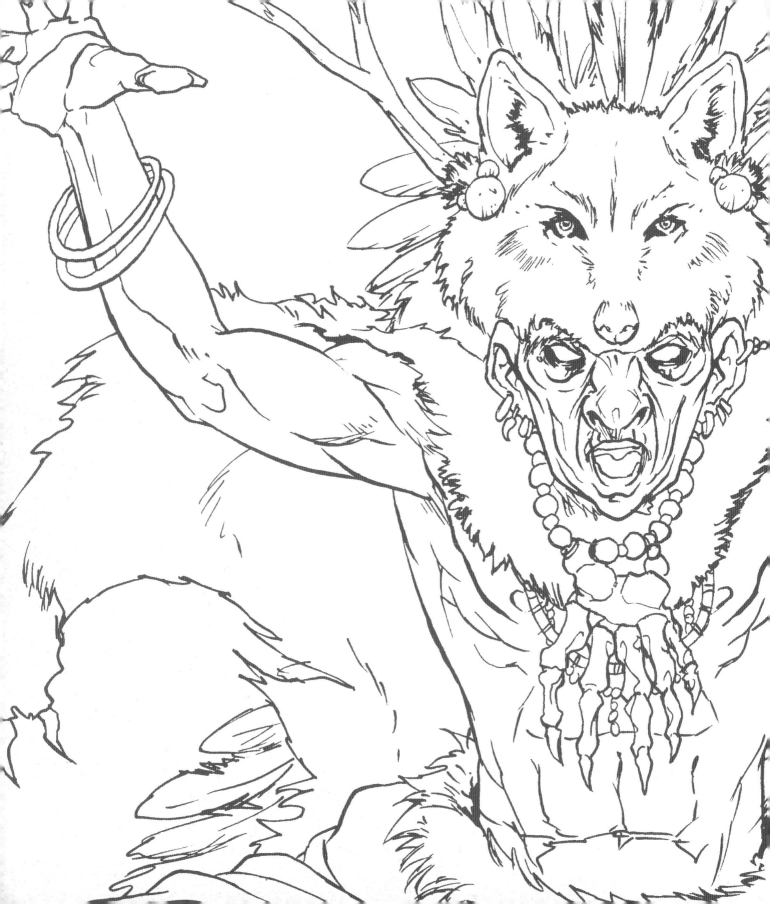

SHADOWLANDS

STONE ORACLE

An oracle is the message from a god using images, priests, fortune tellers, dream interpretation, or ritual sacrifices to relay it. We also use the word for the places where questions are asked and answered. Images of gods are usually found in places or areas dedicated to some deity. We will illustrate an oracle excavated in stone. The idea is to create a lugubrious atmosphere, one that evokes a long-forgotten civilization, and makes for an interesting place our heroes can visit.

1. Shape

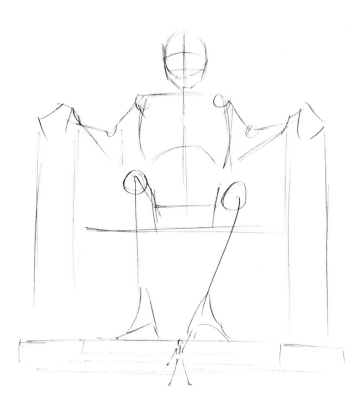

Draw a normal person sitting on a throne. The trick is to lower the horizon, or point of view, to where the character's feet are.

2. Volume

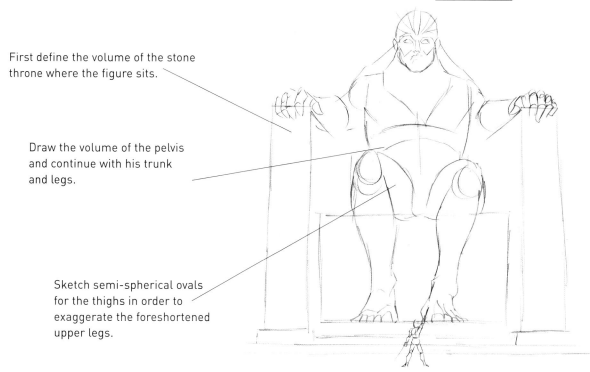

First define the volume of the stone throne where the figure sits.

Draw the volume of the pelvis and continue with his trunk and legs.

Sketch semi-spherical ovals for the thighs in order to exaggerate the foreshortened upper legs.

Draw all the anatomical details, even those which are secondary or won't be seen at all, and make them look as magnificent and idealized as a Greek or Roman statue.

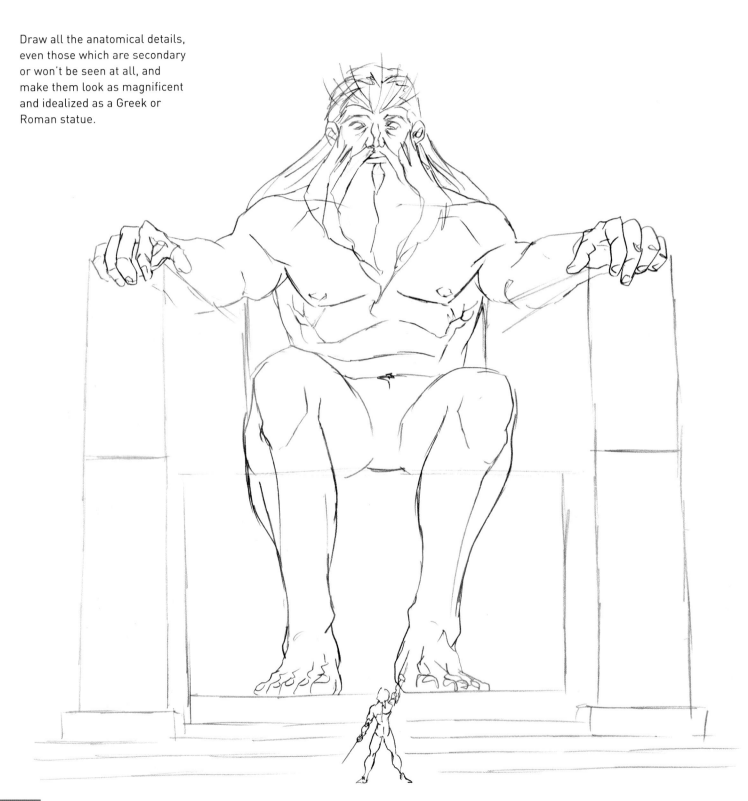

Draw the oracle's stone robes with slightly angular lines that help capture their texture. The volume of the clothes adapts to the figure's foreshortening and perspective.

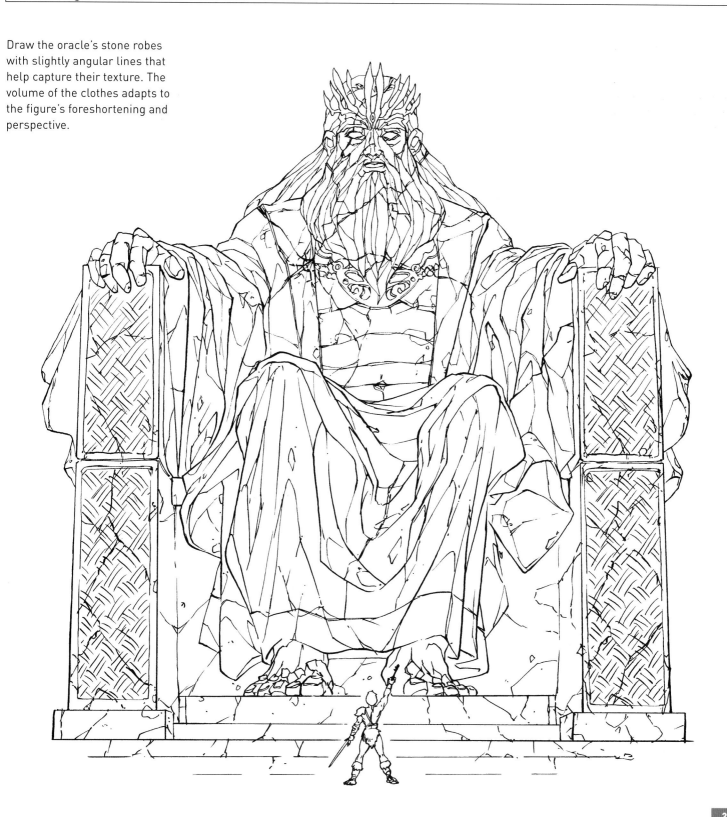

The lighting should be very dramatic. The most important thing is for the light to give the scene some atmosphere.

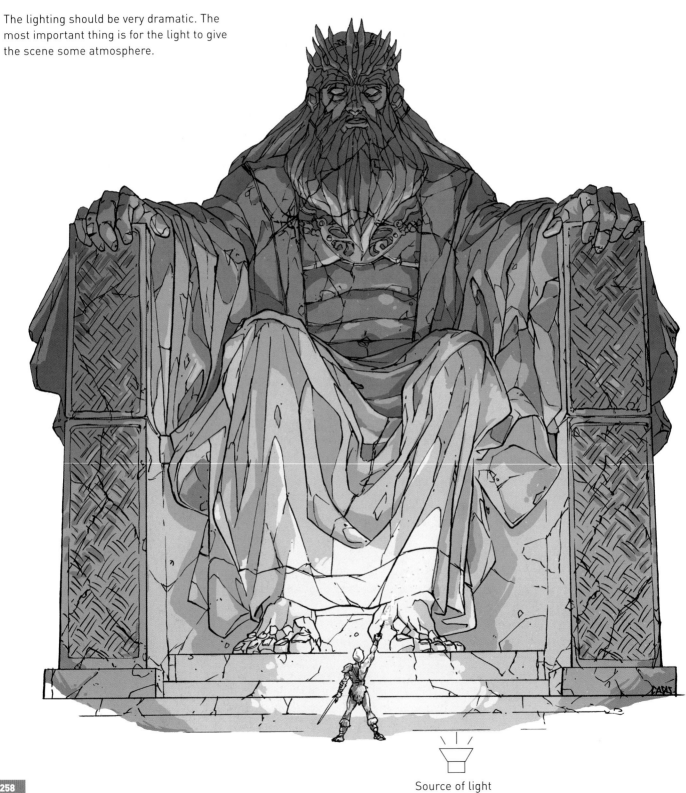

Source of light

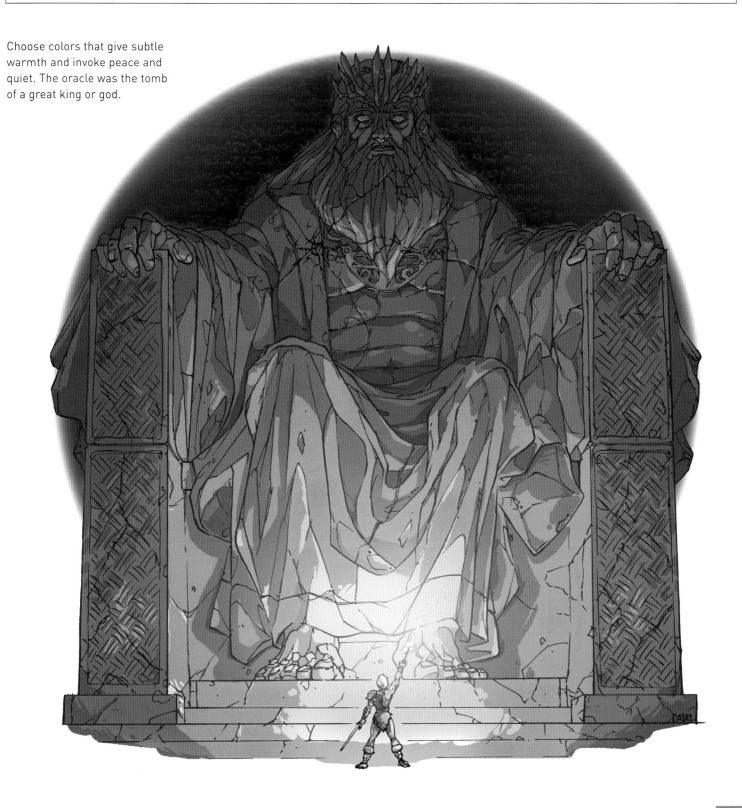

Choose colors that give subtle warmth and invoke peace and quiet. The oracle was the tomb of a great king or god.

BARBARIAN

Originally the word barbarian was associated with an ungraceful, savage brute. These men formed tribes; many were nomadic and believed in primitive gods. They went to war often and their customs involved warrior rituals. Meanwhile work was considered a much less dignified activity, even if it was necessary. They are often confused with beasts because of their primitive lifestyle; they dress in animal skins and not very elaborated clothes, mostly saving their wits for war.

1. Shape

Part of the fun of this pose lies in the foreshortening of the body. The main thing to capture is the figure's movement.

2. Volume

Basic understanding of perspective will help draw the foreshortened volumes. Follow the quick law of perspective: the closer the object, the bigger it looks.

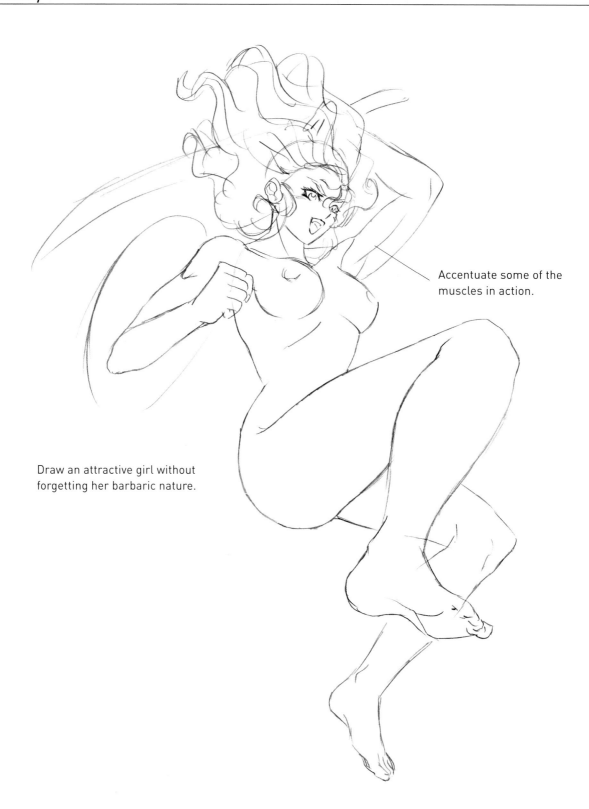

Accentuate some of the
muscles in action.

Draw an attractive girl without
forgetting her barbaric nature.

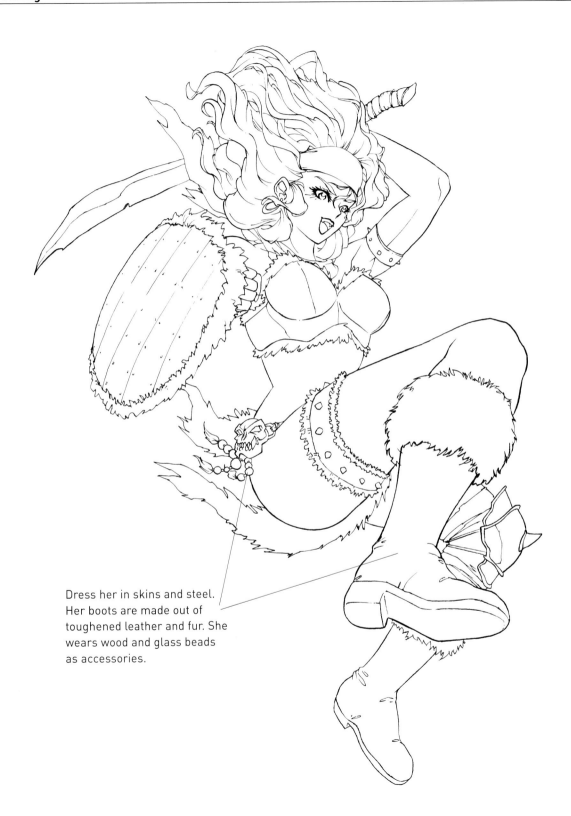

Dress her in skins and steel. Her boots are made out of toughened leather and fur. She wears wood and glass beads as accessories.

Source of light

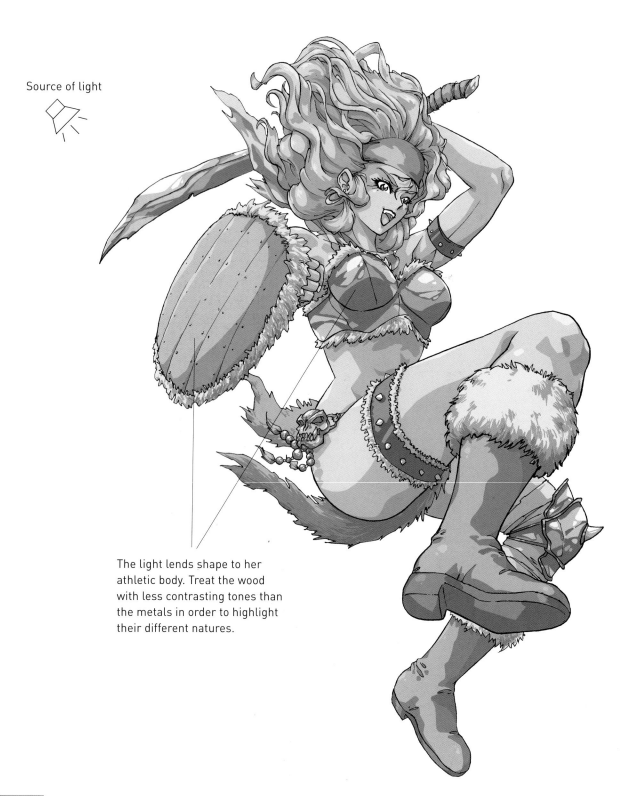

The light lends shape to her athletic body. Treat the wood with less contrasting tones than the metals in order to highlight their different natures.

Enrich the scene by playing with touches of blue to contrast the earth tones. Use blue to adorn the shield and the scarf around her neck.

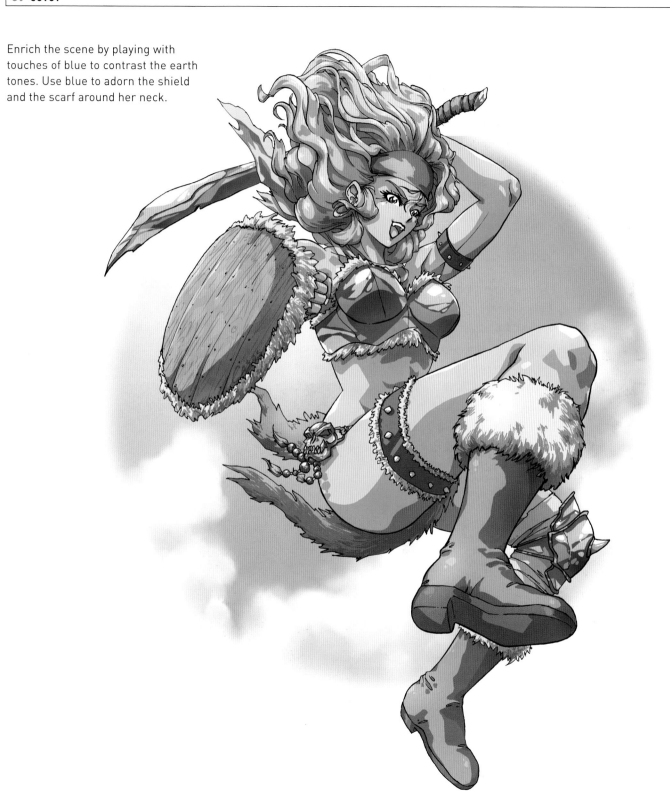

SHAMAN

The most primitive tribes always had someone who tried connecting with the spirit of mother earth. Shamans are individuals with curative abilities, and they're believed to communicate with spirits and even with animals. They also have fortune-telling abilities. Shamans bring spirits of nature and mankind into their families and circle of friends.

In their rituals shamans tend to use herbs, mushrooms, and roots with medicinal and psychotropic properties. Certain animals are considered to be their power totems.

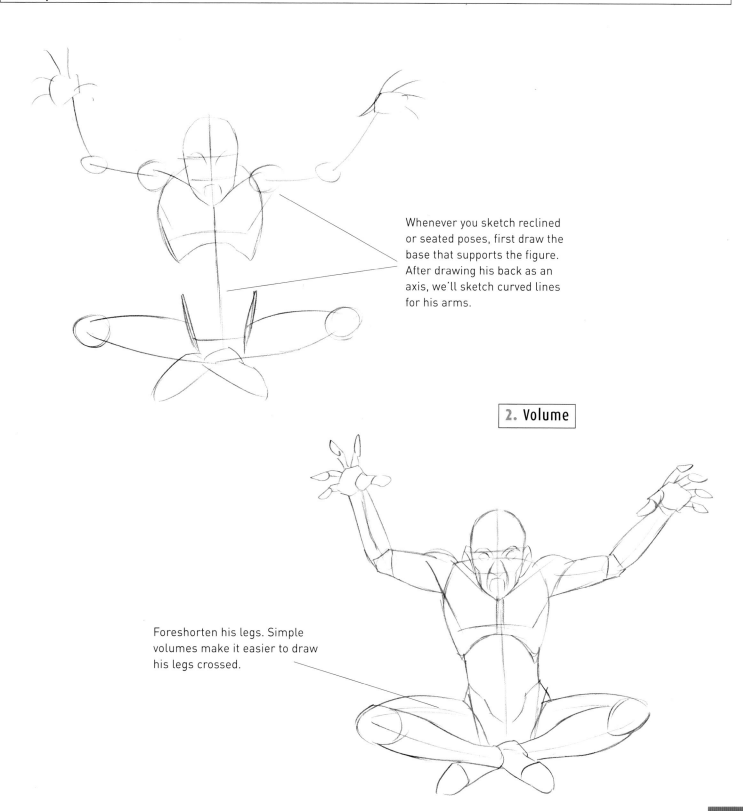

Whenever you sketch reclined or seated poses, first draw the base that supports the figure. After drawing his back as an axis, we'll sketch curved lines for his arms.

2. Volume

Foreshorten his legs. Simple volumes make it easier to draw his legs crossed.

The shaman is a wise old man who has abandoned earthly pleasures. He is ascetically thin and the effects of age have marked his face, which is sorrowful.

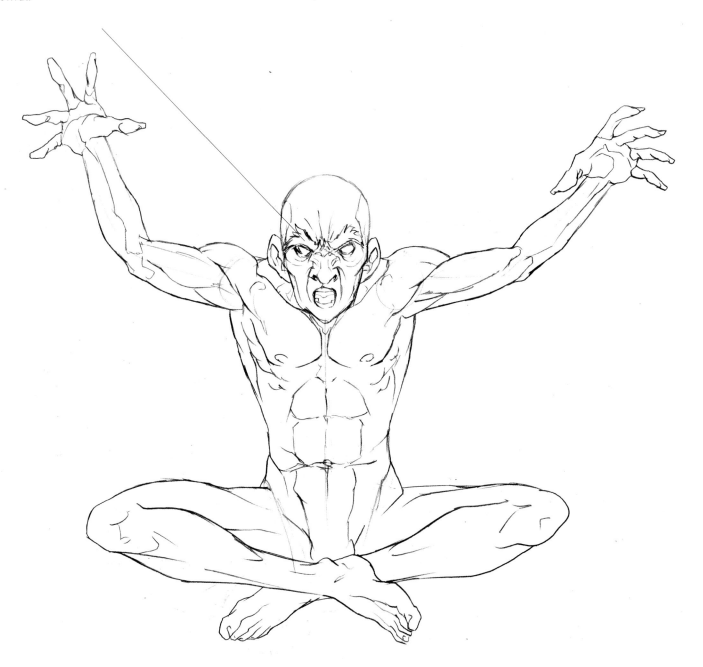

Typically shamans wear the skins of the animals that serve as their power totems.

The complex headdress makes him look supernatural and even more mysterious.

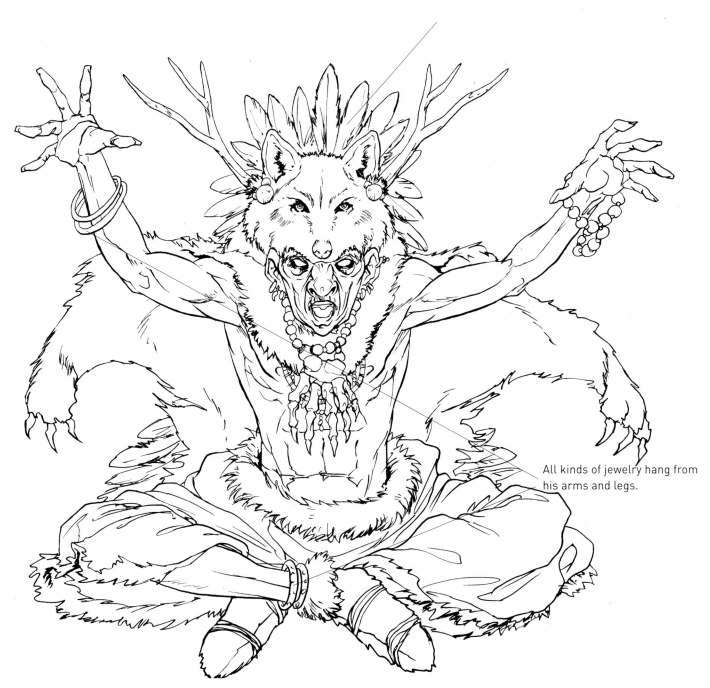

All kinds of jewelry hang from his arms and legs.

Light comes up from the bottom and helps make the mood more mysterious. Use this trick whenever you're looking to create a ghostly effect.

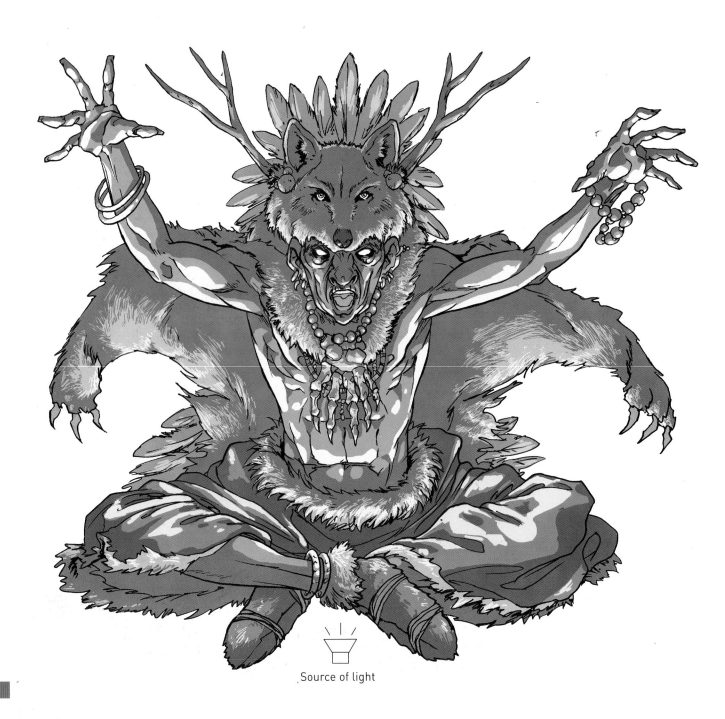

Source of light

The lighting makes the colors look unrealistic. Pendants and rosaries lend touches of color as they dance along with the movement of his arms. The shaman's skin is tanned by the sun because he's spent years outdoors.

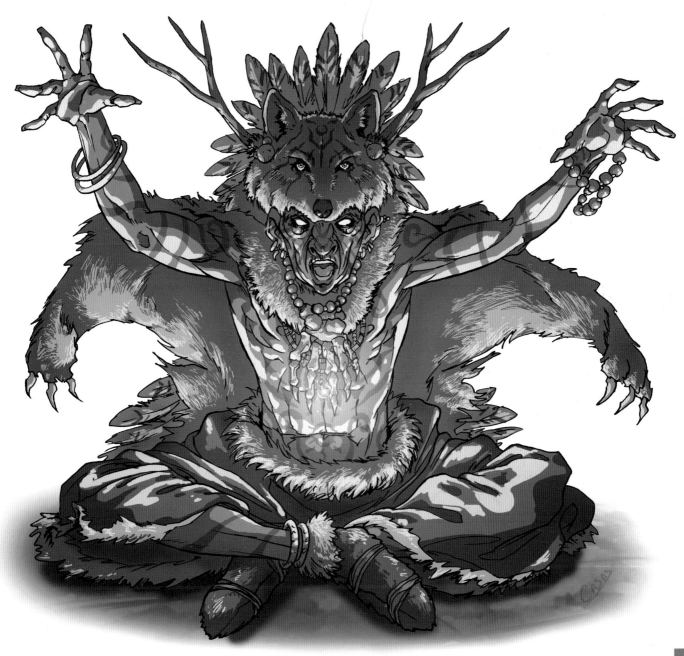

GIANT

Giants are beings who look humanlike, but much bigger in size and strength. They are monsters who appear in stories from many different cultures. They tend to be described as stupid and violent creatures, and it is frequently said that besides devouring beasts in a single bite, they also eat humans, especially children. All the stories about giants speak about them as if they were fearless, powerful warriors. They say that watching them fight is like watching a mountain crush an army and that their gigantic weapons could wipe out entire garrisons.

Our point of view is near the ground and the giant's dimensions must illustrate this. Mark the positions of the soldiers who have fallen victim to our character.

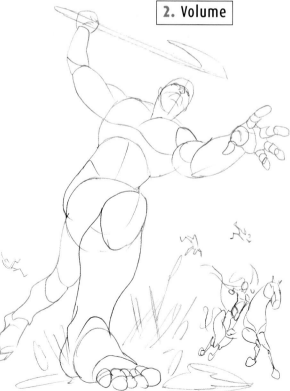

2. Volume

The volumes will get smaller as we move away from the foreground and get closer to the giant's head.

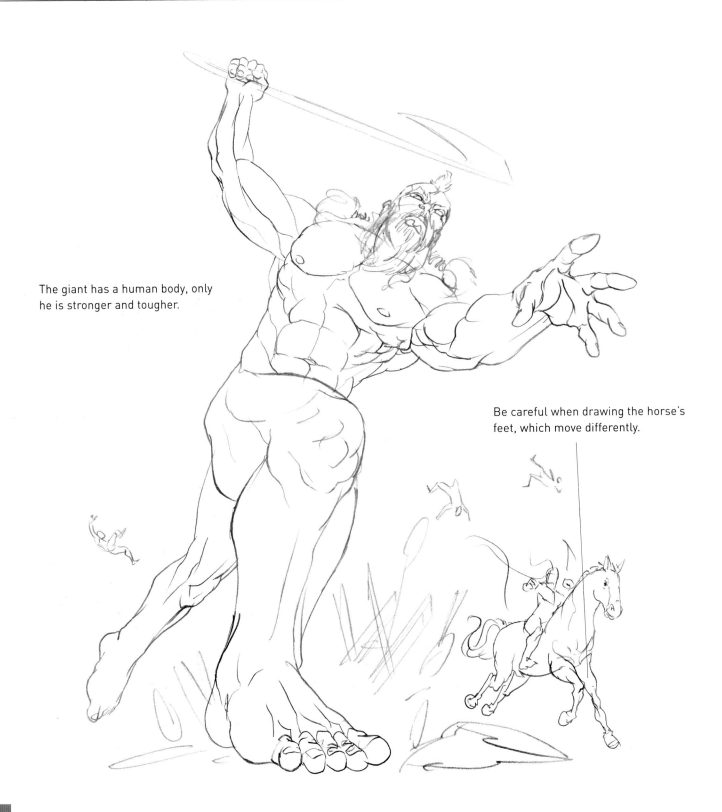

The giant has a human body, only he is stronger and tougher.

Be careful when drawing the horse's feet, which move differently.

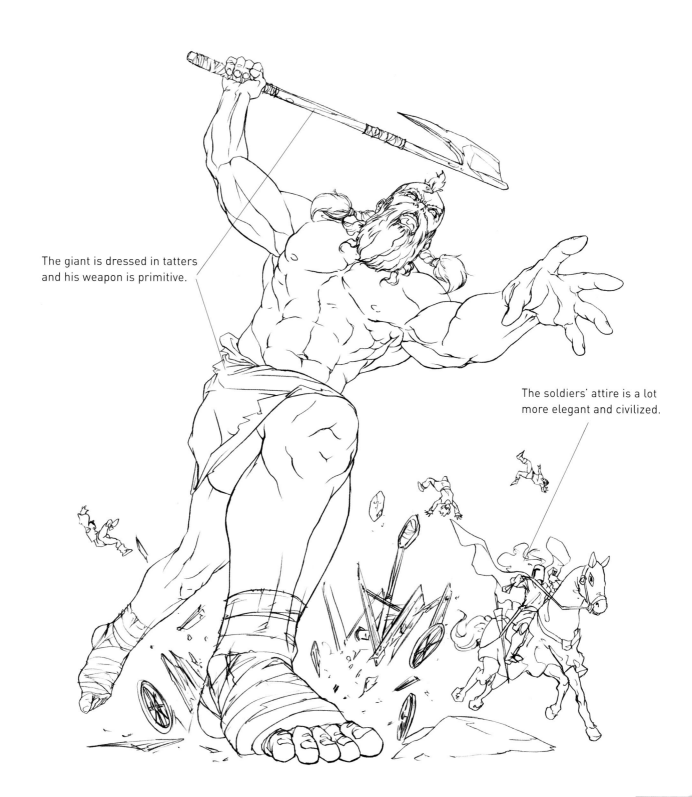

The giant is dressed in tatters and his weapon is primitive.

The soldiers' attire is a lot more elegant and civilized.

Put the source of light slightly behind the giant so his shadow projects over the tiny soldiers. The effect will be much more spectacular.

Source of light

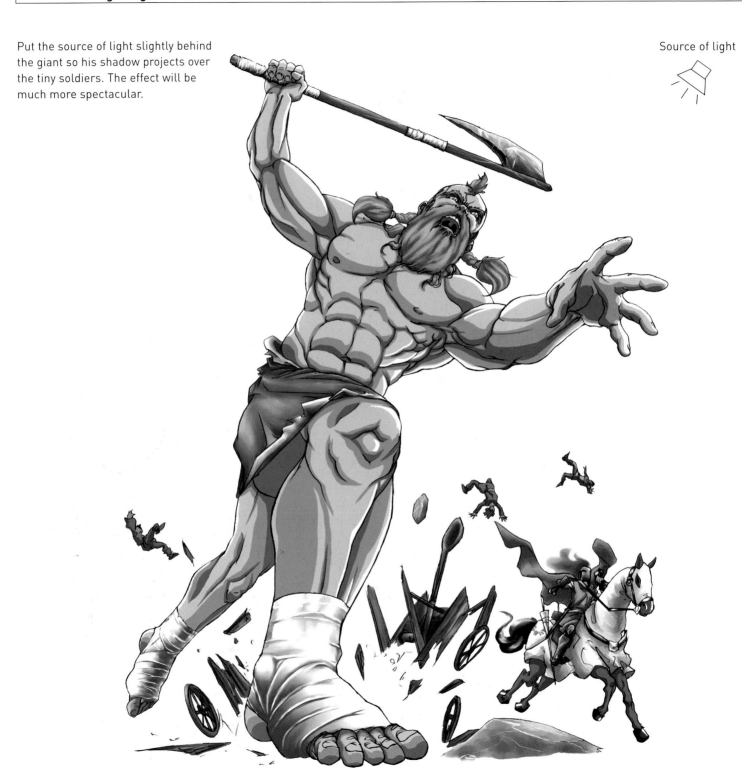

Adorn the giant's body with his clan's war paint. Paint each muscle individually. Make the soldiers' uniforms the same color.

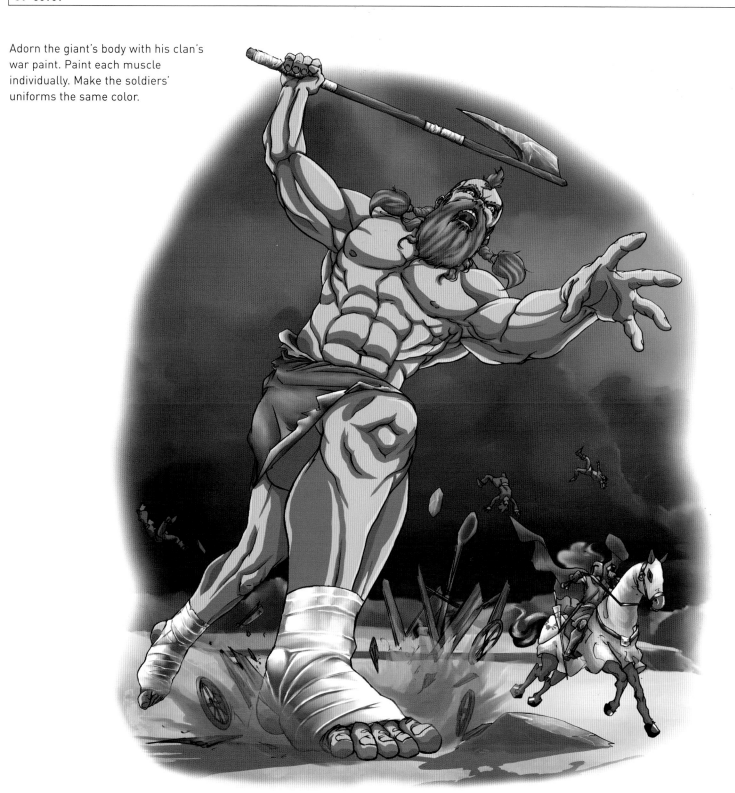

ICE GIANT

Among giants there is one class that deserves special mention: ice giants. Their role is especially important in Nordic mythology, where they're considered very strong, powerful beings that rival the gods. There are legends that say that because of them one day the gods will engage in the greatest war that anyone has ever seen.

Eternal ice is their home. Who knows what will happen the day they decide to leave their fortress.

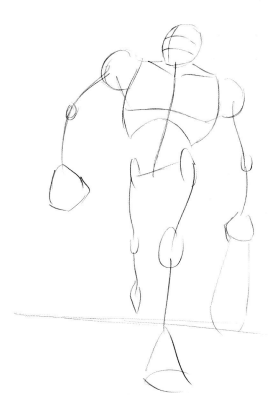

We'll establish our point of view near the ground to capture the giant's size. Magnify the object we're drawing whenever we lower the point of view.

2. Volume

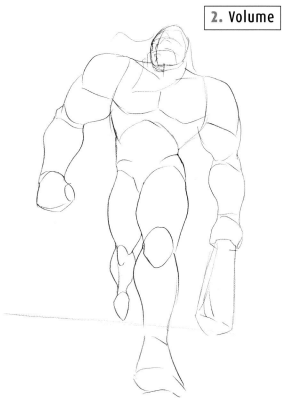

Make a slight curve in the horizon so whatever we draw looks even more gigantic.

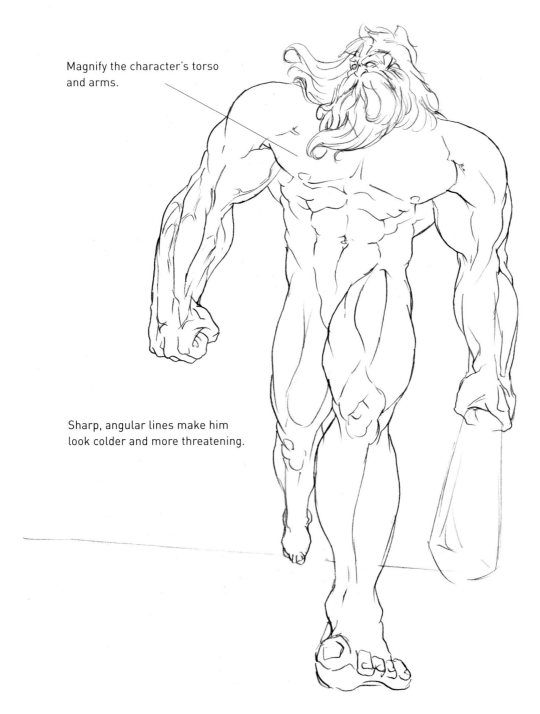

Magnify the character's torso and arms.

Lengthening his arms makes him look more primitive and monstrous.

Sharp, angular lines make him look colder and more threatening.

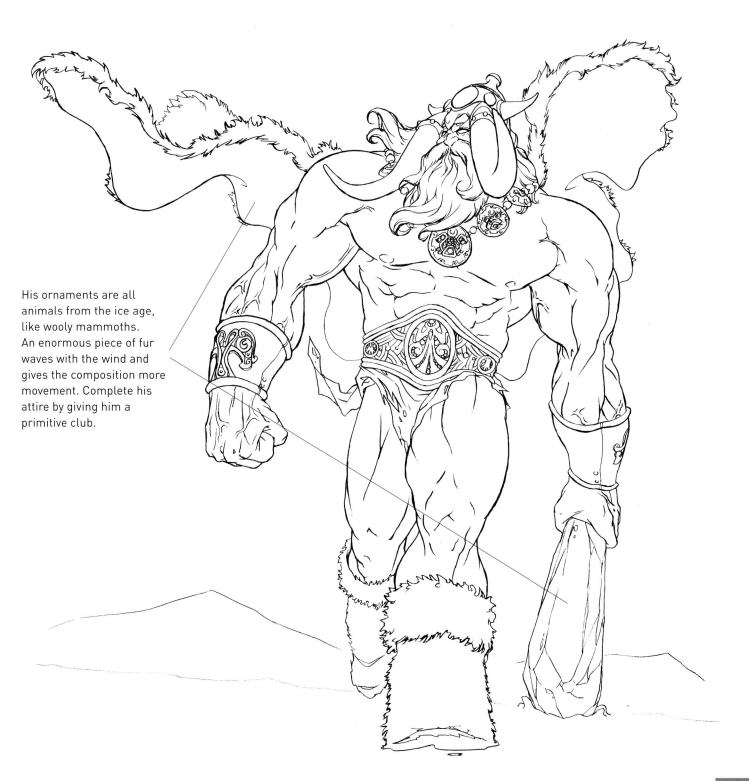

His ornaments are all
animals from the ice age,
like wooly mammoths.
An enormous piece of fur
waves with the wind and
gives the composition more
movement. Complete his
attire by giving him a
primitive club.

Source of light

The contrast between the lit
and shaded areas of the floor
is especially significant.

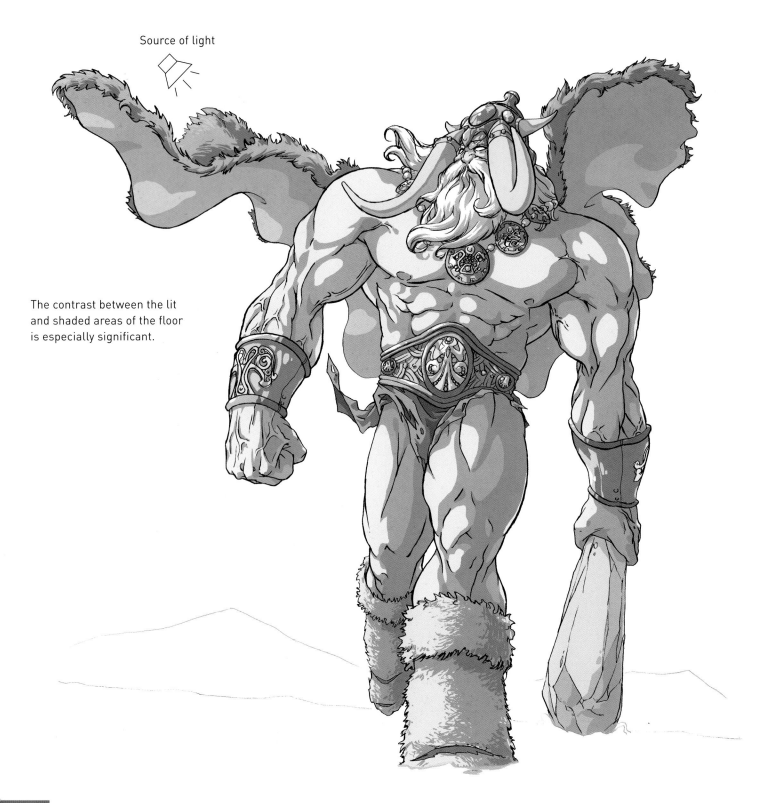

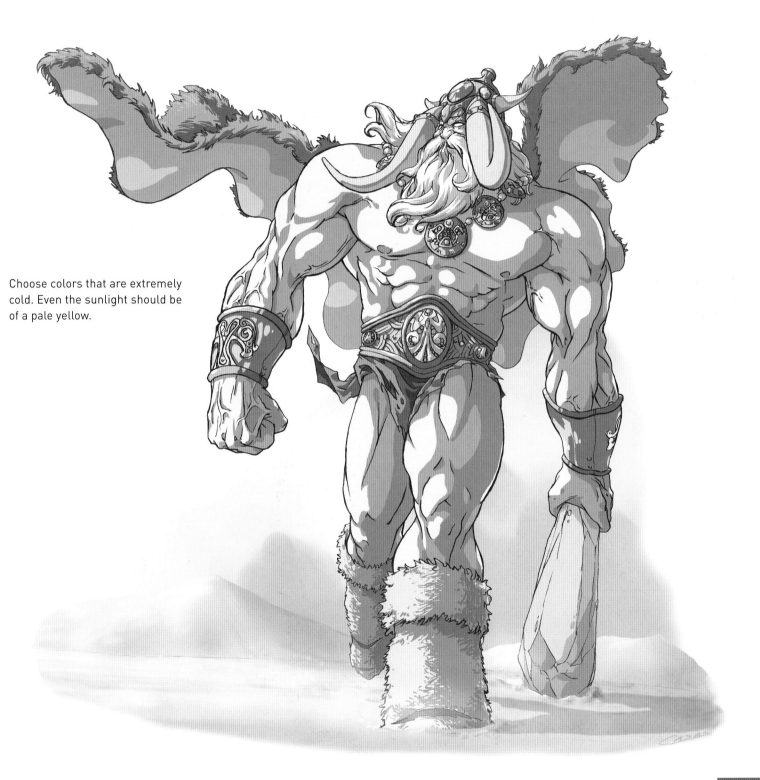

Choose colors that are extremely cold. Even the sunlight should be of a pale yellow.

BEAST MEN

These relatives of mankind's closest ancestors are wild warriors who don't know a thing about weapons or ideals; their only objective is to survive. They are constantly warring against the barbarians, spreading themselves out in groups across the region. They look apelike, most of their body is covered with hair, and they have enormous jaws. Their brutal nature is revealed by the fact that they are capable of devouring the weakest of the pack. They are feared by the great majority of species unaccustomed to the hard life in these whereabouts.

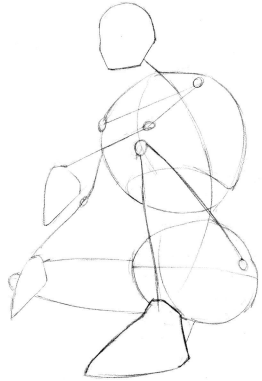

Choose a point of view that emphasizes the character's personality.

2. Volume

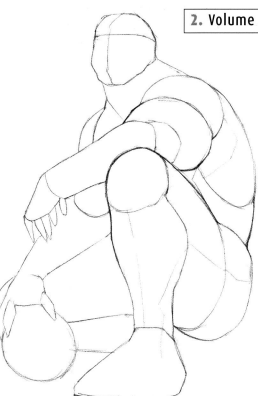

Use perspective to distort volume and create depth.

Add detail to the
nearest elements,
those in the
foreground. We'll
highlight its feet,
hands, and mouth.

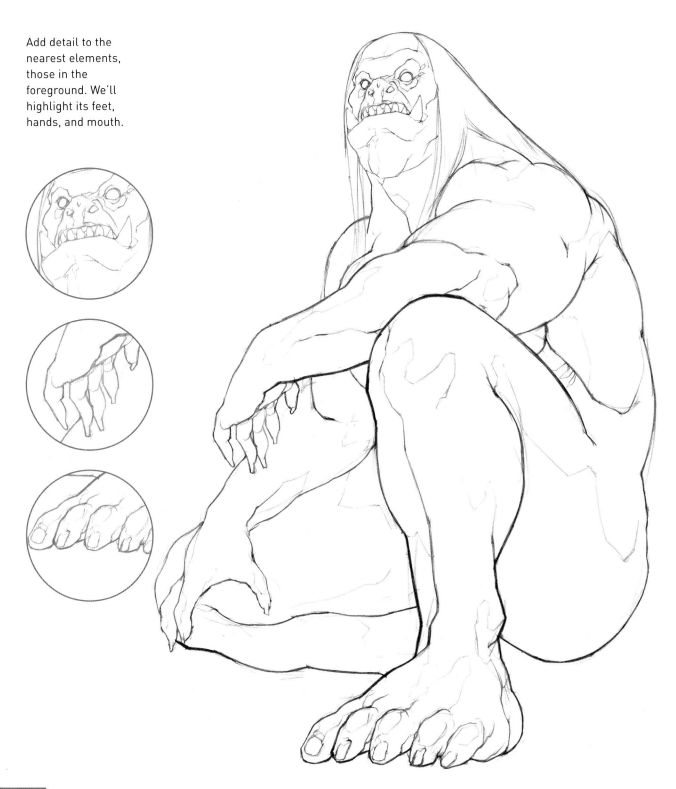

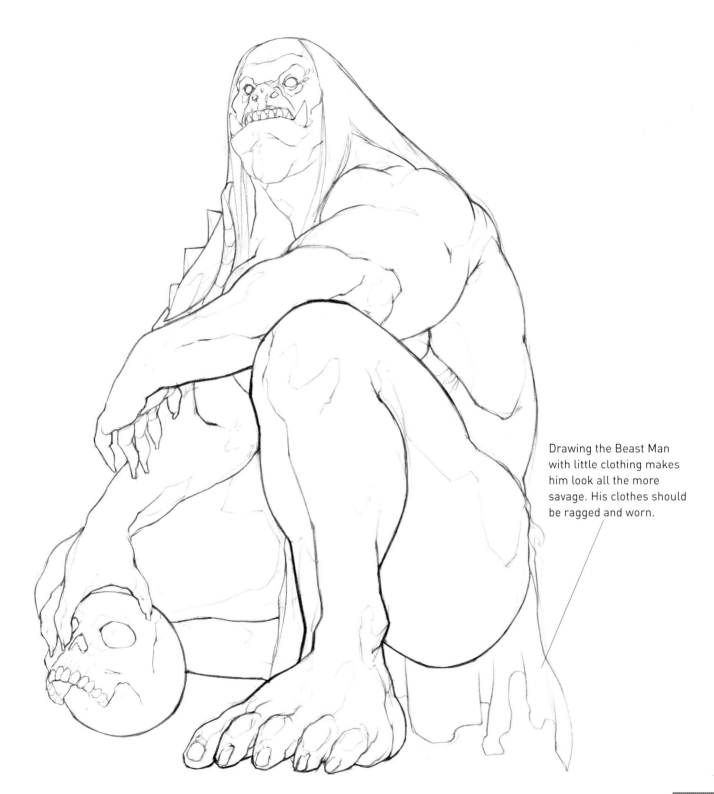

Drawing the Beast Man with little clothing makes him look all the more savage. His clothes should be ragged and worn.

Light from above helps define this character's animalistic features. Draw the shadow cast by the Beast Man.

Source of light

Paint the hair with delicate
dark strokes, so that it
looks realistic.

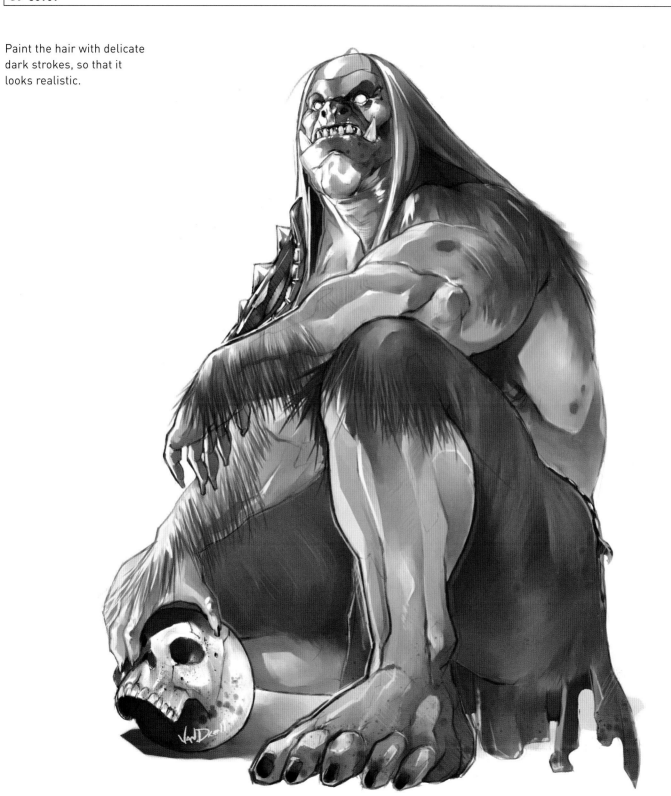

ICE QUEEN

There's a legend that says if you look at the mountains of ice you can see the famous ice sword shining. This weapon was once snatched away from the gods by a woman, an Amazonian. Many say she's immortal, and she reigns over these mountains with an iron hand. Not even the most terrible trolls would choose to travel around these parts. The ice queen lives in the giant tower, and her army consists of the animals that live there.

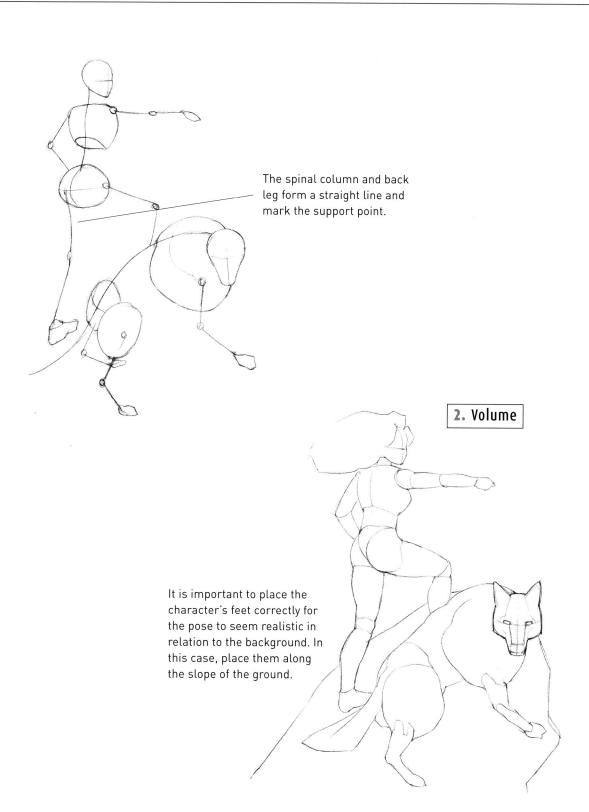

The spinal column and back leg form a straight line and mark the support point.

2. Volume

It is important to place the character's feet correctly for the pose to seem realistic in relation to the background. In this case, place them along the slope of the ground.

The ice queen is an Amazonian so she should have a well-toned body and a confident expression.

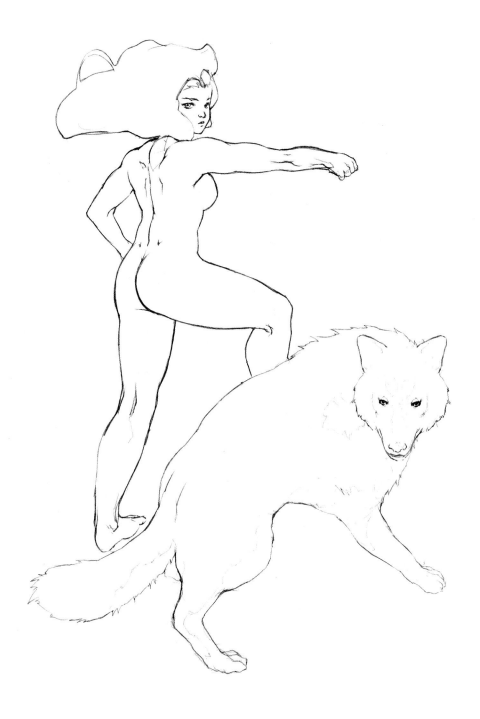

Although she lives in a cold environment, the ice queen doesn't wear many clothes.

Her crown looks like icicles.

The sun peeking through the mountains filters the light, causing contrasts on the inner part of the tower. The sword's reflection casts shadows and light on the characters.

Source of light

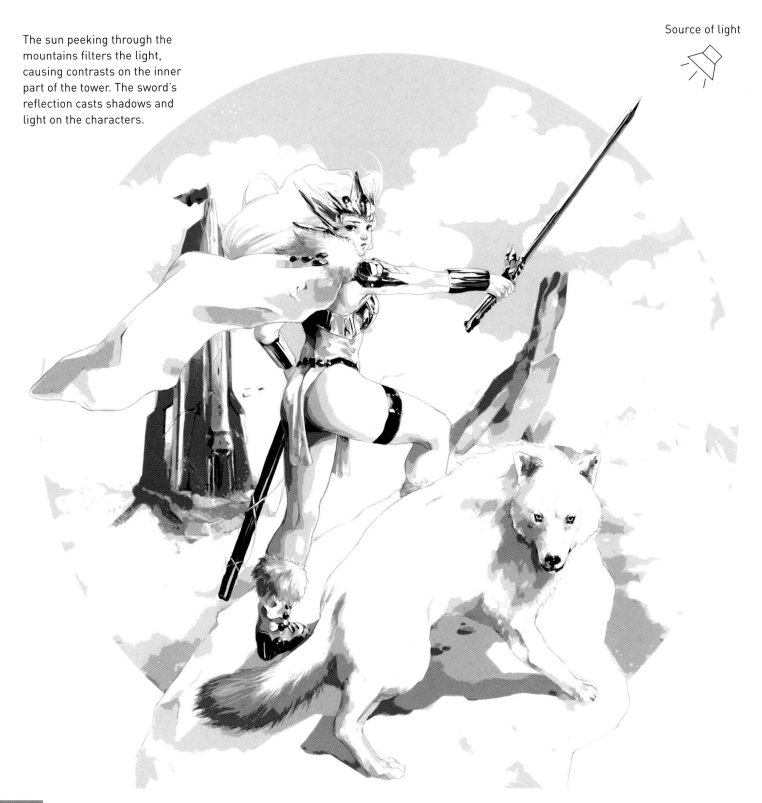

Choose cold colors and make the characters brighter to separate them from the background. Add texture to the rock and tower to make them look more solid.

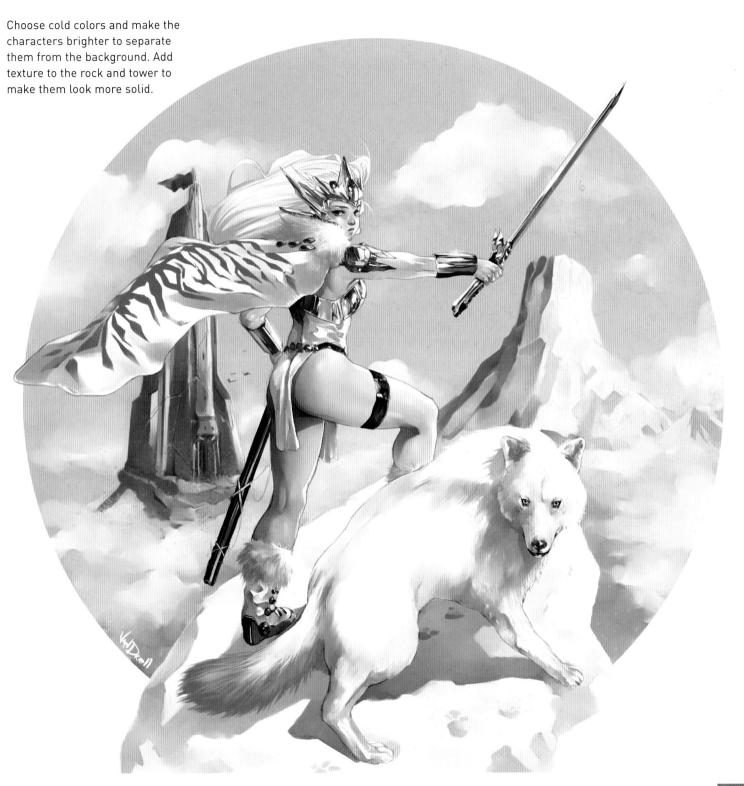

THE MOORS

The moors of these shadowlands are barren, cold, and exposed. The landscape is flat and deserted. These lands are almost uninhabited and conditions are extreme; those who live here must be very tough, and often they're wild and dangerous. Those who don't want to be bothered or discovered might seek refuge in the moors. The moors have been devastated by powerful winds and extreme temperatures. They are seas of desolation where great civilizations might have once prospered and are now long forgotten.

Draw the unevenness that makes up the image.

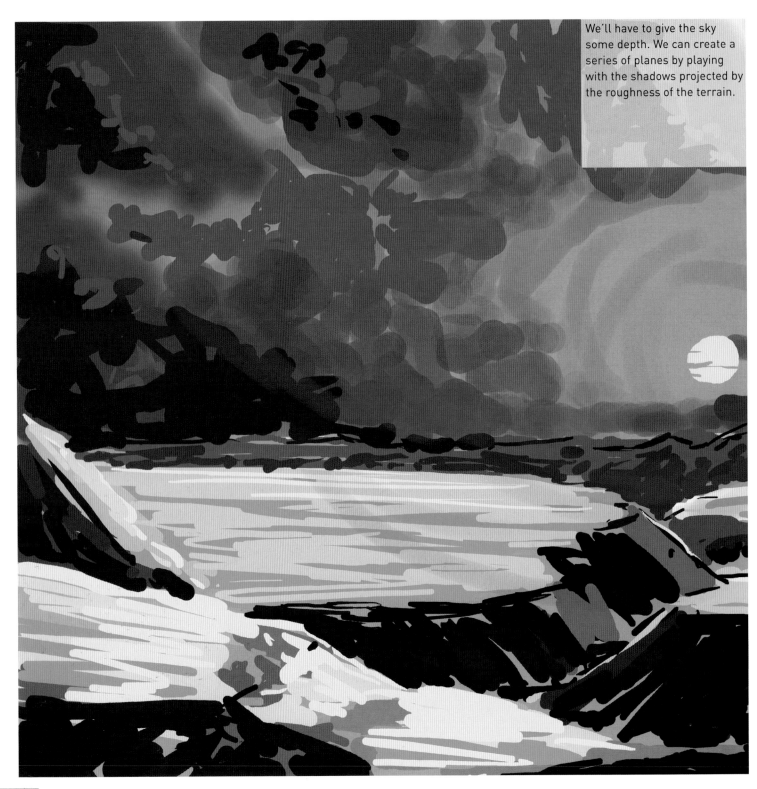

We'll have to give the sky some depth. We can create a series of planes by playing with the shadows projected by the roughness of the terrain.

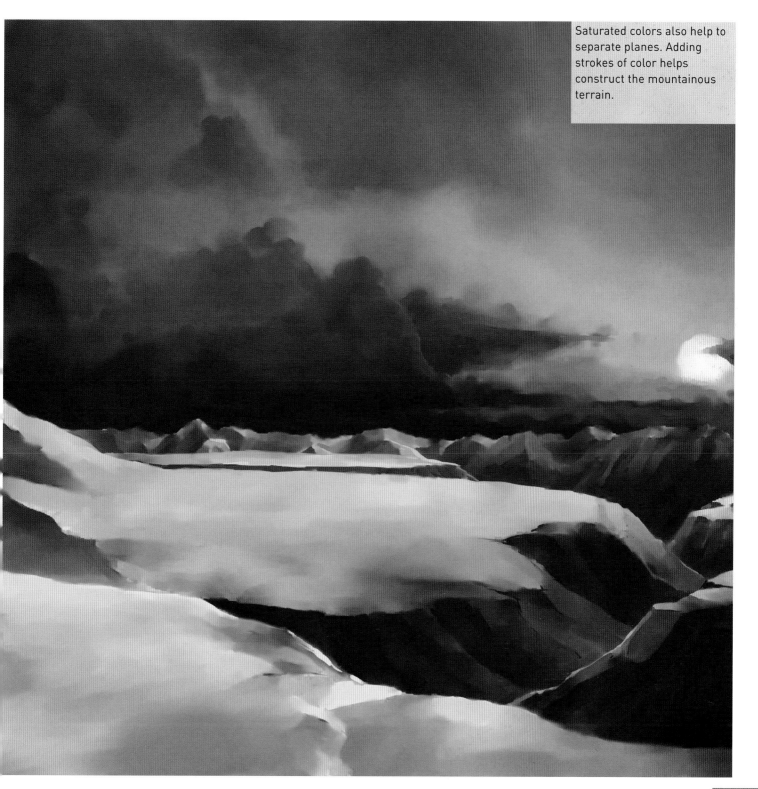

Saturated colors also help to separate planes. Adding strokes of color helps construct the mountainous terrain.

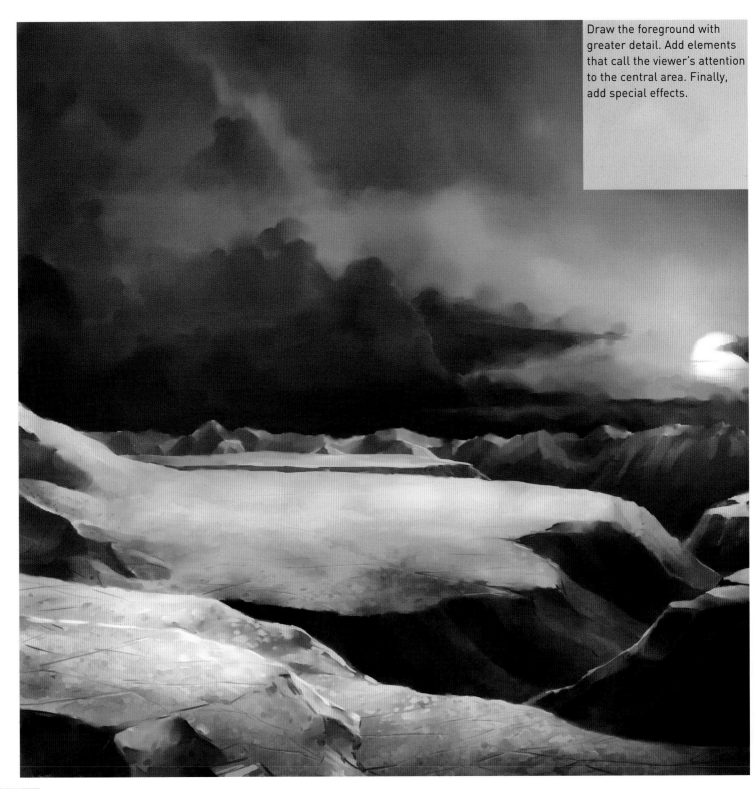

Draw the foreground with greater detail. Add elements that call the viewer's attention to the central area. Finally, add special effects.

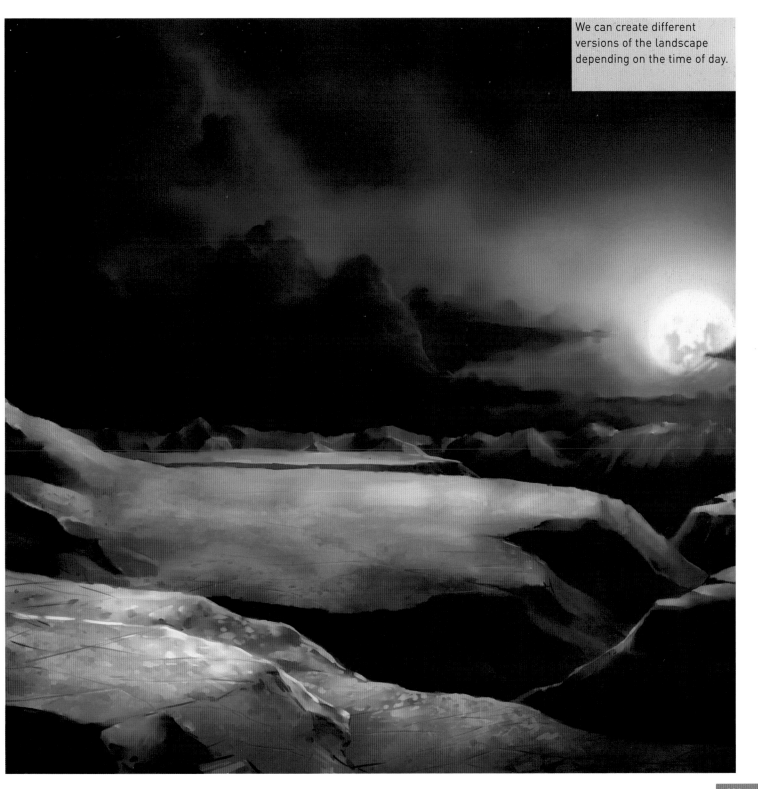

We can create different versions of the landscape depending on the time of day.

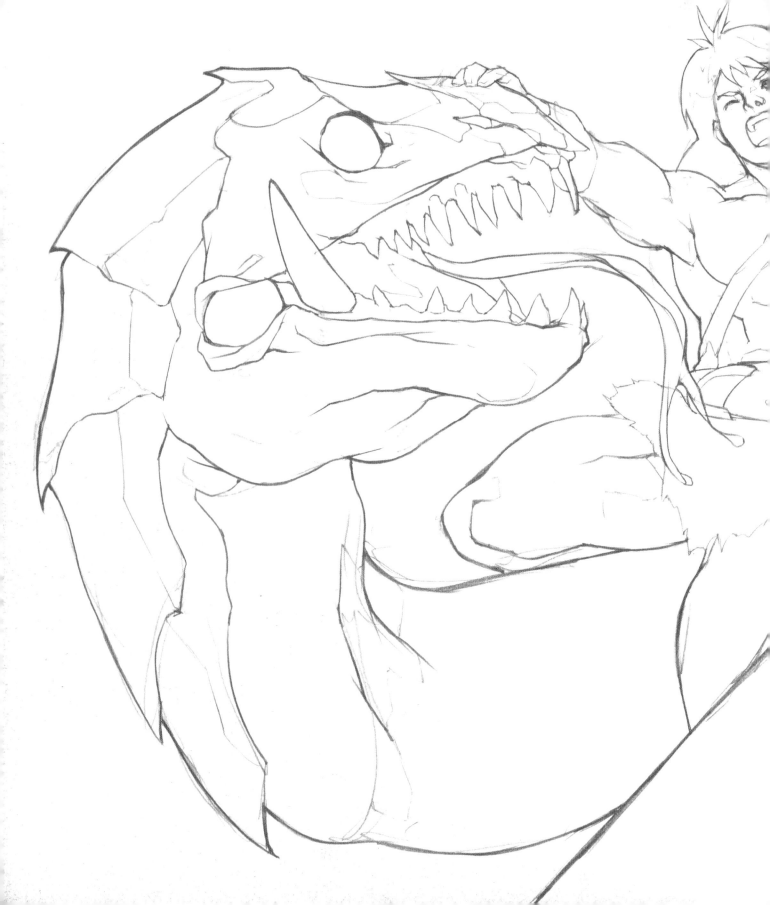

MYTHICAL CREATURES

Unicorn
Lake Monster
Giant Spider
Dragon in its Cave
Phoenix Vs. Hippogriff

UNICORN

According to legends, the unicorn is an animal with a horse's body, a goat's beard, a deer's legs, and a wild boar's tail. But clearly its most characteristic trait is its enormous horn, which possesses magical qualities. We freely adapted that version of the legend and focused on the image of a powerful horse with a magical horn. The legend could have been based on a mistaken interpretation made by the Greeks when they saw Persian bas-reliefs that depicted an antelope. Whatever its origins, the unicorn legend exists and it is powerful.

1. Shape

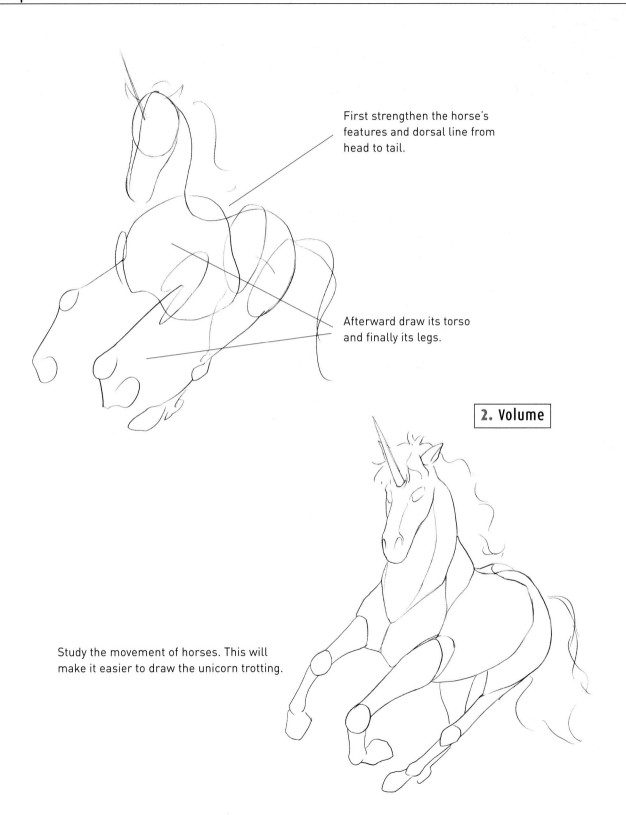

First strengthen the horse's features and dorsal line from head to tail.

Afterward draw its torso and finally its legs.

2. Volume

Study the movement of horses. This will make it easier to draw the unicorn trotting.

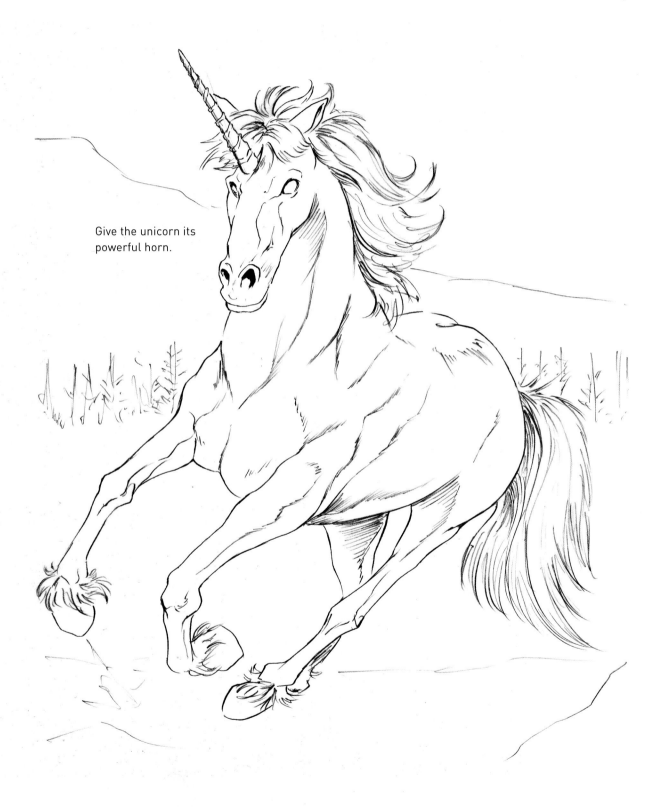

Give the unicorn its
powerful horn.

We'll skip the unicorn's costume (unless you want to dress it up somehow). So let's focus on lighting. Choose a nocturnal setting to emphasize the unicorn's aura and because night is mysterious.

Source of light

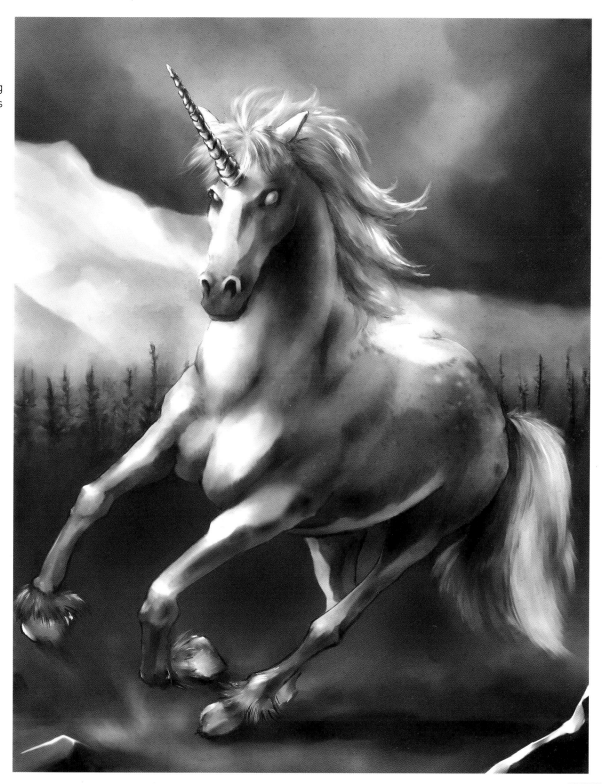

Choose a nocturnal blue as background and then color the figure. Although the horse is white, notice that it has tiny stains and imperfections that make it look more realistic. Continue with the chiaroscuro lighting.

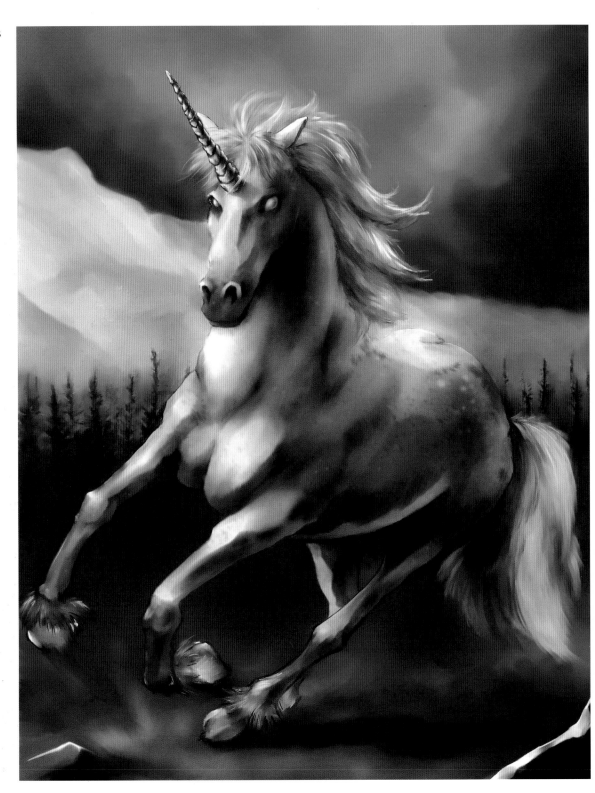

6. Final Color

Now turn it into something really magical. The silver aura and small specks of light that trail behind the unicorn make it look truly mythical. Add a splash of soft light as if the moon were caressing its back.

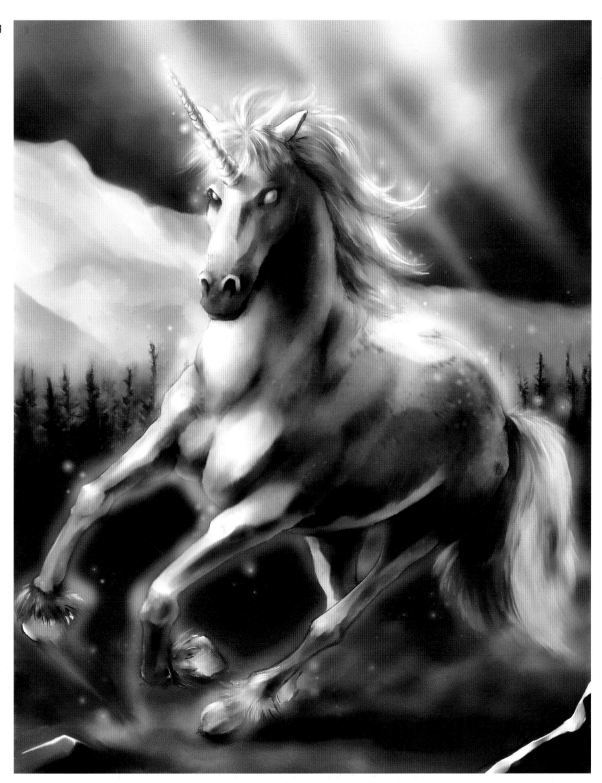

LAKE MONSTER

In these forgotten lands even relaxing by the edge of a lake can be dangerous. Before men and orcs existed, when the earth was covered with water, these monsters already lived all over the world, preying on anything within reach. Sometimes playful, sometimes voracious, they don't think twice about attacking those foolish enough to get near the water. It's not for nothing that they are the oldest species.

1. Shape

Create a point of connection
between the two characters.

2. Volume

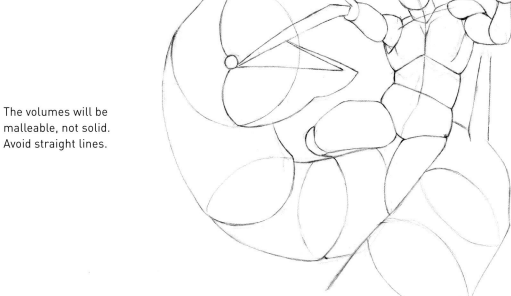

The volumes will be
malleable, not solid.
Avoid straight lines.

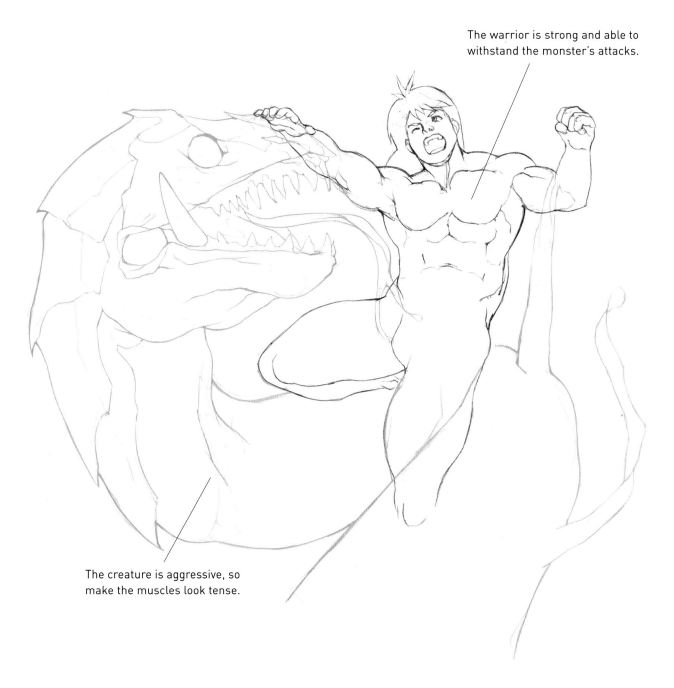

The warrior is strong and able to withstand the monster's attacks.

The creature is aggressive, so make the muscles look tense.

Avoid overdressing the warrior
so we don't take attention
away from the main figure.

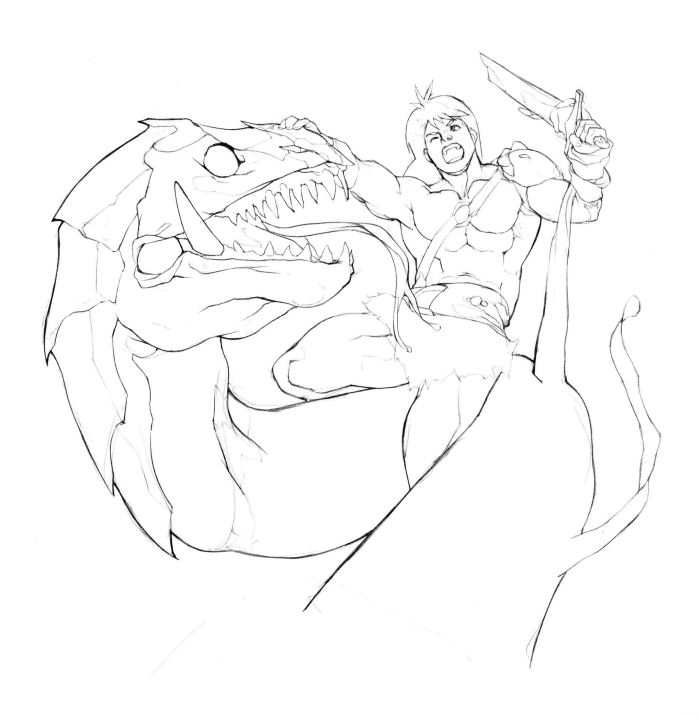

Use contrasting shadows that
come from a single source of light.

Source of light

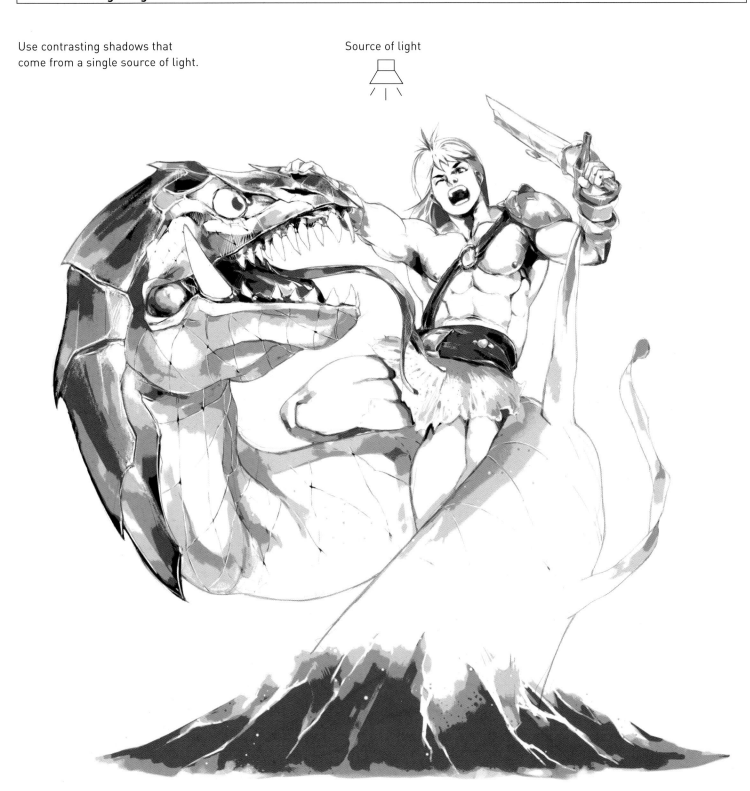

Paint the scales one-by-one to get the right texture. Then give the scales volume by painting some in a base color, others in a darker color, and others in a lighter color.

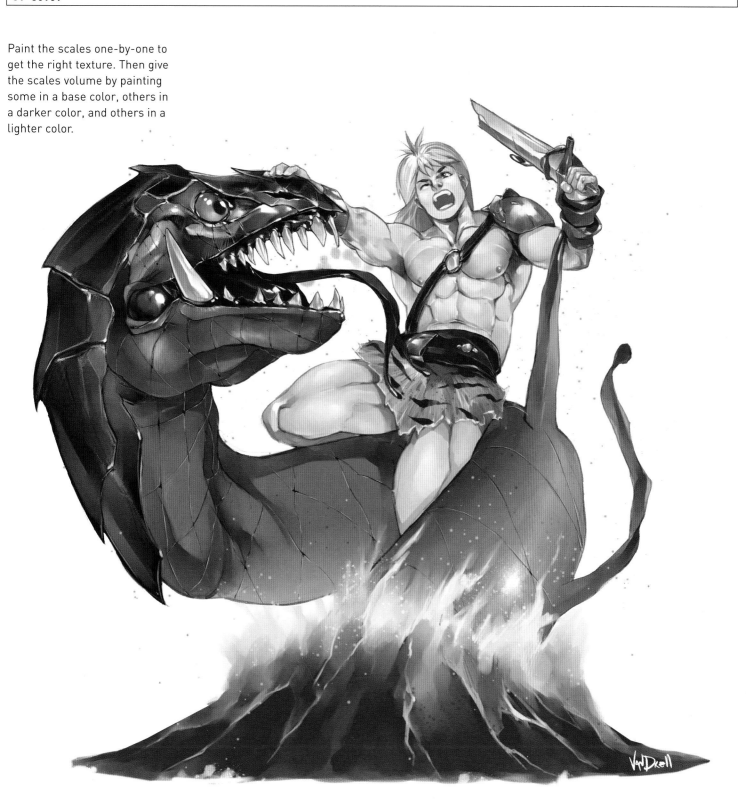

GIANT SPIDER

Even dragons don't trust unknown caves less they be the home to this terrible insect. Intelligent and lethal, giant spiders possess all the virtues of their smaller sisters but in colossal proportions. Their webs are stronger than metal, their speed is unmatched, and they are capable of devouring humans, horses, and even dragons. Perhaps you could say these insects sit at the top of the food chain.

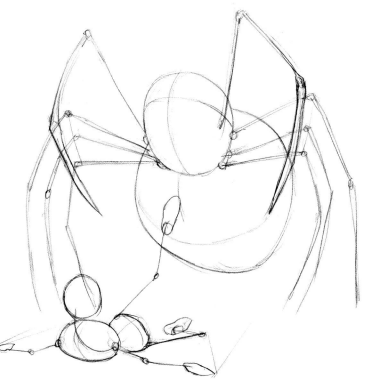

To achieve greater dynamism, distance the legs from the body.

2. Volume

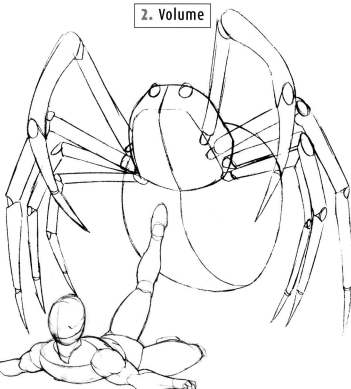

Perspective affects how all the elements look. We'll consider depth when it's time to foreshorten.

Make the giant spider look more aggressive by shaping his legs like needles. Make the man's muscles look tense and define the spider's appearance.

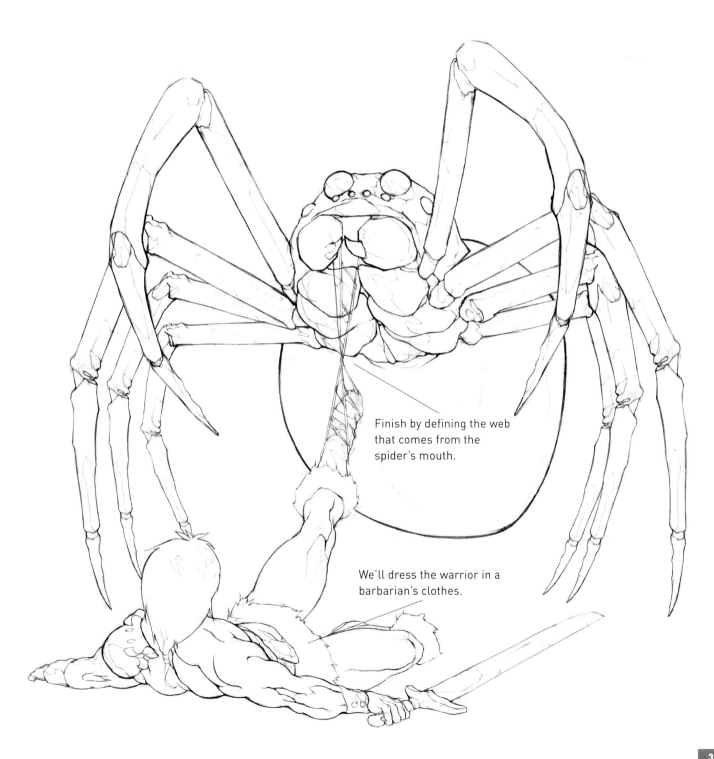

Finish by defining the web that comes from the spider's mouth.

We'll dress the warrior in a barbarian's clothes.

Define the dark areas with
patches of color.

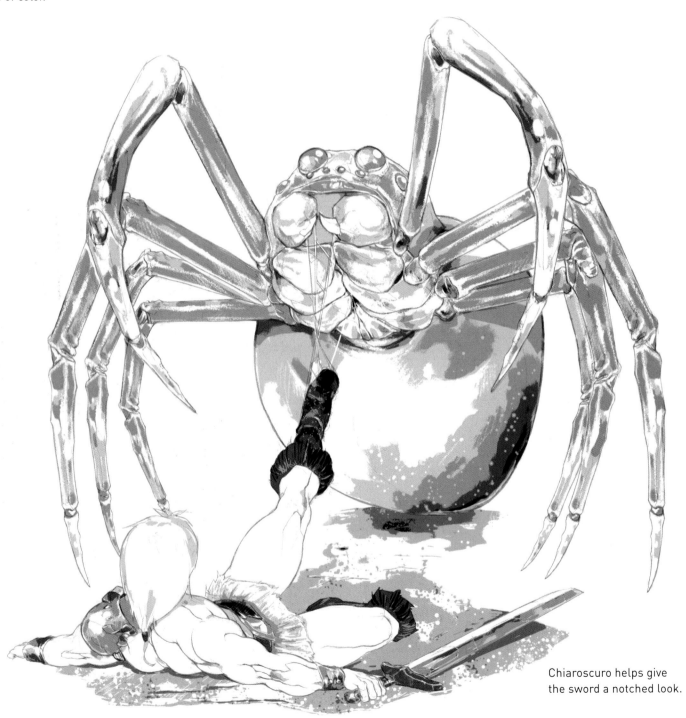

Chiaroscuro helps give
the sword a notched look.

Make the spider look more aggressive by painting it red and black. We'll also develop the texture of the spider's skin by taking advantage of the light.

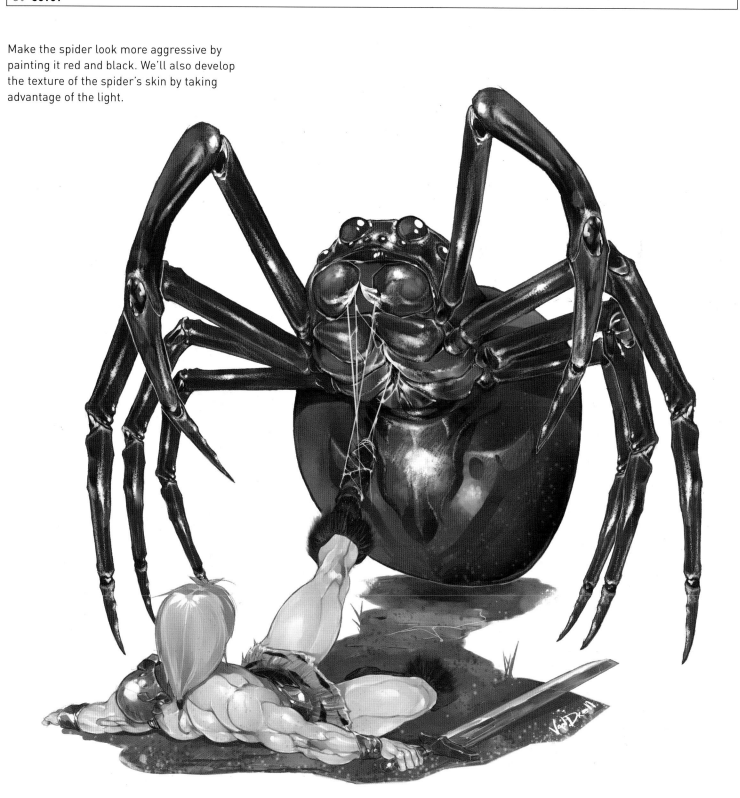

DRAGON IN ITS CAVE

Dragons play an important role in every civilization; they can be gods, guards, and even occasionally demons, but they are very powerful beings sometimes known for their great wisdom. They are represented as giant animals with reptilian features, like giant snakes or scaly lizards, but sometimes they even have feathers. The fire that they spit out of their enormous mouths has become the symbol of dragons.

1. Shape

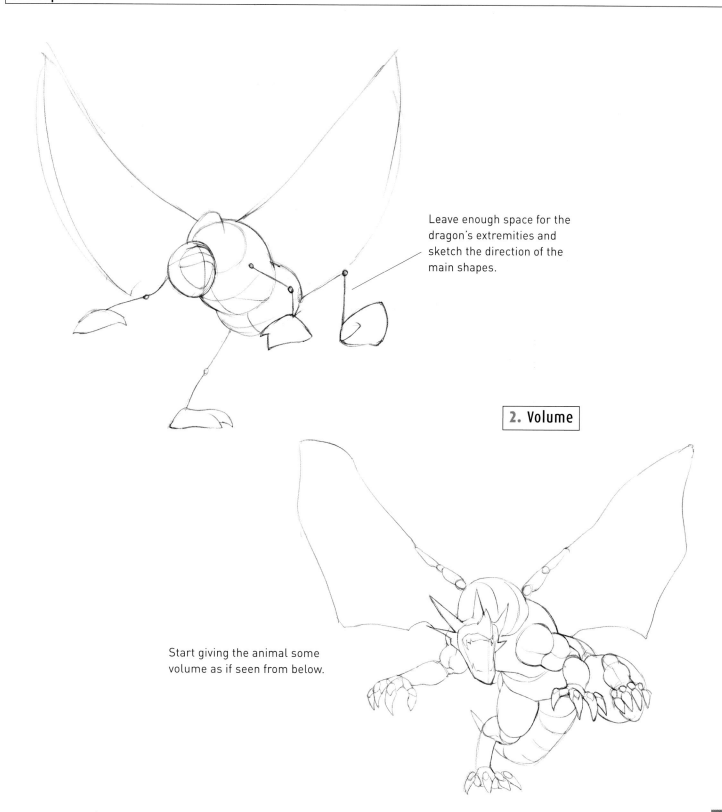

Leave enough space for the dragon's extremities and sketch the direction of the main shapes.

2. Volume

Start giving the animal some volume as if seen from below.

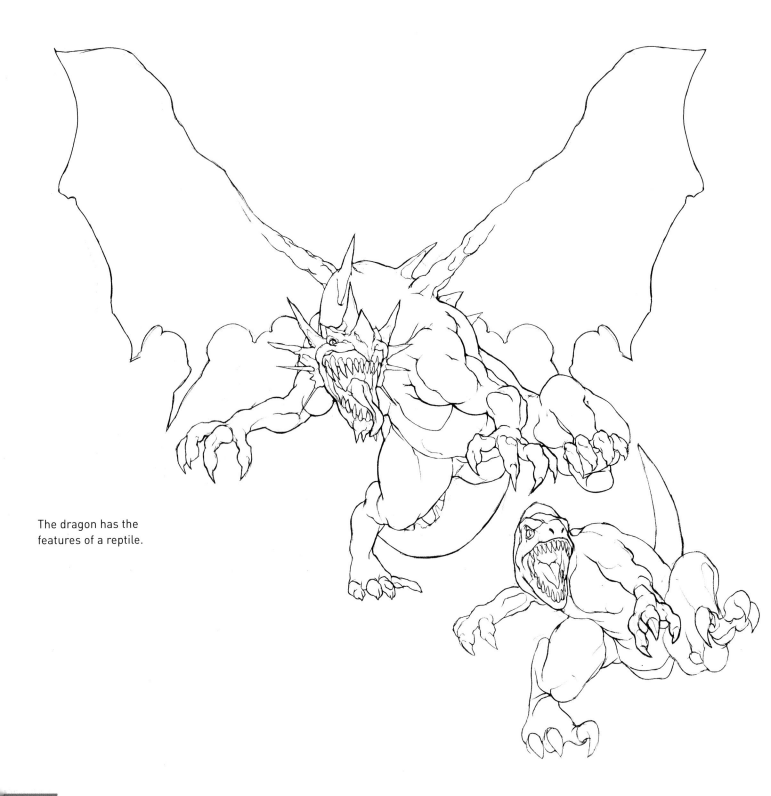

The dragon has the
features of a reptile.

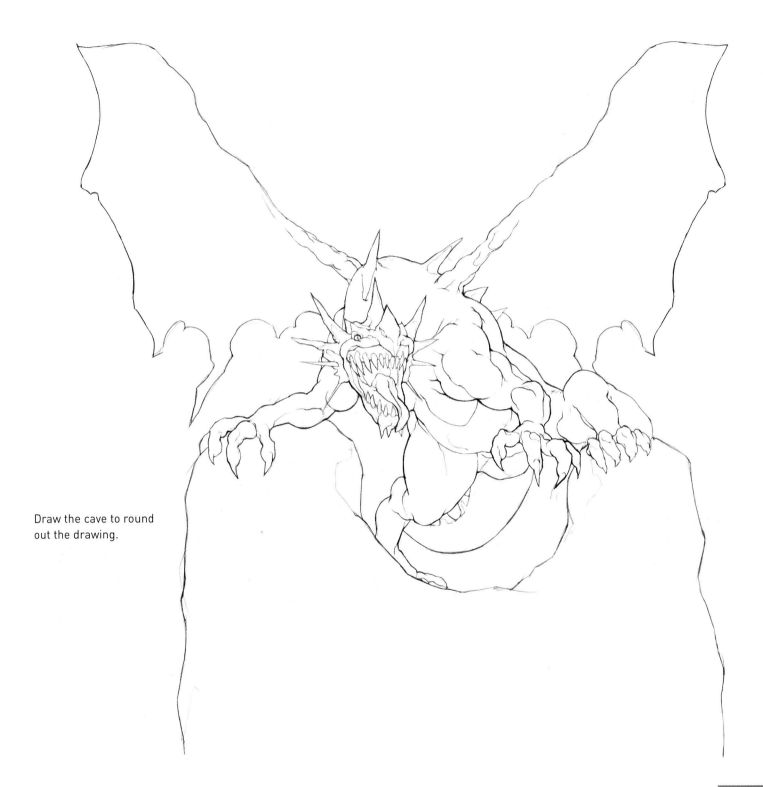

Draw the cave to round
out the drawing.

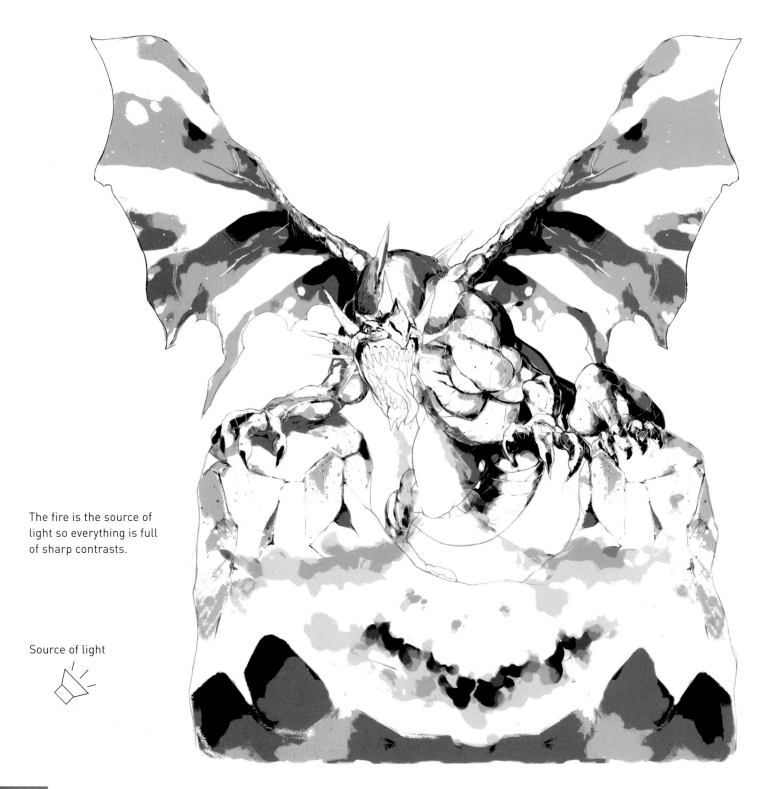

The fire is the source of light so everything is full of sharp contrasts.

Source of light

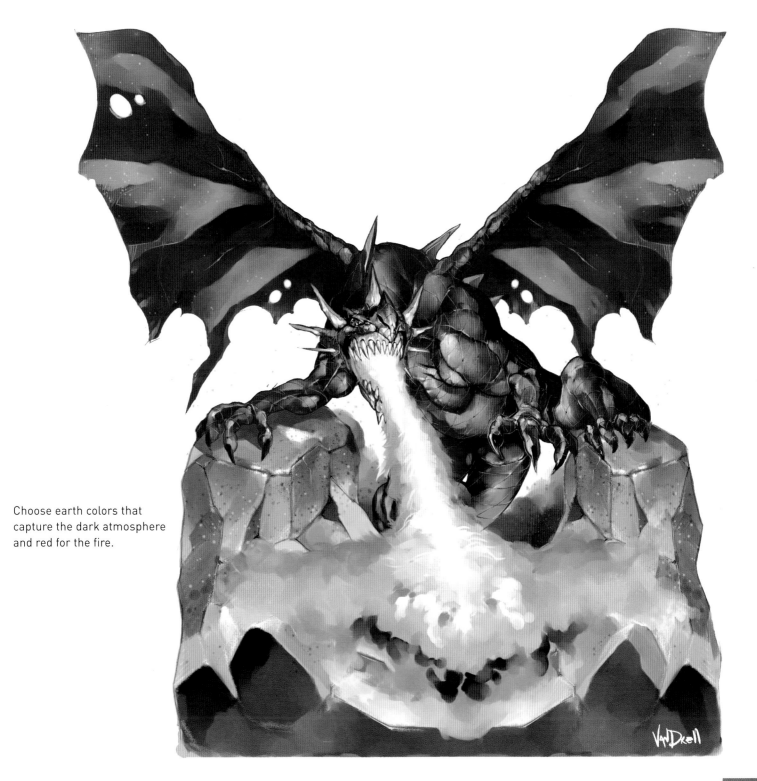

Choose earth colors that capture the dark atmosphere and red for the fire.

PHOENIX VS. HIPPOGRIFF

When it comes to battlegrounds, men aren't always the ones responsible for winning the war. Often their beasts are the ones who decide the final outcome. In this case the beasts are two high-flying animals: the phoenix, the mythical, immortal bird of fire, capable of resurrecting from its ashes and throwing fire balls by moving its wings; and the hippogriff, a cross between the horse and the hawk, as quick as a purebred and as precise as the very best predators.

1. Shape

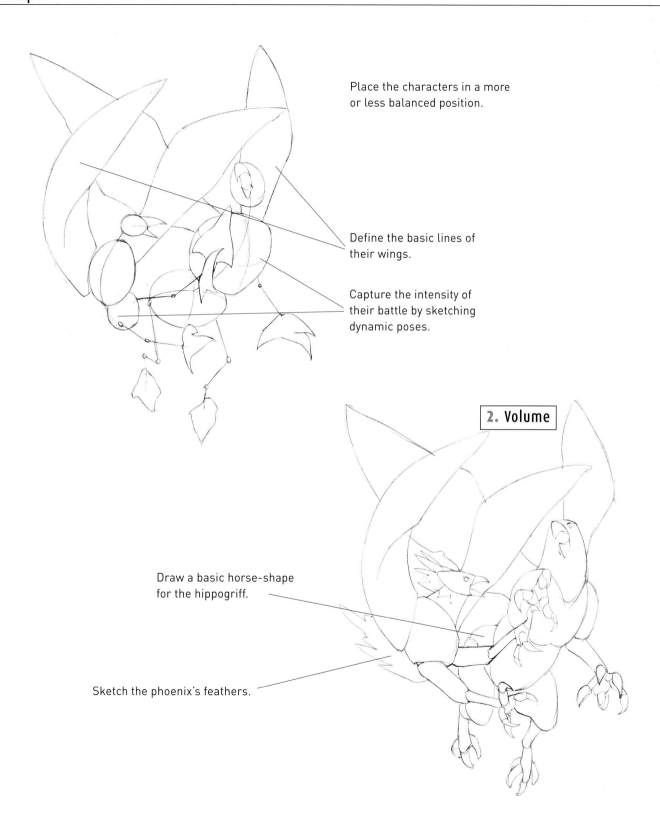

Place the characters in a more or less balanced position.

Define the basic lines of their wings.

Capture the intensity of their battle by sketching dynamic poses.

2. Volume

Draw a basic horse-shape for the hippogriff.

Sketch the phoenix's feathers.

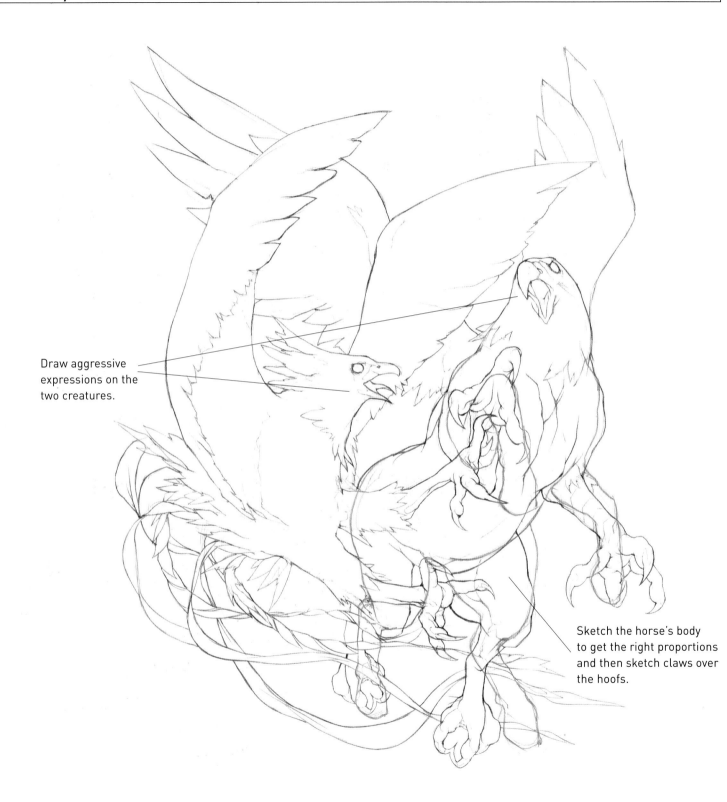

Draw aggressive expressions on the two creatures.

Sketch the horse's body to get the right proportions and then sketch claws over the hoofs.

Source of light

The fire generated by the phoenix lights the scene. Give shape to its feathers by marking the shaded areas of its wings.

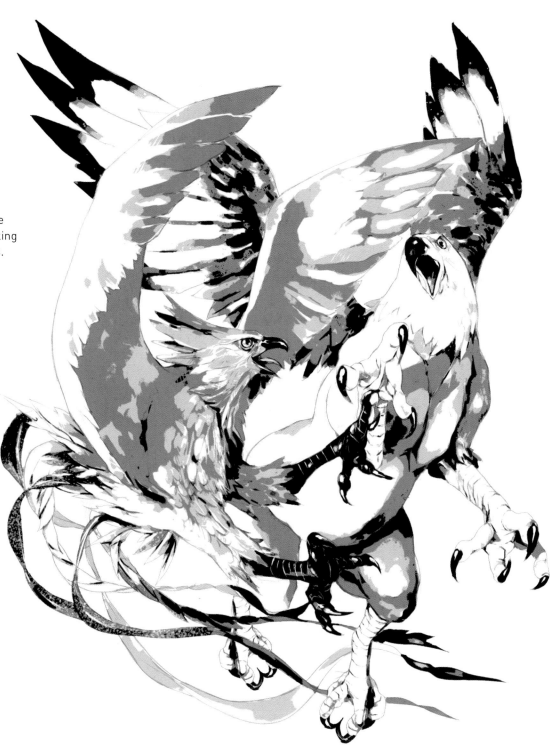

The color of the flames is reflected in the hippogriff's skin. Color helps define the pattern of the phoenix's feathers.

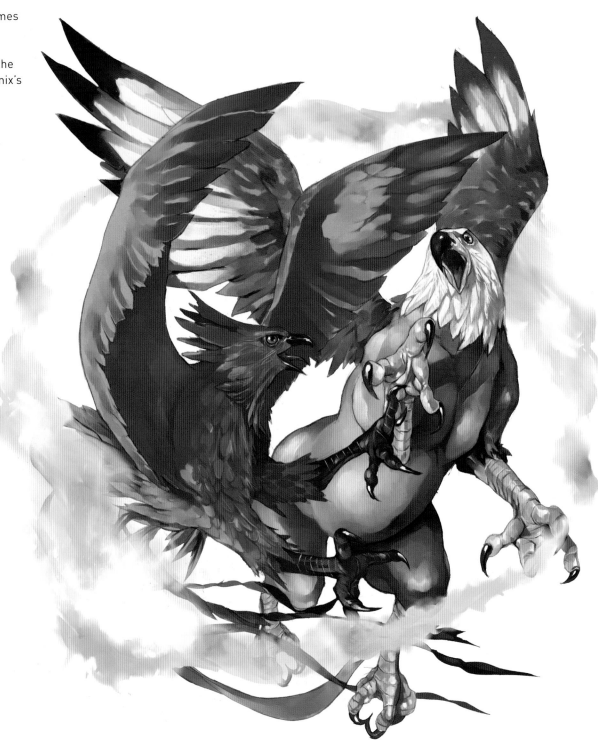

Add more lighting effects, textures, and splashes of color to emphasize the battle. Finish the flames by blending the base tones to make them look more realistic.

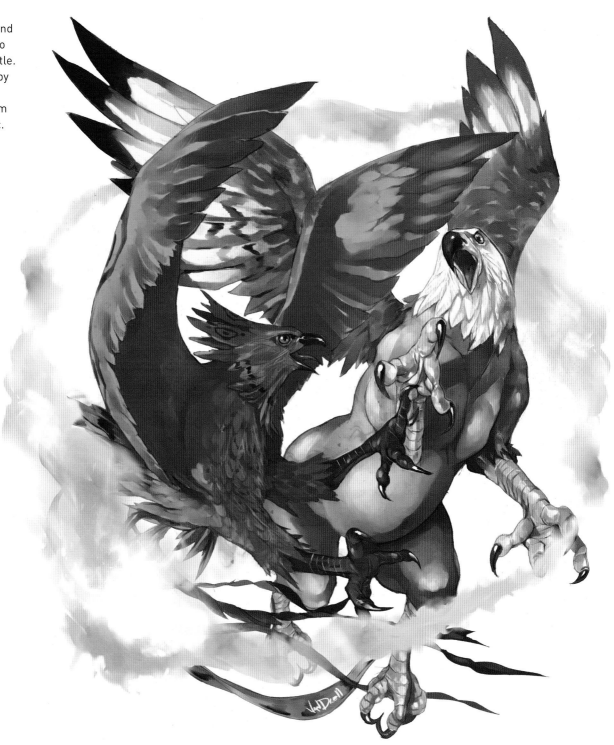

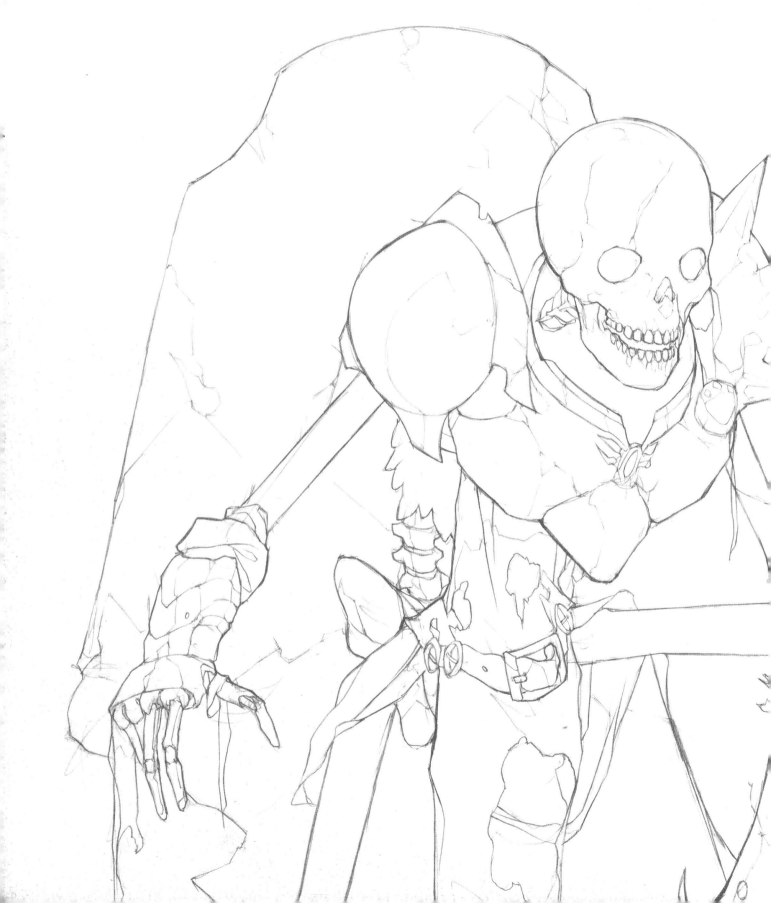

THE UNDERWORLD

SKELETON

Warriors who once died on the battlefield now serve as slaves to black magic. Still wearing some of their armor or carrying their weapons, these beings have no feelings. It doesn't matter how many times they fall or are hit, they will always get up to go after their enemy. These puppetlike creatures form a large part of the army of the underworld. Luckily they can't go beyond these lands since the magic of the lords of the underworld still is not strong enough.

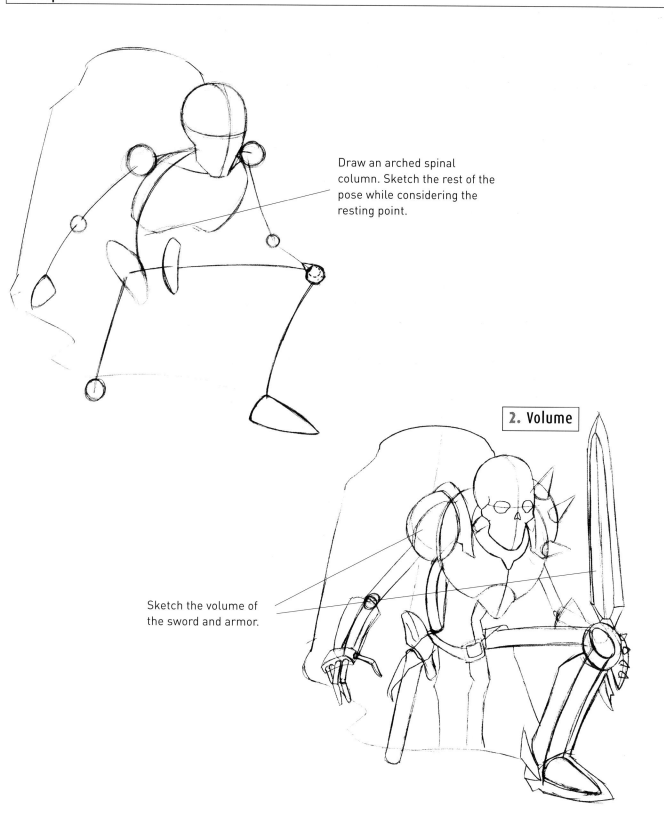

1. Shape

Draw an arched spinal column. Sketch the rest of the pose while considering the resting point.

2. Volume

Sketch the volume of the sword and armor.

Define the skeleton's
skull, hand, and foot.

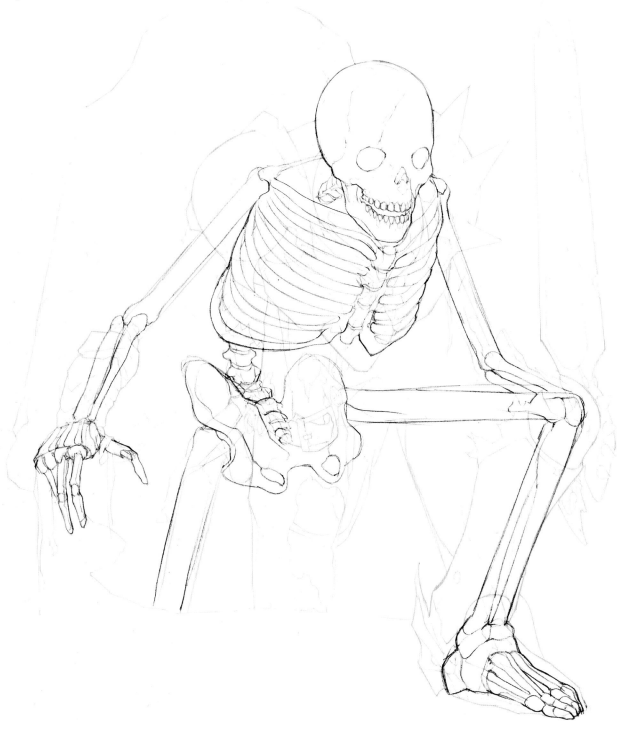

Make the armor, sword, and skeleton look worn. The coat of mail around the waist helps add weight and movement. Finish off by sketching a tombstone and grave.

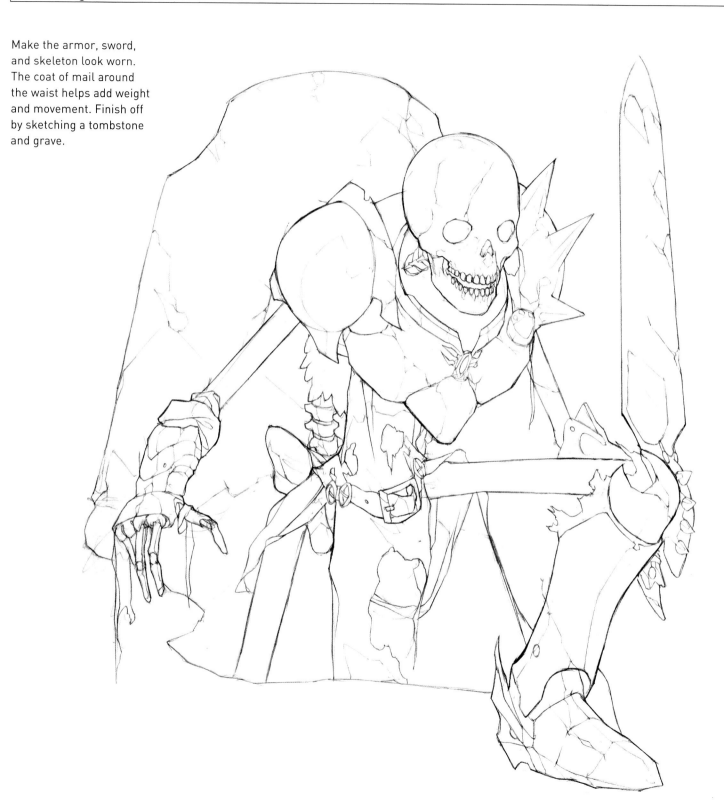

The light comes from the front and projects the skeleton's shadow over the tombstone.

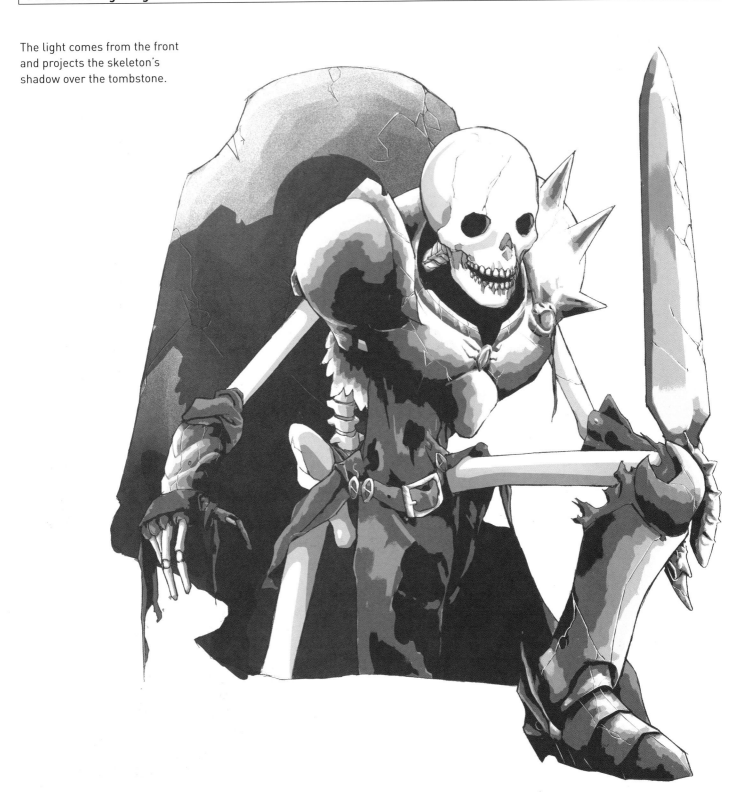

Use a variety of tones to paint the worn and rusty metal. Then use lighter tones of the same colors for the darker areas, like the grave and the inner part of the armor.

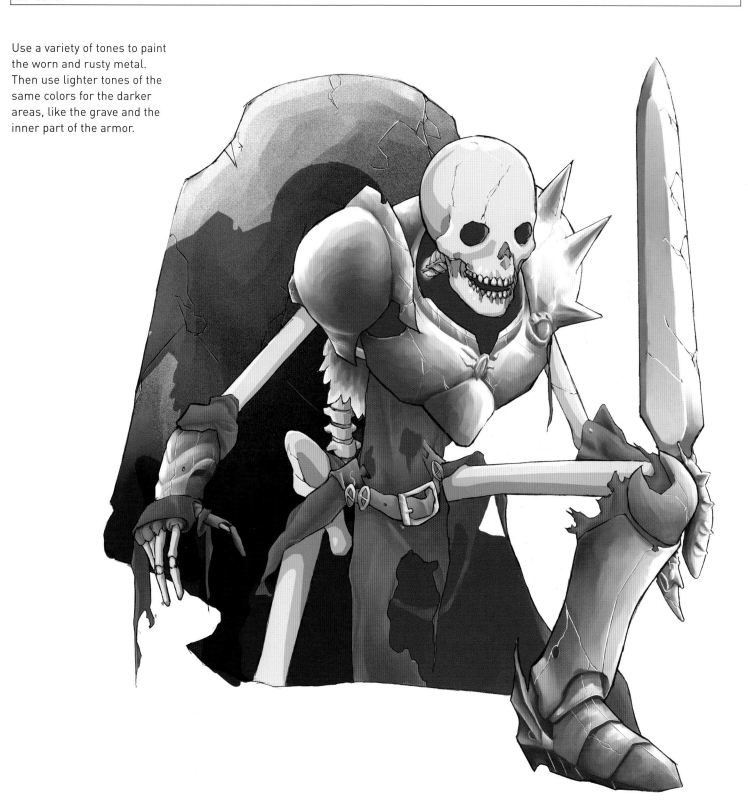

HOUNDS OF HELL

These doglike animals are the terrible guardians you'll find at the gates of the underworld. Thin and ghostly, they move among the shadows; the only things visible are the flames from their backbones and their penetrating red eyes. Faithful until their master's death, they are capable of shredding anyone apart. Victims of their own eternal hunger, they feed off the spirits of their prey.

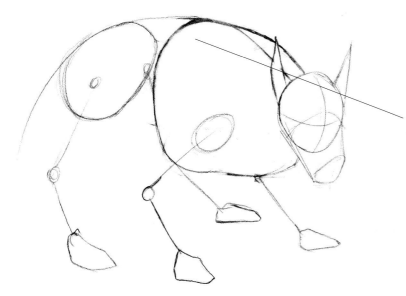

Curve the line of its back so the dog is crouching and looks more aggressive and tense.

2. Volume

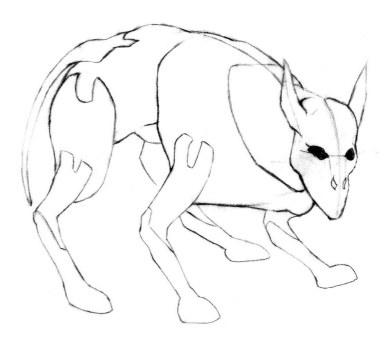

Continue to give the dog a strong, threatening build and sketch its facial features.

Transform the basic volume by
adding exaggerated sharp claws and
drawing an aggressive expression.

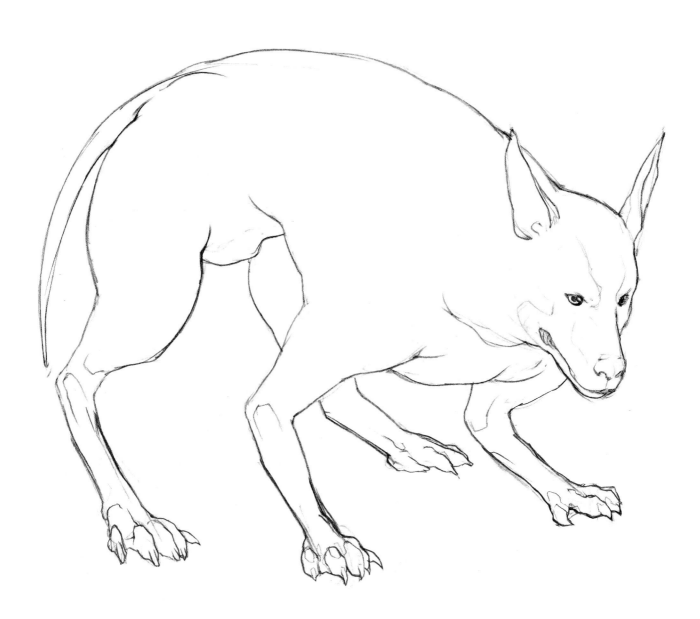

Draw details to make the hound
look thin and ghostly, then define
a remnant of its victim.

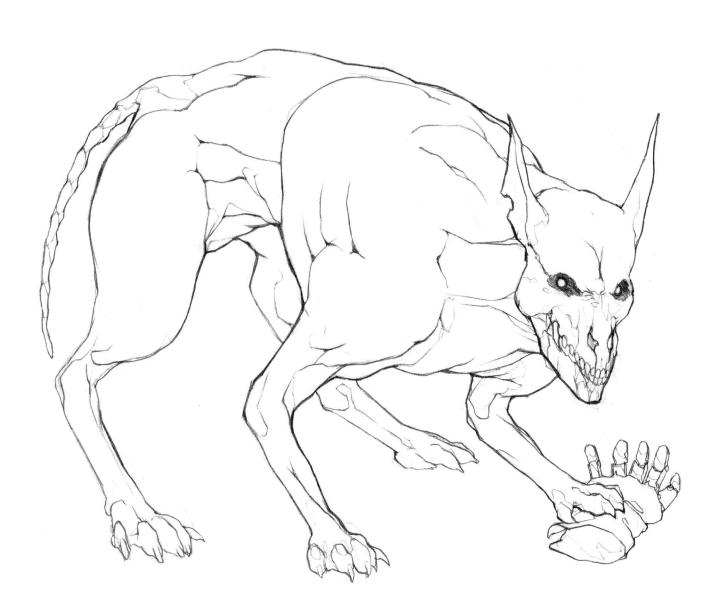

Besides the main source of light, there's the reflection from other sources, like the flames on the dog's back. We'll also decide upon the intensity of the flames.

Source of light

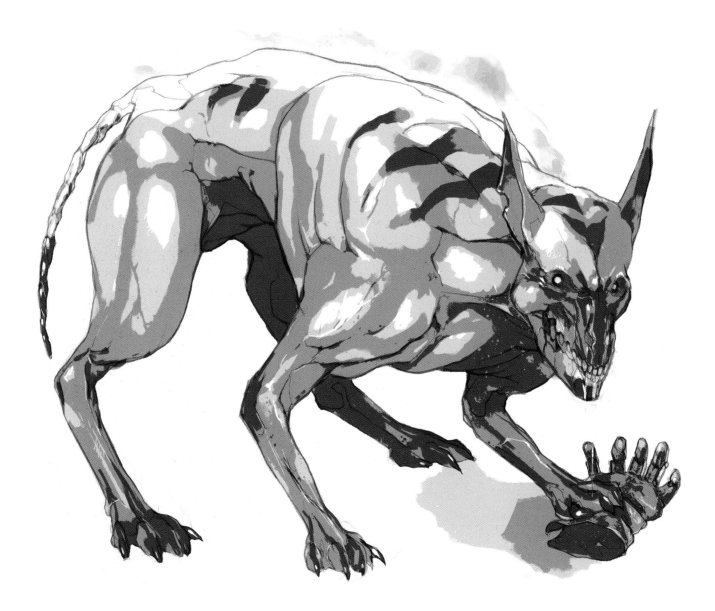

Fading is the most effective technique for giving texture to fire. Use bright colors to highlight the dog's eyes and the look on its face. Finally, paint the worn metal of the glove in subdued tones so you don't take attention away from the dog.

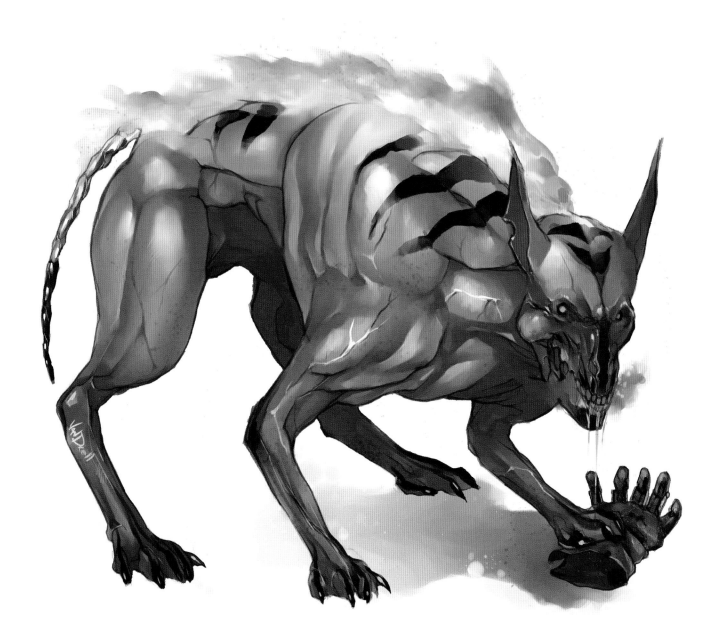

WEREWOLF

Damned since the day he was born or was bitten by another creature, the werewolf is a loner by day and turns into a bloodthirsty savage a few nights a month. Only the death of the original monster can liberate this unhappy soul. The werewolves who managed to escape being hunted walk between the two worlds that exist under an eternal full moon.

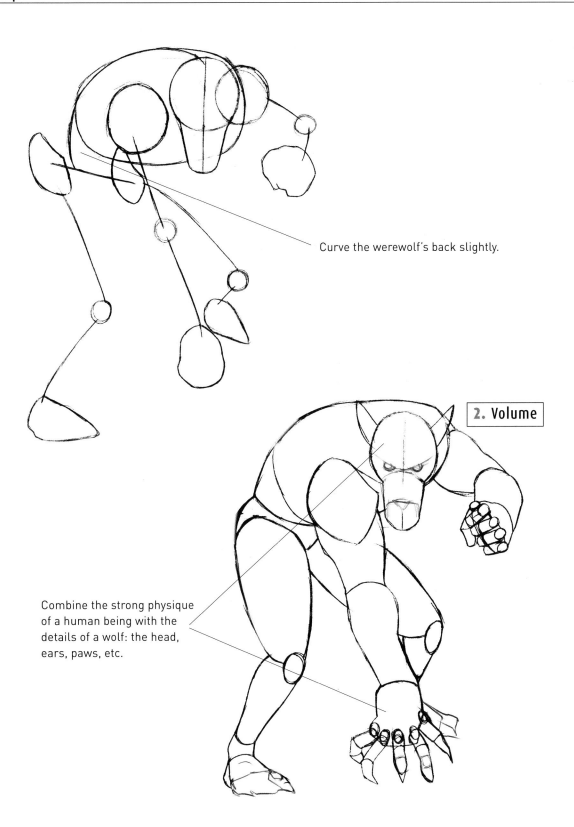

Curve the werewolf's back slightly.

2. Volume

Combine the strong physique of a human being with the details of a wolf: the head, ears, paws, etc.

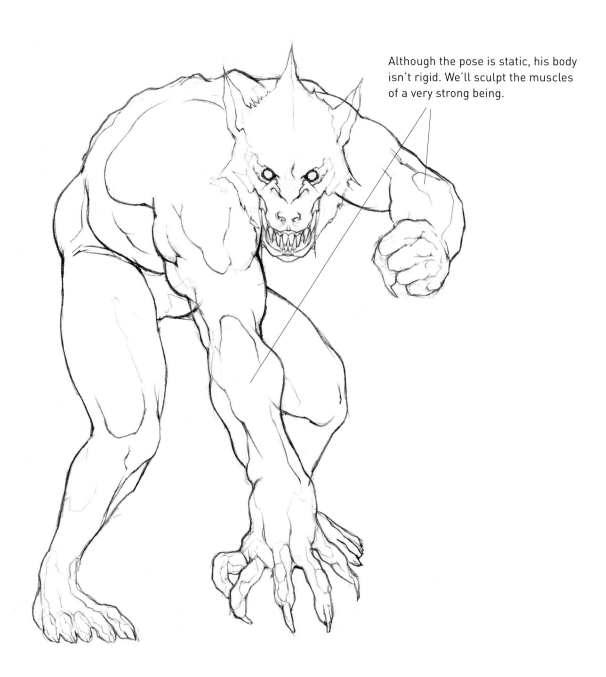

Although the pose is static, his body isn't rigid. We'll sculpt the muscles of a very strong being.

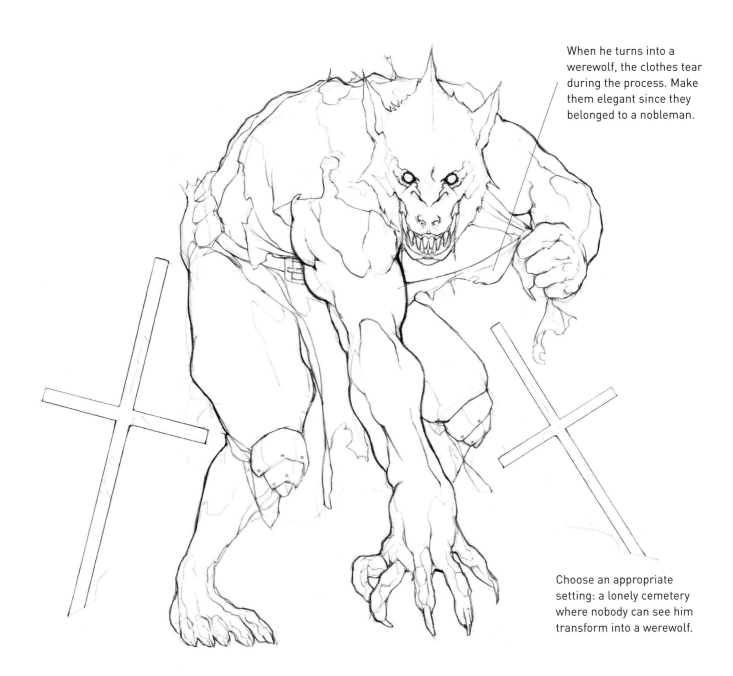

When he turns into a werewolf, the clothes tear during the process. Make them elegant since they belonged to a nobleman.

Choose an appropriate setting: a lonely cemetery where nobody can see him transform into a werewolf.

The lighting comes from behind, so a
simple way of creating the background
is to take advantage of the light's effect.

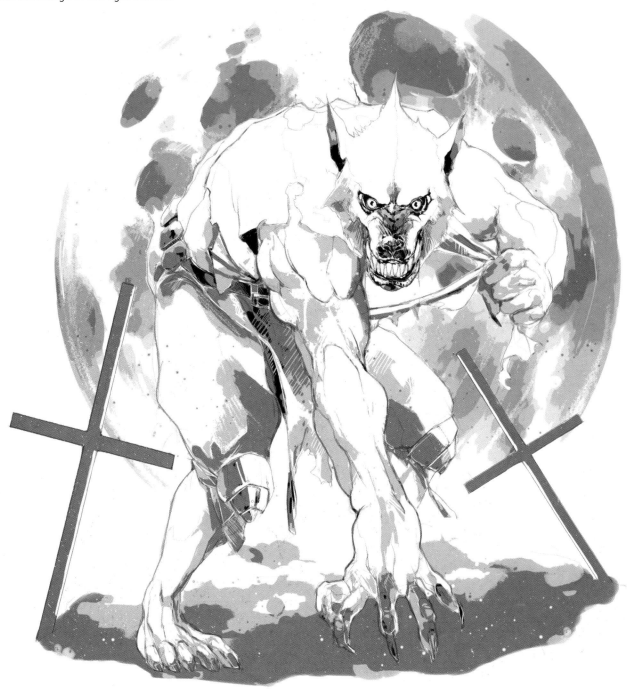

Pick colors emphasize the sinister sensation. The way to achieve more realistic fur is to paint each hair one by one.

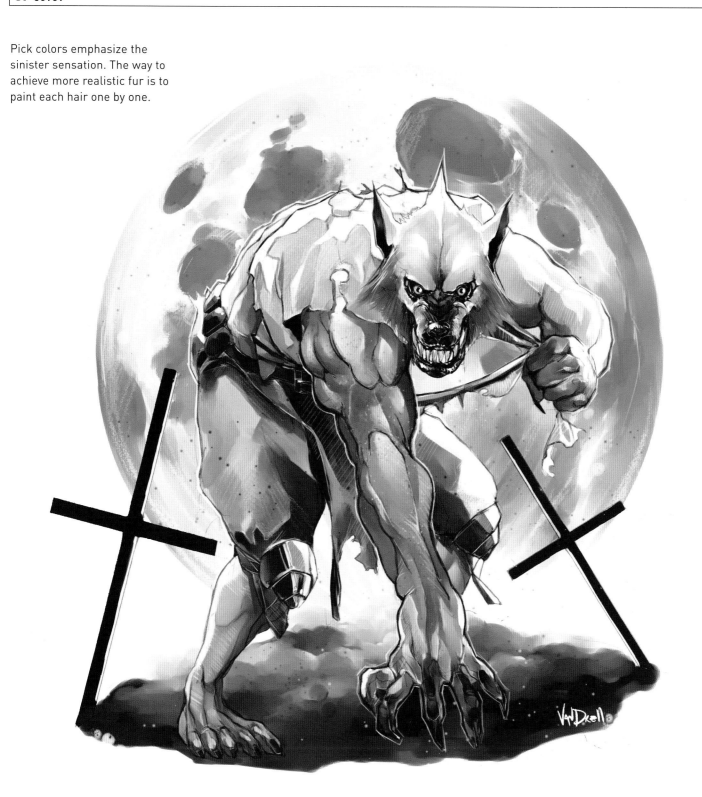

GHOSTS

Furious, unpredictable, and almost always seeking revenge, ghosts wander around these lands lost inside themselves. Sometimes they join others and form horrible nightmarish spectacles. Although they are neither good nor evil, they don't think twice about feeding off of feelings such as resentment, hatred, and fear. It's not for nothing that they embody our deepest fears.

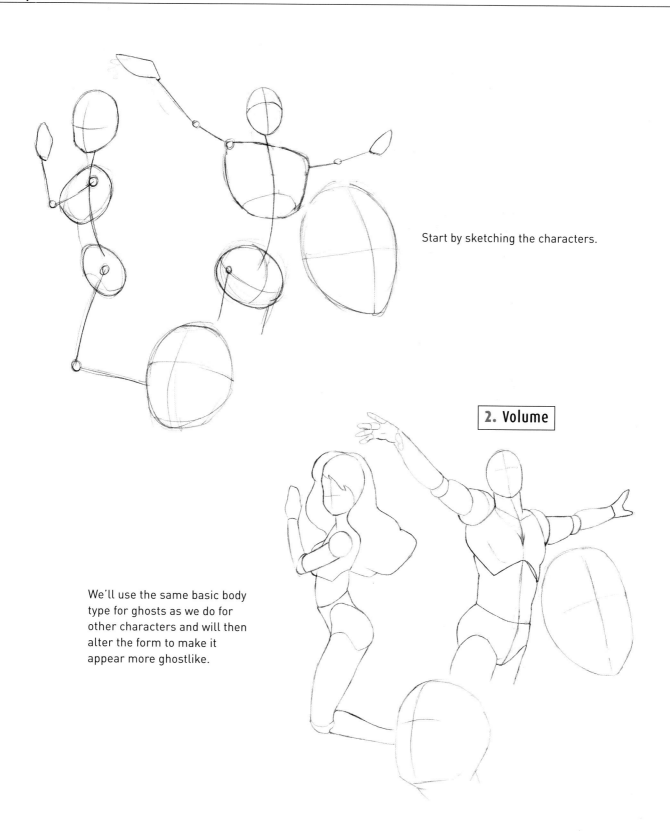

Start by sketching the characters.

We'll use the same basic body type for ghosts as we do for other characters and will then alter the form to make it appear more ghostlike.

Now modify the volumes to create realistic but ghostly bodies.

4. Clothing

In this case the clothes are
the plasma surrounding the
ghosts. Select which parts
remain visible.

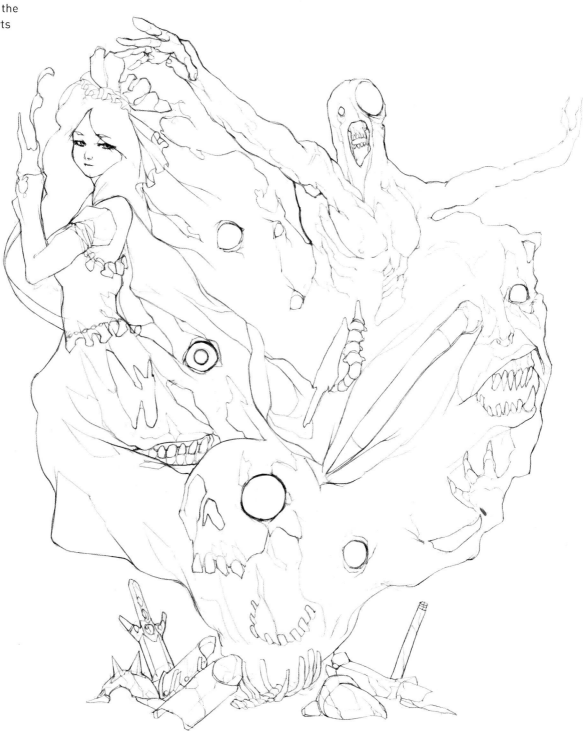

The light comes from the ghosts
themselves. Pay attention to how
transparencies affect the lighting.

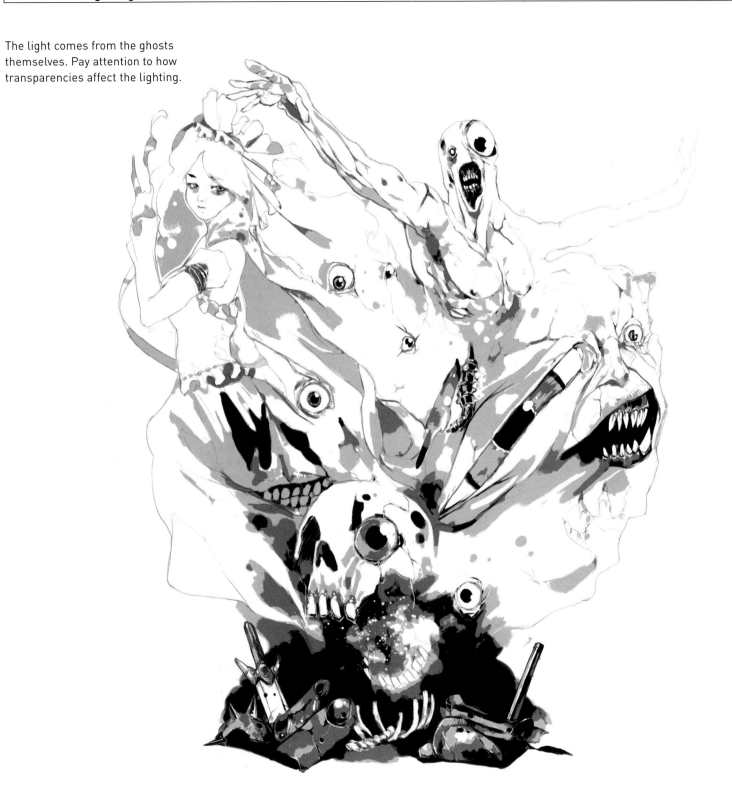

Paint the lines so the ghosts look more ethereal. Choose cold colors in order to evoke death. The way we apply color defines the texture.

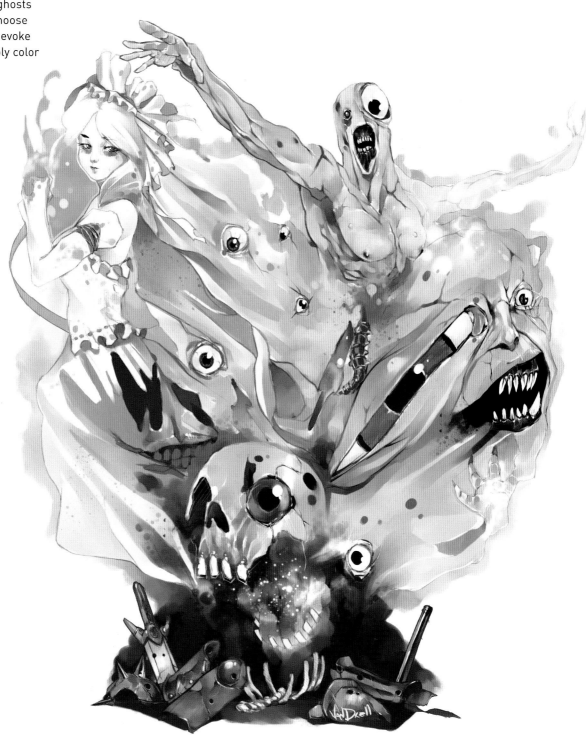

SORCERESS

The sorceress lies between the gates separating the shadowlands from the underworld. Those seeking help must almost always pay a high price for it. With her youthfulness, she hasn't aged a bit over the last 100 years. She spends the day among cauldrons and books, and takes pride in being an expert in love potions, poisons and the dark arts. The sorceress is between good and evil, and the only thing that can be said about her for sure is that she only looks after herself.

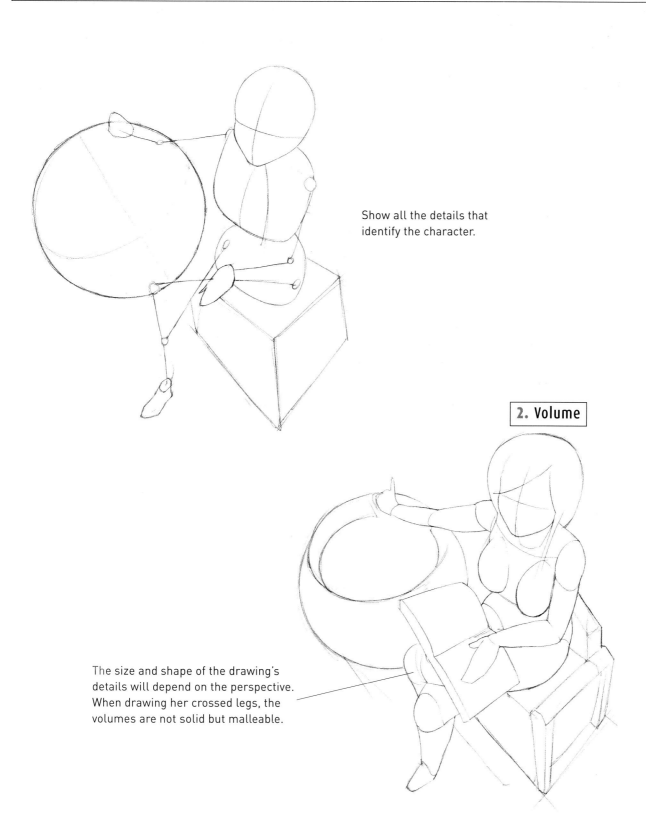

Show all the details that identify the character.

2. Volume

The size and shape of the drawing's details will depend on the perspective. When drawing her crossed legs, the volumes are not solid but malleable.

Draw a pleasant expression on her face.

Make the character look youthful, paying attention to the foreshortening of her legs.

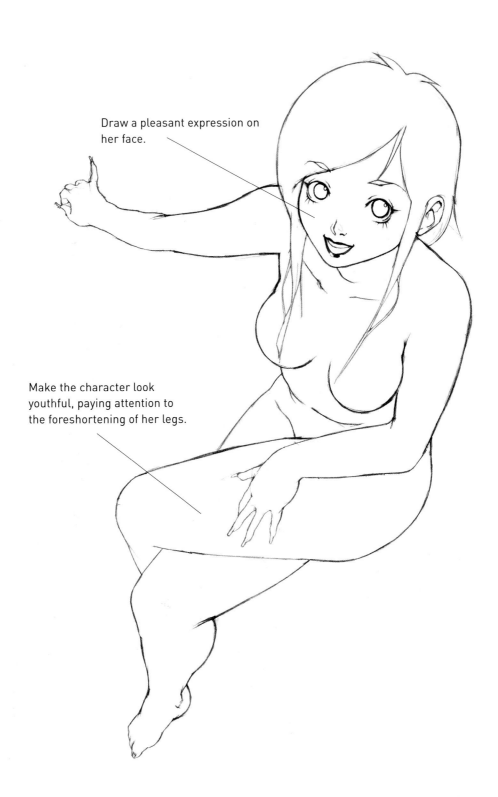

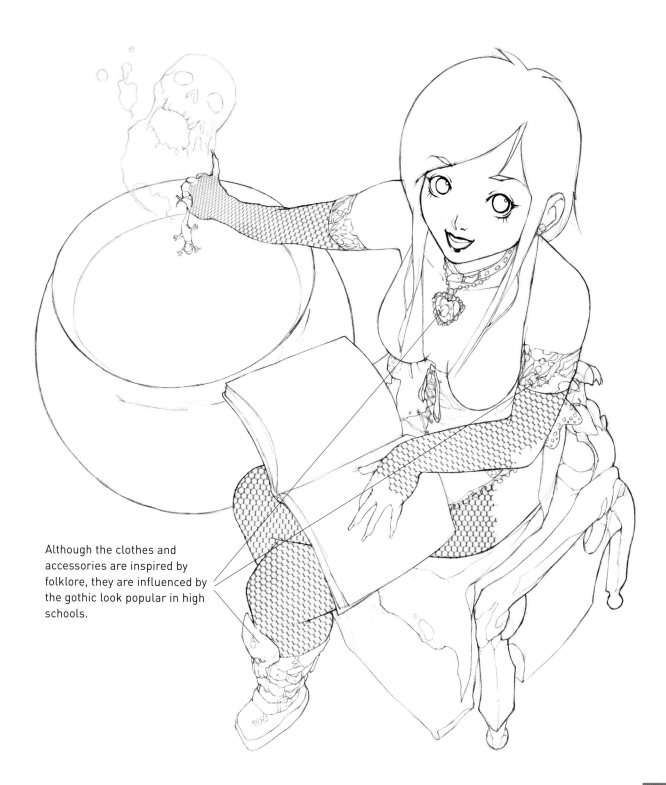

Although the clothes and accessories are inspired by folklore, they are influenced by the gothic look popular in high schools.

The cauldron influences how the character is shaded. Draw vapors without outlines.

Source of light

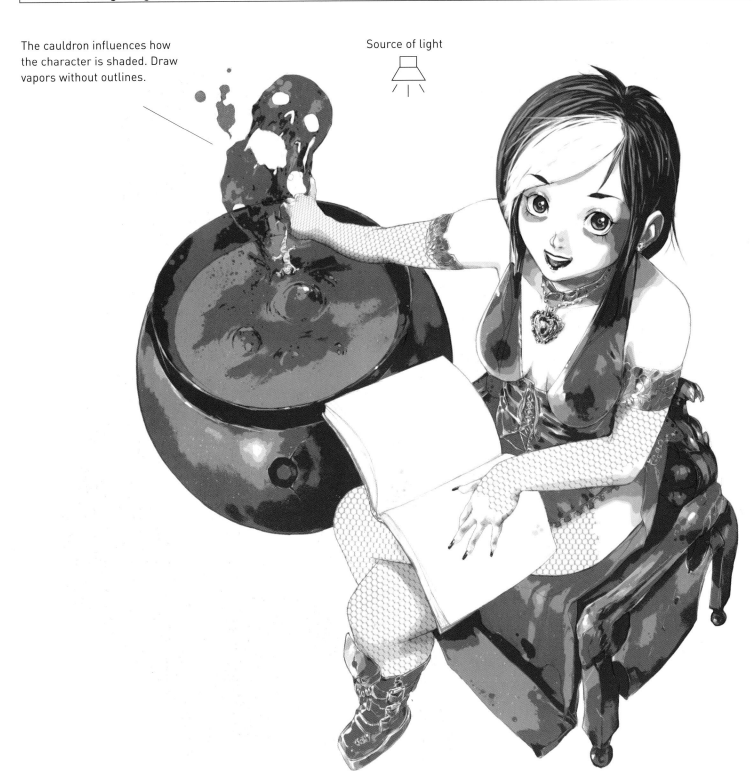

Make the sorceress look more sinister by painting her with baggy eyes and pale skin color. Draw a magical motif, and we'll paint the emanations from the cauldron.

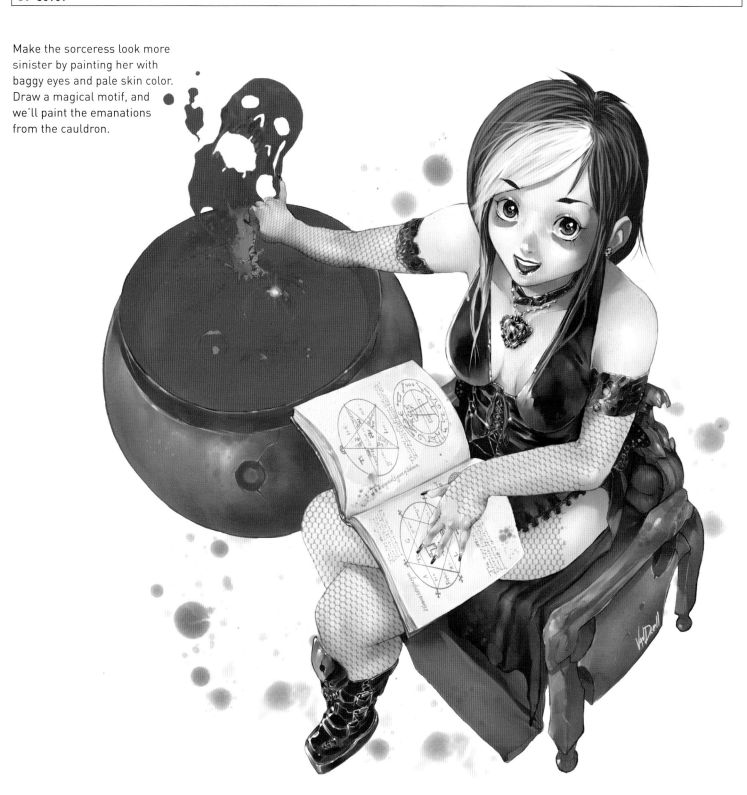

WATCHMAN OF THE UNDERWORLD

Only a few have been able to use their fortune-telling abilities to see what this evil watchman looks like. From a deep dark place, he uses his powers to play an eternal board-game with whoever dares to cross his territory. Protected by the hounds of hell, he spends his time watching over the entire underworld. The last thing those who perish hear is the sepulchral laughter emanating from this evil being.

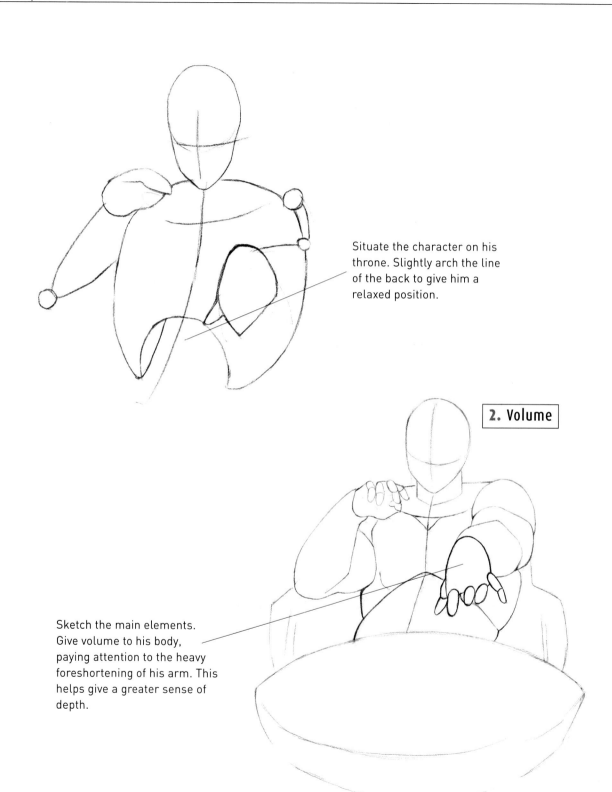

Situate the character on his throne. Slightly arch the line of the back to give him a relaxed position.

2. Volume

Sketch the main elements. Give volume to his body, paying attention to the heavy foreshortening of his arm. This helps give a greater sense of depth.

Define the details of his body, including his muscular build and his expressive hands, which give the character personality.

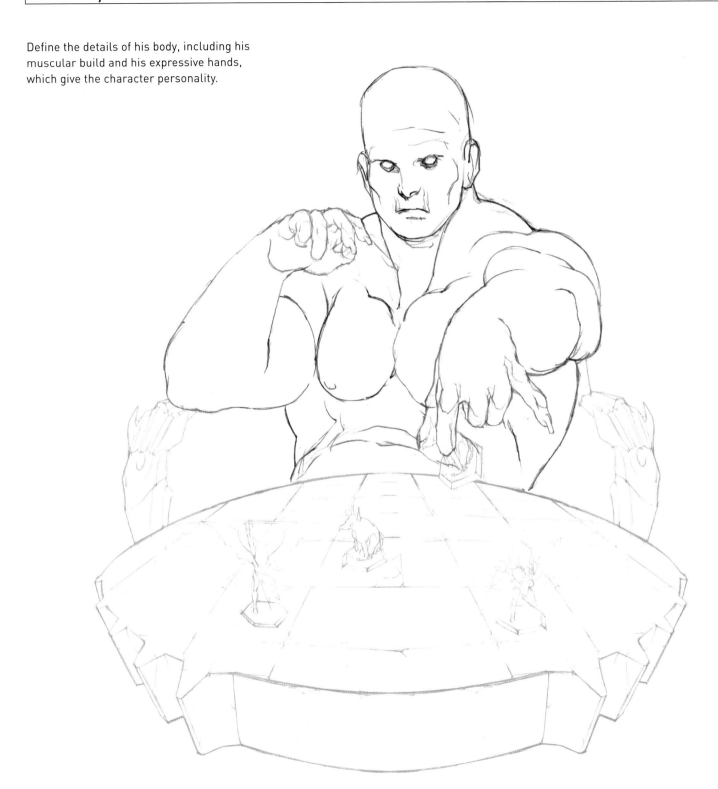

Draw cracks and game pieces on the table
and throne to make the image look more
surreal. Erase the generic face and give him
the medieval costume of an executioner.

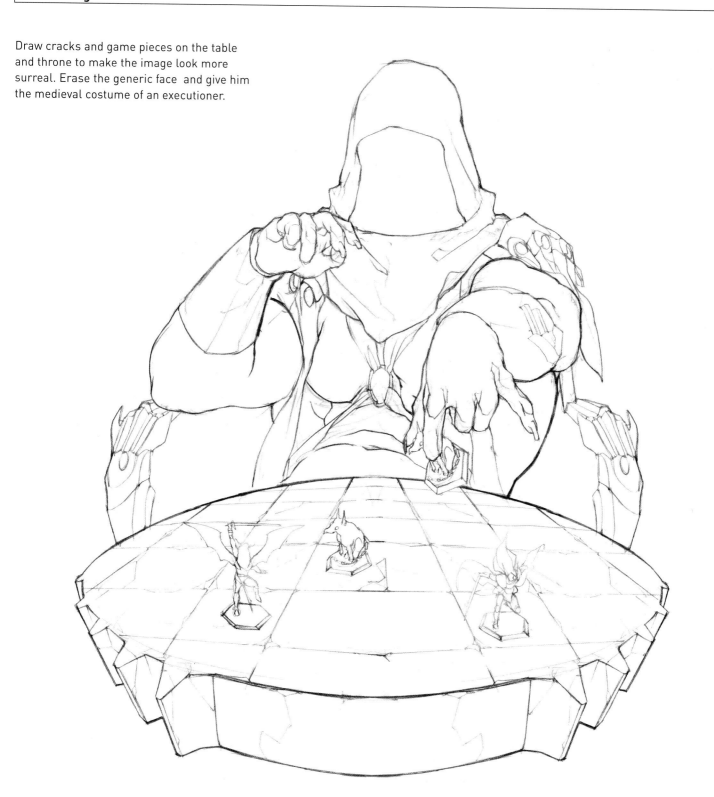

There are two main sources
of light: the atmospheric light,
located above the character,
and the light emanating
from the character.

Source of light

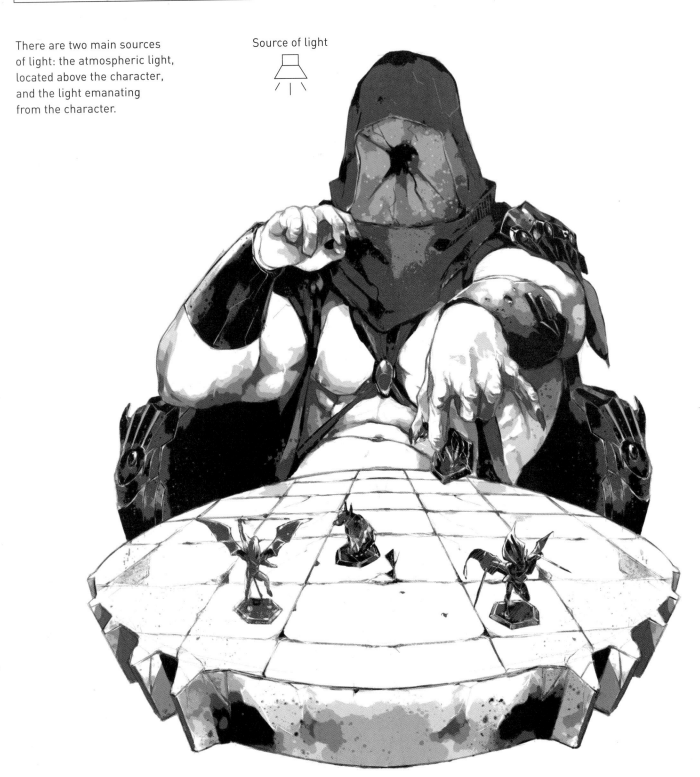

Use a slightly dull palette of colors to contrast with the reddish glow coming from the character. Add splashes of color and texture to highlight the table's worn look.

Highlight the supernatural atmosphere by adding some lightning around the game piece in the watchman's hand.

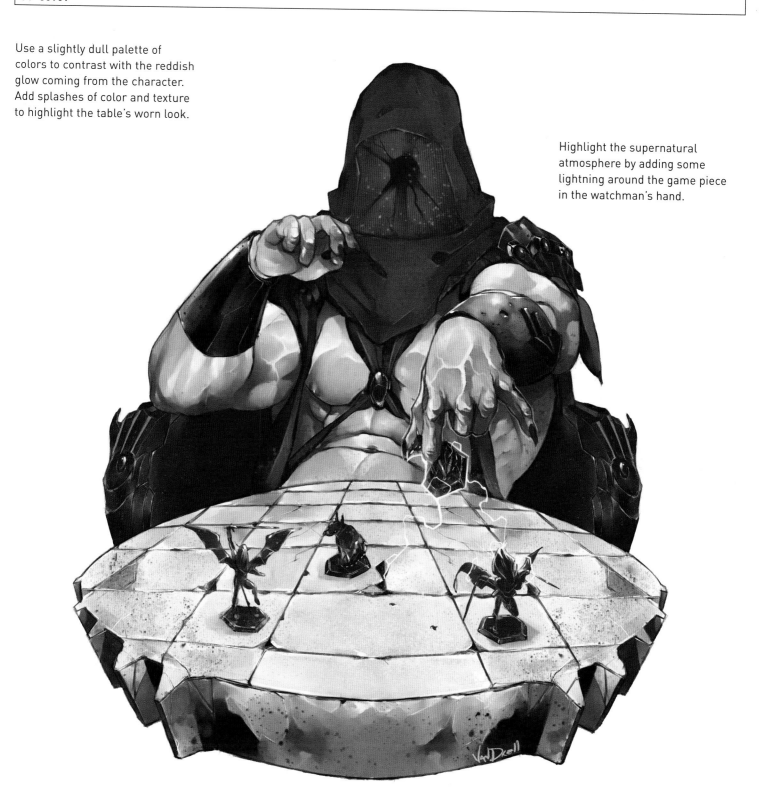

GOD OF EVIL

While angels are protectors of light, gods of evil are the ones responsible for guarding the doors of hell. They are beings who take the form of the worst nightmares imaginable. These are creatures of titanic proportions and cataclysmic powers who wait for the balance between light and darkness to be disrupted so that they can emerge to enslave the world.

1. Shape

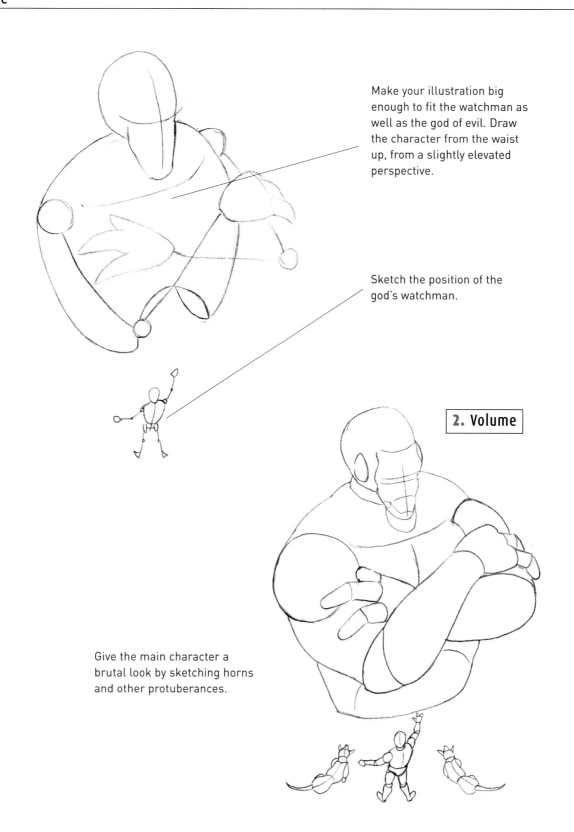

Make your illustration big enough to fit the watchman as well as the god of evil. Draw the character from the waist up, from a slightly elevated perspective.

Sketch the position of the god's watchman.

2. Volume

Give the main character a brutal look by sketching horns and other protuberances.

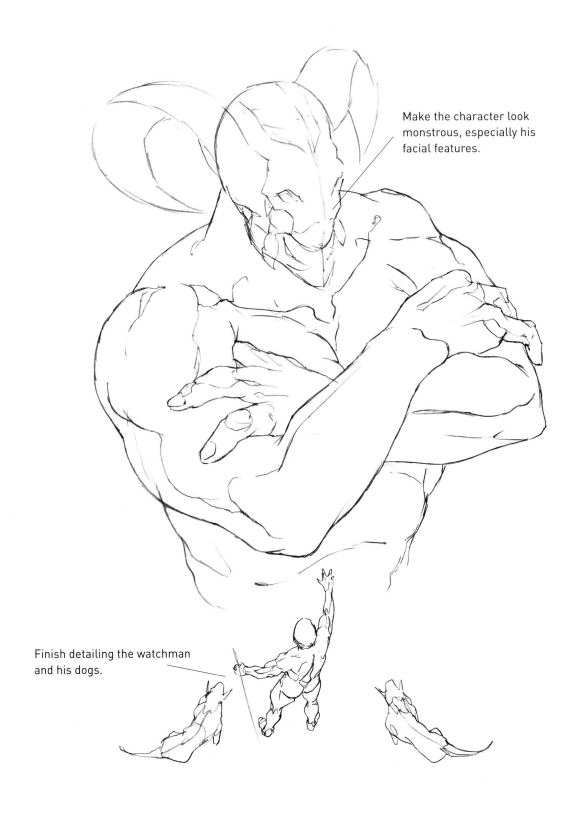

Make the character look monstrous, especially his facial features.

Finish detailing the watchman and his dogs.

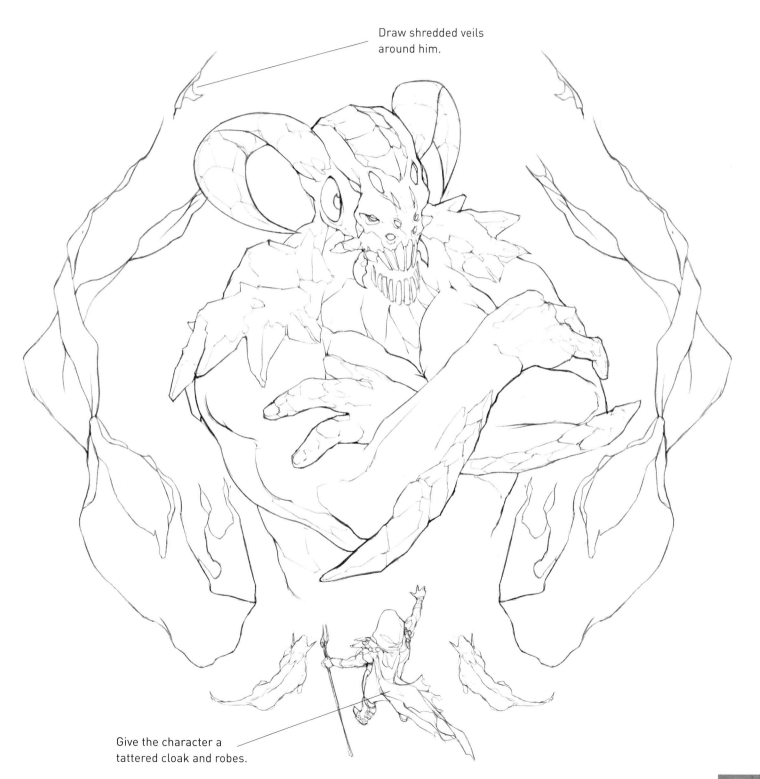

Draw shredded veils
around him.

Give the character a
tattered cloak and robes.

The light comes from the
flames surrounding the god.

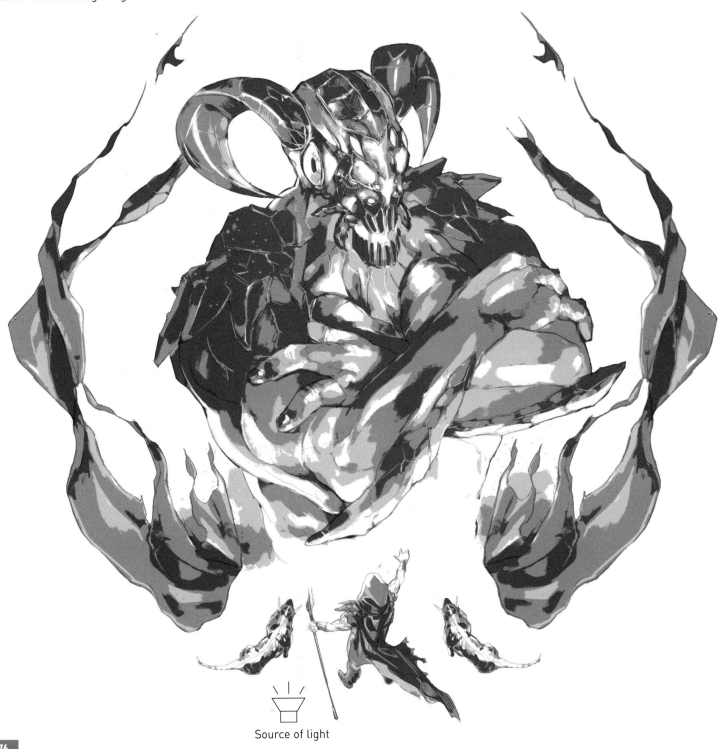

Source of light

Use a range of reds and contrast the two characters to obtain a more shocking effect. Create textures to make the god's skin look hard.

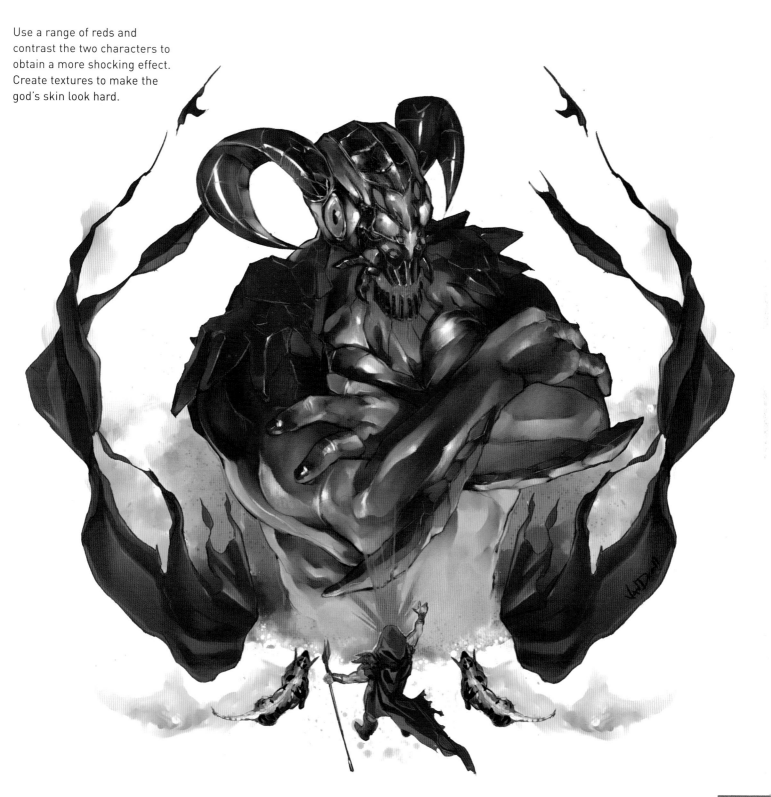

DARK KNIGHT

Few who have seen the dark knight have lived to tell about it. There are many stories about this warrior and his steed finishing off entire battalions and his name is usually invoked to frighten children. Some say he was the first human to sell his soul to the devil, while others believe he's just a pawn to the lords of the underworld.

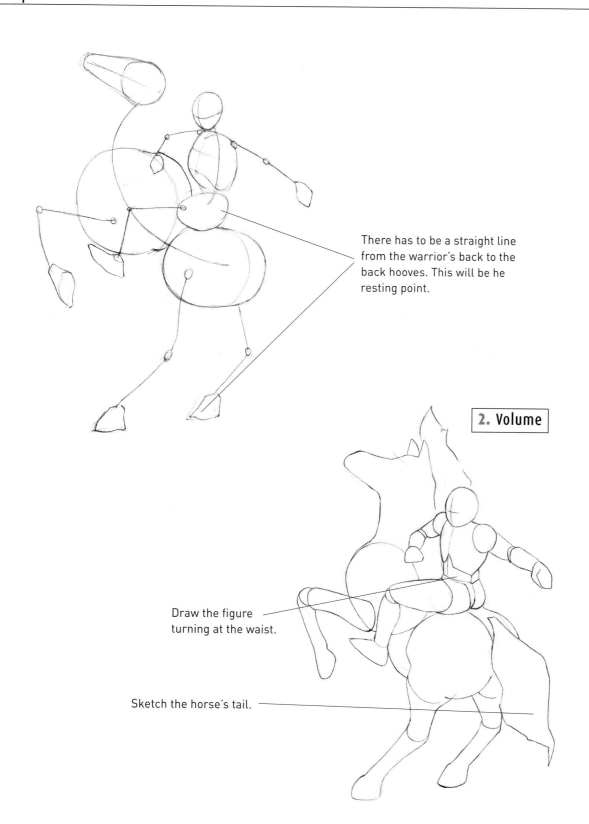

There has to be a straight line from the warrior's back to the back hooves. This will be he resting point.

2. Volume

Draw the figure turning at the waist.

Sketch the horse's tail.

Give the horse an imposing,
muscular tone.

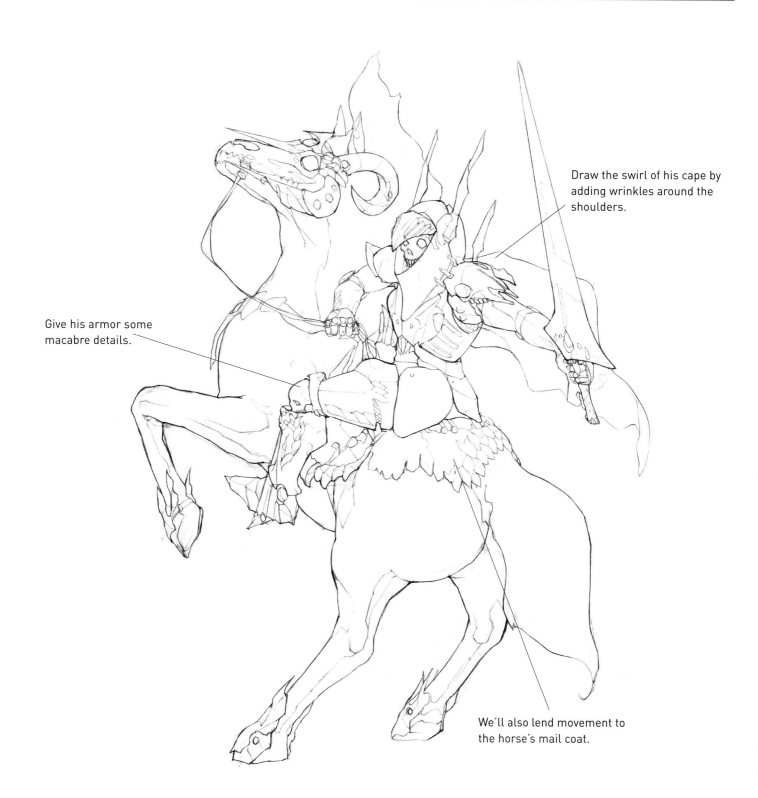

Draw the swirl of his cape by adding wrinkles around the shoulders.

Give his armor some macabre details.

We'll also lend movement to the horse's mail coat.

Consider the way the knight's armor reflects the lightning bolts. Use chiaroscuro to shade the coat of mail.

Source of light

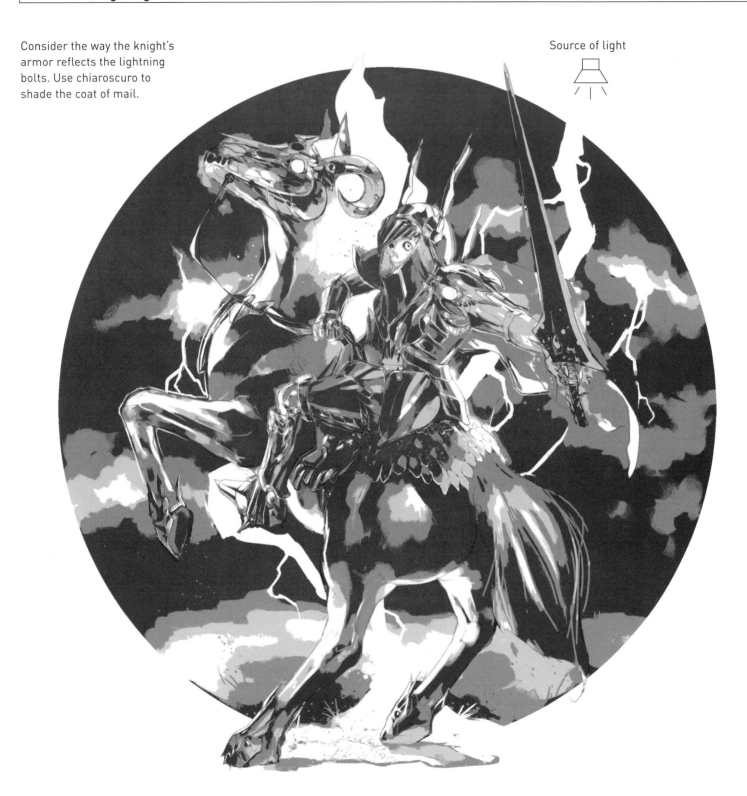

Use color to recreate the sword's
reflection on the armor and to
suggest movement.

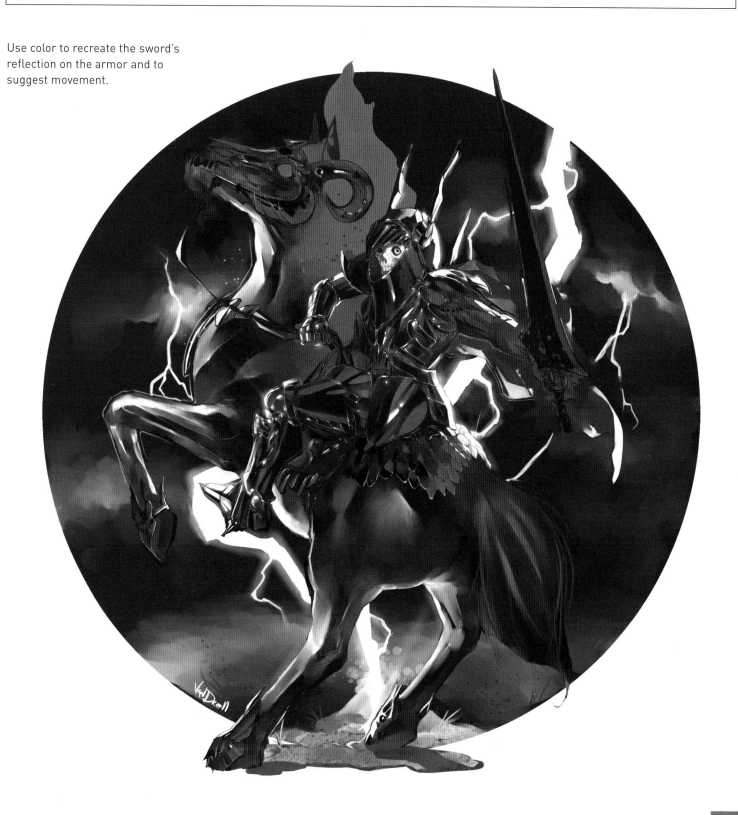

We would like to thank

The members of Ikari Studio would like to especially thank our friends and girlfriends for their unconditional support: to the first for forgiving us for not going out partying with them so often, and to our girlfriends for taking care of us while we were living huddled between pencils and computers.

Thanks to Japan for treating us like kings throughout our stay. We'll never forget you.

Thanks to our families for finally taking us seriously: yes, yes, being an illustrator can actually become a profession.

Finally, once again, thanks to all the people who inspire us every day and help us become better.

Thanks to everyone.